Arts and Crafts objects

MANCHESTER
1824

Manchester University Press

STUDIES IN
DESIGN

general editor
Christopher Breward

founding editor:
Paul Greenhalgh

Arts and Crafts objects

Imogen Hart

Manchester University Press

Manchester and New York

distributed in the United States exclusively by Palgrave Macmillan

Published by Manchester University Press
Oxford Road, Manchester M13 9NR, UK
and Room 400, 175 Fifth Avenue, New York, NY 10010, USA
www.manchesteruniversitypress.co.uk

Distributed in the United States exclusively by
Palgrave Macmillan, 175 Fifth Avenue, New York,
NY 10010, USA

Distributed in Canada exclusively by
UBC Press, University of British Columbia, 2029 West Mall,
Vancouver, BC, Canada V6T 1Z2

British Library Cataloguing-in-Publication Data
A catalogue record for this book is available from the British Library

Library of Congress Cataloging-in-Publication Data applied for

ISBN 978 0 7190 7971 9 hardback
ISBN 978 0 7190 7972 6 paperback

First published 2010

The publisher has no responsibility for the persistence or accuracy of URLs for any external or third-party internet websites referred to in this book, and does not guarantee that any content on such websites is, or will remain, accurate or appropriate.

Typeset in ITC Giovanni by
Koinonia, Manchester
Printed in Great Britain by
CPI Antony Rowe, Chippenham, Wiltshire

For my parents, for my brother, Alex, and for Stephan

Contents

List of plates

List of figures

Acknowledgements

This book was made possible by the generosity of the Arts and Humanities Research Council of Great Britain, which funded my doctoral research, and the Yale Center for British Art, which assisted with the illustration costs. I am grateful to all my colleagues at the Yale Center for British Art for their support, particularly Amy Meyers, Lisa Ford and Martina Droth. Thanks are also due to the staff and anonymous readers at Manchester University Press, with whom it has been a pleasure to work.

I am indebted to everyone who assisted me on my research visits: at Manchester City Art Galleries, Howard Smith and Ruth Shrigley; at Manchester Metropolitan University, Stephanie Boydell, Jeremy Parrett and John Davis; at the William Morris Gallery, Peter Cormack, Amy Clarke and Carien Kremer; at Kelmscott House, Mr and Mrs Birney. I would also like to acknowledge the helpful staff at the National Trust, the Society of Antiquaries of London, the Whitworth Art Gallery, the Hammersmith and Fulham Archives, the National Art Library, the Archive of Art and Design, Manchester Central Library, and the British Library. All those who helped me to acquire illustrations, especially Charles Gariepy, deserve particular thanks. I am also grateful to the convenors and audiences of conferences at which I presented parts of this research.

I have benefited from the guidance and support of marvellous teachers and colleagues. Eleanor Robbins and Kate Dodd first introduced me to the discipline of art history; studying under Alison Wright and Frederic J. Schwartz at University College London convinced me that I wanted to stay in the world of academia a little longer; and as a graduate student, I was lucky enough to find myself in the Department of History of Art at the University of York. I remember with gratitude the many productive conversations I enjoyed with members of the department, particularly Jane Hawkes and Michael White. Since then I have appreciated helpful discussions with scholars in the Yale community and beyond, including Tim Barringer, Jo Briggs, Michael Hatt, Morna O'Neill, Catherine Roach, Peter Trippi, Alicia Weisberg-Roberts and Andrea Wolk Rager. I would especially like to thank Elizabeth Prettejohn and Edward S. Cooke, Jr., for their advice and encouragement. Above all, at York I had the enormous good fortune to acquire not one but two outstanding PhD supervisors, David Peters Corbett and Jason Edwards.

I could not have asked for better advisers or friends than Jason and David have been to me.

Speaking of friends, I would like to thank Saskia, John and Marina Barnden, Rachel Boyd, Amy Evans, Natalie Mera Ford, Beth Hurran, Charmaine Lee, Marisa Ling, David Milne, Marcia Vliet and Melissa Williams. Deborah, Peter and Piers Sanders have been wonderfully supportive in-laws. Finally, Julia, Stephen and Alex Hart, and my amazing husband Stephan Sanders, have all put up with endless conversations about Arts and Crafts objects and offered insightful feedback. They continually inspire me to look at the world in new ways and this book is dedicated to them with love and gratitude.

Abbreviations

AAD	Archive of Art and Design
ACES	Arts and Crafts Exhibition Society
AWG	Art Workers' Guild
BL	British Library
HF	Hammersmith and Fulham Archives and Local History Centre
MCL	Manchester Central Library
MMF & Co.	Morris, Marshall, Faulkner & Co.
MMU	Manchester Metropolitan University
NAAAI	National Association for the Advancement of Art and its Application to Industry
NAL	National Art Library
RMI	Royal Manchester Institution
TIC	Technical Instruction Committee

Introduction

Definitions

'Arts and Crafts' and 'objects'

THIS IS A BOOK about looking at objects. While this sounds like a pretty straightforward task, it is not as simple as it appears. In the first place, there are different kinds of looking. These chapters identify, track and experiment with a specific way of looking that developed in the Victorian period in Britain. In the second place, although the Victorians were busy looking at objects in sophisticated ways, the possibilities for resurrecting those methods of looking have been under-explored. This is particularly true in the case of the 'Arts and Crafts movement'. A standard account of the 'movement', and the objects associated with it, would focus on the politics of production rather than the experience of Arts and Crafts viewers. This is a pity because what we see when we look at Arts and Crafts objects in the present could, if we took the time, be not so very far from what the Victorians saw. What might we learn about the ways the Victorians saw the world if we took seriously 'our sensory overlap'?[1] How do we reconcile that 'a work of art belongs to the past as soon as it has been made' with the fact that 'its beauty is in the present moment of the observer's judgement'?[2] These questions are risky because they raise awkward issues. Looking closely is associated with connoisseurship; focusing on reception rather than production implies a celebration of consumerism; and taking beauty into account may appear politically irresponsible.[3] Academic discomfort with all of these things – connoisseurship, consumerism and beauty – makes looking at Arts and Crafts objects far from simple.

Before we begin looking at them, we need to define what 'Arts and

Crafts objects' are. Both 'Arts and Crafts' and 'object' are loaded terms. 'Object' brings to mind all kinds of associations, from the French objet d'art, with its implications of collecting,[4] to Michael Fried's famous and controversial assertion that 'a work of art' is 'in some essential respect *not an object*'.[5] As these examples demonstrate, 'objects' have a complex relationship with 'art'. The 'objects' discussed in this book usually fall into the category known as 'decorative art'. The division of the arts into 'fine' or 'high' or 'liberal' art versus 'decorative' or 'applied' or 'useful' art had had a long history by the beginning of the Victorian period.[6] Categorisation was usually defined by medium. Broadly speaking, painting, sculpture and architecture belonged to the fine arts, and all other media, including metal, ceramics, textiles and glass, belonged to the 'decorative arts'.[7] Membership of the fine art category tended to confer higher social and intellectual status.[8] In the late nineteenth century, however, many artists and theorists were challenging this hierarchical system and campaigning for greater equality between those who practiced so-called 'fine' and so-called 'decorative' art. The forthcoming chapters therefore discuss many objects that existed on the boundary between the fine and the decorative, raising questions about appropriate ways of looking.

If painting, sculpture and architecture are 'fine' art, then decoration is non-fine art. Designer Lewis Foreman Day adopts this terminology in his book title, *Every-day Art: Short Essays on the Arts Not Fine* (1882). In the Victorian period, this category was designated by a number of alternative, and equally unsatisfactory, terms, including 'decorative art', 'useful art', 'applied art' and 'industrial art'.[9] For consistency's sake, this book will use 'decorative art' to refer to the 'arts not fine'.

The sophisticated methodologies we have for interpreting the 'fine' arts of painting, sculpture and architecture are seldom applied to the 'decorative' arts. Art history rarely takes decorative objects seriously as the focus of visual analysis. As Nancy Troy has observed, 'Historians of modern art have generally failed to acknowledge the significance of the decorative arts in their own right.'[10] This book aims to address this deficiency by experimenting with new ways of examining and interpreting decorative art.

'Objects', then, are things that fall into the 'decorative art' category. 'Arts and Crafts', meanwhile, calls to mind a movement with the same name. The 'Arts and Crafts movement' is a title that can be applied to developments in both architecture and decorative art. Many accounts of

Arts and Crafts focus on its architecture. According to Ray Watkinson, for example, the 'Arts and Crafts Movement's' most 'significant' figures are 'those whose roots, like Morris's, are in architecture'. Watkinson adds, 'Even in the founding of the various bodies which sprang into being to promote the recognition of the craftsman and designer, it was the architects who played the most important part.'[11] Similarly, Alan Crawford claims, 'It is impossible to imagine the Arts and Crafts Movement without architecture.' This, he explains, is because 'buildings can do so much that the Arts and Crafts wanted to do'; 'like no other work, they can create atmosphere'.[12] Crawford is right to highlight the importance of 'atmosphere' in Arts and Crafts contexts, but his restriction of 'atmosphere' to architecture overlooks the crucial role of the interior. This book will demonstrate that Arts and Crafts interiors were expected to, and did, 'create atmosphere'.

Arts and Crafts objects and Arts and Crafts architecture raise very different questions. For this reason, this book does not seek to cover both objects and architecture, or to focus on the latter. Because many of the key secondary texts on Arts and Crafts are primarily, or at least substantially, concerned with architecture, this book returns the focus to objects. An important issue for this book is the status of 'decorative art', a problem that architecture, being a 'fine art', does not face.

For the purposes of this book, 'Arts and Crafts objects' are things that fall into the conventional category of decorative art and belong, in some way or another, to a context associated with the 'Arts and Crafts movement'.

The 'Arts and Crafts movement'

Accounts of the 'Arts and Crafts movement' are inconsistent and sometimes contradictory. One of the aims of this book is to expose the limitations of the concept of the 'Arts and Crafts movement' and to explore alternative ways of contextualising Arts and Crafts objects. For this reason, the phrase 'Arts and Crafts movement' never appears in this book outside inverted commas. Chapter 1, 'Arts and Crafts precursors', examines the prehistory of Arts and Crafts objects with a new goal in mind. Instead of seeking the sources of an 'Arts and Crafts movement', it explores how the attitude to objects found in Arts and Crafts contexts was developed in earlier decades.

A thorough re-evaluation of the usefulness of the concept of the 'Arts and Crafts movement' requires us to reassess what is generally considered

to be most securely within its remit. If we know anything about the 'Arts and Crafts movement' at all, we know that the Arts and Crafts Exhibition Society (ACES), founded in 1887, was its 'public face',[13] and we know that William Morris was its most famous protagonist.[14] That is why William Morris and the ACES take up three of the forthcoming five chapters (2, 3 and 4). These chapters explore what is revealed about Arts and Crafts objects when we examine these contexts without assuming that they belong to an 'Arts and Crafts movement'. The Manchester Municipal School of Art, the subject of the fifth chapter, is at first glance a less obvious place to look for Arts and Crafts objects, but the contents of its Arts and Crafts museum link it firmly to the other contexts discussed, and many of the people we meet earlier in the book find their way to the Manchester School at some point. Of course, there are numerous other contexts that could have taken its place as the final case study in this book if the only criteria for selection were connections with William Morris and/or the Arts and Crafts Exhibition Society. The reason for choosing the Manchester Municipal School of Art is that, rich as its Arts and Crafts connections are, it complicates the story in important ways. It comes out of the Schools of Design system, and as such would conventionally be categorised as part of an industrial design reform trajectory rather than as part of the 'Arts and Crafts movement'.[15] This straightforward division of nineteenth-century design into separate and supposedly incompatible tendencies is misleading. The forthcoming chapters argue for a more integrated history of Victorian design, one that allows for networks of influence and exchange, and one that takes objects seriously as evidence, rather than seeking to subordinate them to overarching concepts such as movements. Writing about an 'Arts and Crafts movement' tends to suppress the individual, perceivable features of objects, since one example will often do just as well as another to illustrate the textually founded concept of a movement. This book challenges the homogenisation of Arts and Crafts objects that results from their categorisation as part of a movement by looking at specific objects in specific contexts.

As well as using objects as evidence, the following chapters bring to light unfamiliar visual and textual sources and synthesise little-used sources in new ways. Rich primary sources survive relating to William Morris, Morris & Co., the Arts and Crafts Exhibition Society, and the Manchester School of Art. This book looks afresh at Arts and Crafts

contexts by returning to both the objects and the archives without taking for granted the existence of an 'Arts and Crafts movement'.

The phrase 'Arts and Crafts movement' is generally used in the scholarship as though its meaning were universally understood and its definition stable.[16] Yet the concept of the 'movement' remains frustratingly vague.[17] For example, there is no general consensus on the chronology of the 'Arts and Crafts movement'. One explanation for this is that the phrase 'Arts and Crafts movement' does not appear in print until 1896. Any claims about an 'Arts and Crafts movement' manifesting itself before 1896 must, therefore, be based on hindsight. The earliest use of the phrase is in Walter Crane's book, *Of the Decorative Illustration of Books Old and New* (1896).[18] Crane seems to have been particularly attracted to the concept of 'movements' and uses the word 'movement' to mean different things in different circumstances. For example, he often uses it to refer to the 'socialist movement'.[19] The prominence of the word in socialist circles may have encouraged him to apply it in an artistic context. This is important because in the history of the Arts and Crafts Exhibition Society up to 1897, it is almost always Crane who uses the word 'movement'.[20] One reason why this may have been overlooked is that Crane was responsible for writing the introductions to the early ACES catalogues. Since these catalogues are a major primary source for researching the ACES, Crane's declarations may have been interpreted as official manifestoes of the 'movement'.[21] As we shall see, however, conflict was not uncommon within the ACES.

Chapter 4 looks more closely at the genealogy of the ACES and the use of the word 'movement' in this process. For now, the important point is that however keen Crane may have been to trace one or more artistic movements, his enthusiasm for the concept does not mean that the existence of such movements was necessarily widely acknowledged. Even if other members of the Society did support Crane's use of the term 'movement', its meaning in that context is far from clear. There are thus two important historical reasons to reassess the usefulness of the 'Arts and Crafts movement' as a concept. First, the phrase 'Arts and Crafts movement' was not used until 1896. Secondly, although the word 'movement' was used in connection with the ACES in the late 1880s, it was used to mean different things in different situations.

Because of the lack of firm evidence relating to the Victorian perception of an 'Arts and Crafts movement', scholars have had to remain

imprecise in their definitions.[22] It is unclear, for example, whether objects or institutions hold the key to the 'movement'. Three different passages from Alan Crawford's writing on the subject demonstrate that even the most erudite and distinguished of Arts and Crafts scholars encounter this difficulty. Crawford acknowledges that 'Arts and Crafts was not an organised movement with definite goals, like women's suffrage or other political movements.'[23] Elsewhere, discussing a photograph of the 1890 Arts and Crafts exhibition (figure 1), Crawford observes:

> The exhibits stretch one's sense of what is Arts and Crafts; because the Society was started before many of the small workshops set up in the wave of Arts and Crafts enthusiasm of the 1890s, it drew many of its exhibits in the early days from the craftsmen generated by the architectural and art movements of the 1870s and from existing firms 'identified with decorative work'.[24]

Crawford thus claims that we have a 'sense' of what 'Arts and Crafts' objects look like, and that some of the objects in this photograph do not fit that image. This suggests that objects define Arts and Crafts. Later, however, Crawford examines some of W. A. S. Benson's work, observing that his 'smooth and regular' objects 'seemed to make a feature of their machine origins'.[25] Crawford claims that this seems to conflict with Arts and Crafts ideals. Despite this, Crawford defends Benson's position in the 'movement': 'Yet he was undoubtedly a part of the Movement, a founder member of the Art Workers' Guild, one of the architects … of the Arts and Crafts Exhibition Society, and a member of the Morris circle.'[26] This suggests that objects do not define Arts and Crafts, and that participation in the 'movement' is defined instead by involvement in certain groups and organisations. As long as the notion of the 'Arts and Crafts movement' remains both undefined and uncriticised, it will be more of a hindrance than a help: despite our awareness that it was not 'an organised movement with definite goals', we will continue trying to define it nevertheless, and risk falling into circularity. Our current understanding of the 'movement' languishes in a paradox. The concept of the 'Arts and Crafts movement' is both independent of and dependent on its organisations and its objects.

Even though it is difficult to pin down, the concept of the 'Arts and Crafts movement' remains a powerful one. Movements are neat ways of

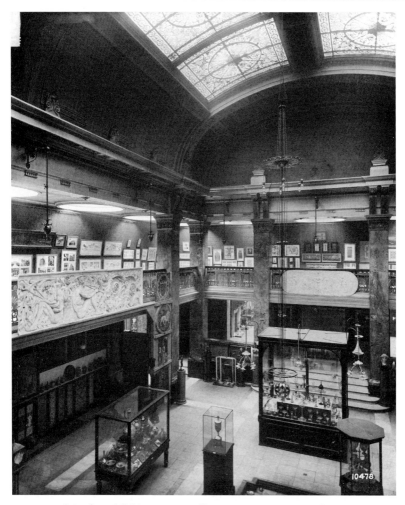

1 Arts and Crafts Exhibition, New Gallery, Regent Street, London, 1890.

organising history and it is easy to see why the 'Arts and Crafts movement' is an appealing idea. It could be argued that we have much to gain, and little to lose, by continuing to link events, people and things together under the heading of the 'Arts and Crafts movement'. We may, however, have more to lose than we think. The first thing we risk losing is historical

accuracy. As we have seen, no one has yet shown that the sense of an 'Arts and Crafts movement' existed before 1896, and even then we do not know how widely, or how quickly, that idea spread, or what precisely was understood by the phrase. The second thing we risk losing is a fuller picture of the decorative arts in the Victorian period. While the concept of a 'movement' brings things together in helpful ways, it also does a good job of keeping other things out. The rich and complex interrelationships between supposedly separate 'movements' are likely to remain unexplored if we persist in looking at Arts and Crafts objects through the lens of an 'Arts and Crafts movement'. This book acknowledges the difficulties that Arts and Crafts historians encounter in defining their field and takes seriously the implications of those difficulties by questioning the helpfulness of the 'Arts and Crafts movement' as a tool for analysing the history of this period.[27]

The 'Arts and Crafts' label

Of course, there are problems even with the term 'Arts and Crafts', as some scholars recognise.[28] 'Arts and Crafts' has evolved into a phrase with the properties of an adjective. We read about 'Arts and Crafts designers', 'Arts and Crafts architecture', 'Arts and Crafts interiors', and 'Arts and Crafts furniture', yet it is unclear what precisely these groups have in common, particularly since it is generally agreed that no stylistic pattern can be identified.[29] Consequently, each of the major texts on the 'Arts and Crafts movement' seeks to establish a non-visual connection between its products. The adjective 'Arts and Crafts' is generally used to tell a reader that something is associated with certain ideas. Drawing on standard accounts, we might summarise these 'ideas' as a rejection of mass-produced, machine-decorated goods and the uninventive mimicry of past styles in favour of individuality, hand-craftsmanship and awareness of the different qualities of different materials, combined with a resistance to the practice of designating certain arts as 'higher' than others.

Yet, in spite of how widespread this assumption has been, the ease with which an object can be associated with a specific set of ideas is not readily apparent. Does an object necessarily represent the ideas of the person who made it? If we answer 'yes' to this question, we face new ones: Does any object count, or only those made by certain recognised processes? Can any person make objects that will represent their ideas,

or only certain recognised types of people? Moreover, how do we identify which of an individual's countless ideas should be included among those associated with the objects they make? These are just some of the limitations of 'Arts and Crafts' as an adjective. Instead of signalling something about the intrinsic qualities of the objects it is attached to, all it tells us is that those objects are judged to be suitable illustrations of what different people who shared certain key ideas made.[30]

As illustrations, Arts and Crafts objects could be defined through biography (for example, 'Morris, who believed x, also made a; his ideas developed and eventually became y, during which period he made b'). They might also be defined socio-historically (for example, 'In the late nineteenth century, many people thought z; some of them were artists, and observed z in their working processes, producing things such as c and d'). In this context, if we know that a tapestry is designed by Morris, for example, our acceptance of its 'Arts and Crafts' status can legitimately predate our encounter with the object itself. If we then discover that the designer of a given wallpaper, previously thought to be n, who violently opposed Morris's politics, was in fact Morris himself, this shift in attributed authorship would be entirely responsible for the wallpaper acquiring the 'Arts and Crafts' label. If we accept the view that Arts and Crafts was about 'ideas' rather than objects,[31] then, because ideas belong to people, we must first identify an Arts and Crafts idea in an object's maker before we can apply the phrase to the object itself.

This simple view that the Arts and Crafts label is based on the known ideology of a known maker encounters problems of its own. The lack of a known maker does not prevent something from being described as an 'Arts and Crafts' object. Although catalogues accompanying the Arts and Crafts exhibitions strove to list the designer, executor and exhibitor of each work, many objects were and are known only under the name of a company or group (for example, the Guild and School of Handicraft) rather than that of an individual designer. As Morris recognised, the objects at the Arts and Crafts exhibitions were often the product of a group of people working together, or in succession. It was impossible, he protested in 1893, to mention everyone involved in the creation process.[32] For scholars of Arts and Crafts, this raises the problem that it is difficult to ascertain whether each person involved in a particular object's creation was supportive of, indifferent to, or even opposed to Arts and Crafts ideas, leaving that

object's status as an Arts and Crafts product unstable. The justification for applying the label must, here, be that the company or group is identified with a certain ethos by its representatives, and that the products it sells and/or makes are therefore presumed to be consistent with that ethos, or are at least advertised as such. In this situation, there must be something about the object that recommends it; this can either be a quality displayed by the object itself or the conditions under which it is known to have been created. The latter of these possibilities demonstrates that an 'Arts and Crafts object' need not have been made or designed by someone with Arts and Crafts ideas. It is enough that the object is perceived to be consistent with those ideas.

Justifying the Arts and Crafts label on the grounds of a direct object-maker relationship therefore proves impractical. Perhaps a more appropriate definition would be one that could incorporate objects whose makers carry out their work according to Arts and Crafts principles, without necessarily supporting those principles themselves. Once again we run into problems, however, since information about the production process is not guaranteed to be readily available. Even if a company or group promotes Arts and Crafts ideas, we cannot take that as evidence that it would have sold and/or made no object produced under conditions inconsistent with those ideas. The Arts and Crafts label tells us, it seems, only that an object is associated with – designed, made, exhibited, sold or owned by – someone who expressed Arts and Crafts ideas. What the Arts and Crafts label helps us to do only in a restricted way is to make sense of an aesthetic encounter with the objects themselves. We might look for evidence of irregularity – a feature associated with handmade objects – or admire the artist's choice of a design that embraces the characteristic qualities of the material. The conclusion we would draw from such an examination – that the work fulfils certain criteria associated with the 'Arts and Crafts movement' – could potentially be the same for every Arts and Crafts object presented to us.

When it is seen as shorthand for the 'Arts and Crafts movement', the 'Arts and Crafts' label risks restricting interpretation and facilitating circular arguments. This book explores what happens when we try to separate the phrase 'Arts and Crafts' from assumptions about a 'movement'. There is an important difference between identifying connections between things and pulling those things together as part of a 'movement'. Similar debates

have taken place regarding the status of the terms 'Aesthetic movement' and 'Aestheticism'.[33] Elizabeth Prettejohn outlines the various positions that have been taken on this subject.[34] For example, she cites Ruth Z. Temple's declaration that 'there was no movement' we can call 'Aesthetic', either in literature or in painting, and R. V. Johnson's decision to call it a 'tendency' instead of a 'movement'.[35] There are, of course, separate issues at stake in the cases of the Aesthetic and Arts and Crafts 'movements'. For one thing, as Prettejohn observes, 'Aesthetic movement' has tended to refer to the 'decorative' arts, while 'Aestheticism' has been employed by critics in the field of literature and 'fine' art.[36] There is no similar division in Arts and Crafts.

This book does not argue, with reference to Arts and Crafts, that 'there was no movement'. It does, however, insist that it is far from clear what 'movement' means in the context of either 'Aesthetic' or 'Arts and Crafts'. Hesketh Pearson writes that 'there was no such thing as the Aesthetic Movement' because 'the aesthetes' were not 'banded together to pursue a common object, which is the usual meaning of the word "Movement"'.[37] On the other hand, Ormond argues that it is 'untrue to say, like Hesketh Pearson, that "there was no such thing as the aesthetic Movement", if "movement" is thought of, not as a coherent group, but as a mood affecting large numbers of people'.[38] This lack of certainty about what 'movement' actually means reduces the usefulness of the phrase 'Arts and Crafts movement'. In other words, 'movement' is more of a problem than 'Arts and Crafts'. There are striking connections between certain people, objects and contexts to which it is customary to attach the 'Arts and Crafts' label. They may not all have shared a 'common object' or even a 'mood', and they may also have had connections to people, objects and contexts that are usually considered separate from, sometimes antagonistic towards, the 'Arts and Crafts movement'. While remaining critical of its limitations, then, this book does use the 'Arts and Crafts' label.

Pearson's reference to a 'common object' raises the possibility of an alternative interpretation of the title *Arts and Crafts objects*. This book is concerned with plural objects. This plurality applies to the material things discussed: the book is not concerned with identifying and analysing *the* Arts and Crafts object. It also applies to objectives. Rather than singling out a single 'common object' for a 'movement', the book is concerned with the multiple, changing, and sometimes contradictory 'objects', or

objectives, of Arts and Crafts contexts.

This book recognises that one of the most important objectives of Arts and Crafts contexts was to open up new ways of engaging with decorative art for both makers and users. It is important to acknowledge this fundamental aspect of Arts and Crafts because its approach to objects was arguably revolutionary. Discussing the idea that the Royal Academy should incorporate 'arts and crafts and *objets d'art'*, one author observed, 'there is no provision for the applied arts, which are entirely out of their scope'.[39] The 'applied arts' had been separated from, and subordinated to, the 'fine arts' since the sixteenth century.[40] By subjecting decorative and fine art to similar modes of analysis, Arts and Crafts contexts thus challenged convention. This book seeks to demonstrate that encouraging people to look at decorative art in new ways is one of the most important Arts and Crafts 'objects'.

The stories so far

Arts and Crafts and modernism

One of the most influential accounts of Arts and Crafts is, of course, Nikolaus Pevsner's *Pioneers of Modern Design: From William Morris to Walter Gropius* (1960).[41] Without suggesting that Walter Gropius's output is visually similar to Morris's, Pevsner constructs a story of influence that sees the implications of Morris's principles finding their fullest expression in the work of Gropius.[42] The notion of connection without imitation is one that we encounter repeatedly in relation to this period, both in primary sources and in the secondary literature. In Pevsner's view, Gropius was influenced by Morris in a theoretical and ideological sense. 'Morris', Pevsner tells us, 'had started the movement by reviving handicraft as an art worthy of the best men's efforts' and 'the pioneers about 1900 had gone further by discovering the immense, untried possibilities of machine art. The synthesis, in creation as well as in theory, is the work of Walter Gropius'.[43] According to Pevsner, Morris made a crucial contribution to the modern movement by drawing attention to the importance of the applied arts. 'We owe it to him', Pevsner writes, 'that an ordinary man's dwelling-house has once more become a worthy object of the architect's thought, and a chair, a wallpaper, or a vase a worthy object of the artist's imagination'.[44] Pevsner thus acknowledges that developing new ways of

looking at decorative art is one of the important legacies of Arts and Crafts. Pevsner also recognises Morris's social and political motivations, arguing that in asking the question, 'What business have we with art at all unless all can share it?',[45] Morris showed himself to be 'the true prophet of the twentieth century'.[46] When it first appeared, Pevsner's argument was, as Peter Faulkner observes, 'unexpected'.[47] Once radical, Pevsner's approach has now become the familiar and conventional story of Arts and Crafts, since many subsequent accounts have followed his lead in situating Arts and Crafts, often represented by Morris, at the beginning of a story of modernism.

For example, Gillian Naylor's *The Arts and Crafts Movement: A Study of its Sources, Ideals and Influence on Design Theory* (1971) takes this approach. Naylor is interested in identifying the common 'ideals' embodied by otherwise disparate products, which allows her to disregard their stylistic dissimilarities. Towards the end of her book, Naylor explores how Arts and Crafts feeds into modernist architecture and design in the USA and Europe. She writes, 'The ways and means differ, as does the nature of the compromise between aesthetic, commercial and functional requirements; but the ideal, as defined by Moholy-Nagy remains the same: to "lay down the basis for an organic system of production whose focal point is man, not profit".'[48] The link is presented explicitly as a theoretical one. Naylor argues that the 'humanising of technology' and the 'harnessing of its achievements to social ends' became the priority of 'the twentieth-century inheritors of Morris's ideals' and adds that 'on this basic level there are obvious similarities between British theory, and that, for example, of Le Corbusier and Gropius'.[49]

Guided by Pevsner's and Naylor's accounts, we are accustomed to thinking about Arts and Crafts as the beginning of something. One of the tasks of this book is to explore how it might rather, in many respects, be considered the culmination of something.[50] Although it is widely acknowledged that the 'Arts and Crafts movement' had roots earlier in the century, this book seeks to examine the history of Arts and Crafts more closely by reassessing the development of Arts and Crafts approaches to objects from the 1830s onwards (see Chapter 1).

Naylor claims that 'those who drew their inspiration from Ruskin' can be categorically distinguished from all the other groups influenced by this range of sources. This conviction that the 'Arts and Crafts movement' can

be defined against contemporary events in such a watertight way makes sense when we consider that Naylor's book presents the 'movement' as a primarily theoretical and 'moral' one.[51] This preoccupation is reflected in the title, which places emphasis on 'ideals' and on 'design theory', indicating a preference for ideas over objects. Similarly, in the book itself, theoretical analysis is accompanied by very little discussion of the objects themselves.

Pevsner's and Naylor's method of convincingly bringing together examples from across the history of modern design that seem in many ways dissimilar can also be employed when looking at the different examples that make up Arts and Crafts. The lack of a consistent style among its products is made up for by the common principles demonstrated in each case. Arts and Crafts objects have thus been considered collectively, in terms of the principles they embody, which explains why it has rarely seemed necessary to examine specific objects.

The continuing influence of Pevsner's and Naylor's modernist historiography may be partly accounted for by an academic bias towards a modernism centred on continental Europe and the United States.[52] With hindsight, the connections between these chronologically and geographically distant phenomena are undoubtedly striking, despite stylistic dissimilarities. Yet some recent accounts do not serve to re-establish the Pevsnerian assumption that Arts and Crafts can be best understood as a precursor of modernism.[53] Alan Crawford, for example, suggests that a more 'profitable approach would be to examine its links with other more obviously sympathetic and contemporary arts'.[54] This book develops that alternative view by demonstrating that a deeper understanding of all aspects of Arts and Crafts can be achieved by looking at its relationship not only with things still to come, and thus unknown to its protagonists, but also with the past.

Elizabeth Cumming and Wendy Kaplan's *The Arts and Crafts Movement* (1991) challenges some aspects of the Pevsnerian approach, while at the same time adopting others. Cumming and Kaplan write that 'few now accept' Pevsner's view of 'Arts and Crafts as an antecedent of Modernism, to which it had contributed a functionalist and stripped-down aesthetic'.[55] Having said this, they nevertheless draw their Arts and Crafts story to a close with a discussion of its various continental manifestations and, finally, its influence on modernist institutions such as the Bauhaus. It

may, then, be the idea that Arts and Crafts initiated a 'functionalist and stripped-down aesthetic' that Cumming and Kaplan are taking issue with rather than its projected role as 'an antecedent of Modernism', which their account of the movement's legacy to Europe tacitly takes for granted.

Cumming and Kaplan's book makes an important point, however, about Pevsner's perception of Arts and Crafts objects. Where he seems to see 'a functionalist and stripped-down aesthetic', those without his agenda see something different. Perhaps Pevsner's one-sided view of Arts and Crafts can be explained by what Louise Purbrick calls his 'dislike of decoration', as displayed most strongly in *Pioneers*, which, in Purbrick's words, is 'a history' of how decoration was 'pressed out of objects until they were properly modern'.[56]

Another respect in which Cumming and Kaplan follow Pevsner's and Naylor's example is in their incorporation of a vast range of work under the Arts and Crafts title. Their book covers both British and American Arts and Crafts, and while some chapters discuss 'craft', others focus specifically on architecture. By seeking to tell the story of Arts and Crafts architecture and applied art in both Britain and America, as well as accounting for the collective influence of these developments in Europe, Cumming and Kaplan require the kind of broad definition of 'Arts and Crafts' established in Pevsner's and Naylor's work. In order to unite this range of material in a meaningful way, Cumming and Kaplan avoid looking at any one example too closely. Approaches of this kind synthesise material and highlight historical connections in important ways. Close analysis of specific examples must be sacrificed in such an approach, however, since anything that does not support the argument's general claims about what Arts and Crafts is must be ignored, de-selected, or downplayed.

Arts and Crafts and beauty

There is an implicit assertion in many secondary accounts of Arts and Crafts that it was not concerned with the appearance of things. Historiographically, this appears to result from three tendencies. First, it is common to find a firm division forged between Arts and Crafts and Aestheticism. Beauty is so fundamental to Aestheticism that attempts to reinforce this dichotomy minimise the role of aesthetics in Arts and Crafts. As we have seen, a second key approach is to see Arts and Crafts as a forerunner of modernism. In order to do this, the appearance of objects must be relegated to the

background, in favour of theories and ideologies that can be reinterpreted in modernist terms. As a result, the aesthetics of Arts and Crafts objects have been seen as less important than the 'proto-modernist' ideas of their makers. A third common approach to Arts and Crafts objects is to situate them within a left-wing politics. With its implications of a denial of luxury, this method seems to demand that the role of aesthetics in Arts and Crafts be suppressed.

Crawford claims that 'The Arts and Crafts was less concerned with what things look like, with style, than with how they were made.'[57] The repeated emphasis on production rather than reception, which runs through the existing literature, leaves an important aspect of Arts and Crafts objects under-examined. This book argues that a concern with 'what things look like' was fundamental to what we call Arts and Crafts.

Some scholars have looked closely at the characteristics of individual Arts and Crafts objects.[58] This book does something slightly different. It looks at objects in context in order to understand how their characteristics functioned in particular circumstances. As Wendy Hitchmough has argued, the 'issue of context and consumption is crucial to a rounded understanding of the work.'[59] Her book, *The Arts and Crafts Home*, considers the ways in which Arts and Crafts interiors fitted into the routines of Victorian domestic life. Hitchmough cites Hermann Muthesius, who declares in *The English House* (1904) that 'The most striking characteristic that the foreigner notices about the English is that their patterns of life are immutable and fixed for all time.'[60] In *The Arts and Crafts Home*, Hitchmough 'explains how the decoration and furnishing of different rooms was specifically tailored to enhance domestic ceremonies and to create settings for social behaviour.'[61] Concerned with the uniformity identified by Muthesius, Hitchmough explores how Arts and Crafts objects relate to social norms shared by a large number of people. While this book is similarly based on the premise that the 'issue of context is crucial', it looks at a small number of specific contexts in order to gain a deeper understanding of how certain objects worked together in complex ways.

The productive interrelation of objects in Arts and Crafts contexts relates to the concept of 'organicism'. As the forthcoming chapters will demonstrate, Arts and Crafts objects frequently belong to an organic whole, where each part has a role to play in relation to the others. In Arts

and Crafts contexts we cannot understand the objects fully without considering those relationships. The idea of 'organicism' has political implications of collectivity and harmony, of course, as Raymond Williams has argued extensively.[62] In observing the interrelationships between objects in these situations, this book does not propose that a self-conscious political position is necessarily being taken by the agents involved. What it does aim to do is to leave open the possibility that this recurring concern with parts and wholes has implications for our understanding of the relationship between aesthetics and politics during the period. In taking seriously the aesthetics of Arts and Crafts objects, this book contributes to an aesthetic 'turn' in art history that challenges what Prettejohn has helpfully described as 'the late-twentieth-century view of beauty as irrevocably opposed to any form of responsible politics'.[63]

Arts and Crafts and Aestheticism

As later chapters will demonstrate, looking closely at Arts and Crafts objects and interiors leads inevitably into explorations of other 'movements', most notably Aestheticism. As S. K. Tillyard observes, 'The Arts and Crafts Movement is pitched successively against the Aesthetic Movement and art nouveau.'[64] The standard view of the relationship between Arts and Crafts and the Aesthetic movement is that the two were fundamentally opposed to one another.[65] When discussing the relationship between Arts and Crafts and Art Nouveau, Joanna Banham *et al.* observe 'the difficulty of distinguishing between the two', but nevertheless strive to draw a firm line between them. They conclude:

> The simplest way to analyse the two is to regard the Arts and Crafts Movement as an essentially ideological expression and Art Nouveau as a purely aesthetic manifestation. Whereas the Arts and Crafts Movement had its origins in the Gothic Revival, Art Nouveau developed from the Aesthetic Movement.[66]

Lambourne makes a similar assumption in relation to *The Studio* magazine. He claims that it was 'an ideal platform for the promulgation of both Art Nouveau style, and Arts and Crafts ideology'.[67] Both accounts situate Arts and Crafts and Art Nouveau in a dichotomy of ideology versus style. Banham *et al.* construct a neat division of Victorian design into separate, linear patterns of events: the Gothic Revival and Arts and Crafts belong

to one story, and the Aesthetic movement and Art Nouveau belong to another.

This type of simplified interpretation has been challenged by some scholars. Hitchmough, for example, argues that 'there were no rigid divisions between Arts and Crafts and Aesthetic ideals in the nineteenth century'.[68] She supports this claim by pointing to similarities between the theories of Morris and Oscar Wilde.[69] Similarly, Tillyard seeks to show that 'there was a middle ground' between Arts and Crafts and Aestheticism where 'ideas and impulses from both movements were fused or held in active tension'.[70] The interrelation between Arts and Crafts and Aestheticism is self-evident in *The House Beautiful: Oscar Wilde and the Aesthetic Interior* (2000) by Charlotte Gere and Lesley Hoskins. 'The influence of William Morris' is presented there as one of the 'Origins of the Aesthetic Movement' and a significant proportion of the 'Aesthetic' interiors feature arguably 'Arts and Crafts' objects.[71] In Gere and Hoskins's context, Arts and Crafts objects are considered important primarily for their contribution to our understanding of Wilde's aesthetic (and Aesthetic) position. As well as investigating this relationship, *The House Beautiful* functions as a kind of compendium or sourcebook, providing an overview of the vast range of interior styles recorded in text and images during the period. By presenting this material together in one volume, Gere and Hoskins draw attention to the difficulty of separating out the products of supposedly distinct movements on purely visual grounds.

This book takes further the reassessment of the relationship between Arts and Crafts and other tendencies. Like Tillyard, it aims to 'get away from a model of change which is essentially linear'.[72] Tillyard's priorities are similar to Pevsner's and Naylor's, in that she is interested in recasting Arts and Crafts as the precursor of a version of modernism. Unlike Pevsner and Naylor, however, her focus is not on the international 'modern movement' in architecture and design, but on early modernism in England between 1910 and 1914. She argues that Roger Fry and his associates made Post-Impressionism 'intelligible' to an English audience by using Arts and Crafts 'language' and 'criteria' to 'describe and evaluate' it. When investigating Arts and Crafts, Tillyard's attention is directed towards identifying links between the audiences of Arts and Crafts and the audiences of early modernism. While Tillyard's book provides an important precedent for problematising the commonly simplified division of Arts and Crafts from

Aestheticism, an account primarily concerned with seeking out the 'roots' of a version of modernism tells only part of the story. One of the tasks of Chapter 1 is to look back at the prehistory of Arts and Crafts, rather than forwards to a modernism whose superior interest is taken for granted, in order to understand how its development can be related to supposedly separate contemporary tendencies, including Aestheticism.

Arts and Crafts and gender

One account that reaffirms the concept of an 'Arts and Crafts movement' but deviates from the conventional story is Anthea Callen's *Angel in the Studio: Women in the Arts and Crafts Movement, 1870–1914* (1979). Callen draws attention to the absence of women in standard histories of Arts and Crafts. Her book thus takes its place alongside other feminist accounts of the 1970s and 1980s that seek to return women to the art-historical canon.[73] Yet it also makes a point that is specific to Arts and Crafts scholarship. Callen observes that 'The history of the Arts and Crafts movement has been traditionally studied and understood within the confines of the history of its leaders.'[74] The exclusion of women from Arts and Crafts histories is another by-product of the same tendencies that have excluded objects. The importance given to architecture in Arts and Crafts histories means that the figures who have received the most attention are architects, who are almost always male.[75] This, combined with the modernist Morris-to-Gropius trajectory, has served to characterise Arts and Crafts scholarship as concerned primarily with a small number of high profile, powerful men.[76] In prioritising architecture over objects, the literature, certainly before 1979, has dealt less often with the activities in which women played an important part. The same thing happens when we adopt the modernist perspective that Arts and Crafts was important primarily for its influential ideas, since it was in practice, as Callen demonstrates, that the role of women was particularly significant (although, as this book will show, May Morris is one example of a woman whose contributions were both practical and theoretical).

The modernist view of Arts and Crafts associates it with a left-wing political stance that is 'avant-garde' in its refusal to respect the traditional boundaries between art and craft (and between artist and craftsperson) and in its endeavour to democratise access to art. The assumption is that the socialist aspects of Arts and Crafts are unquestionably progressive. As

Callen demonstrates, however, socialism often proved surprisingly hostile to feminism,[77] and Emma Ferry observes that some high profile Arts and Crafts men appear at times positively 'misogynistic'.[78] While some socialists, such as Morris, were supportive of gender equality, others, such as J. Bruce Glasier, took a more conventional view.[79] Callen observes that in Glasier's history of the socialist movement, 'the women were shown in typically feminine roles while the men were involved in the politics'.[80] Socialist accounts of Arts and Crafts have thus often overlooked feminism as an equally progressive force. If we turn our attention away from 'ideas' to objects, we find that Arts and Crafts is avant-garde in other ways, apart from its (sometimes) socialist agenda. For example, as Callen points out, it provided 'a crucial sphere of work and thereby autonomy and personal creativity for large numbers of middle-class women'.[81] When we focus on specific objects and contexts, the vital role of women in Arts and Crafts becomes clear. As we shall see, women are key players in most of the contexts examined in this book.[82]

The William Morris connection

Some of the most thorough accounts of Arts and Crafts objects have resulted from investigations that do not use the 'Arts and Crafts movement' as their starting point. A popular alternative starting point is Morris. While our view of Morris is no freer from preconceptions than our view of Arts and Crafts, beginning with Morris rather than Arts and Crafts puts a different slant on interpretation. Morris appears in every chapter of this book, and in two he plays a central role. Fiona MacCarthy's comprehensive biography, *William Morris: A Life for Our Time* (1994), argues that Morris was a more complex (and perhaps contradictory) figure than any of the numerous 'specialist' accounts of him have suggested.[83] The present volume argues that Morris's objects can no more be accommodated to a simple ideological framework than can Morris himself. Only by acknowledging the inconsistencies in and between the contexts in which Morris made and used objects can we hope to arrive at a fuller understanding of Morris's position and of how his objects relate to the rest of the material we call Arts and Crafts.

The William Morris connection complicates the 'Arts and Crafts movement'. Morris is present in every account of Arts and Crafts, but he is not always assigned the same role. Some versions see Morris as the beginning of Arts and Crafts, a view that is reflected in the common claim

that Red House, the home he designed with Philip Webb, and lived in from 1860–65, is 'the first Arts and Crafts building'.[84] Others cast him, often alongside Ruskin, as an influence.[85] For example, Pevsner states, 'The Arts and Crafts Movement originated in the eighties as a direct outcome of Morris's teachings'.[86] Part of the problem lies in the linearity of the 'movement' concept. Arts and Crafts cannot be conveniently divided into a beginning, a middle and an end. It is tempting to try to describe it as such, slotting key figures into place at certain stages in the timeline. Yet attempts to do this, particularly with Morris, do not really work. Morris's contribution cannot be summed up in one context or episode, such as Red House, Morris & Co., or socialism. Even after his death in 1896, Morris's influence is explicitly and implicitly present in Arts and Crafts contexts, as we shall see. One reason why Morris plays such an important role in this book is simply that history has made him an indispensable feature of Arts and Crafts. Another is that highlighting Morris's paradigmatic contradictions and inconsistencies draws attention to the complexities of Arts and Crafts more broadly.

This kind of reassessment of Morris's objects is only made possible by the invaluable primary research into Morris's *oeuvre* that has been carried out over the last half-century. Peter Floud's articles of the 1950s and early 1960s are concerned with charting the development of Morris's style and investigating the relationship between his patterns' formal characteristics and their chronology.[87] Barbara Morris's publications of the 1960s seek to establish a factual account of Morris's products and their histories.[88] More recently, Linda Parry has catalogued Morris's textiles, providing researchers with easily accessible reproductions and detailed information about individual patterns.[89] These contributions, among others, help us to match specific objects to specific contexts, and to see an individual object in the context of the rest of Morris's output in that particular medium. In investigating the precise conditions of specific contexts associated with Morris, this book is indebted to that formidable body of research.

Arts and Crafts objects: the continuing story

The chapters of this book proceed in roughly chronological order, as far as the most important contexts discussed are concerned, although the periods covered in each chapter overlap considerably. Chapter 1 explores

how the approach to decorative objects in Arts and Crafts contexts develops between the 1830s and the 1880s. Chapter 2 examines the interiors of William Morris's two major homes between the 1870s and his death in 1896, Kelmscott Manor (1871–96) and Kelmscott House (1878–96), while Chapter 3 considers the role of objects at Morris's firm, Morris, Marshall, Faulkner & Co. (MMF & Co.), founded in 1861 and later reconstituted as Morris & Co. Chapter 4 examines the Arts and Crafts Exhibition Society (ACES), from its beginnings in the late 1880s to around 1910. Chapter 5 explores the Arts and Crafts Museum at the Manchester Municipal School of Art, focusing mainly on the period 1898–1903, but also investigating the earlier history of the School. Finally, the Conclusion considers how we might begin to explore the legacies of Arts and Crafts ways of looking at decorative objects.

While, on one level, the case-study chapters have an intentionally tight focus, at the same time they have breadth in four important ways: in terms of the time span covered; in terms of the broader design histories with which they interrelate; in terms of the range of objects discussed; and in terms of the audiences implicated. The book as a whole covers the 1830s to the 1910s, and each individual chapter explores a wide time span within this overall period. For example, Chapters 4 and 5 examine the development of the Arts and Crafts Exhibition Society and the Manchester School of Art over several decades, and during this time their histories intertwine with others, such as the histories of the Royal Academy, the crafts and industrial design. In order to understand the case studies discussed as fully as possible, the chapters necessarily look beyond them to the worlds they intersect with. Chapter 2, for example, considers the ways in which Morris's homes have been reconceptualised to support specific agendas, weaving the historiography of Kelmscott Manor and Kelmscott House into broader historiographies, particularly that of modernism. A wide range of objects is implicated within these histories, including carpets, wallpapers, furniture, ceramics, textiles, metalwork and glass. The chapters also investigate how these different media work together in a variety of interior settings. A broad spectrum of audiences, markets and influences come into play. Chapter 1, for example, explores important debates about public taste and also investigates how objects are mediated to a general audience through home decoration manuals. Chapter 3, meanwhile,

examines the perception of different markets in Morris & Co.'s publicity. The intersection of these contexts with other histories and related markets and discourses broadens the book's scope, even while the chapters focus on the specificity of individual objects and particular contexts.

By focusing on the visual aspects of Arts and Crafts objects, and foregrounding the modes of looking that were promoted in the chosen case studies, this book does not seek to privilege the visual over other aspects of design. At the turn of the twenty-first century, aesthetics started to become a compelling subject in art history, partly because it was formerly undervalued in that discipline.[90] Similarly, aesthetics and visual analysis are important tools to bring to the study of Arts and Crafts objects because their relevance has previously been severely underplayed in this field. While this book's way is certainly not the only way of approaching Arts and Crafts objects, it is a new one in the secondary literature and also fully consistent with the surviving evidence relating to the contexts discussed. If this book encourages scholars to return to Arts and Crafts objects, and to the history of nineteenth-century British design, with a fresh perspective, it will have succeeded.

Notes

1 Jules Prown, *Art as Evidence: Writings on Art and Material Culture* (New Haven and London: Yale University Press, 2001), p. 93.

2 Elizabeth Prettejohn, *Beauty and Art, 1750–2000* (Oxford: Oxford University Press, 2005), p. 202.

3 Prettejohn, *Beauty and Art*, pp. 9–10.

4 *Oxford Dictionary of English* (Oxford: Oxford University Press, 2nd edn, 2006).

5 Michael Fried, 'Art and Objecthood' (1967), reprinted in *Art and Objecthood: Essays and Reviews* (Chicago and London: University of Chicago Press, 1998), pp. 151–2 (italics original).

6 See, for example: 'Art', *Chambers' Cyclopaedia: Or, an Universal Dictionary of Arts and Sciences* (London: D. Midwinter, 1738) [unpaginated]; *The Complete Dictionary of Arts and Sciences* (London: printed for the authors, 1764), p. viii; and *Encyclopaedia Edinensis* (Edinburgh: J. Anderson, jun., 1827), p. 465.

7 See Isabelle Frank (ed.), *The Theory of Decorative Art 1750–1940: An Anthology of European and American Writings* (New Haven and London: Yale University Press, 2000), p. 4.

8 See *The Complete Dictionary of Arts and Sciences*, p. viii; Nikolaus Pevsner,

Academies of Art, Past and Present (Cambridge: Cambridge University Press, 1940), p. 243; and Edward Lucie-Smith, *The Story of Craft: The Craftsman's Role in Society* (Oxford: Phaidon, 1981), p. 165.

9 See *Encyclopaedia Britannica* (Edinburgh: A. & C. Black, 9th edn, 1875–89), p. 639; *Encyclopaedia Britannica* (Edinburgh: A. Bell and C. Macfarquhar, 1st edn, 1771), p. 349; William Morris, 'The Arts and Crafts of To-day' (1889), an address delivered in Edinburgh before the National Association for the Advancement of Art and its Application to Industry (NAAAI), *The Collected Works of William Morris, with Introductions by His Daughter May Morris*, 24 vols (London: Longmans, Green & Co., 1910–15), XXII (p. 359); and Sir Philip Magnus, 'Some Notes on the Training of Industrial Artists', in NAAAI, *Transactions of the National Association for the Advancement of Art and its Application to Industry 1888–1891* (New York and London: Garland, 1979).

10 Nancy Troy, *Modernism and the Decorative Arts in France: Art Nouveau to Le Corbusier* (New Haven and London: Yale University Press, 1991), p. 1.

11 Ray Watkinson, *William Morris as Designer* (London: Studio Vista, 1967), p. 69.

12 Alan Crawford, 'The Arts and Crafts Movement', in Crawford (ed.), *By Hammer and Hand: The Arts and Crafts Movement in Birmingham* (Birmingham: Birmingham Museums and Art Gallery, 1984), p. 9.

13 Fiona MacCarthy, *William Morris: A Life for Our Time* (London: Faber and Faber, 1994), p. 593.

14 See Pevsner, *Academies of Art*, p. 264 and Peter Stansky, *Redesigning the World: William Morris, the 1880s and the Arts and Crafts* (Princeton, N. J.: Princeton University Press, 1985), p. 37.

15 For example, see Gillian Naylor, *The Arts and Crafts Movement: A Study of its Sources, Ideals and Influence on Design Theory* (London: Studio Vista, 1971), p. 19.

16 One rare suggestion of a doubt that the 'movement' was an unequivocal fact can be found in Charles Harvey and Jon Press, *William Morris: Design and Enterprise in Victorian England* (Manchester: Manchester University Press, 1991), p. 185.

17 Linda Parry, for example, calls the title 'nebulous' in *Textiles of the Arts and Crafts Movement* (London: Thames and Hudson, 1988), p. 7.

18 Walter Crane, *Of the Decorative Illustration of Books Old and New* (London and New York: George Bell & Sons, 1896), p. 242. For more on Crane, see Isobel Spencer, *Walter Crane* (London: Studio Vista, 1975) and Greg Smith and Sarah Hyde, *Walter Crane: Artist, Designer and Socialist* (London: Lund Humphries in association with the Whitworth Art Gallery, University of Manchester, 1989). Stansky suggests that Crane had used the phrase in 1888, claiming that the talk Crane gave at the 1899 Arts and Crafts exhibition entitled 'The Arts and Crafts Movement: Its Several Tendencies and Possible Outcome' had also been

given at the first exhibition in 1888 (*Redesigning the World*, pp. 217–18 and 260; see ACES Catalogue, 1899, p. 9). Yet no record of this is found in the list of lectures in the 1888 exhibition catalogue, in Crane's autobiography, or in the *Pall Mall Gazette*'s review of the 1888 lecture. In the 1888 catalogue, Crane's lecture title is '"Design" and Presidential Address' (ACES Catalogue, 1888, p. 12); in his autobiography, Crane refers to his lecture on 'Design' (Crane, *An Artist's Reminiscences* (London: Methuen & Co., 1907), p. 302); and the *Gazette* describes it as a 'Lecture on Design' ('The Close of the Arts and Crafts: Mr Walter Crane's Lecture on Design', *Pall Mall Gazette* (30 November 1888), p. 3).

19　See, for example, Crane, *An Artist's Reminiscences*, pp. 256–7. For more on Crane's socialism, see Spencer, *Walter Crane*, pp. 141–58 and Morna O'Neill, 'Paintings from Nowhere: Walter Crane, Socialism, and the Aesthetic Interior', in Jason Edwards and Imogen Hart (eds), *Rethinking the Interior, 1867–1896: Aestheticism and Arts and Crafts* (Aldershot: Ashgate, forthcoming).

20　By 1897 we find another member of the ACES, T. J. Cobden-Sanderson, using the word 'movement' (Archive of Art and Design, London (hereafter AAD), ACES Papers, AAD 1/43 – 1980, ACES minute book, 16 February 1897, p. 225). From this date onwards *The Studio* also uses the word in its reviews of the ACES exhibitions (for example, see 'The Arts and Crafts Exhibition', *The Studio*, IX (1897), p. 55).

21　O'Neill observes of Crane that 'his thinking evolved in such a way that his understanding of art and politics became strikingly singular, even when compared to artists and writers with whom he sympathised' ('Walter Crane: The Arts and Crafts, Painting, and Politics, 1870–1890', manuscript in preparation, p. 1).

22　See Stansky, *Redesigning the World*, p. 12, and Joanna Banham, Sally MacDonald and Julia Porter, *Victorian Interior Design* (London: Cassell, 1991), p. 170.

23　Crawford, introduction to Felicity Ashbee, *Janet Ashbee: Love, Marriage, and the Arts and Crafts Movement* (Syracuse, N. Y.: Syracuse University Press and London: Eurospan, 2002), p. xxiv.

24　Crawford, 'The Arts and Crafts Movement', in Crawford (ed.), *By Hammer and Hand*, p. 11.

25　Crawford, 'The Arts and Crafts Movement', in Crawford (ed.), *By Hammer and Hand*, p. 14.

26　Crawford, 'The Arts and Crafts Movement', in Crawford (ed.), *By Hammer and Hand*, p. 15.

27　For an additional discussion of this issue, see Imogen Hart, '"The Arts and Crafts Movement": *The Century Guild Hobby Horse* (1884–94), *The Evergreen* (1895–7), and *The Acorn* (1905–6)', in Peter Brooker and Andrew Thacker (eds), *The Oxford Critical and Cultural History of Modernist Magazines*, I (Oxford: Oxford University Press, 2009).

28 For example, see Parry, *Textiles*, p. 7.

29 For example, see Alan Crawford, 'The Arts and Crafts Movement in Context', in S. M. Wright (ed.), *The Decorative Arts in the Victorian Period* (London: Society of Antiquaries of London, 1989), p. 95.

30 For more on the potential of objects to carry meaning, see Penny Sparke, *Design in Context* (London: Bloomsbury, 1987), especially p. 8.

31 For example, see T. J. Cobden-Sanderson, *The Arts and Crafts Movement* (London: Hammersmith Publishing Society, 1905), p. 29.

32 Hammersmith and Fulham Archives and Local History Centre, London (hereafter HF), DD/341/319 a–c, 'Art, Craft and Life: A Chat with William Morris', *Daily News Chronicle* (9 October 1893). See Chapter 3.

33 For more on Aestheticism, see Elizabeth Aslin, *The Aesthetic Movement: Prelude to Art Nouveau* (London: Elek, 1969); Robin Spencer, *The Aesthetic Movement: Theory and Practice* (London: Studio Vista, 1972); Jonathan Freedman, *Professions of Taste: Henry James, British Aestheticism, and Commodity Culture* (Stanford, Calif.: Stanford University Press, 1990); Talia Schaffer and Kathy Psomiades (eds), *Women and British Aestheticism* (Charlottesville and London: University Press of Virginia, 1999); Jason Edwards, *Alfred Gilbert's Aestheticism: Gilbert amongst Whistler, Wilde, Leighton, Pater and Burne-Jones* (Aldershot: Ashgate, 2006); and Elizabeth Prettejohn, *Art for Art's Sake: Aestheticism in Victorian Painting* (New Haven and London: Yale University Press for the Paul Mellon Centre for Studies in British Art, 2007).

34 Elizabeth Prettejohn, 'Introduction' to Prettejohn (ed.), *After the Pre-Raphaelites: Art and Aestheticism in Victorian England* (Manchester: Manchester University Press, 1999).

35 Prettejohn, 'Introduction' to Prettejohn (ed.), *After the Pre-Raphaelites*, p. 2. See Ruth Z. Temple, 'Truth in Labelling: Pre-Raphaelitism, Aestheticism, Decadence, Fin de Siècle', *English Literature in Transition*, XVII: 4 (1974), pp. 218–19 and R. V. Johnson, *Aestheticism* (London: Methuen, 1969), p. 46.

36 Prettejohn, 'Introduction' to Prettejohn (ed.), *After the Pre-Raphaelites*, p. 4.

37 Hesketh Pearson, *The Life of Oscar Wilde* (London: Methuen, 1946), p. 43.

38 Leonée Ormond, *George du Maurier* (London: Routledge and Kegan Paul, 1969), p. 247.

39 'The Arts and Crafts in France', *Magazine of Art* (1904), p. 95. Martina Droth points out that 'Smaller Decorative Work' (as it was referred to by William Thomas Whitley, *Art Journal* (1898), p. 302) was displayed at the Academy, but that provision was 'hardly extensive and certainly did not amount to an inclusive policy' ('The Statuette and the Role of the Ornamental in Late Nineteenth Century Sculpture' (PhD thesis, University of Reading, 2000), p. 191, n. 45).

40 See Stuart Macdonald, *The History and Philosophy of Art Education* (London: University of London Press, 1970), p. 17.

41 This was a revised and partly rewritten version of *Pioneers of the Modern Movement* (1936).

42 For more on the importance of 'principles' in decorative art theory, see Frank, 'Introduction' in Frank (ed.) *Theory of Decorative Art*, pp. 2, 6 and 7–8. See also Chapter 1, notes 67 and 112, and Chapter 5.

43 Nikolaus Pevsner, *Pioneers of Modern Design: From William Morris to Walter Gropius* (Harmondsworth, Middx: Penguin, 1960), p. 38.

44 Pevsner, *Pioneers*, pp. 22–3.

45 J. W. Mackail, *The Life of William Morris*, 1899, 2 vols (London: Longmans, Green & Co., 1901), II, p. 99.

46 Pevsner, *Pioneers*, p. 22.

47 Peter Faulkner, 'Pevsner's Morris', *Journal of William Morris Studies*, XVII: 1 (Winter 2006), p. 52.

48 Naylor, *Arts and Crafts Movement*, p. 10. See Laszlo Moholy-Nagy, *The New Vision*, 1928, trans. Daphne M. Hoffman (New York: Wittenborn, Schultz, 4th revised edn, 1947), p. 16.

49 Naylor, *Arts and Crafts Movement*, p. 178.

50 Stuart Durant emphasises how Morris, for example, can be seen in a concluding role rather than, in Pevsnerian style, as a 'prophet' of the future. Durant claims that Lewis F. Day 'evidently saw Morris not as the sole crusader against philistinism, but rather as the culminating figure in a wider movement that had resolved to revitalise decorative art' ('William Morris and Victorian Decorative Art', in Design Council, *William Morris and Kelmscott* (London: Design Council, 1981), p. 63). See Day, 'The Art of William Morris', *Easter Art Annual*, extra number of the *Art Journal* (1899), p. 2.

51 Naylor, *Arts and Crafts Movement*, p. 19.

52 Many accounts that do not explicitly adopt a Pevsnerian approach nevertheless take some of his premises for granted. For instance, when discussing the Great Exhibition of 1851, Asa Briggs writes that 'The "things" that Morris made or praised sometimes point in their design to the 'modern movement' of the twentieth century; the ostentatious "things" of 1851, whatever their inspiration, belong unmistakeably to the mid-nineteenth century' (*Victorian Things* (London: Batsford, 1988), p. 53). Briggs thus affirms Pevsner's view of Morris as prophet of the twentieth century as well as his dismissive judgement on the contents of the Great Exhibition (see Chapter 1 of this book). This is despite Briggs's claim that Pevsner's emphasis on Morris as a key inspiration for the 'modern movement' involves 'more than a touch of exaggeration' (p. 27).

53 For example, Parry's extensive work on Arts and Crafts is not dependent on a modernist agenda. Frank's *Theory of Decorative Art*, although not concerned specifically with Arts and Crafts, also questions the Pevsnerian approach.

Frank writes that accounts such as *Pioneers* 'are useful for constructing narratives of artistic and architectural reform but overlook the larger contribution of nineteenth-century British reformers to the development of decorative art theory as a whole – not just that of Modernism' (p. 131). See also Simon Jervis, *High Victorian Design* (Woodbridge, Suffolk: Boydell Press, 1983), p. 8 and Christopher Reed, *Bloomsbury Rooms: Modernism, Subculture, and Domesticity* (New Haven and London: Bard Graduate Center/Yale University Press, 2004), p. 8.

54 Crawford, 'The Arts and Crafts Movement', in Crawford (ed.), *By Hammer and Hand*, p. 24.

55 Elizabeth Cumming and Wendy Kaplan, *The Arts and Crafts Movement* (London: Thames & Hudson, 1991), p. 7.

56 Louise Purbrick, 'Introduction' to Purbrick (ed.), *The Great Exhibition of 1851: New Interdisciplinary Essays* (Manchester: Manchester University Press, 2001), p. 11.

57 Alan Crawford, *C. R. Ashbee: Architect, Designer and Romantic Socialist* (New Haven and London: Yale University Press, 1985), p. 208.

58 For instance, see Richard and Hilary Myers, *William Morris Tiles: The Tile Designs of Morris and his Fellow Workers* (Shepton Beauchamp, Som.: Richard Dennis, 1996) and Parry, *Textiles*.

59 Wendy Hitchmough, *The Arts and Crafts Home* (London: Pavilion, 2000), p. 11.

60 Hitchmough, *Arts and Crafts Home*, pp. 8–10. See Hermann Muthesius, *The English House*, 1904, ed. Dennis Sharp and trans. Janet Seligman, with a Preface by Julius Posener (London: BSP, 1987), p. 69.

61 Hitchmough, *Arts and Crafts Home*, p. 7.

62 Raymond Williams, *Culture and Society: Coleridge to Orwell*, 1958 (London: Hogarth, 1987). Williams argues that Edmund Burke established 'the idea of what has been called an "organic society", where the emphasis is on the interrelation and continuity of human activities, rather than on separation into spheres of interest, each governed by its own laws' (p. 11). He lists five common uses of the concept: to emphasise 'wholeness' in society; to strengthen the notion of a 'people'; to refer to 'natural growth' (of culture, for instance); in opposition to 'mechanist' and 'materialist' approaches to society; and to refer to a society 'in close touch with natural processes' (pp. 263–4).

63 Ivan Gaskell, 'Beauty', in Robert S. Nelson and Richard Shiff (eds), *Critical Terms for Art History* (Chicago and London: University of Chicago Press, 2nd edn, 2003), p. 279 and Prettejohn, *Beauty and Art*, pp. 9 and 203. See Imogen Hart, Review of Elizabeth Prettejohn, *Beauty and Art*, *Visual Culture in Britain*, VIII: 1 (Summer 2007).

64 S. K. Tillyard, *The Impact of Modernism 1900–1920: Early Modernism and the Arts and Crafts Movement in Edwardian England* (London: Routledge, 1988), p. xvi.

65 Peter Faulkner, *Against the Age: An Introduction to William Morris* (London: Allen and Unwin, 1980), p. 102.

66 Banham *et al.*, *Victorian Interior Design*, p. 177.

67 Lionel Lambourne, *The Aesthetic Movement* (London: Phaidon, 1996), p. 216.

68 Hitchmough, *Arts and Crafts Home*, p. 12. See also Edwards, *Alfred Gilbert's Aestheticism*, p. 14.

69 Hitchmough compares Morris's famous dictum, 'Have nothing in your houses that you do not know to be useful or believe to be beautiful' ('The Beauty of Life' (1880), *Works*, XXII, p. 77) with the following statement from Wilde: 'have nothing in your houses that has not been a joy to the man who made it, and is not a joy to those that use it' (Oscar Wilde, 'Art and the Handicraftsman', *Essays and Lectures* (New York and London: Garland, 1978), p. 190). See Hitchmough, *Arts and Crafts Home*, p. 12.

70 Tillyard, *Impact of Modernism*, p. xvi.

71 Lambourne situates Morris and the 'Aesthetic movement' in a similar relationship. He writes, 'The foundation of Morris & Co. was a key event at the dawn of the Aesthetic Movement' (*Aesthetic Movement*, p. 18).

72 Tillyard, *Impact of Modernism*, p. xv.

73 For example, see Griselda Pollock, *Vision and Difference: Feminism, Femininity and the Histories of Art* (London: Routledge, 1988). Pollock famously argues that 'what modernist art history celebrates is a selective tradition which normalises, as the *only* modernism, a particular and gendered set of practices' (p. 50, italics original).

74 Anthea Callen, *Angel in the Studio: Women in the Arts and Crafts Movement, 1870–1914* (London: Astragal, 1979), Preface.

75 Emma Ferry states that Rhoda and Agnes Garrett 'were the first English women to train in an architect's office and subsequently to work professionally as "house decorators"'. Both women, Ferry observes, were 'active Suffragists' ('"Decorators May be Compared to Doctors": An Analysis of Rhoda and Agnes Garrett's *Suggestions for House Decoration in Painting, Woodwork and Furniture* (1876)', *Journal of Design History*, XVI: 1 (2003), p. 17).

76 Banham *et al.* observe that one result of accounts, like Pevsner's, that 'emphasise progressive developments', is 'to place undue stress on the importance of individual design heroes' (*Victorian Interior Design*, p. 9).

77 Callen, *Angel in the Studio*, p. 215.

78 Ferry, '"Decorators May be Compared to Doctors"', p. 25. Ferry cites Charles Eastlake, *Hints on Household Taste*, 4th edn, 1878, with a new Introduction by John Gloag (New York: Dover, 1969), pp. 8–9 (see Chapter 1 for more on Eastlake) and Christopher Dresser, *Principles of Decorative Design* (London: Cassell, Petter and Galpin, 1873), pp. 1–2. See also Lewis Foreman Day, 'The

Woman's Part in Domestic Decoration', *Magazine of Art* (1881) and 'Decoration by Correspondence', *Art Journal* (1893), p. 85.

79 See J. Bruce Glasier, *William Morris and the Early Days of the Socialist Movement*, 1921 (Bristol: Thoemmes, 1994). For more on Glasier, see Peter Faulkner, 'Introduction' to Glasier, *William Morris*, pp. v–xiii and E. P. Thompson, *William Morris: Romantic to Revolutionary* (London: Merlin Press, revised edn, 1977). MacCarthy observes that 'Attitudes to women amongst Morris's craftsman followers were in general much more conservative than Morris's own' (*William Morris*, p. 593).

80 Callen, *Angel in the Studio*, p. 215.

81 Callen, *Angel in the Studio*, p. 221.

82 For more on women in Arts and Crafts, see Jan Marsh, 'May Morris: Ubiquitous, Invisible Arts and Crafts-woman', in Bridget Elliott and Janice Helland (eds), *Women Artists and the Decorative Arts 1880–1935: The Gender of Ornament* (Aldershot: Ashgate, 2003) and Isabelle Anscombe, 'The Blessed Damozel', in Anscombe, *A Woman's Touch: Women in Design from 1860 to the Present Day* (London: Virago Press, 1984).

83 MacCarthy, *William Morris*, p. viii.

84 Cumming and Kaplan, *Arts and Crafts Movement*, p. 31.

85 According to Stansky, he was both: 'Morris was not only an inspirer but a founder of the Arts and Crafts movement' (*Redesigning the World*, p. 37).

86 Pevsner, *Academies of Art*, p. 264.

87 See Peter Floud, 'William Morris as an Artist: A New View', *The Listener* (7 October 1954); 'The Inconsistencies of William Morris', *The Listener* (14 October 1954); 'Dating Morris Patterns', *Architectural Review*, CXXVI: 750 (July 1959); and 'The Wallpaper Designs of William Morris', *Penrose Annual*, LIV (1960).

88 See Barbara Morris, 'William Morris', *The Handweaver and Craftsman*, XII: 2 (Spring 1961) and 'William Morris: His Designs for Carpets and Tapestries', *The Handweaver and Craftsman*, XII: 4 (Fall 1961).

89 See Parry, *William Morris Textiles* (London: Weidenfeld and Nicolson, 1983).

90 See Prettejohn, *Beauty and Art*.

1 ✧ Arts and Crafts precursors

THIS CHAPTER CONSIDERS how we might trace the history of the approach to objects that we find in Arts and Crafts contexts. That history involves the development of sophisticated ways of looking at and engaging with objects conventionally assigned to the category of decorative art. When dealing with the question of precursors, existing studies of the 'Arts and Crafts movement' tend to be concerned with the origins of ethically motivated craft and design reform. Some of the sources identified in those accounts are relevant here, but this chapter approaches them with the specific goals of the book in mind. For example, A. W. N. Pugin and John Ruskin are usually named the initiators of Arts and Crafts. This chapter will demonstrate that alongside their moral influence, we can find in Pugin and Ruskin's writings the seeds of Arts and Crafts ways of looking.

In its search for Arts and Crafts precursors, this chapter explores the relationships between Arts and Crafts contexts and theoretical and artistic developments since the 1830s. The standard account of these relationships allows for a limited degree of influence but sees Arts and Crafts as straightforwardly distinguished from related developments by its specific moral and political agenda.[1] Hermann Muthesius takes this approach as early as 1904 in *Das englische Haus* (*The English House*).[2] A section entitled 'Up to William Morris's artistic reformation' is followed by 'William Morris: the development through him and beside him', even though many of the figures he discusses in the first section, including Owen Jones, Bruce Talbert, Christopher Dresser and E. W. Godwin, remained active and influential after Morris came on the scene.[3] In contrast to simplified accounts of this kind, the chapter seeks to attain a thorough understanding of how Arts and Crafts ways of seeing developed from earlier debates and activi-

ties. As we shall see, the range of material upon which Arts and Crafts contexts drew raises the question of how – and whether – their prehistory can or should be distinguished from other related histories, such as that of the Aesthetic movement.

In discussing Arts and Crafts precursors, standard accounts conventionally mention certain trends in nineteenth-century design in order to demonstrate what the 'Arts and Crafts movement' was reacting against. For example, the Schools of Design and the Great Exhibition of 1851 frequently fulfil this function.[4] Even the design reform led by Henry Cole and Owen Jones is usually marginalised because of its industrial basis and its perceived lack of an explicitly political agenda. This chapter will revisit these mid-century events to show how they, like Pugin and Ruskin's writings, contain some of the roots of Arts and Crafts approaches to objects. A reassessment of the role of the Schools of Design (later Schools of Art) is particularly important for this book, since one of its case studies is the Manchester School of Art (see Chapter 5).

Having examined the roles these sources play as Arts and Crafts precursors, the chapter explores further the development of Arts and Crafts ways of looking. To do this, it analyses books offering advice on home decoration that were published between the 1860s and the 1880s. It argues that the viewing paradigms embodied by Arts and Crafts contexts can be linked to the practices encouraged by these taste manuals. It also demonstrates that the authors of the taste manuals seem to have had high expectations of their readers' ability to analyse objects, suggesting that the perception of decorative art as meriting close looking was becoming widespread during this period, paving the way for the Arts and Crafts contexts discussed in later chapters.

The Schools of Design

Schools of Design were set up in major manufacturing cities across the United Kingdom from 1837 onwards.[5] Largely government-funded, their purpose was to train designers to produce goods that could compete in an international marketplace.[6] The Schools were the result of a Select Committee inquiry begun in 1835, which was motivated by serious concerns that the quality of British design was highly inferior to that of French design.[7] The inquiry aimed to discover how the aesthetic quality

of British manufactured goods, as measured against continental imports, might be improved. The Select Committee's orders were 'to inquire into the best means of extending a knowledge of the Arts, and of the Principles of Design, among the People (especially the Manufacturing Population) of the Country; also to inquire into the Constitution, Management and Effects of Institutions connected with the Arts'.[8] The Report of the Select Committee of Arts and Manufactures, issued in 1836, concluded that successful design depended on the existence of accessible museums displaying examples of high quality design and the provision of good education and training for designers.' Even before the Report was published, it was decided that countrywide Schools of Design were the answer.[10] Attached to some of these schools were museums of decorative art, most notably, from 1852, the Museum of Ornamental Art at Marlborough House (which was relocated and renamed the South Kensington Museum in 1857 and later, in 1899, became the Victoria and Albert Museum). This institution was affiliated to the London School of Design, which had first been established in 1837 at Somerset House, in rooms previously occupied by the Royal Academy. This connection was somewhat ironic given the fraught relationship between the Academy and the decorative or industrial arts.[11]

At the beginning of the Victorian period, the key institution for art training was the Royal Academy, which, as we have seen, considered the 'applied arts' inferior.[12] As a result, ambitious artists fortunate enough to enter the Academy were guided towards painting or sculpture rather than 'decorative' media such as pottery or metalwork. The Schools of Design were concerned precisely with those arts excluded, or at least far from encouraged, by the Academy. Despite its limited recognition of the decorative arts, the Royal Academy viewed the Government's new schools with suspicion, according to George Wallis, headmaster at Manchester in the 1840s and Birmingham in the 1850s.[13] He reports that to avoid the Schools' interference with the 'standing' of Royal Academy education, it was insisted that 'no person should enter' the School of Design classes for the 'purpose of studying as a painter or sculptor'.[14] Makers of objects were therefore assigned during training to a specific role in society. Those welcomed by the Academy became associated with its 'standing', and were set on the path to becoming a fine artist. Meanwhile, training in the non-fine arts was dispensed by institutions whose target group was made

up of 'the manufacturing population', and thus the working and artisan classes.[15]

One of the main objectives in all the Arts and Crafts contexts discussed in the forthcoming chapters was to experiment with the relationship between art and decoration, and with ways of looking at each. Though it established the decorative arts as a separate category, the introduction of the Schools of Design had the potential to bring the arts closer together, since it was intended to effect a marriage of art and industry. Indeed, the Schools were renamed Schools of Art in 1853 (see Chapter 5). During the Select Committee inquiry, one interviewee made a significant distinction between well-made and well-designed objects. 'I have found generally', testified James Morrison, a Member of Parliament and businessman,[16] 'that we have been very much superior to foreign countries in respect of the general manufacture but greatly inferior in the art of design.'[17] In 1857, moreover, Wallis declared that one of the goals of the Schools was 'the improvement of our artisans in drawing as applicable to their industrial pursuits'.[18] Art was perceived as something to be brought into the manufacturing process through drawing, or *disegno*, which was also the basis of the fine art creation process, and which was prioritised at the Royal Academy.[19] The 'design' of ordinary objects was thereby linked to the production of paintings and sculptures by this skill that was deemed necessary for both.[20]

There was apparently, however, a reluctance among those in control to acknowledge this connection. Frequent changes of policy were introduced, including a swift changeover of directors, and one stage of the Schools' development, in the 1840s, involved the abolition of classes for future masters to be specially trained.[21] Consequently, individuals trained in the fine arts who were, according to Wallis, 'innocent of any love for, or knowledge of, ornamental art, with a profound contempt for art-manufacture', sought masterships in the Schools, on account of the income and status offered by these positions.[22]

It seems that the narrowing of the gap between 'fine' and 'decorative' was hampered by a general unwillingness to extend the concept of 'art' to the activities of the Schools of Design, even after they became known as Schools of Art. In 1882, looking back over the previous half-century, Wallis had become convinced that 'The great radical defect of art-education' had been the 'determination not to regard anything as a

work of art except pictures and statues'.[23] A few years later, the Arts and Crafts Exhibition Society (ACES) was formed in protest against this situation. The ACES, like the other Arts and Crafts contexts discussed in this book, participated in a debate about the perceived boundary between fine and decorative art that stretched back to the Select Committee inquiry of 1835 and the foundation of the Schools of Design. A crucial implication of the Schools of Design project was that the aesthetic quality of everyday objects mattered, a view also shared by A. W. N. Pugin and John Ruskin, as we shall see in the next section.

A. W. N. Pugin

In order to understand Pugin's and Ruskin's relevance for Arts and Crafts objects, it is helpful to begin by considering their influential ideas about the relationship between art and society.[24] Both writers assume that the social conditions of a period affect the way its products look, and that the appearance of its products in turn has an impact upon social conditions. According to Raymond Williams, this belief about the relationship between art and life underlies 'the idea of culture'.[25] This suggests that when we talk about 'culture' we assume that the products of a given society – from art and literature to technological inventions and scientific discoveries – interrelate in such a way that by examining them as a whole, we can understand something fundamental about that society. Williams argues that however natural this approach might seem to us, it is, 'essentially, a product of the intellectual history of the nineteenth century', and he cites Pugin, Ruskin and Morris as important contributors to this history.[26]

Pugin famously claims that he finds in 'Pointed' (or Gothic) architecture 'the faith of Christianity embodied, and its practices illustrated'.[27] This comment is significant for our investigation into the precursors of Arts and Crafts because it invests the visual with great potential. Pugin takes it for granted that material objects can 'embody' a state of mind ('faith') and 'illustrate' the activities performed around them. Central to Pugin's argument is that 'Pointed' or Christian architecture embodies the 'self-denying Catholic principle', which, he observes disapprovingly, has been replaced by the 'luxurious styles of ancient Paganism'.[28] In line with this, his two fundamental 'rules' or principles of architecture are that

'there should be no features about a building which are not necessary for convenience, construction, or propriety' and 'that all ornament should consist of enrichment of the essential construction of the building'.[29] Pugin adds that 'the neglect of these two rules is the cause of all the bad architecture of the present time'. Pugin goes on to argue that construction and design should be 'adapted to the material' employed.[30]

While most figures associated with Arts and Crafts do not adopt Pugin's Catholicism, many do inherit his major field of reference.[31] The Gothic, both on its own merits and as a challenge to Classicism and modernity, is upheld in Arts and Crafts contexts, most notably by Morris, as an admirable paradigm to follow. Pugin is firmly against Classicism, not only because of its pagan associations, but also because it contravenes his rules of architecture. He criticises the Greeks for ignoring the special qualities of stone, and simply retaining the same system of construction they had employed when building in wood, which consisted of a horizontal element supported by vertical columns.[32] Pugin thereby condemns the fundamental formula of Classical architecture as essentially flawed in principle.

A moral justification consistently underpins Pugin's stylistic principles. His claim that 'hinges, locks, bolts, nails, etc., which are always concealed in modern designs, were rendered in pointed architecture rich and beautiful decorations'[33] can be related to his general point that 'the severity of Christian or Pointed Architecture is utterly opposed to all deception'.[34] His insistence that flat patterns on wallpapers and carpets should not create the illusion of three-dimensionality is in line with his rule that use should govern design so as to avoid excess and therefore luxury, which is associated with paganism.[35] Pugin's overall argument thus takes for granted that visual characteristics have moral implications. As Williams observes, 'the most important element in social thinking which developed from the work of Pugin was the use of the art of a period to judge the quality of the society that was producing it'.[36] Williams sees this as a crucial respect in which Pugin influenced Ruskin, citing, in support of this argument, the latter's declaration that 'the art of any country is the exponent of its social and political virtues'.[37]

John Ruskin

Ruskin shares Pugin's admiration for restraint and his distaste for excess. He argues, for example, that 'the safeguard of highest beauty, in all visible work, is exactly that which is also the safeguard of conduct in the soul, – Temperance'.[38] It is, he explains elsewhere, 'far more difficult to be simple than to be complicated; far more difficult to sacrifice skill and cease exertion in the proper place than to expend both indiscriminately'.[39] This suggests that the most gifted artists will be able to see when the 'proper place' to hold back is reached, a skill also highly prized in Arts and Crafts contexts. Charles Francis Annesley Voysey, for example, states that 'to know where to stop and what not to do is a long way on the road to being a great decorator'.[40]

These implications of anti-eroticism, via the 'self-denying' principle, help to explain why history has tended to separate Arts and Crafts from categories associated with an embrace of sexuality, such as Art Nouveau. For example, MacCarthy observes an 'emotional suppression' in the members of the Art Workers' Guild (AWG). She claims that this 'tendency' 'explains much about the sturdy but curiously sexless character of early twentieth-century British design compared with art nouveau as it developed on the Continent and which the Art Workers viewed with an extreme disgust'.[41] I hope to demonstrate, however, that the division of Victorian design into groups that embraced the sexual and sensual (Aestheticism and Art Nouveau) and groups that did not (the Gothic Revival and Arts and Crafts) can be misleading.

To return to Ruskin, his promotion of discrimination suggests 'taste', and, like Pugin, this is something he imbues with a moral aspect. Ruskin defines taste as 'the instinctive and instant preferring of one material object to another without any obvious reason, except that it is proper to human nature in its perfection so to do'.[42] Once again we find the word 'proper', suggesting an independently existing set of rules to be followed, albeit potentially 'instinctively'. A judgement of taste becomes an indication of a person's adherence to the demands of 'human nature in its perfection'. As Williams observes, one of the most important aspects of this intellectual tradition was the idea that 'aesthetic, moral and social judgements are closely interrelated'.[43] For Ruskin, not only is cultural produce subject to moral as well as aesthetic assessment, but aesthetic perception is also

understood to have moral implications.

Like Pugin, Ruskin detests deception. His 'Architectural Deceits' include the suggestion of a different material from the one employed, in line with Pugin's insistence on respecting the characteristic qualities of each material. Ruskin also emphasises that there should be no attempt to mislead the viewer as to the amount of work undertaken. 'The use of cast or machine-made ornaments of any kind' is an Architectural Deceit because it presents an inaccurate impression of the 'quantity of labour' employed.[44]

For Ruskin, Gothic art is exemplary. He insists that for a style to be Gothic it must both express a particular state of mind and display specific characteristics. It should, he argues, combine stylistic features such as 'pointed arches, vaulted roofs, etc.' and 'certain mental tendencies of the builders, legibly expressed in it'.[45] One of the most famous of these 'mental tendencies' is 'Savageness'. Like Pugin, Ruskin defines the Gothic against Classical ornament, which he characterises as 'servile'. By this, he means that 'the execution or power of the inferior workman is entirely subjected to the intellect of the higher' in the quest for perfection.[46] Unlike Classical architecture, Ruskin argues, the Gothic displays the Christian tendency to recognise 'the individual value of every soul' and to confess 'its imperfection' by 'only bestowing dignity upon the acknowledgement of unworthiness'.[47] The 'modern English mind', moreover, shares the Greek desire for 'the utmost completion or perfection',[48] so that the 'perfectnesses' of the modern English room are signs of 'slavery'.[49]

Like Pugin, Ruskin condemns the visual characteristics of both the Classical and the modern on ethical grounds. He launches an attack on these two categories of architecture: 'the whole mass of the architecture, founded on Greek and Roman models, which we have been in the habit of building for the last three centuries, is utterly devoid of all life, virtue, honourableness, or power of doing good. It is base, unnatural, unfruitful, unenjoyable and impious'.[50] The immorality of Classical or 'perfect' modern ornament stems, for Ruskin, from the maker's inability to express his 'soul' in its creation, which means that his individual potential has been wasted. Ruskin believes that 'the work of man cannot be carelessly and idly bestowed, without an immediate sense of wrong'.[51] This explains why Ruskin feels so strongly that ornament should not give a false impression of the amount, and type, of labour expended, since the viewer

could be deceived into wrongly valuing objects for the opportunity they apparently afforded their makers to express themselves. It is thus essential for Ruskin that we can see from looking at an object how much human labour has been expended on it, since 'all objects which bear upon them the impress of the highest order of creative life, that is to say, of the mind of man ... become noble or ignoble in proportion to the amount of the energy of that mind which has visibly been employed upon them'.[52] He reiterates this elsewhere, stating that 'art is valuable or otherwise, only as it expresses the personality, activity, and living perception of a good and great human soul'.[53]

Dignifying unworthiness does not necessarily mean forsaking high quality, however. In Ruskin's system, superior performance is rewarded with greater independence. In medieval times, he observes, 'the mind of the inferior workman is recognised, and has full room for action, but is guided and ennobled by the ruling mind'. This is the truly Christian and only perfect system.'[54] Each member of such a 'system' has his place in a hierarchy. The 'inferior workman' is only free within limits imposed by the 'ruling mind', and by using the word 'inferior' Ruskin demonstrates that despite valuing the input of all 'souls', this does not mean they are equal.[55] In order to situate them in this hierarchy, Ruskin must have a set of standards to measure them by. This allows for aesthetic as well as moral judgements of objects, and explains the disdainful attitude towards amateurism we often find in Arts and Crafts.[56] Ruskin implies that a balance must be struck between liberating the worker and maintaining aesthetic standards.

As well as applying high standards to artists, Ruskin has high expectations of viewers. In an explanation that posits seeing as analogous with listening, Ruskin implicitly elevates both forms of perception to activities requiring skill, focus and sensitivity. He declares, 'that in which the perfect being speaks must also have the perfect being to listen'.[57] In other words, in the case of visual art, the communication of the most sophisticated meaning is dependent not only on the artist's ability, but also on the viewer's. While it is not Ruskin's most obvious area of influence, his insistence on the role of the viewer in making meaning contributes to the development of a model of looking within Arts and Crafts.[58]

The Great Exhibition and its aftermath

Thanks largely to Pevsner, the relationship between the Great Exhibition of 1851 and Arts and Crafts is seen as one in which the former, in its very hideousness, acted as a catalyst to rebellion.[59] In *Pioneers*, Pevsner uses the Exhibition as a kind of springboard from which to launch the bright stars of the modern movement, starting with Morris. Observing the contrast between a Morris textile and a Great Exhibition textile, Pevsner points to 'the fundamental novelty of Morris's designs'. He finds 'live understanding of decorative requirements as opposed to utter neglect of them' and 'simplicity and economy as opposed to wasteful confusion'.[60]

Pevsner continues his criticism of the Great Exhibition in *High Victorian Design: A Study of the Exhibits of 1851* (1951), where, in line with Pugin and Ruskin, he assumes that style reflects social conditions. Pevsner describes 'The Victorian curve' as 'generous', 'full' and 'bulgy', adding that it 'represents, and appealed to, a prospering, well-fed, self-confident class'.[61] Pevsner's unequivocal judgement on the Great Exhibition is summed up in one sentence from *Pioneers*: 'the aesthetic quality of the products was abominable'.[62] Such an impression certainly seems to be upheld by Morris's reported refusal, as a seventeen-year-old, to enter the Exhibition.[63]

Naylor shares Pevsner's view, arguing that the Exhibition 'shocked the design theorists into a new realisation of the enormity of the task which faced them'.[64] Although a sense that British design was inferior clearly pervaded the 1830s, leading as it did to the Select Committee of Arts and Manufactures in 1835, 1851 is usually taken as the year in which the reality of the situation was laid bare before a wider audience and in a way that could not be ignored.[65] However, a question mark regarding the appropriateness of using 1851 as a landmark has been introduced in recent scholarship.[66] Its convenience as a cut-off point may have served to mask its complexities, as I shall now go on to demonstrate.

In yet another book on the subject, *Sources of Modern Architecture and Design* (1968), Pevsner bases his assessment of the 1851 exhibits, and their reception by design reformers, partly on carefully selected quotations drawn from the *Journal of Design and Manufactures*, a publication edited by Henry Cole and Richard Redgrave.[67] While there certainly is evidence in the *Journal* of a negative response to the Great Exhibition's contents, we also find numerous admiring comments.

For example, in a series of articles entitled 'Gleanings from the Great Exhibition of 1851', approval is given to various exhibits. In one instalment, it is claimed that 'the following examples furnish most useful hints to our workers in metal'. Five examples are illustrated, and the author admires the 'taste with which the beautiful suggestions of natural forms have been conventionalised' and notes that '*direct* imitation has been throughout wisely avoided'.[68] A verdict on the Exhibition in general is offered in the *Journal* in an article entitled 'The Prospects of the British Art Manufacture as connected with the Great Exhibition', where the author observes that 'on the whole, considering the few years, comparatively, that art manufactures have been, as a system, commenced in England, it is marvellous how well our countrymen come out of the great competition in this respect'.[69] This comment implies that the contents of the Great Exhibition represent a benchmark for measuring high quality, rather than being the embodiment of bad design.

Another relatively balanced approach to the Great Exhibition's significance can be found in *The Builder*. An author identified as 'E. I.' argues for a 'Museum of Industrial Art', 'under the same roof' as the School of Design, in which the 'gems' of the Exhibition could be 'classified and arranged for constant and continuous reference, so as to make 1851 our starting point in ornamental art'. This enthusiasm is, however, qualified by the recommendation that the new institution should be located near the British Museum for comparison with the 'far exceeding superiority' of the latter building's exhibits. E. I. makes it clear that while the 'gems' of the Exhibition show promise, there is room for much improvement, and predicts that the 'contemplation' of the superior ancient examples 'in juxtaposition with our own best efforts will open our eyes to our infinite shortcomings'.[70] The *Art Journal's Illustrated Catalogue of the Exhibition* also suggests that some of the exhibits were viewed with admiration. In the Preface of that volume, it is stated that the editors have sought to 'include, as far as possible, all such as might gratify or instruct', thereby 'rendering the exhibition practically beneficial, long after its contents have been distributed'.[71]

These clues that the contents of the Great Exhibition were not seen as collectively disastrous are borne out by the fact that some of the objects were in fact purchased, added to the School of Design's small collection, and displayed from 1852 in a new museum at Marlborough House, to

which the School also moved in the same year.[72] Known as the Museum of Ornamental Art, this was the ancestor of the South Kensington Museum.[73] While this museum was not next door to the British Museum, the two were within a mile of each other.

Cole was responsible for obtaining a grant from the Board of Trade to purchase the objects. He was also a member of the selection committee along with Redgrave, Owen Jones and Pugin.[74] Cole and Redgrave represented the Department of Practical Art (later the Department of Science and Art), whose Report in 1853 states that the objects 'were selected without reference to styles, but entirely for the excellence of their art or workmanship'.[75] Naylor's claim that these men were 'unanimous in their condemnation of the exhibits' thus seems hasty.[76] The Catalogue, produced in 1852, emphasises the 'right principle[s]' displayed by the objects selected.[77]

While one member of the selection committee, Pugin, is considered a precursor of Arts and Crafts, Cole, Jones and Redgrave are seen to have little in common with early Arts and Crafts figures such as Morris. In Naylor's view, the difference lay in the fact that Cole's circle took 'a practical rather than a moral approach'.[78] To say that this group saw promise in the Great Exhibition, then, would not be to challenge the dominant view that the Exhibition evoked a primarily reactive response in Arts and Crafts contexts. Yet there are problems with this assumption. As Barbara Morris points out, even though Morris's designs are 'usually regarded as the antithesis of those of Owen Jones', he had his own copy of Jones's *Grammar of Ornament*.[79] It is possible, of course, that the effect of Jones's book on Morris was, much like the Great Exhibition's is held to be, one of inspiring rebellion. Indeed, Floud observes that Morris's designs are much more traditional than the more daring, geometrical contributions of Jones and his circle, suggesting that Morris took little, stylistically-speaking, from Jones.[80]

Yet a glance at the text of *The Grammar of Ornament* indicates that the division between Jones and Morris was not so clear-cut. For example, Jones predicts that 'the future progress of Ornamental Art may be best secured by engrafting on the experience of the past the knowledge we may obtain by a return to nature for fresh inspiration'.[81] Morris's close study of the oriental carpets in the South Kensington Museum bears witness to his respect for 'the experience of the past',[82] and his commitment to nature as

a source of 'inspiration' asserts itself throughout his writing and design.[83] Since Arts and Crafts historians are generally happy to acknowledge that there was no consistent 'Arts and Crafts style', and that members of the 'movement' are unified instead by shared principles and attitudes, the lack of a stylistic connection between Jones and Morris must necessarily be seen as less important than the presence of what appears to be an ideological connection.

A connection, of course, is not proof of a direct influence or an indication of identical concerns. It is certainly possible that Morris was influenced by Jones, and since *The Grammar of Ornament* was published in 1856, just when Morris was beginning to experiment in decoration at his home in Red Lion Square, it would not be surprising if he had been.[84] Some of the principles and approaches Morris was to adopt later may have been anticipated by the design reformers of the 1850s, despite the firm division frequently forged between them in hindsight on account of efforts to safeguard Arts and Crafts as a 'moral' phenomenon untarnished by the more pragmatic concerns about trade associated with the Cole circle.[85]

As a later section in this chapter will demonstrate, Jones and his associates remained influential up to the 1880s, particularly in the contexts in which Arts and Crafts ways of looking were developed. Before going on to examine the continuing influence of the Jones circle, the chapter will next explore the ways in which readers of the taste manuals produced during these decades were encouraged to engage with decorative objects.

Taste manuals

In 1868, Charles Eastlake published *Hints on Household Taste*. Within a decade, a fourth edition of *Hints* had been published in London, and by 1881, six editions had been issued in the USA.[86] If we compare the successive London editions of *Hints* we can identify two important developments. By 1872, the author had added a comment on Morris, Marshall, Faulkner & Co. (MMF & Co.). By 1878, he had disowned the so-called 'Eastlake' furniture enjoying popularity in America. Eastlake writes, 'I find American tradesmen continually advertising what they are pleased to call "Eastlake" furniture, with the production of which I have had nothing whatever to do, and for the taste of which I should be very sorry to be

considered responsible.'[87] This public denunciation seems to have done little to dent the success of such furniture,[88] but for those who did take notice of Eastlake's preface, alternative sources of suitable goods could be found elsewhere in the book. Though Eastlake keeps his discussion of specific suppliers to a minimum, the brief references that do appear must have been welcomed by readers who were eager to put his 'hints' into practice. MMF & Co. is recommended to customers seeking papers 'luxurious in effect' and 'of high artistic excellence' for 'a shilling or eighteen pence a yard'. Eastlake directs his readers to the firm's Green Dining Room at the South Kensington Museum as an accessible means of seeing MMF & Co.'s products in use, including their 'chaste and beautiful stained glass' (see Chapter 3).[89] Visitors to the firm's workshops at Queen Square or the Green Dining Room might thus have arrived with the preconceived aim of uniting Eastlake's 'hints' with something solid.

The brevity of Eastlake's references to specific sources from which goods observing his principles might be obtained raises the question of what his book was aiming to achieve. Unlike some of the taste manuals, including Mrs Haweis's *The Art of Decoration* (1881), *Hints* was not a directory for home decorators, otherwise it would surely have included more comprehensive information about contemporary manufacturers. If Eastlake was hoping to inspire designers to use his 'hints' as the basis for new creations, he was both successful and unsuccessful. His book was embraced by designers, but, according to Eastlake, was misinterpreted.[90] Whatever its aims, the fact that *Hints* enjoyed such a substantial readership indicates that it fulfilled a need; a need that could, it would turn out, sustain a wide range of comparable publications.

In the late 1870s, the 'Art at Home Series' emerged, comprising titles such as W. J. Loftie's *A Plea for Art in the House* (1876), Rhoda and Agnes Garrett's *Suggestions for House Decoration in Painting, Woodwork and Furniture* (1876), Mrs Orrinsmith's *The Drawing Room* (1877), Mrs Loftie's *The Dining Room* (1878) and Lady Barker's *The Bedroom and Boudoir* (1878).[91] Taste manuals beyond the 'Art at Home Series' included *The Art of Furnishing on Rational and Aesthetic Principles* (1876) by 'H.J.C.', the anonymous *Artistic Homes or How to Furnish with Taste* (1881), Mrs Haweis's *The Art of Decoration* and Day's *Every-day Art: Short Essays on the Arts Not Fine* (1882).[92]

Perhaps the most sophisticated of these manuals, in terms of theorising and carrying out an engagement with decorative objects, is Orrinsmith's

The Drawing Room, which sold six thousand copies in its first year.[93] In the book, Orrinsmith offers detailed suggestions as to how a drawing room might be decorated. She illustrates a Morris & Co. wallpaper, but, crucially, leaves it unattributed, mentioning only its name, *Vine* (see figure 2).[94] On the one hand, her choice of a Morris paper suggests that the firm's profile was high enough that its products seemed to her exemplary; on the other, by failing to mention its name she underplays the firm's significance.

Orrinsmith's treatment of the *Vine* specimen has something of May Morris's sensitivity to detail, which will be discussed further in Chapter 2.[95] Orrinsmith observes 'the rich luscious growth of leaves and fruit, wisely combined with the simple slender boughs of the willow, whose delicately-toned leaves contrast with the amber bunches and dark green leaves of the "gadding vine"'.[96] *Vine* is thus examined in terms of its balanced pattern and colour combination. Orrinsmith not only communicates her own ability to identify the means by which a successful design achieves its overall impression, but also encourages the reader to pay a comparable kind of attention to decorative objects. Her advice is not based merely on selecting what is fashionable; instead, she demonstrates how the work of 'first class designers' can be identified.

The Drawing Room's discussion of *Vine* ends with advice about how to display it: 'This paper must always look noble, and suits a wide space, but with a golden background is positively magnificent.'[97] This comment anticipates the Morris & Co. catalogue for the Boston Foreign Fair (1883) in two ways.[98] First, it emphasises the importance of matching pattern and environment; secondly, it allows for different levels of grandeur depending on the reader's status. By advising the reader to select this paper for 'a wide space' and, if a 'magnificent' effect is desired, a 'golden background', Orrinsmith makes room for an approach that puts the design first, by considering how it will look its best, and for an approach that puts the customer first, by showing how he or she can manipulate the design to achieve a specific effect. A customer who had read this book might visit shops (possibly, but not necessarily, including Morris & Co.'s Oxford Street showroom, which opened in the same year) ready to examine patterns closely and to consider their fitness for the rooms requiring decoration. From the Boston catalogue it seems that Morris & Co. would have welcomed customers taking such an approach to shopping with the firm, as we shall see in Chapter 3.

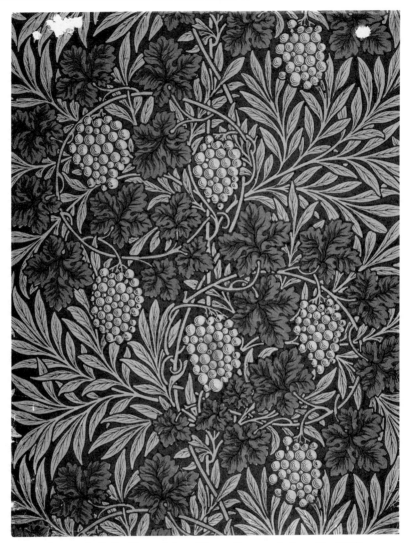

2 Morris, Marshall, Faulkner & Co., *Vine* wallpaper, designed by William
Morris and printed by Jeffrey & Co. from 1874. Block-printed in distemper
colours.

Several pages later, Orrinsmith offers some general advice about furnishing a room:

> It will be readily understood that in a room where there are silken or woollen hangings, there should be no other decoration on the walls; the chimney-piece should be ornamental, and might have a superstructure reaching to the ceiling with shelves and brackets for china, and possibly with small mirrors introduced here and there, forming with a suitable grate a central spot of brightness and beauty in the midst of the surrounding calm comfort.[99]

This sounds remarkably similar both to the appearance of the drawing room at Kelmscott House (Morris's London home from 1878; see figures 13–15, Chapter 2), and to May Morris's description of it. The woollen hangings, the 'ornamental' chimneypiece, and the 'superstructure reaching to the ceiling' hung with china are all features found at Kelmscott House. The claim that in a room hung thus, 'there should be no other decoration on the walls' anticipates May's declaration that there was 'no picture, of course' since 'the simple scheme of the room did not admit of such broken wall-surface'.[100]

This similarity raises the question of whether these decoration manuals were influencing, or were influenced by, the prevailing taste, or both. The Morrises leased Kelmscott House the following year, in 1878, and proceeded to decorate their drawing room along the lines recommended in Orrinsmith's book. Our instinct might be to dismiss immediately any suggestion that Morris, known as a leader of taste, might have been influenced by such a publication. It could, however, be the case that both Orrinsmith and the Morrises participated in an ongoing process of aesthetic exchange rather than seeking to direct or imitate each other or anyone else.

This is made more likely by the fact that *The Drawing Room* was written by the sister of a former partner in MMF & Co., Charles Faulkner. Indeed, as Miss Lucy Faulkner, its author had participated in some of the firm's early work as a tile painter.[101] Her involvement in the firm and her closeness to its members opens another set of possibilities. She may have participated in discussions about the firm's principles of decoration – although Morris & Co. in 1877 was very different from MMF & Co. in the early 1860s – and she and Morris were still corresponding in

the 1870s. It is not surprising, then, that she displays what Morris & Co. would have considered a highly appropriate sensitivity to the components of a pattern. Moreover, her advice on creating a successful room could well have been derived from discussions within Morris's circle. Of course, it could also be the case that the decorative approach we find in Arts and Crafts contexts, including Morris's homes and firm, was inspired partly by Lucy Faulkner's insights. We should avoid making the assumption that Morris and his male associates were necessarily the leaders in taste, leaving their female co-workers and companions to follow in their footsteps.[102] On the contrary, it is likely that the Morris & Co. 'sisterhood' played a more pivotal role in the characterisation of its visual style, at any or all of the stages of its development, than history has tended to suggest.[103]

It is tempting to argue from Orrinsmith's involvement in the Morris circle that her book was an important means by which Morris & Co. was advertised to a wider public. A problem with such an argument is that Orrinsmith does not name the provider of *Vine*. Readers who were unfamiliar with the design and its origin would have to rely on their own visual skills to use Orrinsmith's method for identifying suitable ornament, since they could not simply go directly to Morris & Co., safe in the knowledge that they would find 'first-class' design there. Of course, *The Drawing Room* may have led customers to Morris & Co. indirectly if readers used the manual as a guide when shopping. Yet *The Drawing Room* is no explicit advertisement for Morris & Co. Instead, it teaches readers how to judge for themselves and leaves them free to seek out their own 'first-class' examples of design. Thus readers of this book are not being spoon-fed easy-to-follow directions certain to lead to a stylish, fashionable room; instead, they are being offered advice that will help them to develop a style of their own using the products that are available. This interpretation is supported by Orrinsmith's 'Introduction', where she writes:

> Does it not seem the better course for us to select and create the beauties that are to be our own daily companions out of our individual taste and knowledge, rather than to be compelled from sheer ignorance to bow to, and bind ourselves by, the judgement of any decorator, whatever his ability? Should we continue to be contented to be *told*, not caring to learn to *feel*, that certain harmonies of form and colour are admirable and desirable?

In case the reader is left in any doubt of the book's purpose, Orrinsmith adds: 'In the hope to assist to a more self-helpful Art-knowledge, the following chapters have been written.'[104]

If Orrinsmith had mentioned Morris & Co. by name, the reader's response to the illustration and description of *Vine* could have been very different. Framed by any knowledge he or she might already possess regarding the firm, the reader's impression of the goods Orrinsmith recommends would be formed within the preconceptions developed by that prior knowledge. *The Drawing Room* thus proposes a different set of criteria by which objects can be judged and analysed. Instead of mediating objects through the image of their producer, it mediates them through the eyes of an author presenting herself as the representative of the public rather than the manufacturer.

This is truer of Orrinsmith or Mrs Haweis, whom I will discuss shortly, than Eastlake, who seems to alternate between two identities. On the one hand, he is lamenting 'the public's' lack of taste and perceiving himself as an educator. On the other, he is recommending affordable decorations, which suggests his sympathy for that same public's practical concerns. In this way, Eastlake sets himself up as neither manufacturer nor public, taking on instead an intermediary role. A review of *Hints* in the *Art Journal* emphasises the book's pedagogic function, approvingly declaring: 'Educate the consumers first in the knowledge of what is excellent and really good, and the producers must inevitably labour to meet the demand.'[105]

Eastlake's book could be considered more of an advertisement for Morris & Co. than Orrinsmith's, since the former actually mentions the firm's name in relation to a specific category of goods. Eastlake and Orrinsmith are thus doing subtly different things. Eastlake would like certain kinds of object to be available, and when objects that do fit his criteria are identified, he promotes them. Orrinsmith, in contrast, is more concerned with enabling readers to achieve a harmonious effect in their drawing rooms. Allowing for differences in shape and size, light and colour, she offers advice on how to furnish a drawing room from the choice of furnishings available, suggesting how certain items might be matched with others and how to make the most of what is on the market. A review quoted at the back of *The Drawing Room*, and taken from *The Examiner*, confirms the 'Art at Home Series' as a tool for an eager audience in need of advice:

In these decorative days the volumes bring calm counsel and kindly suggestions, with information for the ignorant and aid for the advancing, that ought to help many a feeble, if well-meaning pilgrim along the weary road, at the end whereof, far off, lies the House Beautiful.[106]

Mrs Haweis is another author who positions herself as the public's representative. She recommends Morris & Co. in several of her books, including *The Art of Decoration*. The title of this book raises high expectations by implying that the ability to decorate successfully can be characterised as, in itself, an 'Art'. Morris & Co. makes a similar claim, stating that 'Pattern-choosing, like pattern-making, is an Architectural Art' (see Chapter 3).[107] Haweis identifies particularly closely with the customer. She advises readers how to make the most of the rooms they have; she directs them to suitable sources of goods, such as Morris & Co.; and she offers an assessment of such goods from a practical point of view. Showing sympathy for those with small rooms, for example, she advises that 'no paper should have a very pronounced and distinct pattern, as that diminishes the apparent size of the room by bringing the walls near to the eye'.[108] While recommending Morris's papers, she warns that although his carpets are 'very pleasing', they 'fade detestably soon'.[109] She thus allows questions of context and durability to balance her aesthetic judgements.

In another book by Haweis, *The Art of Housekeeping* (1889), Morris & Co. appears as a superior option for homemakers who know 'the difference between artistic and non-artistic forms' and 'do not mind paying for what they admire'.[110] Set in this context, Morris & Co. objects take on, in the reader's mind, an aura of distinction. Haweis appears to suggest that some of her readers may have sufficient discrimination to identify quality by themselves. Yet by stating that it is this particular firm that should draw the 'admiration' of her more enlightened readers, she is in fact helping to guide their taste.

The different positions taken by these authors – Eastlake, Orrinsmith and Haweis – are brought together, to some extent, in Day's *Every-day Art* (1882). Like Orrinsmith and Haweis, he offers advice for creating harmonious combinations, recommending, for example, that 'even the little knick-knacks in a room should go together; they should not look as though they had met by accident'.[111] At the same time, he clearly perceives himself as a tastemaker, writing from outside the general public.

Day offers few clues to indicate what his ideal objects might look like. Instead, he focuses on general principles for the consumer's guidance.[112] For example, the furniture in a successful room 'does not all come from one workshop, and certainly it is not what is commercially called "a set", … but whether it be light or heavy, florid or severe, it has some character, and that character pervades everything'.[113] These two pieces of advice, when combined, make quite significant demands of the consumer. While avoiding relying on the manufacturer's idea of harmony by spurning the concept of 'a set', the customer must nevertheless ensure that the separately purchased objects work together, to avoid disharmony. Since Day himself offers little advice about how this might be achieved, he clearly has high expectations of the public's ability to judge harmony for themselves.

Day advises how to make the most of the spaces available and what to include and exclude from the ensemble. Beyond this, the reader is left to cultivate his or her own style. 'The whole argument', Day writes, is that the householder's 'ideal should be the basis of the art around him, whatever that ideal may be'.[114] By following one's own 'ideal', one avoids being guided by fashion. None of these authors suggest that a style or a designer should be preferred simply to accord with the current trend. In *The Dining Room*, Mrs Loftie goes to great lengths to convey her disdain for fashion: 'The style of colouring employed by Mr Morris and his school is also based upon scientific calculations analogous to those which obtain in the sister art of music. It is in no way connected with the caprices of fashion'.[115] Mrs Loftie's reference to 'scientific calculations' characterises Morris's choice of tints as objective and considered, rather than arbitrary or based on personal preference alone.[116] Her defensive tone also suggests that some critics did connect Morris & Co. with 'the caprices of fashion'. By elevating Morris's work on account of its perceived affinity with music, Loftie echoes Walter Pater's famous words that 'all art constantly aspires towards the condition of music'.[117]

While the authors of the taste books may have scorned fashion, some of their readers seem to have expected them to be more prescriptive. Day's confidence in the reader's taste explains why he claims that 'tint is a matter of choice, to be settled according to preference, or perhaps with reference to the other rooms'.[118] Yet the *Art Journal* found this particular pronouncement unsatisfactory. It is 'disappointing', we are told, 'on approaching the all-important question of tint', to receive such imprecise advice.[119]

Although it is presented as a criticism, this comment demonstrates the extent to which books of this kind were welcomed. It is followed by the observation that 'this is a weak point in all books of the sort', suggesting that the wide range of manuals on home decoration were not substantially differentiated from one another. Far from being offended by Day's often supercilious tone, readers seem to have been all too eager to be told exactly what to do. The taste books provided an opportunity to identify the 'right' kind of decoration, and by imitating it to claim membership of a superior cultural – and, by implication, social – class.[120] At the same time, however, some readers seem to have welcomed the didactic condescension of these authors, suggesting a willingness to accept that they are at least one step behind an even higher cultural class. This system has echoes of Ruskin's model of medieval craftsmanship, outlined earlier in this chapter, wherein individuals have a limited amount of freedom but operate under an autonomous supervisor who sets the rules and ensures that personal taste is expressed only within prescribed boundaries.[121] From the reviewer's point of view, the writers of the taste manuals are in no way oppressive. As we shall see, we often find echoes of the content, the register, and especially the approach to decorative objects, of the taste manuals in Arts and Crafts contexts.

The continuing influence of the Owen Jones circle

We saw in the preceding section that there was a healthy market for advice on interior decoration and a wide range of books to meet that demand. There was consequently a degree of competition between authors.[122] It is not surprising, then, that the authors of these taste books sometimes back up their advice with reference to higher authorities. One figure frequently referred to is Owen Jones. Jones was a member of the group who collected items for the new Museum of Ornamental Art, and he became particularly popular with *The Grammar of Ornament*. Indeed, one way of tracking the development of approaches to decoration during the period is to focus on the communication and reception of the position taken by Jones.

For example, when the *Art Journal* publishes an obituary of Jones in 1874, the author declares, 'It would be impossible to mention the name of any one whose genius and taste combined have had greater influence on the decorative arts of this country than that of Mr Owen Jones.'[123] Even

by the 1880s, Jones seems to have kept his place in the public consciousness. The first issue of the *Journal of Decorative Art* in January 1881 declares that a whole 'subject' will be devoted to 'Owen Jones, and his contemporaries: their influence on Modern Decorative Art'.[124]

The taste manuals also acknowledge a debt to Jones. Robert Edis's *Decoration and Furniture of Town Houses* (1881), for example, uses a Jones lecture to support his principles on wall decoration.[125] Haweis, meanwhile, lists Jones, Whistler and Morris among the prominent 'Art-Designers in England' of the nineteenth century, thus making it clear that she feels no compulsion to differentiate their contributions by allocation to precise 'movements'.[126] Haweis's priority is to show that those who strive to 'educate' through their work in the decorative arts have done much more in raising public taste' than the painters who believe that 'art is meant to be a thing apart'. For her, what Crane, Eastlake, Morris and Jones have in common is a concern with making art accessible rather than 'lofty'.[127]

Although Orrinsmith does not mention Jones by name, she makes an implied reference to his circle's influence by observing, 'It is generally supposed that, after a period of decadence, popular taste in domestic art began to amend some five-and-twenty years ago'.[128] Considering that *The Drawing Room* was published in 1877, this comment seems to identify 1852 as the year of change, and thus sees the turn in taste to be contemporary with the Jones circle's activities following the Great Exhibition.

An anonymous taste manual, *Artistic Homes or How to Furnish with Taste* (1881), goes some way towards mapping out a perceived chain of influence. 'It is said of the late Mr Owen Jones that the whole aim of his life was to "bring the beautiful in form and colour home to the household"', writes the author, observing that 'since his death his mantle has fallen on the shoulders of more than one worthy wearer'.[129] Several pages later, the author also mentions Pugin, 'to whose initiative the improved taste of the present day owes so much'. He or she then goes on to declare that 'eminent amongst those to whom the merit of this reformation is due are the Messrs Morris, Marshall & Co.' and Jeffrey & Co., 'many of whose designs have been contributed by the facile pencil of Mr Walter Crane, the well-known artist'.[130] A few pages on, we encounter Jones again, this time providing advice on the subject of colour, while Eastlake is mentioned repeatedly.[131] The author even offers a history of the change in furniture design, arguing that Pugin's efforts, the Pre-Raphaelites and the Great

Exhibition of 1851 collectively influenced a return to 'the strong, honest style of wood-working of the middle ages'.[132]

This approach to the 'reformation' in design sees no incompatibility between the contributions of Jones, Pugin, MMF & Co., Crane and Eastlake.[133] Like Haweis, this author seems to have a sense of a bigger picture in which these figures all played a part. On the one hand, we could criticise both authors for glossing over the differences between these contributors, and conclude that their accounts are generalising to a fault. On the other, wider evidence does seem to support the conclusion that what was important to contemporaries was that a design reform could be discerned, rather than how that reform might be divided into separate strands. The dissimilarity between the Jones circle and Morris is called into question in *Artistic Homes*, while that between Arts and Crafts and Aestheticism is underplayed by Mrs Haweis.

As we have already seen, the historiography has usually striven to emphasise the latter distinction. Edward Lucie-Smith, for example, writes, 'The importance of the Aesthetic Movement lay, not in the means whereby the objects associated with it were made, but in the manner in which people were encouraged to look at them: in isolation from their surroundings and presumed function.'[134] This requires a narrow reading of the Aesthetic movement. If we consider, for example, the phenomenon of the Aesthetic interior, it immediately becomes clear that the Aesthetic movement was often concerned with combinations of objects in specific 'surroundings'.[135] In Lucie-Smith's model, the 'Arts and Crafts movement', as it is conventionally understood, is implicitly defined as the opposite of the Aesthetic movement, because it was concerned with 'the means whereby the objects associated with it were made'.

This association of Arts and Crafts with production and Aestheticism with consumption is explored more fully in Regenia Gagnier's essay, 'Production, Reproduction and Pleasure in Victorian Aesthetics and Economics'. Gagnier argues that the aesthetics of the period can be divided into four categories. One of these categories is represented by Aestheticism, which displays the aesthetics 'of taste or consumption', and one by Arts and Crafts, which promotes the aesthetics 'of production'. Elaborating these contrasting positions, Gagnier writes that 'some were concerned with productive bodies, whose work could be creative or alienated, while others were concerned with pleasured bodies, whose tastes established

their identities'.[136] This dichotomy of production, with its connotations of ethical labour, versus consumption, with its connotations of pleasure and self-indulgence, helpfully maps out the moral issues at stake when exploring the Aestheticism/Arts and Crafts boundary.[137] Gagnier acknowledges that overlaps existed between these two camps, but refers to their 'very different motivations'.[138]

Another way in which Gagnier phrases the contrast demonstrates why we need to take more seriously the 'points of contact or overlap': 'Some aesthetics were concerned with the object produced or created, and others with the consumers of objects and their mode of apprehension'.[139] This book argues that Arts and Crafts, which is conventionally associated with production, also generated a sophisticated 'mode of apprehension'. As we are beginning to see, Arts and Crafts cannot be distinguished from a school of thought that was interested in the perception of decorative objects. The fact that the boundary between Arts and Crafts and Aestheticism is frequently blurred in the taste manuals also supports this argument that the two were closely interrelated.

Conclusion

Looking at the precursors of Arts and Crafts contexts, we can see that it is difficult to separate them out from the other tendencies with which they were intricately linked. These connections are neatly demonstrated in Walter Hamilton's *The Aesthetic Movement in England* (1882). We might expect this book to be concerned with a body of material clearly distinguishable from Arts and Crafts. For a start, in 1882 the Arts and Crafts Exhibition Society and the first mutterings about an 'Arts and Crafts movement' are yet to emerge. In addition, scholars usually relate the book to what we still call 'the Aesthetic movement'.[140]

The first anomaly in *The Aesthetic Movement in England* appears on the title page, where we find a quotation from Morris: 'Have you not heard how it has gone with many a cause before now? First, few men heed it; next, most men contemn [sic] it; lastly, all men accept it – and the cause is won'.[141] Conventional interpretations of the period lead us to wonder what Morris is doing in a book on the 'Aesthetic Movement'. At the same time, the precise quotation chosen leaves room for the possibility that Morris is being cited as a literary authority, rather than an artistic one.

Since the quotation does not mention a specific 'cause', Hamilton could be using it out of context and expecting the reader to interpret it in terms of the concerns of his volume.

This, however, is not Morris's only appearance in *The Aesthetic Movement in England*. Later, when discussing the Bedford Park Estate, Hamilton observes that 'the majority of the residents have chosen from the wall-papers and designs furnished by Mr William Morris'.[142] Moreover, the final chapter before the brief conclusion ends with a long quotation from Morris and the following words: 'Such, in brief, is the teaching of the masters of the new school. Ruskin's volumes all tend in the same direction. Away with all sham; study art for art's sake; avoid false gold and pretentious glitter; adopt a simple style moulded on the forms and colours of nature.'[143] This declaration raises conflicting impressions. Hamilton seems to be putting forward Morris and Ruskin as 'masters' of the 'new school', thus implying that they are the key figures of the 'movement'. Although the *Whistler* v. *Ruskin* trial of 1878 may have artificially cemented the opposition between Ruskin and Aestheticism in our minds, to identify the two calls much of what we would take for granted in defining Arts and Crafts and Aestheticism into question.[144] Looking more closely, however, we can see that Hamilton's interpretation of Ruskin seems to belie a bias towards a more familiar view of Aestheticism. His ability to interpret Ruskin as having believed in 'art for art's sake' serves as a reminder of the countless ways in which any of the major influences of this period could be re-presented to support specific agendas.[145] Finally, in the conclusion, Hamilton lists William Holman Hunt, Burne-Jones, Crane, Morris, A. C. Swinburne, Ruskin and Wilde, among others, as participants in 'Aestheticism'.[146]

It seems, then, that in the early 1880s there was a general perception of a growing interest in the artistic potential of decoration – which at that stage seems to have been a hotchpotch containing elements of what historians would now separate out as the mid-century design reform movement and Aestheticism – into which it was only natural to fit Morris. Tempting as it may be to see Morris's role as one of crusading, virtually single-handedly, against the unsympathetic tide of public opinion, it is hard to avoid acknowledging that the Victorian world was ready for him, especially given his commercial and financial success. What he had to offer seemed to slot into something that already existed, and while the

later establishment of the Arts and Crafts Exhibition Society might have led contemporaries to trace a history that forced a dividing line through what had previously been unproblematically perceived as a whole, this was a retrospective manoeuvre.

This chapter has shown that between the 1830s and 1880s, in circles to which Arts and Crafts figures and events were related, we frequently find unexpected overlaps between apparently conflicting concepts and principles. Relationships that seem less dichotomous than perhaps expected include those between reform and revival; between the fine and the decorative; and between the aesthetic and the moral or political. It is not surprising, then, that when we come to examine Arts and Crafts objects in specific contexts, we again find such overlaps. The next chapter explores how looking closely at the homes of Morris prompts us to question further what we think we know about some of these relationships, about Morris himself, and about Arts and Crafts objects.

Notes

1 For example, see Naylor, *Arts and Crafts Movement*, p. 19.

2 As Dennis Sharp explains, 'Muthesius was the transmitter of the English tradition, particularly that of the English Arts and Crafts movement, to Germany' (Preface to Muthesius, *English House*, p. xiii).

3 Muthesius, *English House*, pp. 153–63.

4 For more on the Great Exhibition, see the *Journal of Design and Manufactures* (1849–52); Ralph Wornum, 'The Exhibition as a Lesson in Taste', *Art Journal: Illustrated Catalogue of the Exhibition* (1851); Jeffrey Auerbach, *The Great Exhibition of 1851: A Nation on Display* (New Haven and London: Yale University Press, 1999); and Purbrick (ed.), *Great Exhibition of 1851*.

5 Schools outside England included those at Glasgow and Belfast.

6 For more on art education see George Sutton, *Artisan or Artist? A History of the Teaching of Arts and Crafts in English Schools* (Oxford: Pergamon Press, 1967) and Macdonald, *History and Philosophy of Art Education*.

7 For more on the Select Committee inquiry and its outcome, see Clive Ashwin (ed.), *Art Education Documents and Policies 1768–1975* (London: Society for Research into Higher Education, 1975), pp. 8–25, and Macdonald, *History and Philosophy of Art Education*, pp. 67–71. Watkinson suggests that the origins of Morris's 'ideas' can be found in the mid-ighteenth century. He situates the Society of Arts, founded in 1753, as an early sign of a newly felt 'need' to 'exercise … taste in the products of industry', and observes that the Society

'played a part in catering for this need'. It was 'concern of this kind', according to Watkinson, that paved the way for the Select Committee inquiry of 1835 (*William Morris as Designer*, p. 28).

8 House of Commons, Report from the Select Committee of Arts and Manufactures (London: House of Commons, 1835), pp. 375–7.

9 Muthesius suggests that the Government initiative to improve design for the purposes of trade was eventually successful. In his section on wallpaper, he claims that 'the increase in exports reported by England during the past twenty years is due entirely to their high artistic quality' (*English House*, p. 171).

10 See Quentin Bell, *The Schools of Design* (London: Routledge & Kegan Paul, 1963), p. 60, and Ashwin (ed.), *Art Education*, p. 10. For more on the Schools of Design, see Macdonald, *History and Philosophy of Art Education*, pp. 73–115.

11 See Ashwin (ed.), *Art Education*, pp. 9–10 and Droth, 'The Statuette', p. 191, n. 45.

12 For more on training at the RA, see Macdonald, *History and Philosophy of Art Education*, pp. 27–31 and Bell, *Schools of Design*, chapters II and III.

13 For more on the Birmingham School of Design, see Crawford, 'The Birmingham Setting', in Crawford (ed.), *By Hammer and Hand*, pp. 27–39. For more on Wallis, see Macdonald, *History and Philosophy of Art Education*, pp. 90–4.

14 George Wallis, *Schools of Art: Their Constitution and Management* (London: Simpkin, Marshall, and Co.; Birmingham: B. Hall, 1857), p. x.

15 See Ashwin (ed.), *Art Education*, p. 9.

16 Lara Kriegel, *Grand Designs: Labor, Empire, and the Museum in Victorian Culture* (Durham, N. C.: Duke University Press, 2007), p. 2.

17 House of Commons, Report, p. 391.

18 Wallis, *Schools of Art*, p. 18.

19 According to Bell, there were claims that the 'mistranslation' of the French '*Ecole de dessin*' as 'school of design' rather than 'drawing school' was the cause of confusion about the role of drawing in the Schools of Design (*Schools of Design*, p. 68).

20 For more on the Schools' curriculum, see 'Plan of Instruction at Somerset House' (1842), Bell, *Schools of Design*, Appendix III, pp. 270–1.

21 Wallis, *Schools of Art*, p. xii. For more on art teacher training, see Macdonald, *History and Philosophy of Art Education*.

22 Wallis, *Schools of Art*, p. xii.

23 George Wallis, *British Art: Pictorial, Decorative and Industrial. A Fifty Years' Retrospect 1832 to 1882* (London: Chapman & Hall; Nottingham: Thos. Foreman & Sons, 1882), p. 16.

24 For more on Pugin, see P. Atterbury and Clive Wainwright (eds), *Pugin: A Gothic Passion* (New Haven and London: Yale University Press in association

with the Victoria and Albert Museum, 1994).

25 Williams, *Culture and Society*, p. 130.

26 Williams, *Culture and Society*, p. 130.

27 A. W. N. Pugin, *Contrasts: Or, A Parallel between the Noble Edifices of the Middle Ages, and Corresponding Buildings of the Present Day; Showing the Present Decay of Taste*, 2nd edn, 1841 (Reading: Spire, 2003), pp. 2–3.

28 Pugin, *Contrasts*, p. iii.

29 A. W. N. Pugin, *The True Principles of Pointed or Christian Architecture*, 1841 (Leominster: Gracewing, 2003), p. 1.

30 Pugin, *True Principles*, p. 1.

31 Arts and Crafts contexts do, of course, include some religious buildings. For example, MMF & Co. undertook a substantial number of stained glass commissions for churches (see Chapter 3).

32 Pugin, *True Principles*, pp. 2–3.

33 Pugin, *True Principles*, p. 20.

34 Pugin, *True Principles*, p. 30.

35 Pugin, *True Principles*, p. 26.

36 Williams, *Culture and Society*, p. 131.

37 John Ruskin, 'Inaugural Lecture' (1870), *Lectures on Art, The Works of John Ruskin*, ed. E. T. Cook and Alexander Wedderburn, 39 vols (Cambridge: Cambridge University Press, 1996), XX, p. 39. Quoted in Williams, *Culture and Society*, p. 136.

38 Ruskin, *Stones of Venice, Works*, XI, p. 6.

39 Ruskin, *Modern Painters*, I (1843), *Works*, III, p. 97.

40 'Some Recent Designs by C. F. A. Voysey', *The Studio*, VII (1896), p. 216.

41 MacCarthy, *William Morris*, p. 593. See Chapter 4 for more on Arts and Crafts versus Art Nouveau.

42 Ruskin, *Modern Painters*, I, *Works*, III, p. 110.

43 Williams, *Culture and Society*, p. 130.

44 Ruskin, *Seven Lamps, Works*, VIII, pp. 59–60.

45 Ruskin, *Stones of Venice, Works*, X, p. 183.

46 Ruskin, *Stones of Venice, Works*, X, p. 188.

47 Ruskin, *Stones of Venice, Works*, X, pp. 189–90.

48 Ruskin, *Stones of Venice, Works*, X, p. 190.

49 Ruskin, *Stones of Venice, Works*, X, p. 193.

50 Ruskin, *Stones of Venice, Works*, XI, p. 227.

51 Ruskin, *Seven Lamps, Works*, VIII, p. 46.

52 Ruskin, *Seven Lamps, Works*, VIII, p. 190. This idea contravenes the ideal of the Academic 'licked surface' by directly contradicting the notion that concealing marks of labour should be considered a skill. For more on the 'licked surface' of Academic painting, see Charles Rosen and Henri Zerner, 'The Ideology of the Licked Surface: Official Art', in *Romanticism and Realism: The Mythology of Nineteenth Century Art* (London: Faber, 1984).

53 Ruskin, *Stones of Venice, Works*, XI, p. 201.

54 Ruskin, *Stones of Venice, Works*, IX, p. 291.

55 Durant argues that this aspect of Ruskin's theory is the key to his difference from Morris. He points out that whereas, for Ruskin, 'the cathedral has become the metaphor for a whole society which, because it is hierarchical, is both stable and organic', Morris 'called for a society of equals' ('William Morris and Victorian Decorative Art', in Design Council, *William Morris and Kelmscott*, p. 65).

56 See, for example, Chapter 4, note 58.

57 Ruskin, *Stones of Venice, Works*, XI, p. 213.

58 For more on Ruskin's approach to vision, see David Peters Corbett, *World in Paint* (Manchester: Manchester University Press, 2004), pp. 24–5.

59 Jan Marsh, for example, claims that Morris's campaign was 'provoked by the horror of the Great Exhibition' (*Back to the Land: The Pastoral Impulse in England, from 1880 to 1914* (London: Quartet, 1982), p. 13).

60 Pevsner, *Pioneers*, p. 53.

61 Nikolaus Pevsner, *High Victorian Design: A Study of the Exhibits of 1851* (London: Architectural Press, 1951), p. 49. This implies a corresponding principle in modernist design, where straight lines could be considered the embodiment of non-indulgence. The *Modernism* exhibition at the Victoria and Albert Museum (2006) emphasised the promotion of exercise and leanness in modernism.

62 Pevsner, *Pioneers*, p. 41.

63 Day, 'The Art of William Morris', p. 1.

64 Naylor, *Arts and Crafts Movement*, p. 20.

65 For instance, Stephan Tschudi Madsen writes that 'it was not until after the Great Exhibition in 1851 that the problems relating to the training of applied artists, as well as a satisfactory production of applied art, were fully realised' (*Sources of Art Nouveau*, trans. Ragnar Christophersen (Oslo: H. Aschehoug & Co., 1956), p. 142).

66 Purbrick observes that 'the assumption that any collection of objects contained in a building has the capacity to signal a change of historical time, or even to instigate that change' is 'an important historical manoeuvre' and 'deserves careful consideration' (Purbrick, 'Introduction' to Purbrick (ed.), *Great Exhibition of 1851*, p. 2). See also Kriegel, *Grand Designs*, p. 10.

67 Nikolaus Pevsner, *Sources of Modern Architecture and Design*, 1968 (London: Thames and Hudson, 1985), especially p. 10. For more on the *Journal*, see Macdonald, *History and Philosophy of Art Education*, pp. 133–4. The key term in the *Journal* was 'principles'. The Preface to vol. VI states that one of the key 'large questions connected with the progress of Industrial Art just appearing above the horizon' when the journal was established in 1849 was 'the establishment and recognition of *principles*' (*Journal of Design and Manufactures*, VI (September 1851 – February 1852), p. iii, italics original). For more on Redgrave's principles, see Macdonald, *History and Philosophy of Art Education*, pp. 233–41. See also 'Mr Redgrave on the School of Design' in *The Builder* (12 December 1846). 'Principles' had been prioritised since the establishment of the Schools of Design. Pugin's *True Principles*, of course, was an important contribution to this trend. The word was also emphasised in *The Builder* in discussions on decoration and design more generally. See, for instance, W. Smith Williams, 'On the Importance of a Knowledge and Observance of the Principles of Art by Designers', *The Builder* (17 March 1849), pp. 122–3 and 'The Wallpapers of the Present Season', *The Builder* (26 September 1863), p. 686. See Introduction, note 42; Chapter 1, note 112; and Chapter 5.

68 *Journal of Design and Manufactures*, VI (September 1851 – February 1852), p. 137 (italics original).

69 *Journal of Design and Manufactures*, VI (September 1851 – February 1852), p. 23. The word 'competition' emphasises the concerns of the 1835 Select Committee inquiry, whose priority was improving Britain's ability to compete with other nations in terms of trade. Watkinson suggests how we might interpret the term 'art manufactures'. He observes that the Great Exhibition included manufactured objects designed 'by men who were not trade designers working to rule of thumb or following fashion; but were by training and profession painters, sculptors and, even more frequently, architects'. Watkinson argues that this was not 'industrial design, as we think of it' but 'art manufacture' (*William Morris as Designer*, p. 30).

70 E. I., 'An Industrial Art Museum', *The Builder* (4 October 1851), p. 621.

71 Preface to *Art Journal: Illustrated Catalogue of the Exhibition* (1851).

72 See Anthony Burton, *Vision and Accident: The Story of the Victoria and Albert Museum* (London: V&A Publications, 1999), pp. 31–2. See also Macdonald, *History and Philosophy of Art Education*, pp. 177–8 and Clive Wainwright, 'Principles True and False: Pugin and the Foundation of the Museum of Manufactures', *Burlington Magazine*, CXXXVI: 1095 (June 1994).

73 For more on the history of the South Kensington Museum, see Edward P. Alexander, *Museum Masters: Their Museums and Their Influence* (Nashville, Tenn.: American Association for State and Local History, 1983); Barbara Morris, *Inspiration for Design: The Influence of the Victoria and Albert Museum* (London: Victoria and Albert Museum, 1986); Burton, *Vision and Accident*; Paul

Barlow and Colin Trodd (eds), *Governing Cultures: Art Institutions in Victorian London* (Aldershot: Ashgate, 2000); Anthony Burton, 'The Uses of the South Kensington Art Collections', *Journal of the History of Collections*, XIV: 1 (2002); and Clive Wainwright, 'The Making of the South Kensington Museum', part I, ed. Charlotte Gere, *Journal of the History of Collections*, XIV: 1 (2002).

74 See Henry Cole, *Observations on the Expediency of Carrying out the Proposals of the Commissioners for the Exhibition of 1851, for the Promotion of the Institution of Science and Art at Kensington* (London, 1853) and Richard Redgrave, *On the Necessity of Principles in Teaching Design* (London, 1853).

75 First Report of the Department of Practical Art (London: Stationery Office, 1853), p. 31. For more on the Department, see Macdonald, *History and Philosophy of Art Education*, pp. 157–9.

76 Naylor, *Arts and Crafts Movement*, p. 20.

77 Wainwright, 'The Making of the South Kensington Museum', part I, p. 29.

78 Naylor, *Arts and Crafts Movement*, p. 19.

79 Barbara Morris, *Inspiration for Design*, p. 46.

80 Floud, 'The Wallpaper Designs of William Morris', p. 42. That Jones and Morris were stylistically dissimilar is a widely held view. For example, Philip Henderson observes that while Jones's and Dresser's designs were 'stiff and formal', Morris's had 'an exciting sense of growth and the abundance and freshness of nature, however traditional his initial inspiration' (*William Morris: His Life, Work and Friends* (London: Thames and Hudson 1967), p. 87). Pevsner presents a similar argument (*Sources*, p. 27).

81 Owen Jones, *The Grammar of Ornament* (London: Day, 1856), p. 2. See Macdonald, *History and Philosophy of Art Education*, pp. 247–9.

82 MacCarthy quotes Morris saying that the South Kensington Museum 'was got together for six people – I am one, another is a comrade [Webb] in the room' (*William Morris*, p. 212). See Barbara Morris, 'William Morris and the South Kensington Museum', *Victorian Poetry*, XIII: 3/4 (1975).

83 Durant has also observed this connection, but in the context of an argument that questions Morris's innovation. He shows that the two key tenets of Morris's design theory, 'Nature as Sourcebook' and 'Museum as Sourcebook', derived from Owen Jones and Pugin ('William Morris and Victorian Decorative Art', in Design Council, *William Morris and Kelmscott*, p. 64). While Durant's point is that Morris 'was saying nothing really new' about design, the important point here is that acknowledging these links raises questions about the generalisations we use to compartmentalise design in this period.

84 For more on Morris at Red Lion Square, see MacCarthy, *William Morris*, pp. 117–50.

85 Day acknowledges these connections. He recalls that the prospectus of Felix Summerly's 'Art Manufactures' (Felix Summerly was Cole's pseudonym)

declared: 'Beauty of Form and Colour and poetic invention were (once) associ-
ated with everything. So it ought to be still, and, we will say, shall be again.'
Day adds, 'Morris put it better; but that is in effect what he said' ('The Art of
William Morris', p. 2).

86 John Gloag, 'Introduction' to Eastlake, *Hints*, 4th edn, p. ix.

87 Eastlake, *Hints*, 4th edn, p. xxiv.

88 Gloag, 'Introduction' to Eastlake, *Hints*, 4th edn, p. ix.

89 Eastlake, *Hints*, 4th edn, p. 124. Once again we find Arts and Crafts objects
associated with the anti-erotic.

90 See note 87.

91 See Ferry for more on the 'Art at Home Series'. Ferry draws attention to the
dismissive treatment the books have previously received from scholars
('"Decorators May be Compared to Doctors"', p. 17).

92 Hoskins has helpfully summarised the phenomenon of the taste manuals,
outlining the wide range of publications available and collating information
about their relative costs, presumed audiences and other key characteristics
(Charlotte Gere, with Lesley Hoskins, *The House Beautiful: Oscar Wilde and
the Aesthetic Interior* (London: Lund Humphries in association with Geffrye
Museum, 2000), pp. 109–36). My aim here is to look in more detail at a
number of specific manuals in order to tease out the ways in which they reflect
and contribute to the development of the ways of looking we find in Arts and
Crafts contexts.

93 Ormond, *George du Maurier*, p. 283.

94 Mrs (Lucy) Orrinsmith, *The Drawing Room* (London: Macmillan & Co., 1877),
p. 17.

95 For more on May Morris, see Jan Marsh, *Jane and May Morris: A Biograph-
ical Story 1839–1938* (London and New York: Pandora, 1986); Marsh, 'May
Morris', in Elliott and Helland (eds), *Women Artists*; and Linda Parry, 'May
Morris, Embroidery and Kelmscott', in Parry (ed.), *William Morris: Art and
Kelmscott*, Occasional Papers of the Society of Antiquaries of London, No. 18
(Woodbridge: Boydell and Brewer, 1996), pp. 57–68.

96 Orrinsmith, *Drawing Room*, p. 15. 'Gadding vine' is borrowed from Milton's
Lycidas (1637), line 40.

97 Orrinsmith, *Drawing Room*, p. 15.

98 National Art Library, London (hereafter NAL), 276.C Box 1, Morris & Co., 'The
Morris Exhibit at the Foreign Fair, Boston', 1883.

99 Orrinsmith, *Drawing Room*, p. 24.

100 May Morris, *Introductions to the Collected Works of William Morris*, 1910–15
(New York: Oriole, 1973), p. 366.

101 For instance, Lucy Faulkner painted tiled overmantels for The Hill at Witley, Surrey in 1863–64 (see Myers, *William Morris Tiles*, pp. 28–31 and 47).

102 Ormond, for example, deduces that Orrinsmith 'was inevitably influenced by the ideas of Morris' (*George du Maurier*, p. 283). Parry, on the other hand, emphasises the importance of women in the Morris circle ('May Morris, Embroidery and Kelmscott', in Parry (ed.), *William Morris: Art and Kelmscott*, p. 58).

103 Accounts that do focus on the role of women in this circle include Callen, *Angel in the Studio*; Jan Marsh, *The Pre-Raphaelite Sisterhood* (London: Quartet, 1985); Marsh, *Jane and May Morris*; and Jan Marsh and Pamela Gerrish Nunn, *Women Artists and the Pre-Raphaelite Movement* (London: Virago, 1989).

104 Orrinsmith, *Drawing Room*, p. 9 (italics original).

105 Review of Eastlake, *Hints*, Art Journal (1869), p. 31.

106 Orrinsmith, *Drawing Room*, end page.

107 NAL, 276.C Box 1, Morris & Co., 'Boston', p. 18.

108 Mrs (Mary Eliza) Haweis, *The Art of Decoration* (London: Chatto & Windus, 1881), p. 226.

109 Haweis, *Art of Decoration*, p. 294.

110 Mrs (Mary Eliza) Haweis, *The Art of Housekeeping: A Bridal Garland* (London: Sampson Low & Co., 1889), p. 33.

111 Lewis Foreman Day, *Every-day Art: Short Essays on the Arts Not Fine* (London: B. T. Batsford, 1882), p. 213.

112 The emphasis on 'principles' found in many of the British taste manuals from this period is shared by the early nineteenth-century American architectural handbooks discussed by Dell Upton in 'Pattern Books and Professionalism: Aspects of the Transformation of Domestic Architecture in America, 1800–1860', *Winterthur Portfolio*, XIX: 2/3 (Summer – Autumn, 1984), pp. 116, 121 and 124–5.

113 Day, *Every-day Art*, p. 213.

114 Day, *Every-day Art*, p. 217.

115 Mrs Loftie, *The Dining Room* (London: Macmillan & Co., 1878), p. 13.

116 The musical analogy indicates the blurred boundary between Aestheticism and Arts and Crafts at this time, since a synaesthetic approach is traditionally associated with the former. See Chapter 5 for more on the perceived correlation of decorative objects to music.

117 NAL, Box 4, 40. F, Walter Pater, 'The School of Giorgione', *Fortnightly Review* (October 1877), p. 528.

118 Day, *Every-day Art*, p. 205.

119 Review of Day, *Every-day Art, Art Journal* (1883), p. 132.

120 See Freedman, *Professions of Taste*, p. xiii. See also Pierre Bourdieu, *Distinction*, trans. Richard Nice (London: Routledge & Kegan Paul, 1979). Bourdieu argues, for instance, that 'art and cultural consumption are predisposed, consciously and deliberately or not, to fulfil a social function of legitimating social differences' (p. 7).

121 See notes 54 and 55. The *Journal of Design and Manufactures* was similarly in favour of a prescriptive approach. It was 'the aim of the Journal to endeavour to find professed advocates for the acknowledgment of *principles in Design*, and to lose no occasion of denouncing the spurious freedom involved in the fallacy of "Every one to his own taste"' (*Journal of Design and Manufactures*, VI (September 1851 – February 1852), p. iii, italics original).

122 As Ferry points out, for example, Haweis takes a disdainful view of the 'Art at Home Series' ('"Decorators May be Compared to Doctors"', p. 26). See Haweis, *Art of Decoration*, p. 336.

123 'Obituary of Owen Jones', *Art Journal* (1874), p. 211.

124 *Journal of Decorative Art*, I (January 1881), p. 1.

125 Robert Edis, *Decoration and Furniture of Town Houses* (London: Kegan Paul & Co., 1881), p. 70.

126 Haweis, *Art of Decoration*, Table showing 'Art-Designers in England' through the centuries.

127 Haweis, *Art of Decoration*, pp. 371–2.

128 Orrinsmith, *Drawing Room*, p. 4.

129 Anon., *Artistic Homes or How to Furnish with Taste* (London: Ward, Lock & Co., 1881), p. 10.

130 Anon., *Artistic Homes*, p. 20.

131 Anon., *Artistic Homes*, pp. 20, 25, 26, 54, 65, 112 and 113.

132 Anon., *Artistic Homes*, p. 55.

133 'Movement'-based accounts usually downplay these relationships, whereas broader histories of the period tend to be more open to them. In a comprehensive study of Victorian objects, Briggs, for instance, acknowledges Eastlake's relationship with the Pugin-Morris tradition (*Victorian Things*, p. 224).

134 Lucie-Smith, *Story of Craft*, p. 218.

135 See Edwards and Hart (eds), *Rethinking the Interior*.

136 Regenia Gagnier, 'Production, Reproduction and Pleasure in Victorian Aesthetics and Economics', in Richard Dellamora (ed.), *Victorian Sexual Dissidence* (Chicago and London: University of Chicago Press, 1999), pp. 130–1.

137 As we have seen, a similar dichotomy operates in accounts of the relationship between Arts and Crafts and Art Nouveau (see note 41). Hitchmough summa-

rises the typical approach to the relationship: 'Unlike their Art Nouveau contemporaries, who exploited the potential of paganism and decadence to titillate or disturb, Arts and Crafts designers and their clients were committed to the aesthetics of innocence and moral purity' (*Arts and Crafts Home*, pp. 161–2). At the same time, Hitchmough makes room for sexuality in Arts and Crafts. For instance, she points to the 'sexual symbolism' in a piano by C. R. Ashbee (1903) with its 'plain exterior which only revealed its decorative riches and beauty when it was opened for play' (p. 8).

138 Gagnier, 'Production, Reproduction and Pleasure', p. 130.

139 Gagnier, 'Production, Reproduction and Pleasure', p. 131.

140 See Prettejohn, 'Introduction' to Prettejohn (ed.), *After the Pre-Raphaelites*, p. 4.

141 Walter Hamilton, *The Aesthetic Movement in England* (London: Reeves & Turner, 2nd edn, 1882), title page.

142 Hamilton, *Aesthetic Movement*, p. 120. For more on Bedford Park, see Moncure Conway, *Travels in South Kensington* (London: Trubner & Co., 1882); Muthesius, *English House*, pp. 30–2; Ian Fletcher, 'Bedford Park: Aesthete's Elysium?', in Fletcher (ed.), *Romantic Mythologies* (London: Routledge & Kegan Paul, 1967); and Mark Girouard, *'Sweetness and Light': The Queen Anne Movement 1860–1900* (Oxford: Clarendon Press, 1977), pp. 160–76.

143 Hamilton, *Aesthetic Movement*, p. 123.

144 For more on the *Whistler v. Ruskin* trial, see Spencer, *Aesthetic Movement*, pp. 78–113 and Linda Merrill, *A Pot of Paint: Aesthetics on Trial in Whistler v. Ruskin* (Washington and London: Smithsonian Institution Press in association with the Freer Gallery of Art, 1992).

145 Even before the phrase 'art for art's sake' emerges, Ruskin directly contradicts it in 1849, when he writes, 'I do not want marble churches at all for their own sake, but for the sake of the spirit that would build them' (*Seven Lamps, Works*, VIII, p. 39). See Prettejohn's discussion of the origins of 'art for art's sake' ('Introduction' to Prettejohn (ed.), *After the Pre-Raphaelites*). See also Norman Kelvin on Morris's influence on artists of the 1890s ('The Morris Who Reads Us' in Linda Parry (ed.), *William Morris*, exh. cat. (London: Philip Wilson in association with the Victoria and Albert Museum, 1996)).

146 Hamilton, *Aesthetic Movement*, p. 142.

2 ✧ The homes of William Morris

THIS CHAPTER LOOKS at Arts and Crafts objects in the interiors of William Morris's two major homes between the 1870s and his death in 1896. Morris leased Kelmscott Manor in Oxfordshire from 1871, while Kelmscott House in Hammersmith was his London home from 1878. This chapter explores how objects functioned in these spaces, investigating what Kelmscott Manor and Kelmscott House have to say when we dim the spotlight on the 'movements' with which they are associated. It argues that in the homes of Morris, sophisticated ways of looking at decorative objects comparable to those discussed in the previous chapter were employed by both inhabitants and visitors. To put Kelmscott Manor and Kelmscott House in context, the chapter begins by outlining the roles played by these two homes, and others, in the lives of Morris and his family.

The biographical context

Having been born and raised in Walthamstow, Morris spent his student days in Oxford, before moving to London in 1856. At their home in Upper Gordon Street, Morris and his friend Edward Burne-Jones enlivened their surroundings so that, in Burne-Jones's words, they lived 'in the quaintest room in all London, hung with brasses of old knights and the drawings of Albert [sic] Dürer'.[1] Their next home, in Red Lion Square, was let as an unfurnished property, for which Morris designed furniture to be executed by a local cabinet-maker. In 1859, together with his architect friend, Philip Webb, Morris designed the house that became the most famous of all his homes, even though he was to live there for only five years. Red House, which still survives as a National Trust property, is situated ten miles from

London in Bexleyheath, Kent. Morris and his wife, Jane, moved into Red House in 1860, and two daughters, Jenny and May, were born in 1861 and 1862 respectively. The task of furnishing and decorating the house formed part of the household's daily life. Embroideries, hangings, wall paintings, stained glass and tiles were among the objects created for Red House by the Morrises and their friends, particularly Burne-Jones and his wife, Georgiana. In 1861 Morris and Burne-Jones, with six others, co-founded MMF & Co., which was based in London (see Chapter 3).

Built on an L-shaped plan, Red House anticipated the addition of a mirroring extension, intended for the Burne-Joneses.[2] This dream of a home to be shared by the two families was known as the palace of Art.[3] The ideal was never realised, however, mainly on account of troubles within the Burne-Jones family.[4] In 1865, the Morrises themselves were forced to abandon Red House, partly for financial reasons, and partly because the regular journey to and from London was proving detrimental to Morris's health.[5]

The family went to live above the firm's new premises at Queen Square in London. The move was not a satisfactory one: Morris's wife and

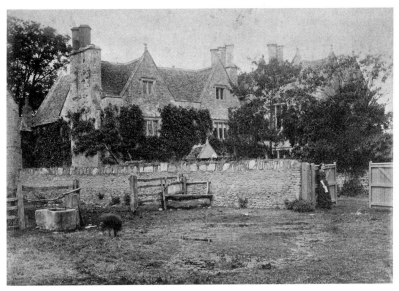

3 Kelmscott Manor, Oxfordshire, *c.* 1885.

daughters became ill, and he blamed the city. Morris took Jane abroad to restore her health in 1869,[6] while in the spring of 1871 he expressed concern for Jenny and May, writing that 'the little ones are better, thank you, but have not lost their cough yet: I think I shall have to find a little house out of London for them to live in mostly, as I am beginning to be nervous about London for them.'[7] In the course of his search for a 'house for the wife and kids',[8] Morris discovered Kelmscott Manor, situated in a tiny Oxfordshire village, which he leased jointly with Dante Gabriel Rossetti in June 1871 (figure 3).[9]

Morris had another motive for leasing a country house. Kelmscott Manor provided a place in which Jane and Rossetti could continue an affair of which, it is widely concluded, Morris was fully aware.[10] Almost immediately after signing the lease, Morris departed for Iceland, leaving his family and Rossetti at Kelmscott.[11] Even when in England, Morris often stayed away, sometimes sleeping in the living quarters above the firm.[12]

Some misunderstanding regarding the sharing of the house seems to have occurred as time went on. Morris wrote in November 1872 that 'Rossetti has set himself down at Kelmscott as if he never meant to go away.'[13] He directly accused Rossetti along the same lines eighteen months later in a letter which declares 'you have fairly taken to living at Kelmscott, which I suppose neither of us thought the other would do when we first began the joint possession of the house'.[14] Later in 1874, Rossetti departed for good, after which time Morris made greater and more regular use of the house. He had resented Rossetti's keeping him away from 'that harbour of refuge',[15] which, despite its role being partly to harbour his wife and Rossetti, Morris had become firmly attached to. He described Kelmscott as 'a house that I love with a reasonable love I think'.[16]

Being a rented property, the interior bore the mark of previous occupants. In addition, although Rossetti had left four years earlier, in 1878 he sent Jane a list of items belonging to him that remained at Kelmscott. He asked her to send some of them, but many, he wrote, should only be sent 'if not needed'.[17] Other objects he specifically bequeathed to Jane, including most of his furniture.[18] These letters indicate that even after Rossetti's departure, the house retained signs of his contribution to its interior.[19]

During the early days of the tenancy, when Morris was often away, Jane orchestrated some improvements and adornments for the house in

his absence. Morris chose some of the wallpapers for Kelmscott but left it to Jane to make the final arrangements.[20] Jane had a more creative role in organising other decorations, however. For example, she writes to Webb to order some tiles and asks, 'Will they look best of various patterns or all alike?', adding firmly, 'They must be blue.'[21]

Kelmscott provided an opportunity to escape from the noise, smoke and bustle of London. It was, to an extent, a holiday house. This was partly because it was barely habitable in the winter. Looking back in 1919, Wilfrid Scawen Blunt, who succeeded Rossetti as Jane's lover, describes Kelmscott Manor in 1889 as 'extremely primitive', for 'there were few of the conveniences of modern life'.[22] Despite its name, it was not in fact a manor house.

Because it was primarily a summer home, Kelmscott was associated with warmer, finer weather and outdoor activities such as fishing and walking. Its inhabitants repeatedly refer to the house's surroundings and Morris himself frequently describes to his correspondents the view from the room in which he sits. On one occasion, he writes, 'I am sitting now, 10 p.m., in the tapestry-room, the moon rising red through the east-wind haze, and a cow lowing over the fields'[23] and, in another letter, he declares that it was 'pretty as one sat in the tapestry-room to see the loads [of wheat] coming on between the stone walls'.[24] This suggests that when considering how Kelmscott Manor was used and the role it played in the Morrises' lives, we must think about not only the house itself, and the objects that it contained, but the broader interior and exterior environment it provided.

Meanwhile, in 1873, Morris had leased a house in London, which allowed him to expand the workshops at Queen Square into the former living quarters. This London base, Horrington House in Turnham Green, had its disadvantages. It was small and, as the ceramicist William de Morgan recalls, situated on a street so noisy that Morris was almost 'driven mad'.[25] After five years, Morris began to search for something better and in 1878 he leased The Retreat, next to the Thames on Hammersmith Mall, and renamed it Kelmscott House (figure 4) after Kelmscott Manor. A larger house in a more peaceful environment, Kelmscott House must have seemed more dignified and private than the family's previous London bases. Nevertheless, May declares that Morris never 'felt in his heart' that Kelmscott House was 'our real home', observing that 'writing from London

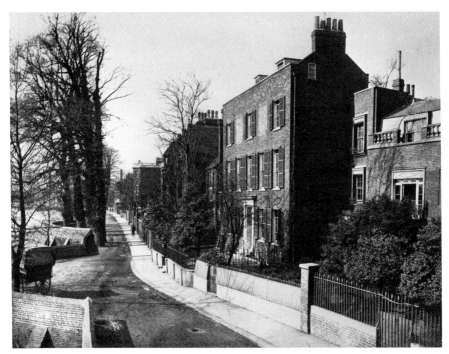

4 Kelmscott House, Upper Mall, Hammersmith, London.

to us at Kelmscott he often spoke of "coming home"'. Summarising the house's role, May describes it as 'a convenient and seemly shelter from the weather, a place to keep books and pretty things in, but at best a temporary abode'.[26]

A family home in London provided a convenient site for socialising. Morris had predicted, 'we will lay ourselves more for company than heretofore',[27] and he was proved right. In the spring of 1879, for example, Kelmscott House welcomed over ninety guests on the day of the Boat Race for lunch and garden games.[28] Visitors to Kelmscott House often report meeting members of Morris's family,[29] while many of Jane's letters are sent from this location.[30]

As with every house in which Morris spent much time, work featured in various ways at Kelmscott House. Morris wove his tapestries here, for example, and Marsh suggests that it was where May taught her embroidery

pupils.[31] Socialist meetings were also held in a separate building in the garden.[32] Though not officially an outlet or workshop for the firm, Kelmscott House may have been a kind of showroom, since May writes of an 'open-house day', when Morris appeared in the drawing room 'looking plaintive and as if he needed a moment's refreshment with his women-folk'.[33] She does not elaborate on the nature of these 'open-house' days, but her words give us a clue as to how public an image the house was required to project.

Morris's attitude towards Kelmscott Manor and Kelmscott House seems to have been somewhat feverish. Though he saw Kelmscott Manor as an escape from London, it was not an escape from work. According to Edward Carpenter, May said of Morris that he 'never takes any recreation, he merely changes his work'.[34] In one letter from Kelmscott Manor, he writes, 'I have an important piece of work on hand which I want to push, and I am all alone and enjoying that, & [sic] it makes me fit for work.'[35]

While he could get on with his work at Kelmscott, however, he seems to have had a sense that he was missing out on activity and opportunity by being away from London. For example, according to Mackail, '"I rather want to be in London again", he writes once on a golden day of early September, "for I feel as if my time were passing with too little done in the country: altogether I fear I am a London bird; its soot has been

5 Merton Abbey, near Wimbledon. From Lewis Foreman Day, 'The Art of William Morris', *Easter Art Annual*, 1899.

rubbed into me, and even these autumn mornings can't wash me clean of estlessness.'"[36] Similarly, he writes in 1879, 'I feel as if there must soon be an end for me of playing at living in the country: a town-bird I am, a master-artisan, if I may claim that latter dignity.'[37] It is interesting that Morris seems here to equate 'town-bird' with 'master-artisan', suggesting that art is an urban pursuit dependent more on the culture available in the city than the nature accessible in the countryside.[38]

add much since work of desire from nature

 While Kelmscott separated Morris from aspects of city life that he valued, in his letters he repeatedly demonstrates a reluctance to leave and, when away, a desire to return. From Queen Square, in 1877, he writes to Jane, 'I confess I sigh for Kelmscott.'[39] A few years later, in 1880, he tells Georgiana, 'I can't pretend not to feel being out of this house and its surroundings as a great loss.'[40] It is clear that neither London nor Kelmscott can on its own satisfy his needs. Instead, by dividing his time between the two, he strikes an unsettled balance. Morris displays a restless lack of contentment in each place, only too aware, it seems, that by fulfilling one role each home was ill-equipped to fulfil the other.

 In 1881, Morris was looking for a new, concentrated site for the firm, to share with William de Morgan.[41] During his search, Morris 'fell in love with' premises at Blockley in Gloucestershire, over sixty miles from London. The firm's business manager, George Wardle, however, considered the site to be impractically far away, and 'at last Morris reluctantly abandoned it'.[42] Instead, they settled on Merton Abbey, a site only seven miles from central London, near Wimbledon (figure 5).[43]

 A letter to de Morgan discussing their decision to lease Merton Abbey jointly demonstrates Morris's attitude to the city/country question at this time: 'adieu Blockley and joy for ever, and welcome grubbiness, London, low spirits and boundless riches'.[44] Morris appears to have perceived Blockley as a place that could offer him something like the escape from London he enjoyed at Kelmscott Manor. In November 1881, five months after signing the lease for Merton Abbey, he writes, 'We had a jolly time of it at Kelmscott, & were one and all very ill content to come back: I now blame myself severely for not having my way & settling at Blockley; I knew I was right, but cowardice prevailed.'[45] Morris thus suggests that parting with Kelmscott would be easier if he were bound for Blockley instead of Merton Abbey.

 During the years of Morris's socialist activity, from the early 1880s

onwards, he seems to have become more involved in London life and spent less time at Kelmscott Manor. Yet his fondness for Kelmscott did not wane, as it was in 1890 that he published *News from Nowhere*, which contains an affectionate description of a house that is identical to Kelmscott Manor in all but name.[46] In 1891, he also founded the Kelmscott Press, once again transferring the name of his country home to his London life.[47]

Though a 'sordid loathsome place' to Morris,[48] London seems to have been made more bearable by Kelmscott House. Both Morris's and May's positive comments about the house usually refer to its situation. According to May, Kelmscott House 'was a pleasant place "for London"', what with the long garden behind and the busy river in front'.[49] In a letter communicating to Jane his decision to purchase the house, Morris focuses on the same two features, reassuring her that people will visit them there 'if only for the sake of the garden & river'.[50] Both comments demonstrate the importance attributed to surroundings. In a letter to Jenny, Morris paints the scene before him: 'I am sitting in my room with the leaves dancing about in the sunshine on the table and the water sparkling outside so that it looks quite pretty'.[51] Once again, as in his letters from Kelmscott Manor, Morris describes himself looking out.

When considering how these houses were used, therefore, we must remember that they were not entirely self-contained spaces and that they functioned as windows and doorways to the surrounding world. The boundary between interior and exterior seems to have been particularly blurred in the Morrises' lives. An object was encountered not in isolation, nor simply against the background of the room, but in a certain season, at a certain time of day, and in certain light conditions. One feature of Morris's descriptive letters is their lack of a sense of permanence. He relates the experience he is having at a particular moment, describing how it feels to be there at that precise time.[52] May, looking back, expresses a similar preoccupation with the fleeting and the temporary, as we shall see.

By contrast, the surviving photographs of Kelmscott Manor and Kelmscott House frame the interiors in isolation from the outside world. Windows are rarely included within the photographs and, when they are, the brightness has left the film overexposed, preventing the view through the window from being recorded. As viewers of these photographs, we are subject to a selective blindness, whereby the exterior is invisible to us. The photographs thus draw a forced line around the interior, separating

it artificially for us from the context consciously acknowledged and appreciated by its inhabitants.

Yet, like the verbal descriptions, the photographs represent one frozen moment. It is important to acknowledge that each description or photograph of these homes records the impression given at a particular time. In the photographs these interiors are usually unpopulated, except for three surviving images of Morris in his Kelmscott House study.[53] This is particularly significant when we consider the gendering of these spaces, as suggested by May's description of Morris retreating into the drawing room for 'a moment's refreshment with his womenfolk'.

It is also worth bearing in mind that the surviving photographs are themselves Arts and Crafts objects of a kind. Although they provide crucial information about the interiors of Morris's homes, it is important to consider the possible reasons for their production, and the ways in which the images may have been constructed the better to fulfil those purposes. For example, some of the photographs may have been intended to memorialise Morris.[54] The available evidence on the subject of Morris's homes thus has inevitable limitations. Keeping this in mind, this chapter explores how Morris's homes might have looked in his lifetime, and experiments with new approaches to their interiors, beginning with Kelmscott Manor.

Kelmscott Manor

Kelmscott Manor and News from Nowhere

An engraving of Kelmscott Manor forms the frontispiece to *News from Nowhere* (1892), Morris's socialist utopian novel (figure 6).[55] In the novel, the house appears as a haven at 'Journey's end'.[56] Morris's narrator describes the experience of approaching this house, admiring first the garden and then the building itself. He observes the blurred boundary between interior and exterior, noting how 'the door and the windows were open to the fragrant sun-cured air: from the upper window-sills hung festoons of flowers', before stepping through the 'rose-covered porch'.[57] This passage in *News from Nowhere* also refers to a specific room at Kelmscott Manor hung with seventeenth-century tapestries depicting the Biblical story of Samson (figure 7). The narrator describes the tapestries as 'originally of no artistic value, but now faded into pleasant grey tones which harmonised

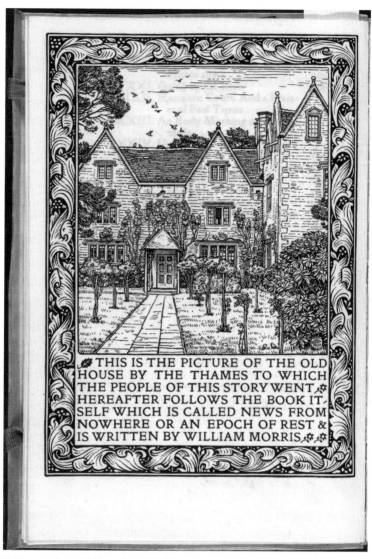

THIS IS THE PICTURE OF THE OLD HOUSE BY THE THAMES TO WHICH THE PEOPLE OF THIS STORY WENT HEREAFTER FOLLOWS THE BOOK IT SELF WHICH IS CALLED NEWS FROM NOWHERE OR AN EPOCH OF REST & IS WRITTEN BY WILLIAM MORRIS

6 Frontispiece of *News from Nowhere, or, An Epoch of Rest: Being Some Chapters from a Utopian Romance* (Hammersmith: Kelmscott Press, 1892), depicting the east front of Kelmscott Manor. Drawn by C. M. Gere, with border designed by William Morris. Wood engraving by W. H. Hooper.

thoroughly well with the quiet of the place, and which would have been ill supplanted by brighter and more striking decoration'.[58]

These comments are echoed in an essay from 1894, 'Gossip about an old house on the Upper Thames', where Morris writes that the tapestries 'look better, I think, than they were meant to look: at any rate they make the walls a very pleasant background for the living people who haunt the room; and ... they give an air of romance to the room as nothing else would quite do'.[59] We get a strong sense here that Morris was eager to accept the house as it was, embracing the eclectic atmosphere. He seems to treat the tapestries almost reverently, as though, through their long association with the house, they have become interwoven with it, forming an essential part of its character. Morris appears to be in awe of the mood conjured up by the room, feeling that he 'haunts' it as if he were a trespasser in a place that still belongs to the past, or as if he steps into the past when he is there.

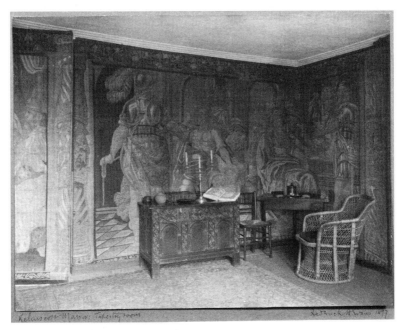

7 Frederick Evans, photograph of the Tapestry Room, Kelmscott Manor, 1897.

There is one particularly revealing paragraph in *News from Nowhere* in which Morris provides a summary of the house.

> Everywhere there was but little furniture, and that only the most neces-
> sary, and of the simplest forms. The extravagant love of ornament which
> I had noted in this people elsewhere seemed here to have given place to
> the feeling that the house itself and its associations was the ornament of
> the country life amidst which it had been left stranded from old times,
> and that to re-ornament it would but take away its use as a piece of
> natural beauty.[60]

Here 'ornament' appears as something that would be rendered unneces-
sary if all homes were as embedded in nature as this house is; or, rather, the
thing to be ornamented shifts from the house to the earth itself.[61] Morris
seems to be suggesting that in 'old times' the house, and the lifestyle it
provided (or 'its associations'), functioned as an ornament in the context
of a 'country life'. It is 'a piece of natural beauty' both because its materials
link it to the earth and because it is an adornment of the natural world.

We might ask how Morris can put forward this apparently anti-
ornament ideal, while at the same time contributing to the ornamenta-
tion of so many homes. First, it is worth noting that at this stage of his
life, Morris was investing more time in the Kelmscott Press than in Morris
& Co., suggesting that his priorities had changed. It is also significant that
News from Nowhere is a socialist utopia. This text, with its specific agenda,
does not necessarily present a fully balanced image of Morris's views on
interior decoration.[62] *News from Nowhere*, while it offers some insights
into Kelmscott Manor, does not provide a complete picture of the house.
As we shall see, Kelmscott did acquire new decorations during Morris's
time there.

Kelmscott Manor, 'whitewashed walls', and modernism

According to May Morris, W. R. Lethaby writes that Morris 'just *repaired*
and cared for' Kelmscott 'without any improvements and Art furniture,
and lived there in the summer in a delightful scrubbed table and white-
washed wall sort of way'.[63] This somewhat scornful attitude towards the
self-conscious home-improvement represented by 'Art furniture' is echoed,
and intensified, by Edward Carpenter, a fellow socialist, who declares that
Morris 'certainly was no drawing room sort of man'. Carpenter claims that

Morris told him, 'I have spent, I know, a vast amount of time designing furniture and wall-papers, carpets and curtains; but after all I am inclined to think that sort of thing is mostly rubbish, and I would prefer for my part to live with the plainest whitewashed walls and wooden chairs and tables.'[64]

Carpenter's testimony should, however, be viewed in the context of his own hostility to interiors.[65] Michael Hatt has observed that Carpenter sought outdoor spaces in protest at the civilising, and repressive, influence of interiors. Hatt argues that Carpenter 'exhibits an intense antipathy to the object and insistently identifies furniture, decorative objects and schema as the visual and material culture of capital'.[66]

May Morris, having quoted Lethaby earlier in the same volume, writes that her father's favourite home environment would feature whitewashed walls and no furniture at all.[67] The repetition of 'whitewash' in all these retrospective accounts suggests a particular desire to dispel any notion that Morris was primarily a wallpaper designer.[68] This word also conjures up a sense of negation, calling to mind perhaps a slate wiped clean or an image of obliteration. The 'whitewashed wall' criticism functions as a kind of writing out of Morris's decorativeness. This approach seems to be as much about denying certain aspects of Morris – particularly symbolically, his decorated walls – as it is about promoting his modernism. If we also consider that Lethaby is writing at a time when whitewashed interiors are indeed popular with architects such as M. H. Baillie-Scott and Charles Rennie Mackintosh, and that May and Carpenter are writing many years after Morris's death, it is possible that these writers are recasting their image of Morris, and Kelmscott Manor, in the light of current tastes and fashions.[69] Lethaby's and Carpenter's comments are early signs of the tendency to paint Morris as a modernist that finds its paradigm in Pevsner's *Pioneers*.[70] In fact, Pevsner's view of Arts and Crafts may have been influenced, indirectly, by Lethaby. Watkinson points out that Lethaby was acquainted with Muthesius, who was responsible for spreading news of English Arts and Crafts in Germany.[71] Pevsner's German education may well have taught him to see Arts and Crafts through the eyes of Lethaby, among others.

May's account in *William Morris: Artist, Writer, Socialist* is exactly contemporary with the first edition of Pevsner's *Pioneers* (1936). Marsh notes that at first, Basil Blackwell was unwilling to back such a substantial

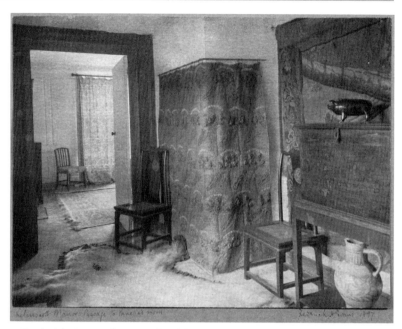

8 Frederick Evans, photograph of the passage, Kelmscott Manor, 1897.

publication about Morris, who was 'altogether out of fashion in the 1930s, with the emphasis on Modernism'. May had hoped to publish, at last, all her father's unpublished writings, and she eventually succeeded.[72] It is likely, then, that in these circumstances May was keen to show her publisher, and potential readers, that Morris was not as out of date as he seemed. By examining the criticism in the light of the visual evidence, this chapter aims to show that the concept of the 'whitewashed wall Morris' is tied to a critical agenda and a historiographic narrative and, as such, tells only part of the story.

The impression of Kelmscott Manor given by these writers seems to be coloured by a desire to attribute to Morris tastes and views compatible with certain moral and political attitudes.[73] For example, while Morris's and Carpenter's paths crossed in a socialist context, decorated objects were not part of Carpenter's politics, as we have seen.[74] Carpenter may therefore be attempting to accommodate Morris to his own version of socialism. It is possible that from his perspective Morris did appear more

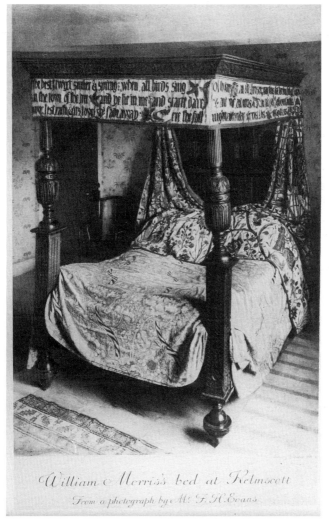

9 Frederick Evans, photograph of William Morris's bedroom,
Kelmscott Manor, 1896.

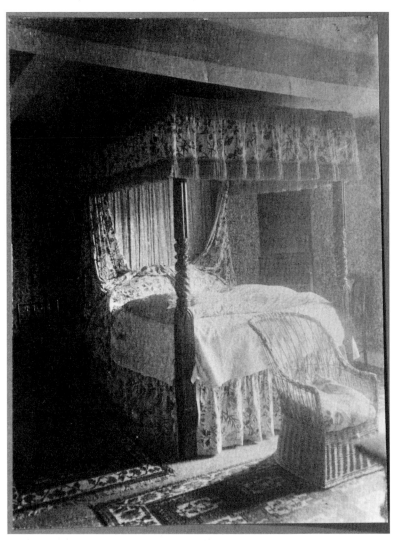

ᵉ **10** Frederick Evans, photograph of Jane Morris's bedroom, Kelmscott Manor, 1896.

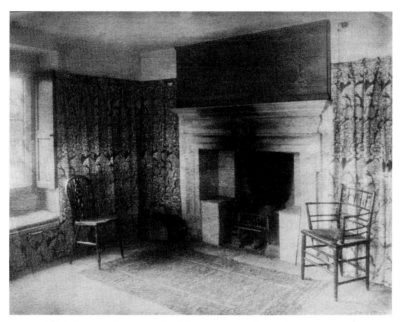

11 Frederick Evans, photograph of the Green Room, Kelmscott Manor, 1896.

compatible with that version than he does to us, either because Morris emphasised a specific side of his own character in Carpenter's company or because Carpenter saw what he wanted to see.[75]

The anecdotes have been chosen selectively by all of these writers, none of whom mentions a passage from Morris's lecture, 'Some Hints on Pattern-Designing' (1881), from which Day quotes in his 1899 account of Morris:

> Doubtless there will be some, in these days at least, who will say, "'Tis most helpful to me to let the bare walls alone.' So also there would be some who, when asked with what manner of books they will furnish their room, would answer, 'With none.' But I think you will agree with me in thinking that both these sets of people would be in an unhealthy state of mind, and probably of body also.'[76]

Day uses part of this quotation to back up his claim that 'Decoration' was to Morris 'not so much a luxury as a necessity.'[77]

When set against other evidence, the comments of Lethaby, Carpenter and May cited above betray a bias that does not portray a complete picture of how Kelmscott Manor looked during Morris's tenancy. As Bosomworth argues, 'it is impossible to accept Wilfrid Scawen Blunt's comment that the house was extremely primitive'.[78] In order to move beyond this one-sided approach, we need to reassess the available descriptive and visual evidence.

Though Lethaby bases his image of Morris precisely on Kelmscott Manor, when we look at the photographs of the interior from 1896–97, it is clear that the rooms combine the plain with the decorative.[79] For example, on the one hand, many of the chairs are of a simple design, and several rooms, such as the Tapestry Room, are uncluttered, with much empty space visible (figure 7). At the same time, the rich tapestries themselves; the *Kennet* chintz hung all around the Green Room; the *If I Can* embroidery and fur rug in the passage; the wallpaper and carpets in the bedrooms; and the patterned hangings over Morris's bed indicate a decision to add both horizontal and vertical adornments, conflicting with a 'whitewashed wall' image of living (figures 7–11).

The Green Room at Kelmscott Manor

Although Morris did not comprehensively redecorate Kelmscott Manor, the photographs demonstrate that changes were made to the interior during his tenancy. Particular attention seems to have been given to the Green Room (figure 11). A large, L-shaped room, surrounded with windows and hung all over with *Kennet* chintz (figure 12), the Green Room would have been a light, airy space.

Kennet is one of several Morris & Co. fabrics whose names are shared with tributaries of the Thames. As Stephen Eisenman observes, Morris 'understood about tides and eddies, jets and vortices, small whirlpools and sudden inundations', and signs of this knowledge emerge in these designs.[80] Lucia van der Post identifies the flora featured in *Kennet* as river plants, and claims that the 'wavy, diagonal patterning' evokes 'the movement of the river'.[81] While these features would have the same effect if the design were transferred to wallpaper, the evocation of the river is made particularly strong by the folds of the chintz, which, like ripples on water, distort the pattern as if it were a reflection. Indeed, the details of the *Kennet* pattern suggest a desire to convey the impression of a reflection, since the bright white of the flowers can be related to the dazzling effect

12 William Morris, *Kennet* chintz, registered 1883. Block-printed and indigo-discharged cotton.

of light on the surface of water. The long chain of flowers is regularly interrupted by a leaf that is half green, and half blue, suggesting that the leaf is partly covered by water. We thus get the impression that the flowers are gradually being submerged by the sky-reflecting water.

Since Morris repeatedly describes his experiences at Kelmscott Manor in terms of the surrounding natural environment, it seems likely that by using the *Kennet* pattern here, he was recreating indoors one of his favourite features of outdoor life at Kelmscott. Alternatively, he may have been seeking to blur the distinction between indoors and outdoors, which, as we are beginning to see, is characteristic of Morris. It is, perhaps, surprising that at Kelmscott Manor, Morris did not turn to stained glass as a means of blurring this indoor/outdoor boundary, as later American architects such as Frank Lloyd Wright and Purcell & Elmslie would, since Morris after all had considerable experience with stained glass.[82] A textile, however, may have seemed to Morris more capable of evoking the fluid,

rippling effect of a river than a stained glass window, which may explain why he chose to use chintz in this instance.

As well as being draped in *Kennet* chintz, the Green Room acquired new fireplace tiles in 1873. Most of the tiles feature one of two designs. Significantly different in overall composition, these two types of tile – *Swan* and *Artichoke* – are both blue (plates 1 and 2).[83] While the *Artichoke* design reaches right to the corners with no repetition within an individual tile, each *Swan* tile is divided into sixteen tiny squares of two alternating designs. Of these two *Swan* motifs, one is sometimes reversed, producing an abbabaab pattern.

Richard and Hilary Myers call the arrangement of tiles in the Green Room fireplace a 'confused jumble'. This assessment is based on their observation that 'an overall cohesive effect relied upon the [*Artichoke*] tiles being arranged so that left- and right-facing forms alternated'.[84] It is true that the Green Room hearth does not follow this formula. Looking closely at the fireplace, however, it seems that whoever arranged the tiles did have an overall order in mind, but not one that governed the orientation of individual tiles (plate 3). Instead, the placement of the tiles takes advantage of the different characteristics of the two contrasting designs. The top five rows of tiles, as well as the twelve tiles that form two shelves flanking the grate, are consistently of the *Swan* design. It is at the base, reaching down from these two shelves, that the *Artichoke* tiles feature. The upper part consisting of *Swan* tiles is recessed, while the *Artichoke* tiles reach out towards us. By using the subdivided pattern for the largest area, a sense of lightness and space is created, making the fireplace appear to extend further upwards than it in fact does. The larger, bolder *Artichoke* design, on the other hand, weighs the fireplace down at the base, creating an impression of permanence and substantiality. A kind of false perspective is thereby introduced, in which the fireplace is treated somewhat like an architectural interior. This arrangement divides the fireplace into sections, emphasising its three-dimensionality and setting the recessed *Swan* tiles as a background to the more conspicuously positioned *Artichokes*. At the same time, the flat patterns draw attention to surface and the shared colour unifies the overall design of the fireplace.

The light freshness created by the *Kennet* chintz and fireplace tiles in the Green Room must have contrasted strongly with some of Rossetti's belongings elsewhere in the house. He possessed furniture in dark, stained

wood patterned in gold.[85] From Rossetti's letters to Jane it seems that he had left many of his things in the Tapestry Room, which he had used as a studio, sleeping in the adjoining bedroom that was later Morris's.[86] Combined with the faded tapestries, this furniture would have given the room a very different atmosphere – dark, rich and old – from that created by the more modern decorations in the Green Room. Kelmscott's existing decorations combined with Rossetti's eighteenth-century furniture to root its style in tradition; at the same time, new furnishings brought the interior into the late nineteenth century.

The Kelmscott Manor interior prompts us to think again about Morris's relationship with modernism. As we have seen, some accounts that take the more mainstream modernist line, which prioritises 'white-washed walls' and simplicity, emphasise certain aspects of Kelmscott Manor over others in order to accommodate Morris to their version of modernism. The *Lily* wallpaper in Morris's bedroom, for example, does not sit comfortably with this interpretation (figure 9). It is helpful to return to MacCarthy's reminder of Morris's 'idiosyncrasy' and 'strange-ness'.[87] With this in mind, we might want to abandon the idea that Morris and his objects fit into any clearly defined system.

The Morris & Co. products introduced to Kelmscott Manor did not jar with the existing decoration. Consisting of natural forms and materials, they blended into the environment in which Kelmscott was situated, thus contributing to its function as a peaceful rural retreat. The informality of Kelmscott Manor forms a sharp contrast to the much more elaborate environment provided, from 1878, by Kelmscott House.

Kelmscott House

Three rooms at Kelmscott House have attracted the most attention from both primary and secondary commentators: the drawing room, the dining room, and the study. The study was to be found immediately to the left on entering the house, and it was here that Morris usually entertained the many interviewers who visited him at Kelmscott House. At the back and to the left, also on the ground floor, the relatively small, dark dining room looked out on the large garden. Upstairs on the first floor, and stretching across the whole width of the house, was the drawing room. It was a spacious, bright room with windows all along its front wall, looking out

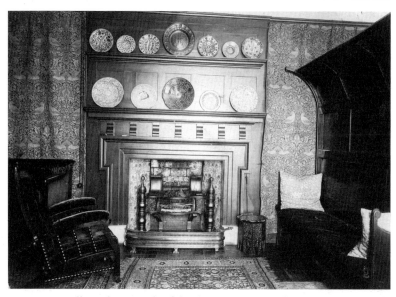

13 Emery Walker, photograph of the drawing room, Kelmscott House, north wall, *c.* 1896.

on to the road and, beyond it, the Thames.

The house's aesthetic role is clear from May's assessment that it was a 'seemly … place to keep books and pretty things in'. Yet her detailed description of the house treats it much more seriously as the focus of aesthetic contemplation than this somewhat dismissive comment would suggest. For example, she sees the unity of the drawing room's design as something that must not be disrupted; the space included 'no picture, of course' as 'the simple scheme of the room did not allow of such broken wall-surface' (figures 13–15).[88] The walls themselves are thus perceived as a kind of canvas whose adornments have been carefully arranged, any addition to which would unbalance the composition.

This approach is not unique to May. George Bernard Shaw, who had met the Morrises through the Socialist League and was 'the love of [May's] life',[89] expresses a similar response to the house. Shaw observed 'an extraordinary discrimination at work' so that 'everything that was necessary was clean and handsome: everything else was beautiful and beauti-

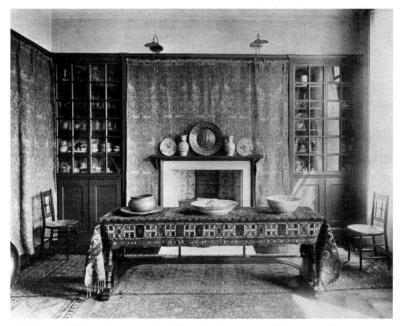

14 Emery Walker, photograph of the drawing room, Kelmscott House, east wall, *c.* 1896.

fully presented'.[90] Helena M. Swanwick, née Sickert, who was a friend of May's, was similarly struck by the 'exquisite cleanliness of the whole house'.[91] Shaw's comment has echoes of Morris's famous motto, 'Have nothing in your houses that you do not know to be useful or believe to be beautiful',[92] a maxim that May declared was 'carried out' at Kelmscott House,[93] although Shaw attributes aesthetic value to the 'necessary' as well as the 'beautiful' components of Morris's home.[94] Like May, Shaw treats the house as an object to be evaluated and stresses the importance of introducing nothing that would interfere with the unifying aesthetic.[95] This chapter will follow these contemporary sources in taking the interior of Kelmscott House seriously as the subject of visual analysis.

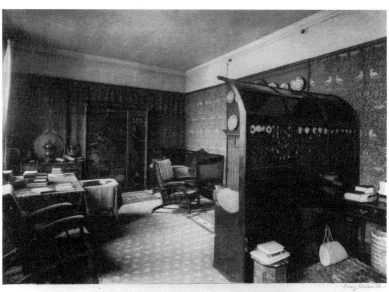

The Drawing Room, Kelmscott House, Hammersmith

15 Emery Walker, photograph of the drawing room, Kelmscott House, west end, *c.* 1896.

The Kelmscott House drawing room

May Morris focuses mainly on the drawing room, which she discusses on two levels. First, she considers the experience of being in the room from an aesthetic point of view; secondly, she recalls the ways in which the room was used. For May, colour and light are vital in characterising the drawing room (figures 13–15). Two of the most striking objects in the room came from Red House, the settle and the *Prioress's Tale* wardrobe, which had been a wedding present from Burne-Jones (plate 4 and figures 15 and 16). May describes the latter as 'a splendid central note and gathering-in of all colour in the room', while the settle, placed perpendicular to the grate, 'caught the gleams of the fire on its tawny gold panels in winter evenings, and in summer the dancing reflections of the river'. Similarly, 'the lustre plates above the chimneypiece suggested flushed sunsets and dim moonlit nights beyond the elms'.[96] By observing how the components

of the room respond to light, May, echoing a tendency of Morris's, takes a viewing position that is framed by a particular moment and by specific surrounding conditions. She does not try to isolate the room from the outside world; instead she acknowledges that it is a dynamic space in which environmental conditions are never constant.[97]

May's comments on the effect of the lustre plates are particularly interesting. The word 'suggested' implies some kind of appeal to the imagination. Not only do the plates catch the light from the windows, but the experience of looking at them also 'suggests' to the viewer the appearance of sunsets and moonlight. We thus find May observing the potential of decorative objects to represent in an abstract way under certain conditions. Importantly, May here provides a precedent for looking at Arts and Crafts objects in terms of their context, as parts of a whole that work together to create an overall effect, and as triggers for the imagination.

Alongside these lyrical passages, we find examples of a more pragmatic approach to the house. May also considers the room as a space in which daily activities are carried out. She explains that no unnecessary furniture was tolerated: 'no occasional tables, no chairs like featherbeds, no litter of any sort'.[98] MacCarthy echoes this description of May's when she observes that the 'hospitable but not flirtatious' drawing room 'did not exude luxury or encourage intimacy'.[99] By characterising the room as one that is not flirtatious and does not 'encourage intimacy', MacCarthy emphasises how different Kelmscott House was from Kelmscott Manor in a way that is only suggested by May. If we consider that one of the main purposes of Kelmscott Manor was to provide a hideaway for Jane and Rossetti, May's denial of features reminiscent of the bedroom in her description of Kelmscott House is significant. It may be that May's description of Kelmscott House is coloured by her sense of its contrast, in terms of what went on there, to Kelmscott Manor.[100]

Thanks to the lack of 'litter', May recalls, there was 'plenty of "quarter-deck" in which to march up and down when discussions got animated and ideas needed exercise'.[101] Carpenter recalls such an occasion, describing how Morris 'would jump from his chair and stride up and down the room in ardent monologue'.[102] Swanwick, too, remembers that 'Sometimes, on red-letter days, Mr Morris himself would ramp up and down the long sitting room reading and expounding one of his loved Icelandic sagas'.[103]

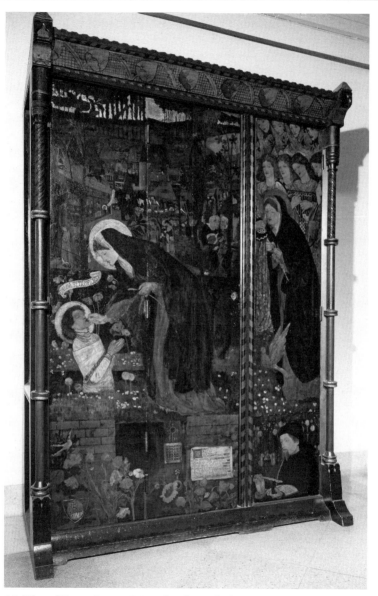

16 Edward Burne-Jones, *Prioress's Tale* wardrobe, 1858. Oak and deal
painted in oil. 222 x 160 x 57 cm.

The ideal that demanded an uncluttered wall surface is thus applied to every dimension of the room, so that the freed-up living spaces become vital components of the unified interior, both practically and aesthetically. May implies that the space has been so carefully constructed that to add or take away anything would have a significant impact on the overall result. If we look in detail at surviving photographs of the drawing room, we can explore the way in which each component contributes to the effect of the room as a whole.

The *Bird* hanging (figure 17 and plate 5), which covers the walls, creates a sense of continuity that unites the room while simultaneously introducing a hierarchy among the room's features.[104] Faced with so much cloth printed with a repeating motif, we are discouraged from focusing too closely on one part of it. Because the design continues beyond our visual field, we cannot take control of the image before us. Tempted always by another equally attention-deserving section of the fabric, we may find our eye flitting rapidly over the surface, never resting for long at one point.

If we do look closely at the *Bird* fabric, however, we find that a careful balance of colour adds a restrained richness to its overall appearance (plate 5). The richest colour, a brick red, is applied to the bird's head, with a slightly paler shade in the feet and tail. The upper body is a sandy pink colour (matched in the flower to the left) while the lower body and tip of the wing are an olive green. The middle strip of the bird's body is the same blue as the leaves forming the background. This blue spills over to dapple the green, pale pink, and red nearby, introducing light and shade and gently suggesting the presence of feathers.

The colours, though varied, follow a logical pattern. The darkest parts, the head and feet, mark the boundaries of the major motif, making it stand out against the background. In between the two reddish areas, the green and pink are of a similar tone, adding a lighter, almost golden tint. The bird form is linked to the background by the blue at its centre. Our attention having been drawn to the darker red of the bird's extremities, it is then diverted back to the surrounding fabric via this chromatic link. This colour scheme contributes to the unfocused, all-over effect of the fabric's design. Our eye discovers points of interest, but none to dominate over any other.

The circular nature of this viewing experience, combined with the repetition of the motif, characterises the fabric as a background of which

we are aware, but in a distant, non-committal way. Out of this background emerge the significant features around the walls of the room: the main grate, whose wooden surround reaches right up to the picture rail; the second fireplace flanked by two cabinets set into the wall; and the *Prioress's Tale* wardrobe. Like paintings whose protective curtains are drawn back to reveal them, these major wall features – especially those whose front surface lies flat against the wall – appear as objects that have self-consciously been put on display. In contrast with the surrounding *Bird* fabric, each plate, vase and fan on the two mantelpieces is different and offers the viewer a new visual motif to absorb. Smaller and more self-contained, these objects invite closer and more focused contemplation than the wall hanging. In the case of the small mantelpiece, we are required to view the objects against the fabric, so that we must limit our visual attention to the space contained by the object's outline if we do not wish to incorporate the *Bird* pattern.

Moving towards the centre of the room, we find this dichotomy of background versus main feature echoed on a smaller scale. The long table at the end of the room, for example, is draped with a carpet bearing a repetitive motif on which large pots are displayed (figure 14). In this case, the background – the carpet – is smaller than the wall-hanging, presenting less of a challenge to our visual field when we attempt to take in the whole object; yet in comparison with the individual pots, the carpet takes the role of background nonetheless. Covering much of the floor is one large Morris & Co. *Tulip and Lily* carpet (figure 15), which is overlaid in places – before the grate, under the long table and in front of the Chaucer cabinet, for example – with smaller rugs. The large carpet's much more ordered, simpler pattern, which fills the visual field, contrasts with the more intricate and varied designs of the small carpets, which are prioritised by their superior position, overlapping the edges of the former.

The drawing room presents a succession of patterns that overlap with one another and, depending on the viewer's position, shift between foreground and background status. Set against these patterns, more self-contained, less malleable objects stand out, their physicality as heavy, solid presences contrasting with the floating spatial illusions conjured by the surrounding surface patterns. This creates a sense of balance: lightness with mass, flat with multi-faceted, straight with round. The ordered, almost symmetrical theme running through the room contributes to this

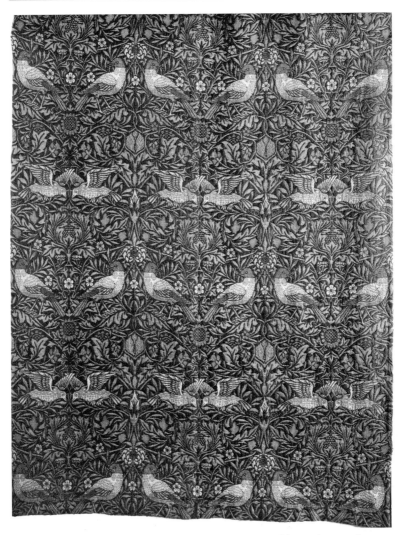

17 William Morris, *Bird* wall hanging, 1877–78. Hand-loom jacquard-woven woollen double cloth.

impression. The end of the drawing room, for example, has a balanced composition: a long table is placed so that it almost exactly fills the space between the two cabinets; an inward-facing chair is positioned on either side; and the pots arranged on mantelpiece and table are distributed evenly over the available space, allowing one object to take the central position. While the style of the drawing room is quite subtle, consisting of layers and variations on a theme, the dining room gives the impression of being a self-conscious stylistic statement.

The Kelmscott House dining room

The overall effect of the dining room (figures 18 and 19) is one of eclecticism. The two walls visible in the photographs seem to compose a literal opposition of Classical and anti-Classical. One wall (figure 19) is framed by two identical doors topped with round arches, between which a centralised cabinet stands below three layers of shelving neatly divided into twelve sections, each of which displays three plates. The thirty-six plates are of equal size, creating a sense of order and proportion, and the decorative scheme is crowned by a row of shining plates of which the largest, fittingly, forms the central and highest point, roughly describing the triangular shape of a Classical tympanum.

Perpendicular to this wall, which embodies Classical discipline, proportion and symmetry, we are presented with a wall decorated in a completely different style (figure 18). A vast Persian carpet hangs from the ceiling over an Italian chest laden with eastern metalwork.[105] The carpet stretches right down the wall, slicing through the background – this time provided by the *Pimpernel* wallpaper – and interrupting the clean line between ceiling and wall. The carpet pattern next to the *Pimpernel* wallpaper creates a sense of ornament overload, an effect that does not sit comfortably with the idea that Morris favoured simplicity. Dominated by the carpet, the wall seems to disappear behind it. Rather than fitting architectonically into predetermined spaces, the carpet imposes its own rules. To the right, the door is topped not by a smooth rounded arch but by a portrait of Jane; amid the confusing juxtaposition of wallpaper pattern with carpet design, a figurative painting pierces the flat surface of the wall. There is no concern about 'broken wall-surface' here, it seems.[106] On the chest below the carpet are displayed two brass peacocks (see figure 20). The peacock motif is, of course, typically associated with Aestheticism.[107]

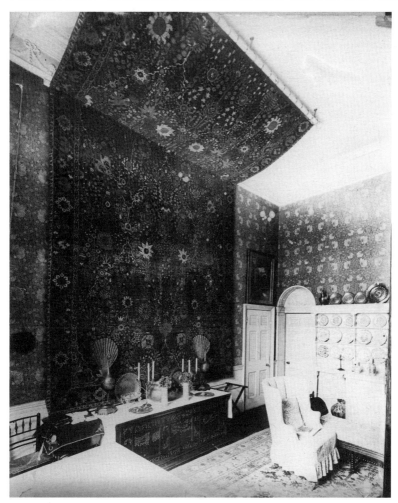

18 Emery Walker, photograph of the dining room, Kelmscott House, east wall, *c.* 1896.

May acknowledges the exoticism of this ensemble, observing: 'That side of the room had more than a touch of the Thousand and One Nights, for above this table of Eastern riches rose up a carpet spread like a canopy across the ceiling.'[108] By applying this description specifically to 'that side

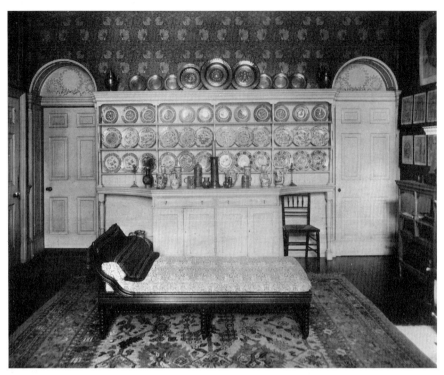

19 Emery Walker, photograph of the dining room, Kelmscott House, south wall, *c.* 1896.

of the room' May seems to acknowledge that the room has an element of disunity.

May reports that Morris felt no attraction to the dining room when he purchased the house, its 'fine cold proportions' being 'miles away from his taste and sympathies'.[109] Yet in a letter to Jane he refers to it as 'the dismallish *handsome* room: ('tis really very handsome)', concluding, 'I believe by dint of cheerful papering, book cases & the like it might be made a very good dining room'.[110] The exotic, anti-Classical wall may be a deliberate attempt to cancel out to some degree the existing character of the room.

One contemporary interviewer described this space as 'a sumptuously furnished dining room'.[111] Another saw the house as an elaborate marvel:

'as soon as you open the front door you are in another world. Rows of pictures meet the eye as you enter, and you have a vision of old oak, wrought iron, and shelves and shelves of bulky old volumes.'[112] A third interviewer, however, observed 'Hardly a sign of luxurious furnishing, except a magnificent collection of rare incunabula [early printed books] and finely illuminated manuscripts.'[113] This is difficult to reconcile with the first observer's 'sumptuous' impression. On the other hand, the third interviewer writes for *Bookselling*, so it is unsurprising, perhaps, that he or she highlights Morris's books and works on paper. Still, there is a clear discrepancy among contemporary views of Kelmscott House, one that urges us to reconsider how we are interpreting the language used. Quinbus Flestrin gives us a clue to the issues at stake, observing 'no veneer or unprofit-able ornaments ... No pretentious shams, no morbid decadent fancy'.[114] Flestrin seems to be concerned with dishonesty, repre-sented by 'veneer' and 'shams', and excess, in the form of 'unprofitable ornaments' and

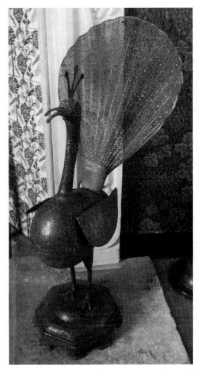

20 Brass Persian peacock, originally at Kelmscott House.

'morbid decadent fancy'. It is not 'ornaments' themselves that are objected to, but 'unprofitable' ones; by extension, visual complexity and decora-tion are not rejected, but 'luxurious furnishing' is.

These distinctions can help us to make sense of MacCarthy's other-wise perplexing conclusion regarding Kelmscott House. MacCarthy writes of the drawing room that 'as in all Morris's interiors from Red House onwards there was a sense of reduction to essentials'.[115] This verdict, which suggests by implication that the dining room can be described in the same terms, requires a very specific understanding of the term 'reduction to essentials'. What MacCarthy means by this term is very different from a minimalist or anti-decoration reductionism, but instead a quality similar to the 'discrimination' referred to by Shaw. She is pointing to the absence

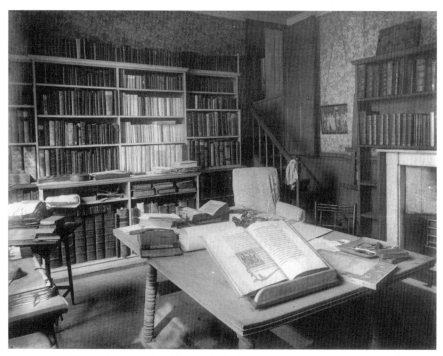

21 Emery Walker, photograph of the study, Kelmscott House, dated 3 October 1896.

of arbitrary objects – the 'interesting or quaint or rare or hereditary'[116] in Shaw's words – and to a kind of connoisseurship with which the house's decoration is overseen. The Kelmscott House interior is reduced to what is aesthetically 'essential'. A 'reduction to essentials' can be perceived in these spaces in comparison with the accumulative character for which the Victorian interior is often ridiculed.[117] It is the evidence of a guiding connoisseur who strictly governs the acquisition of objects that sets this interior apart.

The Kelmscott House study and the question of 'simplicity'

The part of the house that might perhaps be seen as displaying a 'reduction to essentials' is Morris's study (figure 21). According to May, this room was 'almost frugally bare'.[118] MacCarthy claims that the photographs 'confirm

May's description', and points out the absence of carpets and curtains in the study.[119] Yet we can see from the photograph that at least two walls are papered, a reproduction of Botticelli's *Primavera* hangs by the door and patterned tiles decorate the fireplace. Glasier, another socialist friend, remembers 'the bookshelves all round the room laden with all manner of books, new and old, and great antique tomes on the lower row'.[120] Considering the fact that one of Morris's most important artistic projects was the production of books, it would be inaccurate not to include the book-filled shelves as an aesthetic contribution to the room. Morris clearly derived pleasure from them, telling Jenny in one letter, 'I rather like my room with all the books about'.[121] Furthermore, we should not overlook the presence of a table designed by Webb in the very centre of the room. The detailing on the legs and underneath the edge of the tabletop jars with the concept of this room as 'almost frugally bare'. An earlier critic acknowledged these decorative aspects of Morris's study, 'where more old oak, more quaint china and pottery, more beautiful pictures attract at every turn'.[122]

May's description of the study makes more sense if we compare this room with the rest of the house. Lacking the grand ceramics and intricate carpets of the more public rooms the study was certainly a more modest space, and in the photograph the floorboards are visible. MacCarthy's emphasis on the absence of carpets and curtains suggests that she is highlighting the limited comfort of the study, rather than a lack of decoration. In this room we therefore perceive a 'reduction to essentials' that limited provision for the body but not for the eye.[123]

We can observe in these and other accounts the same tendency to emphasise the simplicity of Morris's interiors as that found in the scholarship on Kelmscott Manor.[124] Parry, for example, argues that both houses 'displayed a comfort and simplicity of style absent from many of the firm's commercial schemes'.[125] Similarly, Marsh writes that 'visitors to Kelmscott House [were] impressed by the simplicity of items like a scrubbed oak dining table, which indicates that [Jane] as well as her husband abjured unnecessary expenditure'.[126]

This claim seems to be based on the recollections of Swanwick, whose account of Kelmscott House Marsh quotes from a few pages earlier.[127] Swanwick remembers, 'I delighted in the trestle-table, a long oak-board, scoured grey-white with sand', but makes no suggestion that it was its 'simplicity' that delighted her.[128] Since Swanwick also recalls admiring 'a

cabinet with panels decorated in gold and colours by Burne-Jones' and 'a splendid eastern rug hung on the wall in the dining room', she seems to have been just as delighted by the more elaborate features of the house.[129] The Kelmscott House interior, taken as a whole, does not suggest a particularly frugal household.

Another conclusion MacCarthy draws is that the Kelmscott House decorations 'can be regarded as the ultimate example of Morris's style in its maturity'.[130] This statement requires us to perceive Morris's 'mature' style as an adaptable one. As we have seen, the various rooms at Kelmscott House are very different from one another. The character of each room stems from the subtle interplay between objects. Although certain principles seem to be common throughout the house, a freedom of style is permitted. While every object appears to have its own place and symmetry is often observed, the design concept varies according to the particular requirements of each room. The dining room displays what could be described as a rebellious streak, a willingness to juxtapose the disparate.[131] It bears witness to a taste that is above all confident. It was certainly in these terms that Shaw responded to Kelmscott House, observing 'an extraordinary discrimination at work' which demonstrated an 'artistic taste of extraordinary integrity'.[132] His repetition of the word 'extraordinary' may not be simply coincidental as he also describes the house as 'magical'. Swanwick remembers feeling 'as if I were entering a land of faery',[133] while to Sydney Cockerell, the dining room was an 'enchanted interior'.[134]

Conclusion

In some respects, Kelmscott House would have had the air of a museum. Like Morris's other London houses, it seems to have been a showroom displaying the effect of Morris & Co. products in a real domestic setting. Yet it also functioned as a kind of reliquary in which certain objects bring with them memories of the past. For example, the settle and *Prioress's Tale* wardrobe from Red House were located in the drawing room (plate 4 and figures 15 and 16). MacCarthy describes the drawing room as 'a composite of objects' from 'remembered places', creating a sense of 'melancholy'.[135] She thus implies that objects have a certain power enabling them to evoke the state of being in which they are originally experienced and to cause nostalgia for that state when encountered later.

These are what Christopher Bollas calls 'mnemic objects', which when experienced conjure up a specific memory with which they are associated.[136]

This reinforces the argument that context is vital for an understanding of Morris's homes. Kelmscott Manor and Kelmscott House are examples of Arts and Crafts interiors that could 'create atmosphere'.[137] The kinds of atmosphere they created were more varied and temporary than summaries that focus on their straightforward 'simplicity' accommodate. Morris's homes do not bear out his declaration that he would prefer 'the plainest whitewashed walls' to any other kind of decoration. This is only one of many inconsistencies in the surviving evidence about Morris. He can be, and has been, shown to be a self-denying socialist and a scrupulous connoisseur, a lover of beauty and a hater of luxury, a promoter of simplicity and an admirer of elaborate decoration.

This chapter has demonstrated that Morris's homes were as complex and contradictory as Morris himself. It has also argued that Kelmscott Manor and Kelmscott House have much more to say if we resist filtering them through the concept of the 'Arts and Crafts movement'. In their diversity, they again draw our attention to the links between what we usually take to be conflicting tendencies. Like the other contexts examined in this book, the homes of Morris challenge assumptions about how decorative objects should be approached. In the same way that Morris's homes cannot be summed up as a product of the 'Arts and Crafts movement', neither can his firm, Morris & Co., as we shall see in the next chapter.

Notes

1 Edward Burne-Jones, quoted in MacCarthy, *William Morris*, p. 110.

2 There was also a plan to transfer the firm to nearby Upton (MacCarthy, *William Morris*, p. 193).

3 Morris to Burne-Jones, November 1864. Cited in Norman Kelvin (ed.), *The Collected Letters of William Morris*, I (Princeton and Guildford: Princeton University Press, 1984), p. 38. The name may have been drawn from Tennyson's poem 'The Palace of Art' (1833).

4 Their newborn baby had recently died of scarlet fever. MacCarthy notes that Burne-Jones himself was 'delicate' and 'financially careful', and suggests that he 'may have felt the Red House scheme too reckless' (MacCarthy, *William Morris*, pp. 194–5).

5 See MacCarthy, *William Morris*, pp. 193–6. See also Rob Allen, 'Why William Morris Left His Joyous Gard', *Journal of the William Morris Society*, XIV: 3 (Winter 2001) and David Rodgers, *William Morris at Home* (London: Ebury Press, 1996), p. 59.

6 See letters cited in Kelvin (ed.), *Letters*, I, pp. 77–96.

7 Morris to Edith Marion Story, 10 May 1871. Cited in Kelvin (ed.), *Letters*, I, p. 133.

8 Morris to Charles James Faulkner, 17 May 1871. Cited in Kelvin (ed.), *Letters*, I, p. 133.

9 For more on Rossetti's tenancy, see Joseph Acheson, '"An Artist of Reputation": Dante Gabriel Rossetti and Kelmscott Manor', in Design Council, *William Morris and Kelmscott*.

10 For more on this, see Marsh, *Jane and May Morris*, pp. 70–3, 77–8, 81–2, 86–92 and 119–32. See especially p. 81: 'By the end of 1868 Morris seems to have been fully aware of the state of affairs.' See also MacCarthy, *William Morris*, pp. 258–9.

11 MacCarthy, *William Morris*, p. 276.

12 MacCarthy, *William Morris*, pp. 326 and 335.

13 Morris to Aglaia Ionides Coronio, 25 November 1872. Cited in Kelvin (ed.), *Letters*, I, p. 172.

14 Morris to Rossetti, 16 April 1874. Cited in Kelvin (ed.), *Letters*, I, p. 222.

15 Morris to Aglaia Ionides Coronio, 25 November 1872. Cited in Kelvin (ed.), *Letters*, I, p. 172.

16 Morris, 'Gossip About an Old House on the Upper Thames', *The Quest* (November 1894).

17 Rossetti to Jane Morris, Friday, August 1878. Cited in John Bryson (ed.), in association with Janet Camp Troxell, *Dante Gabriel Rossetti and Jane Morris: Their Correspondence* (Oxford: Clarendon Press, 1976), p. 71.

18 Rossetti to Jane Morris, Wednesday, September 1878. Cited in Bryson (ed.), *Dante Gabriel Rossetti*, p. 79.

19 See Dorothy D. Bosomworth, 'Traditional Furniture and Personal Items from Kelmscott Manor', in Design Council, *William Morris and Kelmscott*. Bosomworth writes that the length of Rossetti's list 'accentuates the impact of his presence on the household' (p. 83).

20 Morris to Jane Morris, 6 July 1871. Cited in Kelvin (ed.), *Letters*, I, p. 139.

21 Cited in Society of Antiquaries of London, *Kelmscott Manor: An Illustrated Guide* (London: Society of Antiquaries of London, 1999), p. 4 and Design Council, *William Morris and Kelmscott*, p. 91.

22 Wilfrid Scawen Blunt, *My Diaries: Being a Personal Narrative of Events, 1888–1914*

(London: Martin Secker, 1919), p. 29. For more on Blunt's relationship with Jane, see Marsh, *Jane and May Morris*, pp. 188–98 and MacCarthy, *William Morris*, pp. 447–52.

23 Morris to unknown recipient (possibly Georgiana Burne-Jones), late autumn 1879. Cited in Kelvin (ed.), *Letters*, I, p. 525.

24 Morris to Georgiana Burne-Jones, 4 September 1881. Cited in Norman Kelvin (ed.), *The Collected Letters of William Morris*, II (Princeton and Guildford: Princeton University Press, 1987), p. 63.

25 See MacCarthy, *William Morris*, p. 326 and Anna Stirling, *William de Morgan and His Wife* (London: Thornton Butterworth Ltd, 1922), p. 113.

26 May Morris, *Introductions to the Collected Works*, p. 360.

27 Morris to Jane Morris, 2 April 1878. Cited in Kelvin (ed.), *Letters*, I, p. 469.

28 Marsh, *Jane and May Morris*, p. 156. Helena Swanwick also recalls a Boat Race day (*I Have Been Young* (London: Gollancz, 1935), p. 101).

29 See Glasier, *William Morris*, pp. 45–7 and William S. Peterson (ed.), *The Ideal Book: Essays and Lectures on the Arts of the Book by William Morris* (Berkeley and London: University of California Press, 1982), p. 106.

30 See Peter Faulkner (ed.), *Jane Morris to Wilfrid Scawen Blunt: The Letters of Jane Morris to Wilfrid Scawen Blunt Together with Extracts from Blunt's Diaries* (Exeter: University of Exeter, 1986) and Bryson (ed.), *Dante Gabriel Rossetti*.

31 Marsh, *Jane and May Morris*, p. 168.

32 Glasier, *William Morris*, p. 116. See also Peterson (ed.), *The Ideal Book*, pp. 98–9.

33 May Morris, *William Morris: Artist, Writer, Socialist*, 1936, II (New York: Russell, 1966), p. 617.

34 Edward Carpenter, *My Days and Dreams: Being Autobiographical Notes* (London: George Allen & Unwin, 1916), p. 218.

35 Morris to Aglaia Ionides Coronio, 11 October 1881. Cited in Kelvin (ed.), *Letters*, II, p. 69.

36 Mackail, *Life*, I, p. 239.

37 Morris to unknown recipient (possibly Georgiana Burne-Jones), 3 October 1879. Cited in Kelvin (ed.), *Letters*, I, p. 524.

38 For more on the role of cities in Arts and Crafts, see Alan Crawford, 'The Importance of the City', in Karen Livingstone and Linda Parry (eds), *International Arts and Crafts*, exh. cat. (London: Victoria and Albert Museum, 2005).

39 Morris to Jane Morris, 2 August 1877. Cited in Kelvin (ed.), *Letters*, I, p. 392.

40 Morris to Georgiana Burne-Jones, 27 September 1880. Cited in Kelvin (ed.), *Letters*, I, p. 591. See Jan Marsh, 'Kelmscott as an Object of Desire', in Parry (ed.), *William Morris: Art and Kelmscott*, p. 73.

41 For more on de Morgan see Walter Shaw Sparrow, 'William de Morgan and His Pottery', *The Studio*, XVII (1899); Julia Cartwright, 'William de Morgan: A Reminiscence', *Cornhill* (April 1917); Anna Stirling; William Gaunt and M. D. E. Clayton-Stamm, *William de Morgan* (London: Studio Vista, 1971); Jon Catleugh, *William de Morgan Tiles* (London: Trefoil, 1983); Martin Greenwood, *The Designs of William de Morgan* (Ilminster, Som.: Richard Dennis and William E. Wiltshire III, 1989) and Lakeland Arts Trust, *The Ceramics of William de Morgan* (Bowness: Blackwell, 2002).

42 Mackail, *Life*, II, pp. 32–3.

43 For more on Merton Abbey see Harvey and Press, *Design and Enterprise*, pp. 128–57 and David Saxby, *William Morris at Merton* (London: Museum of London Archaeology Service and London Borough of Merton, 1995).

44 Morris to de Morgan, 16 April 1881. Cited in Kelvin (ed.), *Letters*, II, p. 42. Morris's reference here to 'joy for ever' echoes both Keats's opening lines to the poem 'Endymion' (1818) – 'A thing of beauty is a joy for ever' – and the title of one of Ruskin's lectures, 'A Joy For Ever', published in *The Political Economy of Art* in 1857 (*Works*, XVI). See Judith Goodman, 'William de Morgan at Merton Abbey', *Journal of the William Morris Society*, XIII: 4 (Spring 2000).

45 Morris to George James Howard, 3 November 1881. Cited in Kelvin (ed.), *Letters*, II, p. 73.

46 Morris, *Works*, XVI, pp. 202–3.

47 For more on the Kelmscott Press, see Henry Halliday Sparling, *The Kelmscott Press and William Morris Master-Craftsman* (London: Macmillan & Co., 1924); Peterson (ed.), *The Ideal Book*; Paul Needham (ed.), *William Morris and the Art of the Book* (New York: Pierpont Morgan Library and London: Oxford University Press, 1976); Peterson, *The Kelmscott Press: A History of William Morris's Typographical Adventures* (Berkeley: University of California Press, 1991); and Harvey and Press, *Design and Enterprise*.

48 Morris to Louisa Macdonald Baldwin, 26 March 1874. Cited in Kelvin (ed.), *Letters*, I, p. 218.

49 May Morris, *William Morris: Artist, Writer, Socialist*, p. 618.

50 Morris to Jane Morris, 2 April 1878. Cited in Kelvin (ed.), *Letters*, I, p. 469.

51 May Morris, *William Morris: Artist, Writer, Socialist*, p. 619.

52 Morris also seems to have been particularly sensitive to the weather. In his journal from 1881, for example, he jots down details of the weather every day (British Library, London (hereafter BL), Add. MS 45407 B, Morris Papers, XVII, journal, 1881).

53 Henry Halliday Sparling photograph, National Portrait Gallery, London, no. 45369; Emery Walker photograph, Cheltenham City Museum and Art Gallery; and Emery Walker photograph, HF, ref. H920MOR HP74/4452.

54 The photograph of the Study is dated 3 October 1896, shortly before Morris's death, but the other photographs have no more precise a date than *c.* 1896.

55 See Design Council, *William Morris and Kelmscott*; Parry (ed.), *William Morris: Art and Kelmscott*. While many of the essays in both of these volumes are to do with other aspects of Morris's life and work, some discuss Kelmscott Manor. Morris's biographers also discuss the house, but little attention is paid to its interior, even by MacCarthy (see MacCarthy, *William Morris*, pp. 654–5). Parry claims that Kelmscott 'had little done to it in the form of repair or decoration during his occupancy' ('Domestic Decoration', in Parry (ed.), *William Morris*, exh. cat., p. 145). This is the standard approach to the Kelmscott interior. See Paul Thompson, *The Work of William Morris* (London: Quartet, revised edn, 1977), p. 40.

56 Morris, *Works*, XVI, pp. 202–3.

57 Morris, *Works*, XVI, p. 202.

58 Morris, *Works*, XVI, p. 203.

59 Morris, 'Gossip'.

60 Morris, *Works*, XVI, pp. 202–3.

61 This suggests a link with the 'back to the land movement'. See Marsh, *Back to the Land*; Fiona MacCarthy, *The Simple Life: C. R Ashbee in the Cotswolds* (London: Lund Humphries, 1981), pp. 9–12, 91 and 99–100 and Michael Hatt, 'Edward Carpenter and the Interior: Home and Homosexuality', paper given at Institute for English Studies, University of London, 'The Aesthetic Interior: Neo-Gothic, Aesthetic, Arts and Crafts', 28–9 October 2005.

62 This is another moment when it is helpful to recall MacCarthy's insistence upon Morris's 'idiosyncrasy' (*William Morris*, vii).

63 W. R. Lethaby, cited in May Morris, *William Morris: Artist, Writer, Socialist*, p. 363 (italics original). May gives the *Architectural Review*, November 1896 as her source, but this issue does not include an article by Lethaby. On p. 623, May directs the reader to another article by Lethaby in the *Architectural Review*, XLV (April 1919). However, this article, 'Kelmscott Manor and William Morris', does not include May's quotation. Aslin claims that the term '"art" furniture' seems to derive from Eastlake's *Hints* (Aslin, *Aesthetic Movement*, p. 52).

64 Carpenter, *My Days and Dreams*, pp. 216–17.

65 See Marsh, *Back to the Land*, pp. 17–23. In 1889 Carpenter published *Civilisation: Its Cause and Cure* (London: Swan Sonnenschein & Co.), which was, according to Marsh, 'a kind of text for the back-to-the-land movement' (p. 21).

66 Hatt, 'Edward Carpenter and the Interior'. Carpenter may have influenced the Morris circle in this respect. May declares, for example, that 'Carpenter was the first to bring the sandal amongst us' (May Morris, *William Morris: Artist, Writer, Socialist*, p. 89).

67 May Morris, *William Morris: Artist, Writer, Socialist*, p. 616.

68 In 'How I became a Socialist', Morris declares, 'Apart from the desire to produce beautiful things, the leading passion of my life has been and is hatred of modern civilisation' (*Works*, XXIII, p. 279). He thus puts 'the desire to produce beautiful things' first, and implies that it is of at least equal importance in motivating his work as his 'hatred of modern civilisation'.

69 Max Beerbohm's famous cartoon of Morris and Burne-Jones also emphasises an extreme simplicity (*Rossetti and His Circle*, 1922 (New Haven and London: Yale University Press, 1987), plate 6). *Topsy and Ned Jones, Settled on the Settle in Red Lion Square* situates the two figures in an almost empty room with bare floorboards, and a loaf of bread and a bottle of beer on an otherwise bare table. Morris is dressed in the characteristic blue overalls for which he was notorious, which again reinforces the down-to-earth, unfussy version of Morris.

70 See Faulkner, 'Pevsner's Morris'.

71 Watkinson, *William Morris as Designer*, p. 78.

72 Marsh, *Jane and May Morris*, pp. 289–91.

73 Parry also supports this interpretation of Kelmscott Manor. She writes that both it and Kelmscott House 'displayed a comfort and simplicity of style absent from many of the firm's commercial schemes' (*William Morris*, exh. cat., p. 142).

74 For more on Morris and socialism see Glasier, *William Morris*; E. P. Thompson, *William Morris*; Paul Meier, *William Morris: The Marxist Dreamer*, trans. Frank Gubb with a Preface by Robin Page Arnot (Hassocks, Sussex: Harvester Press, 1978); Larry Baker, 'The Socialism of William Morris', in Design Council, *William Morris and Kelmscott*, pp. 93–5 and Walter Crane, 'William Morris', *Scribner's Magazine*, XXII (July 1897), p. 97.

75 Kelvin observes a similar state of affairs with respect to Morris's influence on 'the young artists and poets' of the 1890s. Kelvin argues that 'The Morris they admired and to whom they looked for support and encouragement was the Morris they needed, and therefore constructed' ('The Morris Who Reads Us', in Parry (ed.), *William Morris*, exh. cat., p. 347).

76 Morris, 'Some Hints on Pattern-Designing' (1881), *Works*, XXII, pp. 175–6.

77 Day, 'The Art of William Morris', p. 27.

78 Bosomworth, 'Traditional Furniture', in Design Council, *William Morris and Kelmscott*, p. 83.

79 May and Carpenter's texts are not accompanied by illustrations of Kelmscott Manor. Lethaby's 1919 article includes drawings by Hanslip Fletcher but we do not know whether the Lethaby comment May quotes was illustrated (see note 63).

80 Stephen F. Eisenman, 'Class Consciousness in the Design of William Morris', *Journal of William Morris Studies*, XV: 1 (Winter 2002), p. 21.

81 Lucia van der Post, *William Morris and Morris & Co.* (London: V&A Publications in association with Arthur Sanderson & Sons, 2003), p. 71.

82 I am indebted to Edward S. Cooke, Jr., for this observation.

83 According to Myers, *Swan* was designed by Morris and *Artichoke* by either Morris or de Morgan (*William Morris Tiles*, pp. 68–70 and 105). Other scholars, such as Jon Catleugh, have attributed *Swan* to Webb and *Artichoke* to Morris (*William de Morgan Tiles*, pp. 46–7). Both types were made and decorated in Holland. The fireplace also features several *Sunflower* tiles, but these face inwards, and thus have a minimal effect on the overall impact.

84 Myers, *William Morris Tiles*, p. 104.

85 For example, see Society of Antiquaries, *Kelmscott Manor*, p. 20. Many of Rossetti's belongings were of Japanese origin (Paul Thompson, *Work of William Morris*, p. 88).

86 See Bryson (ed.), *Dante Gabriel Rossetti*, pp. 71 and 79.

87 MacCarthy, *William Morris*, p. vii.

88 May Morris, *Introductions to the Collected Works*, p. 366.

89 Marsh, *Jane and May Morris*, p. 229.

90 George Bernard Shaw, *William Morris as I Knew Him* (New York: Dodd, Mead & Co., 1936), p. 20.

91 Swanwick, *I Have Been Young*, p. 101.

92 Morris, 'The Beauty of Life' (1880), *Works*, XXII, p. 77.

93 May Morris, *Introductions to the Collected Works*, p. 368.

94 See note 122.

95 'Cleanliness' is also a recurring theme in the taste manuals. See Mrs Loftie, *Dining Room*, pp. 74–6 and W. J. Loftie, *A Plea for Art in the House* (London: Macmillan & Co., 1876), p. 90.

96 May Morris, *Introductions to the Collected Works*, p. 366.

97 There are echoes of Whistler here, both in May's prioritisation of colour over detail and in her description of the effects of light on water, which call to mind Whistler's painted *Nocturnes*.

98 May Morris, *Introductions to the Collected Works*, p. 366.

99 MacCarthy, *William Morris*, p. 395.

100 This approach also corresponds to the 'restraint', 'propriety' and 'holding back' advised by Pugin and Ruskin, as discussed in Chapter 1.

101 May Morris, *Introductions to the Collected Works*, p. 366.

102 Carpenter, *My Days and Dreams*, p. 217.

103 Swanwick, *I Have Been Young*, p. 101.

104 For more on the *Bird* pattern, see Jacqueline Herald, 'On Designing Textiles with Birds', in Design Council, *William Morris and Kelmscott*. Herald demonstrates that 'Birds were extremely important to Morris' (p. 117).

105 According to Barbara Morris, the carpet dates from the late sixteenth or early seventeenth century ('William Morris and the South Kensington Museum', p. 169).

106 May Morris, *Introductions to the Collected Works*, p. 366.

107 This may be partly due to Whistler's *Peacock Room* (1876–77). See Linda Merrill, *The Peacock Room: A Cultural Biography* (Washington, D. C.: Freer Gallery of Art and London: Yale University Press, 1998).

108 May Morris, *Introductions to the Collected Works*, p. 367.

109 May Morris, *Introductions to the Collected Works*, p. 367.

110 Morris to Jane Morris, before 28 March 1878. Cited in Kelvin (ed.), *Letters*, I, p. 460 (italics original).

111 Anon., 'Representative Men at Home: William Morris at Hammersmith', *Cassell's Saturday Journal* (18 October 1890), reprinted in Tony Pinkney (ed.), *We Met Morris: Interviews with William Morris, 1885–96* (Reading: Spire Books, 2005), p. 45.

112 Anon., 'The Poet as Printer: An Interview with Mr William Morris', *Pall Mall Gazette* (12 November 1891), p. 1.

113 I. H. I., 'The Kelmscott Press: An Illustrated Interview with Mr William Morris', *Bookselling* (Christmas 1895), p. 3.

114 Quinbus Flestrin, 'Interview with William Morris', *Clarion* (19 November 1892), p. 8.

115 MacCarthy, *William Morris*, p. 395.

116 Shaw, *William Morris as I Knew Him*, p. 20.

117 See Banham *et al.*, *Victorian Interior Design*, p. 9. See also Edwards and Hart (eds), *Rethinking the Interior*.

118 May Morris, *Introductions to the Collected Works*, p. 362.

119 MacCarthy, *William Morris*, p. 397.

120 Glasier, *William Morris*, p. 46.

121 May Morris, *William Morris: Artist, Writer, Socialist*, p. 619.

122 Anon., 'The Poet as Printer: An Interview with Mr William Morris', *Pall Mall Gazette* (12 November 1891), p. 1.

123 Glasier neatly echoes Morris's famous words, 'Have nothing in your houses that you do not know to be useful or believe to be beautiful' (Morris, 'The Beauty of Life' (1880), *Works*, XXII, p. 77), perhaps intentionally, when he recalls of the study that 'only useful and beautiful things were there' (*William Morris*, p. 112).

124 See also Rodgers, *William Morris at Home*, p. 109.

125 Parry (ed.), *William Morris*, exh. cat., p. 142.

126 Marsh, *Jane and May Morris*, p. 176.

127 Marsh, *Jane and May Morris*, pp. 171–2.

128 Swanwick, *I Have Been Young*, p. 101.

129 Swanwick, *I Have Been Young*, p. 101.

130 MacCarthy, *William Morris*, p. 396.

131 MMF & Co.'s early work was sometimes described in terms of 'wilfulness' and 'independence' (see, for instance, the *Building News*, 29 July 1870, pp. 73–4 and Chapter 3). Summarising Morris's work, Crane writes, 'One sees an English taste and reserve united with a luxuriant and almost Oriental fancy' ('Note on the Late President of the Society, William Morris', ACES Catalogue, 1899, p. 12).

132 Shaw, *William Morris as I Knew Him*, p. 20.

133 Swanwick, *I Have Been Young*, p. 101.

134 Sydney Cockerell, cited in MacCarthy, *William Morris*, p. 396.

135 MacCarthy, *William Morris*, p. 395.

136 Christopher Bollas, *Being a Character: Psychoanalysis and Self Experience* (New York: Hill & Wang, 1992), pp. 19 and 35.

137 Crawford (ed.), *By Hammer and Hand*, p. 9.

3 ✧ Objects at Morris & Co.

H ELEN SNOWDON HAS drawn attention to the challenges facing the historian of Morris & Co. She argues,

> The history of the Firm has often been pieced together from ... statements made at the time – the fairy tale history of a small brotherhood of romantic artists who alone took on the Victorian furniture trade, refusing to compromise either their design philosophy or their belief in the value of pre-industrial modes of work.[1]

Snowdon observes that 'there is a strong temptation to overload the patchy evidence with a significance which it can never have had at the time'.[2] For Snowdon, the solution is to focus on Morris & Co. objects. She insists that Morris was 'a synthesiser rather than an innovator' and adds, 'But the historian of design has to look closely at the Firm's products – rather than at the justly influential manifestoes which surrounded them – in order to come to this commonsense conclusion.'[3]

Since Snowdon's essay, which was published in 1981, there have been important contributions to the Morris & Co. scholarship. Perhaps the most significant of these has been the work of Harvey and Press. As business historians, Harvey and Press have investigated the previously underplayed commercial aspects of the firm. They have unearthed valuable primary sources to support their account of the firm, rather than 'piecing it together' from 'statements made at the time'. They have thus addressed part of the deficiency highlighted by Snowdon. This chapter seeks to address the other side of that deficiency by examining the objects themselves, not instead of the text that surrounded them, but in conjunction with it. It aims to explore how the firm's products were presented to customers, and to look critically at the way they have been framed by

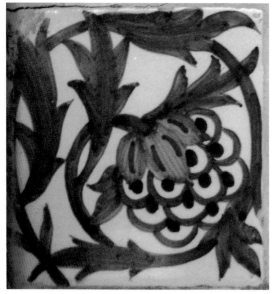

1 *Swan* tile from Kelmscott Manor, probably designed by William Morris, *c.* 1870. In-glaze blue, 12.7 x 12.7 cm.

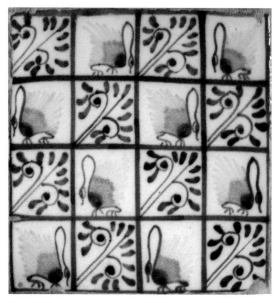

2 *Artichoke* tile from Kelmscott Manor, designed by William Morris or William de Morgan, *c.* 1870. In-glaze blue, 12.7 x 12.7 cm.

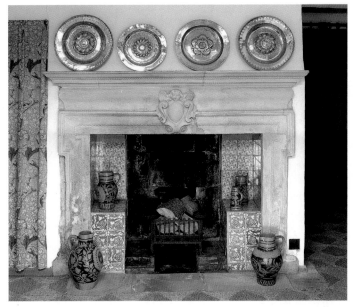

3 Green Room fireplace, Kelmscott Manor.

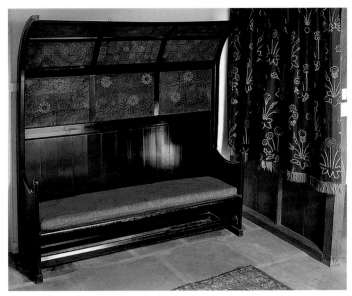

4 Philip Webb, settle, *c.* 1860. Ebonised oak with panels of embossed leather, painted and gilded. 209 x 194 x 56.5 cm.

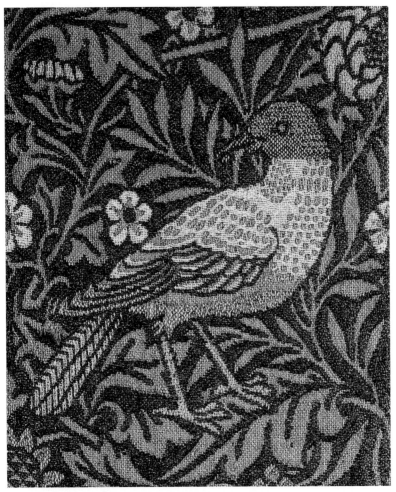

5 William Morris, *Bird* wall hanging, 1877–78 (detail). Hand-loom jacquard-woven woollen double cloth.

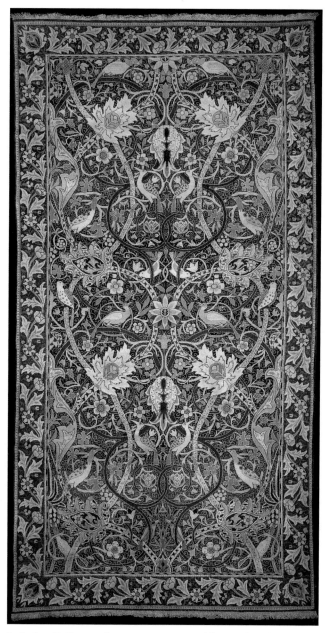

6 Morris & Co., *Bullerswood* carpet, 1889. Hand-knotted with woollen pile on a cotton warp. 764.8 x 398.8 cm.

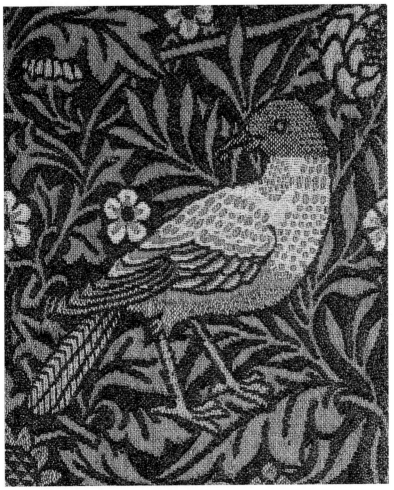

5 William Morris, *Bird* wall hanging, 1877–78 (detail). Hand-loom jacquard-woven woollen double cloth.

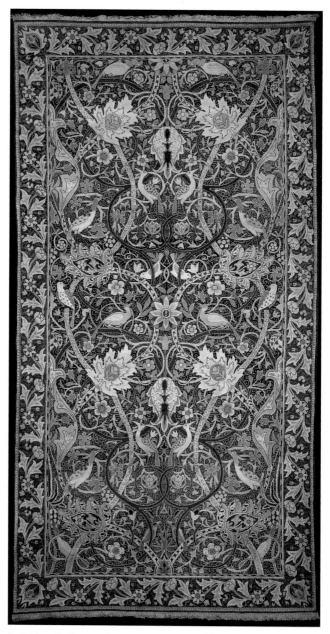

6 Morris & Co., *Bullerswood* carpet, 1889. Hand-knotted with woollen pile on a cotton warp. 764.8 x 398.8 cm.

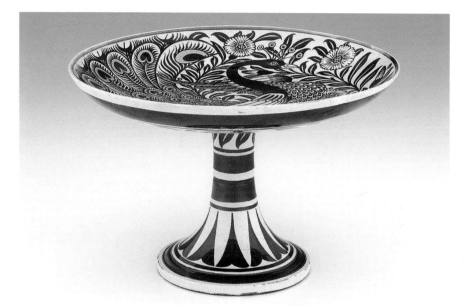

7 William de Morgan, tazza, purchased in 1894 by Manchester Municipal School of Art. Earthenware with lustre decoration.

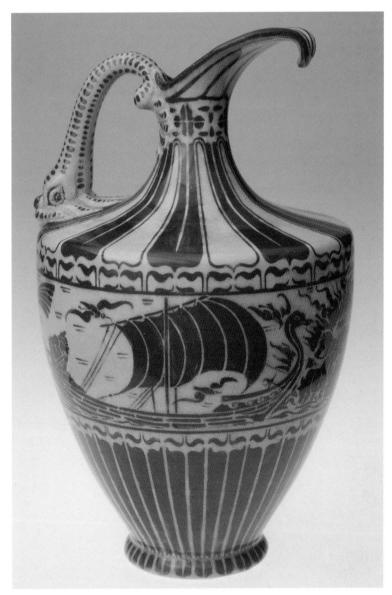

8 Walter Crane, ewer, made by Maw & Co., 1889. Earthenware with lustre decoration.

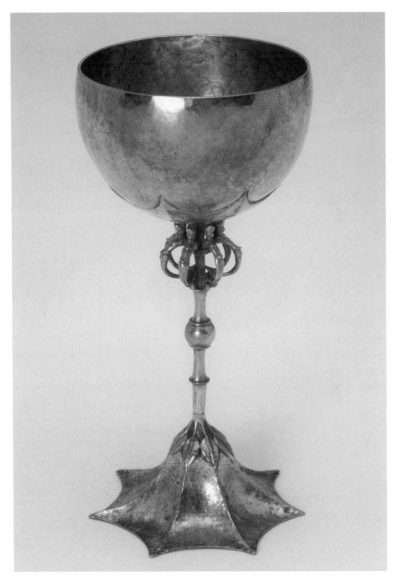

9 C. R. Ashbee and the Guild and School of Handicraft, wine cup, purchased from the 1896 Arts and Crafts exhibition. Silver-plated copper with cast foot and stem.

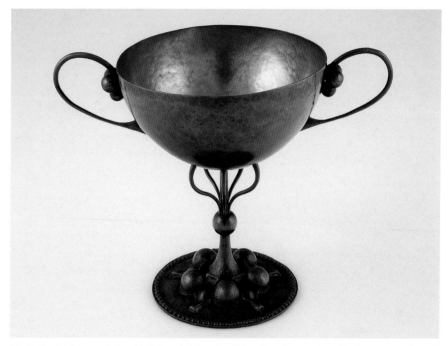

10 C. R. Ashbee and the Guild and School of Handicraft, two-handled cup, purchased from the 1896 Arts and Crafts exhibition. Copper with cast stem and gilded lining.

comments made in other contexts. This chapter argues that we have to 'look closely at the Firm's products' not only to come to the conclusion that Morris was 'a synthesiser rather than an innovator' but also to understand the relationship between ideas and objects in this context.[4]

Many critics of Victorian design are concerned with justly ascribing credit for innovation where it is due. This tendency supports, though not always intentionally, the assumption that signs of proto-modernism are of primary interest. Like Snowdon, Floud and Wainwright insist that we look at Morris & Co. objects in order to confirm their arguments that Morris was not an innovator.[5] This chapter will argue that there are other ways in which Morris & Co. objects can reward visual analysis. It is not primarily concerned with whether Morris & Co. produced proto-modernist, or otherwise innovative, objects. Instead, it explores the relationship between words and objects at Morris & Co., and the ways in which that relationship generated sophisticated modes of looking. The objects become important not for their perceived novelty, but for their participation in a discourse on how decorative art functions in people's lives.

The chapter begins by outlining the history of the business and then goes on to examine its publicity in detail. It explores, for example, what expectations of the objects were raised by the literature provided to customers, and how viewers were encouraged to respond. Finally, it considers how well the objects themselves fit into the frameworks set up by this publicity.

The history of the firm

Morris, Marshall, Faulkner & Co.

When it was first founded in April 1861, 'the firm', as it was affectionately known, was called Morris, Marshall, Faulkner & Co. (MMF & Co.).[6] It had eight partners: Morris, Rossetti, Webb, Burne-Jones, Ford Madox Brown, Peter Paul Marshall, Charles Faulkner and Arthur Hughes, although Hughes withdrew before the company started business. The seven remaining men were officially equal partners, each holding a £20 share, of which £1 was called on initially. Yet they were not as financially equal as this arrangement suggested, since the business was made possible by a £100 loan from Morris's mother.

Their artistic work was also valued unequally. Morris and Marshall, whose credentials as artists were inferior certainly to those of Burne-Jones, Brown, Rossetti and Webb, were consistently paid less for their designs. For example, the cartoons for single figures in the Bradford East window were distributed between four of the partners, and while Rossetti and Burne-Jones each received £3 per cartoon, Marshall and Morris commanded only £2 each.[7] While the friends may have been aware of differences in artistic status before they became partners, under business conditions the hierarchy became much more explicitly marked, its levels being signalled in financial terms.

It would appear that the partners' commitment to the administration of the firm was also unequal. As early as January 1862, Rossetti wrote,

> Morris and Webb the architect are our most active men of business as regards the actual conduct of the concern – the rest of us chiefly confine themselves to contributing designs when called for, as of course the plan is to effect something worth doing by co-operation, but without the least interfering with the individual pursuits of those among us who are painters.[8]

This description not only outlines the respective administrative contributions of the partners, but also suggests an assumption, at least on Rossetti's part and perhaps more widespread, that the painters' work outside the firm was considered more important than their work within it.

Rossetti's verdict is supported by evidence in the firm's minute book. It was rare for all seven members to be present at a meeting and common for five or fewer to meet. This situation was clearly considered unsatisfactory, since on 18 February 1863, it was agreed that for every meeting of the firm he attended, each partner would receive ten shillings.[9] While the following few months saw some of the best-attended meetings recorded in the firm's minute book, by May of that year it was once again common for only three or four members to attend.[10]

These instances of inconstant and uneven commitment seem to be early warning signs that, from the beginning, some members needed the firm more than others. Brown and Rossetti had established careers as painters, and Burne-Jones and Webb were also making names for themselves, in painting and architecture respectively. During the 1860s, Marshall and Faulkner, never having played a central role in the artistic

work of the firm, had returned to the professional paths they had started on before 1861, Marshall to sanitary engineering and Faulkner to an academic career.[11] In 1875, Morris set out to take over the firm on his own, and Brown, Rossetti and Marshall responded with indignation, backed up by legal action. Morris was instructed to pay each of the partners £1,000, although Burne-Jones, Webb and Faulkner waived their entitlement.[12]

A decorating firm was more in line with Morris's professional inclinations than with those of the other partners. The competing claims on his colleagues' time also provided them with an additional source of earnings, whereas the firm had come to represent Morris's livelihood. As a gentleman with a substantial inheritance in the form of shares, Morris may not have expected money to play a vital role in guiding his professional decisions.[13] Unpredictably, however, the value of his shares in Devon Great Consols (a copper-mining company) had dwindled during the 1860s and by 1873, his income from that source had disappeared altogether.[14] Signs of financial hardship appear in his letters of the period.[15] For Morris, the firm was not merely an enthusiasm; it was a job.

As time went on, not only did Morris feel that his income from the firm was not representative of his input, but that discrepancy took on a much more urgent significance. He became increasingly aware of the vital role he was playing in the running of the firm,[16] and his decision, although no doubt accelerated by his conflicts with Rossetti in the preceding years (see Chapter 2),[17] was also taken because it made sound business sense. In March 1875, MMF & Co. was officially reconstituted as Morris & Co., much to Morris's relief.[18]

This event divides the firm's history into two sections. Though in many ways the decade following 1875 was the firm's most important and successful period, this is not to say that the fourteen preceding years were unimportant. From 1861 to 1875, the firm was moving forward, albeit not as fast as it would later, and significant developments were taking place. For example, one of the firm's most famous commissions, the decoration of the Green Dining Room at the South Kensington Museum, was carried out between 1866 and 1868 (figure 24).[19]

This was not the first time the South Kensington Museum had endorsed the work of the firm's partners. In 1864, glass by Morris and Burne-Jones had been purchased for the museum's collection.[20] Stained glass was the major category in which the firm specialised during the early

years, and demand for its services grew rapidly.[21] The 1860s also saw the firm paving the way for future commissions. For example, their decoration of the Armoury and Tapestry Room at St James's Palace in 1866 would lead eventually, in 1880, to Morris & Co.'s decoration of the Throne Room and Blue Room there.[22]

Other important developments during this period occurred in terms of administration. In 1865, George Warington Taylor was appointed business manager at an annual salary of £120. This appointment acknowledged the need for an objective overseer who could concentrate on the financial and organisational aspects of the business. Indeed, J. W. Mackail makes a direct link between Taylor's influence and the success of the firm, as it was due to him 'that the business became organised and prosperous'.[23] It seems that Taylor took very seriously the task of introducing efficiency and discipline. Not only did he keep the accounts 'like a dragon',[24] he also kept a close eye (by correspondence, being an invalid in Hastings from 1866) on Morris's personal spending.[25]

It seems that the firm was in serious need of organisation. Deadlines were not always met and inefficiency was clearly a problem. Taylor declares in one letter, 'if you cannot get a higher price – let it be admitted that the business is not profitable'.[26] In 1867, the partners agreed to pay Webb £80 per annum as 'consulting manager', an idea first suggested by Taylor, who was convinced that Webb undertook too much responsibility for too little recompense.[27] When Taylor died in 1870, George Wardle, who had been working for the firm as 'draughtsman, book-keeper and utility man' since 1866,[28] took over the job of manager and kept it until his retirement in 1890.

The prosperity enjoyed in the years following the firm's reconstitution was possible, and so swift in coming, only because of these administrative developments in the preceding years. When Morris took over in 1875, he had a reliable and experienced manager in George Wardle; he had, in Webb, a colleague who had undertaken business responsibilities for some years; he had customers who, thanks to Taylor, had been retained despite stretched deadlines; and he had a public that had been familiarised with Morris & Co. products by some high profile commissions during the preceding years.

Morris & Co.

Over its first fourteen years, the firm changed, developed, experimented and gained a reputation. From 1875 onwards, a renewed and sustained zest, initiative and productivity can be observed. In his first year as sole head of the company, Morris introduced dyeing and carpet weaving, and produced his first chintz.[29] The years 1876 and 1883 saw the highest number of new wallpaper and textile designs for the firm – despite the fact that 1883 was the year Morris first took on socialist commitments, joining the Democratic Federation – while in 1877 a showroom was opened in Oxford Street (figure 25). In 1879, Morris began to experiment with high-warp tapestry weaving, another new category of goods, and in 1881, as we saw in Chapter 2, the company moved its workshops to Merton Abbey, where it could carry out its own dyeing, weaving and printing under one roof.[30] During this period, the firm also began to reach markets outside London. In 1878, an agent was appointed in the United States, and in 1883 the firm's Manchester showroom opened.[31] By 1884, the company not only allocated an annual £1,800 to Morris, but also sustained three other salaries, those of George Wardle, the manager (£1,200), and Frank and Robert Smith, who ran the Oxford Street shop (£600 each).[32]

Morris's conviction that the firm could be run more efficiently and successfully by him alone thus proved to be well founded. While in the early years of the firm Morris had seemed to lack stamina and discipline, post-reconstitution he showed himself to be an inspired, committed and well-informed leader.[33] The company moved on to a grander scale, concurrently catering for commissioning patrons and the more casual buyer of ready-made stock. It acquired a certain authority by offering comprehensive decorative schemes, and the extended list of manufactures undertaken encouraged customers to trust entire rooms to the company, an appealing option for both practical and stylistic reasons.

The increasingly business-like conduct of the firm grated somewhat with the image of the firm retained by contemporaries, many of whom, like the architect Arthur Heygate Mackmurdo, saw the firm primarily as a 'brotherhood'.[34] Lethaby, for example, certainly believed selling and marketing were far from the firm's priorities. 'The "Firm", it should be clearly understood,' he writes in 1935, 'was not conceived as a manufac-turing or shopkeeping company; it was primarily a group of artists

producing together.'[35] Lethaby's use of language associates commercial concerns, those central to 'shopkeeping', with 'manufacture', which is separated from the work of 'artists'. His claim thus exploits the well-established hierarchy of artistic language that I examined in Chapter 1, in which 'manufacture' occupies a low status, and demonstrates a desire to separate commerce from artistic production. We can perceive the same hints of an account informed by hindsight as we observed in Lethaby's description of Kelmscott Manor in Chapter 2. In both cases, Lethaby's approach seems to be guided by a desire to put forward an idealised, anti-commercial (and anti-consumption) image of the figures he is writing about.[36]

Morris's role in the business

A detailed account of Morris's artistic role at Morris & Co. is provided in Wardle's manuscript history of the firm.[37] Wardle tells us that it was Morris who, in consultation with the customer, planned the 'general scheme' for stained glass windows, and who distributed the various parts to his colleagues.[38] He oversaw much of the firm's work, watching the stained glass painters and checking the preparatory tracings for block printing before they were sent off. To himself, he tended to allocate the tasks of pattern design and colouring. For example, in stained glass, he contributed the 'ornamental' portions of the cartoons and decided how the finished windows should be coloured. In the case of carpets, Wardle recalls that 'in designing them everything depended on him'.[39] It is unlikely to be a coincidence that the goods Morris played the most substantial role in producing – printed cottons, wallpapers and carpets, for example – were introduced to the firm, or significantly expanded, after he took over. Based originally on a collaborative model of manufacture, the firm thus shifted towards a system centred on one dominant designer. Harvey and Press observe that a similar change occurred in the firm's marketing: 'Originally, when the main task had been to establish the identity of the firm, the partners had agreed to keep secret the names of individual designers. This policy was later reversed.'[40]

Although Morris and Burne-Jones became, in a sense, the firm's master-designers, this is not to say that wider collaboration did not occur after the firm was reconstituted. Tapestry, a manufacture introduced in 1879, depended on the creativity and co-operation of a team of producers. In producing the *Holy Grail* tapestries (woven between 1892 and 1895),

for example, Burne-Jones was entrusted with the figures and composition, while Morris and John Henry Dearle, a young assistant Morris had taken on in 1878, contributed decorative details including patterns and borders.[41] We are told that this collaboration necessitated a 'to and fro' process whereby the designs were gradually adjusted to incorporate each participant's additions or refinements.[42]

In an interview with Aymer Vallance published in 1894, Morris emphasises the collaborative aspect of the work undertaken at the Merton Abbey tapestry works, explaining that the weavers themselves, being 'both by nature and training, artists, not merely animated machines', were allowed 'a considerable latitude in the choice and arrangement of tints'.[43] Bearing in mind Morris's reputation as a socialist, this remark may have been made in a self-conscious effort to persuade critics and potential customers that the firm was run in line with his political beliefs. Even his more right-wing clients, who would not have been attracted by an explicitly socialist agenda, might have been impressed with his providing opportunities for non-alienating labour. Morris's comment is not only unreliable evidence of the production process at Morris & Co., but it also provides clues about the self-image promoted by the firm. By informing the public that the products for sale were made by workers who enjoyed a level of autonomy, Morris invests those products with a value derived from something external to them, the system that produced them.

Of course, it was important to reassure the public that despite the 'considerable latitude' given to the workers, standards were nevertheless being strictly maintained. In an 1893 interview, Morris strikes a careful balance. Speaking in front of one of the *Holy Grail* tapestries at the fourth Arts and Crafts exhibition, he explains, 'it is really freehand work, remember, not slavishly copying a pattern', but adds, 'our superintendent, Mr Dearle, has of course been closely watching the work all the time, and perhaps he has put in a few bits, like the hands and the faces, with his own hands'.[44] Morris's attitude here is consistent with Ruskin's model of craftsmanship as 'Savageness' supervised by the 'ruling mind', discussed in Chapter 1.

While collaboration formed an important part of tapestry making, it is nevertheless the case that tapestry was neither the most popular nor the most profitable component of the firm's produce. In fact, its manufacture was subsidised by profits from far less collaborative products such as

chintzes and woven fabrics, which, after a slow start in the mid-1870s, had become extremely successful by 1880.[45] Cheaper and quicker to produce, chintzes, like wallpaper, were easier to sell than tapestries, which were only accessible to the wealthiest clients.

Morris's dominant role in the business was fairly short-lived. In 1885, May took over the embroidery section of the firm and, in 1889, Dearle took Morris's place as overseer of commissions. Morris's focus shifted to printing with the foundation of the Kelmscott Press in 1891, and in the same year the Smiths were made partners. Morris's highest level of involvement in the firm spanned the years 1875–85, although his fame, influence and experience both secured customers and guided employees in the years that followed.

The objects produced by the company therefore emerged from different conditions depending on their period of origination. Perhaps because many of the original members of MMF & Co. were painters, the emphasis in early years tended to be on pictorial goods such as painted furniture and stained glass.[46] Later, when Morris took over, he played to his strengths, focusing on pattern-based products. At the beginning, most of the firm's work sprung from commissions, whereas later ready-made goods became equally important. By examining the firm's publicity we can see how its priorities shifted over the years, and identify the kind of rhetoric associated with the objects produced at different stages of the firm's development.

Publicity

There is no question that publicity was important to the founders of MMF & Co. from the beginning. In the early years, the strategic use of connections kept the business going.[47] For example, Webb often recommended the firm to patrons whose architectural commissions he had undertaken.[48] Like many companies, MMF & Co. was also publicised in taste manuals such as Eastlake's *Hints on Household Taste* (see Chapter 1). There were two other important ways in which the firm became known to the public. First, the firm's products were on display in various public spaces. Second, the firm promoted itself through the distribution of circulars.

The International Exhibition of 1862 and the 'medieval'

MMF & Co.'s first major public display took place at the International Exhibition of 1862.[49] The firm spent £25 on two stalls for stained glass, furniture and embroidery, which were displayed in the Medieval Court.[50] The Great Exhibition of 1851 had also featured a Medieval Court, in which Pugin had been the dominant figure.[51] The 1862 exhibition was specifically designed to bear witness to improvements in design since the Great Exhibition, and for that reason was confined to objects made since 1851.[52] This event was crucial in displaying the firm's goods to potential customers.[53]

The firm's exhibits won medals and much praise from the International Exhibition's judges, but from other sources they faced a mixed reception incorporating enthusiasm, scorn and confusion. The negative responses to the firm's work included comments in *The Builder* that the furniture was 'unnecessarily rude and ugly'[54] and the stained glass 'irredeemably bad'.[55] *The Ecclesiologist* was more elaborate in its condemnation:

> We must totally decline to praise the design or execution of these speci-
> mens. The colouring in particular is crude and unpleasing, while the
> design is laboriously grotesque … Neither in furniture nor in painted
> glass, can we tolerate deliberate archaisms and grotesqueness, which are
> enough to bring the very word 'mediaeval' into deserved contempt.[56]

A number of opponents signed a petition in the hope of disqualifying the firm's stained glass on the basis that it was old glass 'touched up'.[57] The latter response indicates that the glass was admired, however reluctantly, and in taking such trouble the petitioners admitted that they viewed MMF & Co. as competitors. At the same time, the complaint characterised the firm's work as old-fashioned, perhaps in an attempt to minimise the threat it posed to more modern, cutting-edge designers.[58] The glass made a similar impression on the exhibition's judges, although it was expressed in a much more positive way:

> Messrs Morris & Co. have exhibited several pieces of furniture, tapestries,
> &c., in the style of the Middle Ages. The general forms of the furniture, the
> arrangement of the tapestry, and the character of the details are satisfac-
> tory to the archaeologist from the exactness of the imitation, at the same
> time that the general effect is excellent.[59]

While the International Exhibition brought the firm new clients and increased publicity, it also fuelled a widespread misunderstanding bemoaned by Wardle in his manuscript account of the firm. According to Wardle, interpretations of the kind offered by the judges bore witness to a 'hopeless mistake that assumed that Mr Morris's work was purposely "medieval"', a view that prevented many from recognising 'the real originality and modern-ness of his art'.[60] Wardle argues that Morris, for all his admiration of medieval paradigms, disapproved of 'imitation'.[61] Instead, Morris strove to emulate the tolerance of individuality and co-operation that was, both for him and for Ruskin, embodied in the medieval guilds. While some of his work certainly shares some of the stylistic characteristics associated with the Gothic, he did not aim to produce simulations of medieval designs.[62]

Further information about Morris's attachment to the medieval can be gleaned from his interview with the *Daily News Chronicle* in 1893. Of course, this interview takes place three decades after the International Exhibition, but it is clear that at this stage the firm's image still has medieval associations. Standing in front of a Morris & Co. *Holy Grail* tapestry, the journalist, with self-conscious mischievousness, asks, 'Why don't you turn your art and your great influence to the production of something which corresponds to our beliefs and our needs as these things did to those of the people for whom they were made?' Morris retorts, 'What is there in modern life for the man who seeks beauty? Nothing – you know it quite well.' He adds, 'The age is ugly – to find anything beautiful we must "look before and after". Of course, if you don't want to make it beautiful, you may deal with modern incident, but you will get a mere statement of fact – that is, science.'[63]

This is an indication of how much Morris valued beauty, a characteristic that was also prized within Aestheticism and, as we shall see, at the Arts and Crafts Exhibition Society. It also suggests that it was his professed inability to find inspiration in 'modern incident', as much as his admiration for medieval society, that led him to work in a medieval style. Morris did not seek to produce imitations of past work, however. In the *Daily News Chronicle* interview, he goes on to say, 'it isn't fair to call us copyists, for in all this work here, which you complain of as being deficient of a particle of modern inspiration, there is no slavish imitation. It is all good, new, original work, though in the style of a different time.'[64] Once again, we find the metaphor of slavery, borrowed from Ruskin.

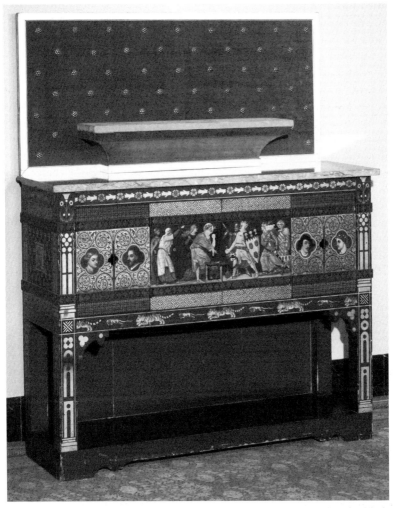

22 William Burges, *Wine and Beers* cabinet, 1859. Wood, painted and gilded, with velvet-lined replacement backboard. 167.7 x 139.7 x 43.2 cm.

MMF & Co. were not alone in facing the kind of misunderstanding observed by Wardle. Eastlake's *Hints*, for example, met with similar responses. After the first edition was criticised by the *Art Journal* for its overtly medieval emphasis, Eastlake clarified his position in later editions.[65]

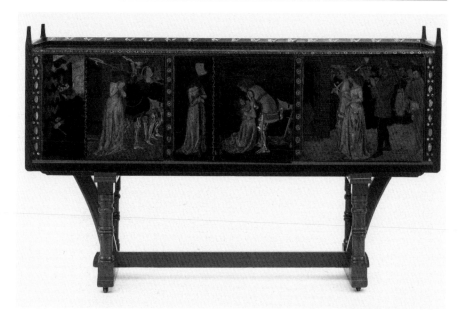

23 Morris, Marshall, Faulkner & Co., *St George* cabinet, designed by Philip Webb and painted by William Morris, 1860–62. Mahogany, oak and pine, painted and gilded, with copper handles. 95.9 x 177.7 x 43.2 cm.

He explained, 'it is the spirit and principles of early manufacture which I desire to see revived, and not the absolute forms in which they found embodiment'.[66] Eastlake's explanation would fit MMF & Co.'s position equally well.[67]

Paul Thompson claims that 'It was as extreme mediaevalists that Morris and Company made their first public impact'.[68] Wainwright argues, however, that MMF & Co.'s furniture differed from the medieval furniture it was inspired by in an important respect. He claims that the 'distinction' between 'painted furniture' and 'furniture that was painted' was 'a very real one that Webb and Morris had at this date not yet grasped'. In 'painted furniture', Wainwright explains, 'the programme of decoration is designed to fit the object', whereas, for example, 'the whole front of the *Prioress's Tale* wardrobe is painted, like an easel painting so that when the door opens the picture itself splits in the middle' (see figure 16). Wainwright compares the wardrobe with William Burges's *Wine and Beers* cabinet

(1859), which was painted by Sir Edward Poynter and displayed at the International Exhibition of 1862 (figure 22). According to Wainwright, Burges's cabinet follows the 'medieval tradition' because 'the doors have separate pictures on each with an architectonic frame'.[69]

Wainwright's argument seems to be based on that of J. Mordaunt Crook.[70] Mordaunt Crook claims that MMF & Co.'s furniture was in fact inspired by Burges's cabinet: 'Bold, almost starkly simple in design, this piece clearly appealed to Morris: his "St George" cabinet of the following year (1860) [figure 23] is suspiciously similar in conception'.[71] Of MMF & Co.'s 'secular pictorial furniture', Mordaunt Crook writes that 'somehow all these pieces fail to integrate furniture and painting in quite the Burgesian way'.[72] Mordaunt Crook thus puts forward a double criticism of MMF & Co. After observing that the firm was 'suspiciously' dependent on Burges, he claims that the alleged imitation was a failure. Wainwright adds that, unlike Burges, MMF & Co. also failed to take into account the importance of iconography.[73]

Wainwright and Mordaunt Crook seem to be suggesting that MMF & Co.'s furniture, far from being imitatively medieval, was not medieval enough. Harvey and Press point to a similar situation regarding the firm's stained glass. They observe that the 'distinctive' qualities of Burne-Jones's stained glass designs made them unsuitable for customers who sought 'straightforward Gothic Revival work'.[74] These points strengthen Wardle's argument that MMF & Co.'s objects showed 'originality' rather than 'imitation'.[75]

The firm's relationship with medieval styles was thus rather subtler than contemporary critics usually acknowledged. Yet with publicity came audiences eager to stamp the firm with a specific character. The tendency to generalise for the purposes of marketing made no distinction between the object that was imitatively 'medieval', the object that was inspired by medieval designs and the object based on an interpretation of 'medieval' principles.

The Green Dining Room and the Oxford Street showroom

MMF & Co. made its first powerful impression on the public with the Green Dining Room (figure 24). The commission was still unfinished when the *London Standard* raised high expectations of the final result by observing in 1868, 'the stately refreshment rooms are themselves an

24 Morris, Marshall, Faulkner & Co., Green Dining Room, 1866–68.

attraction which would alone repay a visit', adding that 'there is room for invention yet in the nature and variety of foods sold'.[76] Similarly, Moncure Conway evaluates the room in terms of its function, observing that the 'allegorical' figures by Burne-Jones 'bear too much of that mystical light and expression which invest all forms and faces evoked by his magic touch to be gastronomically suggestive'.[77]

On 29 July 1870, a review of the Green Dining Room appears on the front page of the *Building News*.[78] This room, 'wisely entrusted by the Department to MMF & Co.', is compared with the larger, adjacent Gamble Room, which had been reviewed the previous week. The latter 'has the appearance rather of scholarly adaptation of recognised precedents than of homogenous design'. It is 'sumptuous, but lacking in tone, by which we mean that quiet repose and harmony which alone is permanently satisfactory'. According to the reviewer, 'it is quite refreshing to look from its glitter and garishness into the quiet and inviting rooms on either side'.[79] We are told that the MMF & Co. room 'is what every decorated room

should be, quiet and reposeful; one is not distracted by glitter in every direction'. The favourable contrast is made more explicit by the claim that 'the work possesses that essential quality of tone to which we referred in our last article on the subject'.[80] The author praises the 'exquisite harmony' of the 'moulded plasterwork' and adds that 'this portion of the decoration is, to our minds, simply perfect'.[81]

Yet the reviewer also identifies some unsatisfactory elements in the decoration. For example, the artists display 'a certain wilfulness in all they do, and set one's teeth on edge occasionally, as if with *malice prepense*, for the sake of asserting their independence'.[82] Thus, while the 'scholarly adaptation of recognised precedents' was perceived as a negative feature of the Gamble Room, the Green Dining Room is clearly understood to trespass too far in the opposite direction, towards 'independence'. Above all, the reviewer disapproves of the frieze, in which 'disport greyhounds and hares of the most comic description. They are ungainly and clumsy, and we are quite at a loss to account for their introduction.' Towards the end of the review, a balance is reached in favour of the positive. 'Altogether', concludes the *Building News*, 'we congratulate Messrs. Morris on this result, which we consider highly successful, in spite of the hare hunt, which would disgrace a nursery, and be hooted at by its infant occupants'. [83]

This review leaves the reader with an impression of both the firm's identity and the specific character of the Green Dining Room. Early in the article, we are told, 'At the hands of this firm of decorative artists we expect much, and need not be disappointed in this instance'.[84] This informs the reader not only that the firm is to be judged by high standards, but also that it meets them. Thus the firm and its work are both infused with an association of high quality, while, at the same time, being represented as somewhat unfathomable and unconventional. Although this review mixes criticism with praise, it is clear that this commission was a crucial step forward for the firm. According to Mackail, it was 'of great value at the time in making known the name of the firm and the specific character of their work', 'seen as it is yearly by many thousands of persons'.[85]

A later arena in which the public encountered the firm's products was the Morris & Co. showroom opened in 1877, which was located in a new block of buildings on Oxford Street.[86] The surviving photograph of the shop seems to date from 1911, when it appeared in Morris & Co.'s small book, *A Brief Sketch of the Morris Movement and of the Firm Founded*

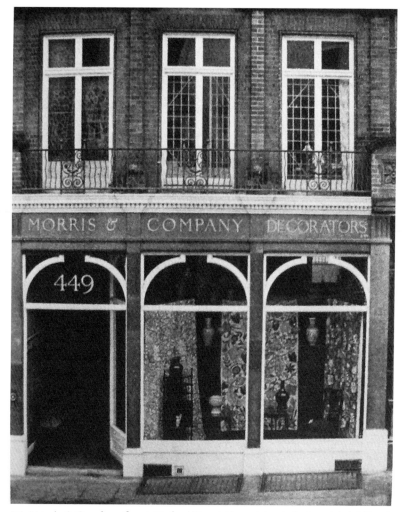

25 Morris & Co. shop front, Oxford Street. From Morris & Co., *A Brief Sketch of the Morris Movement*, 1911.

by William Morris to Carry Out His Designs and the Industries Revived or Started by Him (figure 25).[87] While the arrangement of objects in the shop window is potentially revealing of Morris & Co.'s practice in a later period, therefore, this photograph is primarily useful for our present

purposes in terms of the information it provides about the architectural features of the shop front. The Classical impact of the façade is surprising, considering Morris's distaste for the tradition (see Chapter 2). Though simple and understated, the pilasters and the rounded arches provide a distinct framework for the objects displayed. From the firm's choice of the Medieval Court for their exhibit at the International Exhibition, and the reviews of the goods they displayed there, we would not expect the shop's overall style to contrast so strongly with the Gothic influence identified in the firm's early work. A shop provided the firm with a permanent location in which to construct signals for potential customers, and the exterior provided no further support for a 'medieval' image of the firm. Morris's tolerance for the Classical style here, as at Kelmscott House, indicates that he did not see it as entirely incompatible with his own position. The Classical front may in fact have helped to broaden the audience that the company might appeal to.

Advertising

Spaces such as the International Exhibition, the Green Dining Room and the Oxford Street shop helped to promote the firm to the public. The other important form of publicity was the printed circular or catalogue. These official advertisements, which have not previously been thoroughly analysed and compared, provide an insight into the way the firm chose to present itself. They include the original prospectus, sent out in April 1861 on the foundation of the company; a document announcing the introduction of the Hammersmith Carpets in 1882; and a circular summarising the services offered by the firm also believed to date from 1882.[88] By examining these documents, we can develop a better understanding of how the firm communicated with customers and the way it encouraged viewers to respond to its goods.

If we compare the 1861 prospectus with the later circular from *c.* 1882, we can see how the firm's projected image changed over its first two decades. The early document is mostly prose, and while the five categories of work are numbered, this list makes up less than half of the circular. By 1882, the list of goods – which, apart from a short introduction and conclusion, takes up the whole of the circular – has been expanded to include twelve different manufactures, each of which is clearly separated from the others. This makes it easier to see at a glance what is being

advertised, whereas the specifics of the produce are somewhat lost in the surrounding text of the former circular. The heading of the early prospectus in part makes up for this, since at its head, along with the partners' names, is the title 'Morris, Marshall, Faulkner & Company, Fine Art Workmen in Painting, Carving, Furniture and the Metals', immediately informing the reader of its subject. In contrast, the later circular addresses the reader more directly from the start, acknowledging more openly its role as an advertisement, by stating, 'We beg to call your attention to the following List of Goods Manufactured by MORRIS & COMPANY'.

Looking in more detail at the text of the two circulars, we find that the first presents itself as a kind of justification for the firm's existence, explaining that 'it must be generally felt that attempts of this kind hitherto have been crude and fragmentary'. It emphasises the 'co-operation' prioritised by the firm, and claims that this will produce results 'at the smallest possible expense' and 'of a much more complete order' than 'if any single artist were incidentally employed in the usual manner'. This document leaves the reader with the sense that an experiment is to be undertaken, since it ends with the words, 'it is believed that good decoration, involving the luxury of taste rather than the luxury of costliness, will be found to be much less expensive than is generally supposed'. A dichotomy is thus set up between the 'luxury of costliness', measured in exchange value, and the 'luxury of taste', measured in aesthetic value. There is an implication that other things, namely time, effort, skill and collaboration, are to be more highly prized by the new firm than money.

The tone of the later circular is more confident but less crusading. The conclusion, in particular, suggests that the firm values its own authority and status. It emphasises the exclusivity of the designs and promotes the Oxford Street shop as an environment in which the visitor can acquire 'a true idea of the decoration that we recommend' by seeing the objects together 'in such a way that one can support the other, and form a congruous style'. This indicates that organicism was important at Morris & Co. as well as at Morris's homes. While this circular takes on the role of an advertisement, communicating the facts in a clear and assured manner, the first comes across as a manifesto intended to communicate somewhat controversial assertions.

This interpretation is supported by Vallance's account of the 1861 circular's reception. He writes,

The announcement came with the provocation and force of a challenge, and dumbfounded those who read it at the audacity of the venture. The amount of prejudice it aroused would scarcely be believed at the present time. Professionals felt themselves aggrieved at the intrusion, as they regarded it, of a body of men whose training had not been strictly commercial into the close premises of their own peculiar domain; and had it been possible to form a ring and to exclude MMF & Co. from the market, the thing would infallibly have been done.[89]

We cannot imagine the circular of *c.* 1882 provoking this kind of indignation. While the first circular's critical attitude to existing decoration could have been understood by 'professionals' in the field as a deliberate attack on their practice, the later circular concentrates on the firm's own produce rather than emphasising its competitors' inferiority.

The Hammersmith Carpets announcement blends aspects of the two documents discussed above. It is more discursive than the general circular of *c.* 1882 and its tone is more self-assured than that of the 1861 prospectus. This announcement is not simply aimed at familiarising the public with a new product. It sets the carpets in the context of a general history of carpet making, evaluating past achievements and setting out principles for success in the field. Morris thus claims a pedagogic role for the firm.[90]

Morris's tone also expresses a degree of humility, however, as the circular states, 'we hope ... that you will think our attempt worthy of your support'.[91] Here we see a strategy of maintaining a high status for the salesman, the better to win respect, while crediting the customer with the education and refinement required to understand the firm's aims and assess its products. The circular provides the information that the customer needs in order to judge. The reader would thus approach these objects knowing that while the firm has officially granted him or her the right to evaluate them, Morris has already demonstrated that he is in a far better position to make such evaluations than most of the general public could be expected to be. This would therefore seem a clever strategy; in order to criticise the product, without looking uncultivated, the customer would have to show that he or she was as informed as the maker.

The tone of this circular is, however, notably different from the more dogmatic, and perhaps patronising, style of many of the taste books. Morris accords the customer a degree of power and respect, looking for approval rather than assuming a superior role, as the authors of the taste

books often implicitly do. Of course, as we saw in Chapter 1, those authors are often responding to a professed need for guidance and straightforward instructions. This contrast suggests that Morris & Co. and the taste books are aimed at slightly different audiences. It would seem that Morris & Co.'s anticipated customers are more self-assured and less anxious than those to whom the taste books are marketed.

The Hammersmith Carpets circular sets high standards for the carpets to meet. They are expected to make England 'independent of the East for the supply of hand-made carpets which may be considered works of art'.[92] This has strong echoes of the Schools of Design project, part of whose aim was to make Britain independent of countries such as France for industrial patterns (see Chapters 1 and 5). Morris & Co. may be seeking to tap into the public's awareness of this as a broader concern within national design. The circular also declares that western handmade carpets should 'show themselves obviously to be the outcome of modern and western ideas, guided by those principles that underlie all architectural art in common'. 'Architectural art' is one of Morris's preferred terms for decorative art in general.[93]

While these demands appear at first very precise, when we look closer it is in fact difficult to see how success or failure in fulfilling these conditions could be established. How, for example, do we determine whether or not a certain carpet should be considered a work of art? Perhaps the claim to being considered 'works of art' could be based on the amount of time and labour demanded by the hand-knotted Hammersmith carpets, combined with their uniqueness, yet these are not sufficient conditions.[94] The second requirement is even more abstract. While they should avoid imitation, the carpets should nevertheless link themselves to 'modern and western ideas'. This seems to depend on the concept of an abstract visual language through which 'ideas' can be communicated. As we shall see in Chapter 5, this is similar to an approach recommended by Crane, who believes in just such a visual 'speech' or 'language' through which the decorative artist can convey what is in 'his eye and mind'.[95]

The Boston Foreign Fair

Exhibits and written advertising come together in 1883 when the firm holds an exhibition in the United States at the Foreign Fair, Boston. A detailed catalogue, probably written by Wardle, was produced to

accompany the show.[96] This catalogue shares some of the characteristics of the taste manuals discussed in Chapter 1, offering advice on display and maintenance and drawing attention to comparisons of quality. For example, the superiority of the Hammersmith to the machine-made Kidderminster carpets is emphasised, but at the same time the author is careful to observe 'how well the cheaper but not necessarily vulgar material consorts with the more dignified Hammersmith'.[97] It is implied that while there is no competition in terms of quality, the aesthetic effect of combining the two types, if financially necessary, can be successful.[98] A careful balance is drawn between demonstrating the firm's ability to evaluate its own products and reassuring customers that whatever they can afford, the firm has something to offer them.[99] It is significant that the contrast between the two production processes, and their impact on the labourer, is given no significance in weighing up the relative value of the two types of carpet.

In this catalogue, Morris & Co. are careful to define the role they have taken on at the exhibition, explaining that they are 'exhibiting here as manufacturers only, and the arrangement of the goods is that which seemed best for showing them in the ways most accordant to their actual use'.[100] Wardle reiterates this point later, advising that the separate rooms in the Morris & Co. exhibit must not be taken 'as consistent decorations, but simply as showrooms'.[101] This seems to indicate an anxiety that their reputation as tasteful room decorators should not be harmed by the inharmonious co-display of different patterns, made necessary by the wish 'to exhibit as many varieties as there was space for'.[102]

Perhaps partly in an effort to make up for these undesirable display conditions, Wardle demonstrates the firm's cultivated taste by including advice about displaying the objects in the home. For example, he recommends that a room dressed with *Honeysuckle* cotton velvet 'should have the woodwork of very richly toned walnut or mahogany; or, if meaner wood be used, it should be painted a rich, deep green, and varnished'.[103] Again, customers for whom the highest quality products would be unaffordable are accommodated as well as those with the freedom to choose the best. By suggesting how to match its products to suitable surroundings, Morris & Co. claims a connoisseurial role for itself. In the next section, I examine some of the firm's products in the light of this literature.

Morris & Co. objects

Wallpaper

The Boston catalogue divides the wallpaper designs into distinct, but some-times overlapping, categories. It advises, 'If there is a reason for keeping the wall very quiet, choose a pattern that works all over without pronounced lines, such as the *Diapers, Mallows, Venetians, Poppy, Scroll, Jasmine,* etc.' If, on the other hand, the customer requires 'more decided patterning', they should 'choose the *Daisy, Trellis, Vine, Chrysanthemum, Lily, Honeysuckle, Larkspur, Rose, Acanthus,* or such'.[104] A comparison between *Jasmine* (figure 26) and *Vine* (figure 2) may help to clarify this contrast. The two designs seem at first to be composed of similar groups of forms. The strongest similarity is the presence of pointed leaves in both designs, while the clusters of seven flowers in *Jasmine* could be seen to parallel the wider leaf-shapes in *Vine*.

In *Jasmine*, the seven-flowered clusters are more or less equally distrib-uted over the design, which dissuades us from paying more attention to one part than to any other. In *Vine*, however, the wider leaves and the bunches of grapes forge, intertwined, across the background of narrower leaves, leaving some areas undisturbed. This separates the design into areas of greater and lesser importance, immediately inviting our gaze to linger while we follow through the logic of the design. This seems to be consistent with the catalogue's distinction between a pattern that 'works all over without pronounced lines' and 'more decided patterning'.

The different forms in *Jasmine* seem to hold each other in, folding over and under each other to minimise the sense of depth. By contrast, the bunches of grapes in *Vine* challenge the flatness of the paper, adding a sense of heaviness and substance to the design. This is not to say that they add perspective, however. If we look closely, we can see that each grape is equally close to the surface. We are not presented with a bunch where some grapes are part-hidden behind others, or whose outer grapes are further away, and thus smaller. Each grape is treated separately. The stylistic trio of lines on the left side of each grape creates a self-contained sense of roundness, without asserting the roundness of the bunch as a whole. The bunch of grapes thus catches our eye, but, once we focus on it, refuses to sustain an illusion of depth. This means that even a 'more decided' pattern is designed to draw us in only temporarily. By using the

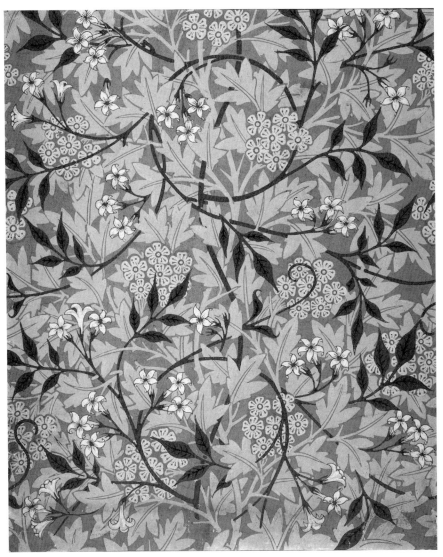

26 Morris, Marshall, Faulkner & Co., *Jasmine* wallpaper, designed by William Morris and printed by Jeffrey & Co. from 1872. Block-printed in distemper colours.

word 'quiet' to describe the effect of patterns such as *Jasmine*, the catalogue implies that 'more decided' patterns can be loud.[105] It is perhaps in order to control this implied loudness, and limit its intrusion into the room, that the pattern quickly relinquishes its apparent initial claim on our attention when we look more closely.

The advice the firm offers is consistent with Morris's tendency to be affected by environments (see Chapter 2), suggesting that Wardle was guided by Morris in preparing this catalogue. Wardle demonstrates a keen awareness of how surroundings can have a significant impact on those

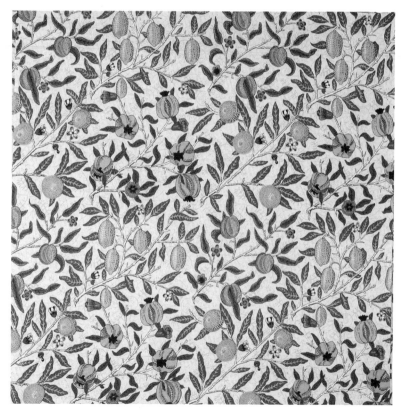

27 Morris, Marshall, Faulkner & Co., *Fruit* wallpaper, designed by William Morris and printed by Jeffrey & Co. from *c*. 1866. Block-printed in distemper colours.

who inhabit them.[106] He also encourages the customer to make his or her choice based on the intended destination of the pattern, rather than on 'personal liking' alone, advising that 'Pattern-choosing, like pattern-making, is an Architectural Art. A pattern is but a part of any scheme of decoration, and its value will be derived in great part from its surroundings.'[107] This seems to reiterate Ruskin's conception of architecture as the unifying structure in which interrelating components are brought together, and fits with Morris's interchangeable use of the terms 'architectural arts' and 'applied arts'.[108]

Wardle offers even more precise recommendations based on the perceived 'defect' of the room to be decorated; if the room's 'defect' is 'rigidity', 'soft, easy lines, either boldly circular or oblique-wavy' are recommended.[109] Among those suggested are *Scroll* and *Fruit*. Both of these patterns have a sprawling, unconstrained tone, created in *Scroll* by the long stems reaching out in all directions, and in *Fruit* (figure 27) by the loosely diagonal thrust, which draws the eye across the wall without emphasising either the vertical or the horizontal.[110] Wardle's awareness of the potential strengths and weaknesses of different types of room also suggests the firm's sensitivity to the varying social and economic positions of its customers. He does not posit a pinnacle of aesthetic aspiration, but instead allows for a variety of different, yet equally valid, approaches.

However, the conclusions as to suitability drawn from examining several examples from the categories Wardle puts forward cannot necessarily be applied to the other designs in those categories. While certain tendencies do seem to be shared by a number of different patterns, the most striking feature of Morris's designs is that they are not in fact interchangeable. This, perhaps, is why Morris & Co. goes to so much trouble to explain the advantages of the various patterns in specific circumstances. The firm wants to encourage customers to think carefully about their choice, rather than being overwhelmed by the variety of options and giving no one pattern their full attention. While Wardle does offer some guidance, the expectations facing the customer are quite daunting. To select a pattern based on the strengths and weaknesses of a given space, the customer is required to arrive at an unbiased assessment of the room and to imagine the impact of each pattern in that room. The decision must be an objective one, dictated more by the architecture than by the personal taste of the customer. It is thus in a particular frame of

mind that the customer is invited to approach the task of selecting Morris & Co. designs.

As in the case of the Hammersmith Carpets circular, however, the customer is attributed only a limited amount of autonomy in the choice facing him or her. In setting up such a complex system for matching designs to situations, the superior expertise of the firm is implicitly emphasised. This suggests that we would find a similar level of attention to the relationship between object and setting in other areas of the firm's work, as well as in wallpaper design.

The Bullerswood *carpet*

In order to explore this question further, we can consider to what extent the pattern of a Morris & Co. carpet is tailored to its specific location. The *Bullerswood* carpet (plate 6) was woven in 1889 for the Sanderson family's house in Kent. Reproductions allow us a view of the entire carpet, which is misleading, since, at 764.8 x 398.8 cm, it was large enough to cover

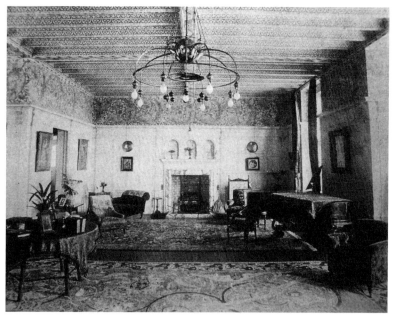

28 Drawing room, Bullerswood, Chislehurst, after 1889.

most of the floor in a spacious drawing room (figure 28). When we look
at the image of the carpet shrunk to fit inside this book, it is difficult to
visualise it translated on to such a grand scale. No user of the Bullerswood
drawing room would have had the view of the carpet now available to us.
Not only were parts of it covered by furniture, and, when the room was
in use, people, but a viewer would either see a small section out of the
context of the whole, or have a general view of the entire carpet distorted
by perspective.

The carpet's swirling red lines that on a small scale seem rather
twee and fussy take on a commanding presence when expanded, while
the birds swell from well-camouflaged, almost cartoon-like figures into
creatures of more noble and dignified stature. The busy, cluttered appear-
ance of the carpet in reproduction is absent from the original, in which,
bearing in mind the relative proportions of carpet and viewer, the spaces
within the pattern would be more noticeable and the general impression
less crowded. In fact, the size of the carpet makes the detail all the more
necessary, since interest must be given to whichever part of the carpet a
viewer happens to have access to. In contrast, the smaller Hammersmith
rugs tended to be less elaborate than the carpets, without the intricate
outlining and added detail seen in the larger pieces. This demonstrates
the designer's skill in judging how to match purpose, scale and pattern in
the most visually effective way.

This investigation has shown that we cannot know Morris's designs in
general. We have to consider each as an individual pattern with its own
unique characteristics. The firm's publicity reveals that the same task faced
Morris & Co.'s customers. Repeatedly, we are told that different patterns
suit different environments. Morris & Co. objects are designed to be
examined, assessed, compared and matched to specific contexts. This
section has therefore attempted to deal with some Morris & Co. objects
in this way.

Conclusion

The history of Morris & Co. is conventionally divided into two phases.
Broadly speaking, the early phase is seen as the beginning of the 'Arts and
Crafts movement' and the later phase is associated with a more troubling

increase in fashionability and financial prosperity. Consequently, the Morris of the 1880s becomes more important in accounts of Arts and Crafts for his socialism, than for his practical example. Fashion and profit are not words that sit comfortably with conventional versions of Arts and Crafts. When we look at the firm, and its objects, without an 'Arts and Crafts movement' agenda, it becomes clear that the firm develops a much more complex and interesting approach to objects during both of these phases than is allowed for in conventional generalisations about its history. This has implications for its relationship both with other Arts and Crafts contexts and with 'Aesthetic' and commercial contexts.

Another common approach to the firm is to see it in terms of innovation. Critics have challenged the view that Morris & Co. was innovative and demanded that we reassess its relationship to contemporary design. By looking at the firm, and its objects, without this innovation-seeking agenda, we are free to pursue other lines of enquiry. This chapter has shown that regardless of their perceived innovativeness, Morris & Co. objects can help us to develop a more specific language for talking about decorative objects. For example, as we have seen, 'medieval' proves an ambiguous term when applied to MMF & Co. objects. Similarly, Morris & Co. encourages us to take seriously the ways in which objects relate to their contexts.

The investigations carried out in this chapter support the argument that specificity is key to Arts and Crafts contexts, and that generalisation involves a fundamental misunderstanding of the priorities upheld by those contexts. As we have seen, the publicity at Morris & Co. takes the specific characteristics of individual objects seriously. By analysing the objects in relation to this literature, I have shown how carefully the potential of certain objects to suit specific contexts was considered. In this way, claims were made for the power of domestic interiors to 'create atmosphere', to use Crawford's phrase again, and for the validity of a sophisticated engagement with decorative objects.[111] These claims take for granted that we consider an object's individual characteristics and specific context (or intended context), rather than suppressing those considerations in favour of an approach that sees objects collectively and homogenously. This is very different from the approach cultivated at the Arts and Crafts Exhibition Society, as we shall see in the next chapter.

Notes

1 Design Council, *William Morris and Kelmscott,* p. 74.

2 Design Council, *William Morris and Kelmscott,* p. 73.

3 Design Council, *William Morris and Kelmscott,* p. 80.

4 See Clive Wainwright, 'Morris in Context', in Parry (ed.), *William Morris,* exh. cat.

5 Floud, 'The Wallpaper Designs of William Morris', p. 42 and Wainwright, 'Morris in Context', in Parry (ed.), *William Morris,* exh. cat.

6 For more on the firm, see Harvey and Press, *Design and Enterprise.*

7 HF, DD/235/1, Morris & Co. minute book, 22 April 1863.

8 William E. Fredeman (ed.), *The Correspondence of Dante Gabriel Rossetti,* II *The Formative Years 1835–1862* (Woodbridge: D. S. Brewer, 2002), p. 441.

9 HF, DD/235/1, Morris & Co. minute book, 18 February 1863.

10 The minute book features regular entries between 1862 and 1863 and sporadic entries from 1863–74.

11 Faulkner took up a fellowship in Mathematics at University College in 1864 (Charles Harvey and Jon Press, 'The Business Career of William Morris', in Parry (ed.), *William Morris: Art and Kelmscott,* p. 9).

12 MacCarthy, *William Morris,* p. 342. Harvey and Press observe that even though he was successful, Burne-Jones was characteristically anxious about money, and he, 'like Webb and Faulkner, needed work and income, not membership of a pleasant, civilised, unremunerative club' ('The Business Career of William Morris', in Parry (ed.), *William Morris: Art and Kelmscott,* p. 6). It is interesting, in the light of this, that Burne-Jones, Webb and Faulkner were the three partners who voluntarily disclaimed the £1,000 to which they were each entitled. See David Elliott, 'Burne-Jones and the Dissolution of Morris, Marshall, Faulkner & Co.', *Journal of the William Morris Society,* XIV: 3 (Winter 2001).

13 While MacCarthy refers to Morris's 'Ruskinian misgivings about commerce' (*William Morris,* p. 171), Harvey and Press point out that Morris 'came from a commercial background' ('The Business Career of William Morris', in Parry (ed.), *William Morris: Art and Kelmscott,* p. 3). It is therefore possible that he anticipated a commercial career with more readiness than his later socialist outlook might suggest.

14 Harvey and Press, 'The Business Career of William Morris', in Parry (ed.), *William Morris: Art and Kelmscott,* p. 5. See also Eisenman, 'Class Consciousness', pp. 24–9.

15 For example, Morris writes to Charles Augustus Howell, 'as to the £20 don't think me a curmudgeon if I ask for it within a month or so as I am pretty hard up' (11 September 1868. Cited in Kelvin (ed.), *Letters,* I, p. 65).

16 Morris to Aglaia Coronio, 11 February 1873. Cited in Kelvin (ed.), *Letters*, I, p. 178.

17 MacCarthy, *William Morris*, p. 341.

18 Morris wrote to Charles Fairfax Murray, "'tis a great blessing, & has set me working hard to make things go' (27 May 1875. Cited in Kelvin (ed.), *Letters*, I, p. 254).

19 See Linda Parry, 'William Morris and the Green Dining Room', *Magazine Antiques* (August 1996) and Sally-Anne Huxtable, 'Re-reading the Green Dining Room', in Edwards and Hart (eds), *Rethinking the Interior*.

20 Barbara Morris, 'William Morris and the South Kensington Museum', p. 162.

21 MacCarthy, *William Morris*, p. 193.

22 See Charles Mitchell, 'William Morris at St James' Palace', *Architectural Review* (January 1947); J. Moyr Smith, *Ornamental Interiors: Ancient and Modern* (London: Crosby Lockwood & Co., 1887), pp. 155–7; John Y. Le Bourgeois, 'William Morris at St James's Palace: A Sequel', *Journal of the William Morris Society*, III: 1 (Spring 1974); and Parry, 'Domestic Decoration', in Parry (ed.), *William Morris*, exh. cat., p. 140.

23 Mackail, *Life*, I, pp. 175–6. Harvey and Press claim, however, that Taylor 'was by no means the "expert in business methods" described by Mackail' (*Design and Enterprise*, p. 65). They argue that while he was able to put pressure on the partners to deliver designs and keep to deadlines, Taylor did not have the necessary knowledge of the market.

24 Georgiana Burne-Jones, *The Memorials of Edward Burne-Jones*, 2 vols (London: Macmillan & Co., 1904), I, p. 291.

25 NAL, 86.SS.57, Philip Webb Correspondence, George Warington Taylor.

26 NAL, 86.SS.57, Philip Webb Correspondence, George Warington Taylor, undated letter.

27 HF, DD/235/1, Morris & Co. minute book, 16 May 1867.

28 BL, Add. MS 45350, Morris Papers, XIII, George Wardle, manuscript history of Morris & Co., p. 4.

29 For more on Morris's dyeing, see Deryn O'Connor, 'Red and Blue', in Design Council, *William Morris and Kelmscott*.

30 See H. C. Marillier, *History of the Merton Abbey Tapestry Works Founded by William Morris* (London: Constable & Co., 1927). Marillier claims that of the twenty-six tapestries (or 'sets' of tapestries) produced between 1879 and 1896, Morris designed six, and co-designed one with Webb. Other designers included Crane, Burne-Jones, Webb and Dearle (pp. 31–4).

31 See Harvey and Press, 'The Business Career of William Morris', in Parry (ed.), *William Morris: Art and Kelmscott*, pp. 13–14 and Nicholas Salmon and David

Taylor, 'Morris & Co. in Manchester', *Journal of the William Morris Society*, XII: 3 (Autumn 1997).

32 Harvey and Press, 'The Business Career of William Morris', in Parry (ed.), *William Morris: Art and Kelmscott*, p. 14.

33 See Harvey and Press's important work on Morris as a businessman. They write that Morris was 'a practical, hard-working, hard-headed, imaginative and original man of affairs', and that 'the success of his firm owed little if anything to luck' ('The Business Career of William Morris', in Parry (ed.), *William Morris: Art and Kelmscott*, p. 3).

34 William Morris Gallery, A. H. Mackmurdo, 'History of the Arts and Crafts Movement', unpublished MS.

35 W. R. Lethaby, *Philip Webb and His Work* (London: Oxford University Press, 1935), p. 31.

36 Similarly, Harvey and Press suggest that Rossetti's reminiscences about the firm are not entirely reliable. As they observe, 'the view later put about by Rossetti that MMF & Co. was "mere playing at business" might well reflect his own feelings about its purpose, but tells us little about the other members' ('The Business Career of William Morris', in Parry (ed.), *William Morris: Art and Kelmscott*, p. 6).

37 BL, Add. MS 45350, Morris Papers, XIII, Wardle.

38 The glass painting was done by 'two experienced craftsmen', George Campfield and Charles Holloway (Martin Harrison, *Victorian Stained Glass* (London: Barrie and Jenkins, 1980), p. 40).

39 BL, Add. MS 45350, Morris Papers, XIII, Wardle, pp. 14–15.

40 Harvey and Press, 'The Business Career of William Morris', in Parry (ed.), *William Morris: Art and Kelmscott*, p. 15. Harvey and Press offer the example of a circular in which the firm boasts that Burne-Jones 'entrusts us alone' with his designs (NAL, 276.A Box 1, Morris & Co., circular, *c*. 1882, London).

41 For more on the *Holy Grail* tapestries, see 'The Arras Tapestries of the San Graal at Stanmore Hall', *The Studio*, XV (1899) and Helen Proctor, *The Holy Grail Tapestries Designed by Edward Burne-Jones, William Morris and John Henry Dearle for Morris & Co.* (Birmingham: Birmingham Museums and Art Gallery, 1997).

42 A. B. Bence-Jones, cited in Proctor, *Holy Grail Tapestries*, p. 17.

43 Morris, cited in Aymer Vallance, 'The Revival of Tapestry-weaving: An Interview with William Morris', *The Studio*, III (1894), p. 101. Vallance seems anxious here to emphasise Morris's Ruskinian sympathies.

44 HF, DD/341/319 a–c, 'Art, Craft and Life: A Chat with William Morris', *Daily News Chronicle* (9 October 1893).

45 Oliver Fairclough and Emmeline Leary, *Textiles by William Morris and Morris & Co. 1861–1940* (London: Thames and Hudson, 1981), p. 14.

46 For more on the firm's stained glass, see David O'Connor, 'Pre-Raphaelite Stained Glass: The Early Work of Edward Burne-Jones and William Morris', in Parry (ed.), *William Morris: Art and Kelmscott*.

47 For example, the architect George Street, under whom Morris had studied briefly in 1856, proved a useful contact for Morris and Webb (Harvey and Press, *Design and Enterprise*, p. 58) while Rossetti persuaded William Cowper to engage MMF & Co. at St James's Palace (Harvey and Press, 'The Business Career of William Morris', in Parry (ed.), *William Morris: Art and Kelmscott*, p. 8).

48 For example, Morris & Co. gained commissions from the Bell family through Webb (Parry, 'Domestic Decoration', in Parry (ed.), *William Morris*, exh. cat., p. 143).

49 For more on the International Exhibition of 1862, see F. G. Stephens, 'Applied Art at the International Exhibition', *Weldon's Register* (November 1862).

50 For more on the Medieval Court, see the *Building News* (8 August 1862), pp. 98–101.

51 See Myers, *William Morris Tiles*, p. 26.

52 Joanna Banham and Jennifer Harris (eds), *William Morris and the Middle Ages* (Manchester: Manchester University Press, 1984), p. 125.

53 According to a history of the firm printed in 1911, the 'most important outcome' of the exhibition for MMF & Co. was to 'bring about relations with G. F. Bodley', an architect who 'entrusted the new firm with commissions for stained glass for a fine series of churches' (Morris & Company, Decorators, Ltd, *A Brief Sketch of the Morris Movement and of the Firm Founded by William Morris to Carry Out His Designs and the Industries Revived or Started by Him*, privately printed for Morris & Co. (London: Morris & Co., 1911), p. 17).

54 *The Builder* (14 June 1862), pp. 420–1.

55 *The Builder* (16 August 1862), pp. 577–8.

56 *The Ecclesiologist* (June 1862), p. 171. Cited by Banham and Harris (eds), *William Morris and the Middle Ages*, p. 124.

57 Aymer Vallance, *The Life and Work of William Morris*, 1897 (London: Studio Editions, 1995), p. 60.

58 Other viewers also arrived at the conclusion that the firm's work was old-fashioned. See A. R. Dufty, *Morris Embroideries: The Prototypes* (London: Society of Antiquaries of London, 1985), p. 10.

59 Vallance, *Life and Work of William Morris*, p. 59.

60 Day agrees that the judgement was not entirely accurate: 'The wording of the award may express more nearly the point of view of the judges than the aim of the exhibitors' ('The Art of William Morris', p. 3).

61 BL, Add. MS 45350, Morris Papers, XIII, Wardle, pp. 23–4.

62 Watkinson similarly rejects the idea that Morris's work was 'imitation Gothic' (Watkinson, *William Morris as Designer*, p. 68). He observes that in the *St George* cabinet (figure 23), for instance, 'Echoes of the late medieval are strong, but there is nothing imitative' ('William Morris as a Painter', in Parry (ed.), *William Morris: Art and Kelmscott*, p. 35). For more on Morris's medievalism, see Banham and Harris (eds), *William Morris and the Middle Ages*; Meier, *William Morris*, pp. 94–164; and Stansky, *Redesigning the World*, p. 5.

63 HF, DD/341/319 a–c, 'Art, Craft and Life: A Chat with William Morris', *Daily News Chronicle* (9 October 1893). 'Look before and after' is borrowed from Percy Bysshe Shelley's *To a Skylark* (1820), line 86.

64 HF, DD/341/319 a–c, 'Art, Craft and Life: A Chat with William Morris', *Daily News Chronicle* (9 October 1893).

65 Review of Eastlake, *Hints*, *Art Journal* (1869), p. 31.

66 Eastlake, *Hints* (Boston: J. R. Osgood, 1st American edn, 1872), p. xxv.

67 A similar kind of interpretation of Morris's medievalism can be seen in an 1897 article by Crane. He claims that MMF & Co. 'represented in the main a revival of the medieval spirit (not the letter) in design; a return to simplicity, to sincerity; to good materials and sound workmanship; to rich and suggestive surface decoration, and simple constructive forms' ('William Morris', pp. 89–90). He also writes that the 'movement' to which Morris belonged was 'Essentially Gothic and romantic and free in spirit as opposed to the authoritative and classical' (p. 91). Here Crane echoes Pugin's and Ruskin's emphatic preference for the Gothic over the Classical (see Chapter 1).

68 Paul Thompson, *Work of William Morris*, p. 21. Thompson supports this argument by referring to the petition mounted against the firm's work on suspicion that it was 'old work touched up'.

69 Wainwright, 'Morris in Context', in Parry (ed.), *William Morris*, exh. cat., p. 357.

70 Mordaunt Crook claims that 'Morris and Co. produced furniture which was painted; Burges designed painted furniture' (*William Burges and the High Victorian Dream* (London: John Murray, 1981), p. 298). Later in the book he argues, 'The painted furniture of Morris and Webb is little more than an easel or framework for paintings. Burges manages to incorporate pictorial elements without destroying the apparent structure of the design' (pp. 321–2).

71 Mordaunt Crook, *William Burges*, p. 295.

72 Mordaunt Crook, *William Burges*, p. 299.

73 Wainwright, 'Morris in Context', in Parry (ed.), *William Morris*, exh. cat., p. 357.

74 Harvey and Press, 'The Business Career of William Morris', in Parry (ed.), *William Morris: Art and Kelmscott*, p. 8 and Martin Harrison, 'Church Decoration and Stained Glass', in Parry (ed.), *William Morris*, exh. cat., p. 131.

75 See Harrison, *Victorian Stained Glass*, p. 39.

76 'The South Kensington Museum', *London Standard* (26 December 1868).

77 Conway, *Travels*, p. 135.

78 *Building News* (29 July 1870), pp. 73–4.

79 *Building News* (22 July 1870), p. 55.

80 *Building News* (29 July 1870), p. 73.

81 *Building News* (29 July 1870), p. 74.

82 *Building News* (29 July 1870), pp. 73–4 (italics original).

83 *Building News* (29 July 1870), p. 74.

84 *Building News* (29 July 1870), p. 73.

85 Mackail, *Life*, I, pp. 176–7.

86 See Harvey and Press, *Design and Enterprise*, p. 122.

87 See Jan Marsh, *William Morris and Red House: A Collaboration between Architect and Owner* (London: National Trust, 2005), p. 71.

88 Original prospectus, Mackail, *Life*, I, pp. 150–2; NAL, 276.A Box 1, Morris & Co., 'The Hammersmith Carpets', October 1882 and circular, *c.* 1882.

89 Vallance, *Life and Work of William Morris*, p. 58. See also *The Craftsman*, I: 1 (1901), p. 26.

90 Morris was the author of the announcement, according to NAL, 276.C Box 1, Morris & Co., 'Boston'.

91 NAL, 276.A Box 1, Morris & Co., 'The Hammersmith Carpets'.

92 The emphasis on making the west 'independent of the East' may have something to do with the Eastern Question. Morris had been an active member of the Eastern Question Association (EQA) in the 1870s during a period of conflict between Russia and Turkey. As Turkey's ally, Great Britain had also been drawn in. It may be that the frailty of Britain's relationship with the east was on Morris's mind when he set out to create carpets that could rival those of the Middle East. For more on Morris's involvement in the EQA, see E. P. Thompson, *William Morris*, pp. 202–25 and MacCarthy, *William Morris*, pp. 378–86. See also Patricia L. Baker, 'William Morris and His Interest in the Orient', in Design Council, *William Morris and Kelmscott* and A. R. Dufty, *Kelmscott: Exoticism and a Chair by Philip Webb*, reprinted from the *Antiquaries Journal*, LXVI: 1 (London: Design Council, 1986).

93 Morris, 'Art and its Producers' (1888), an address delivered in Liverpool before the NAAAI, *Works*, XXII, p. 343.

94 Although repeat versions could be made, the only time saved was that taken to produce a design.

95 Walter Crane, 'The Work of Walter Crane', *Easter Art Annual*, extra number of the *Art Journal* (1898), p. 32.

96 See Parry (ed.), *William Morris*, exh. cat., pp. 145, 204 and 231.

97 NAL, 276.C Box 1, Morris & Co., 'Boston', p. 10.

98 For a contrasting approach to the combination of high quality and inferior furnishings, see Lewis Foreman Day, 'A Kensington Interior', *Art Journal* (1893), p. 143.

99 Conway approves of this aspect of Morris & Co., observing: 'Their decorations, apart from their undeniable beauty, derive importance from the fact that they can be adapted to the requirements of persons with moderate incomes, or to the needs of those who are prepared to pay large sums' (*Travels*, p. 200).

100 NAL, 276.C Box 1, Morris & Co., 'Boston', p. 5.

101 NAL, 276.C Box 1, Morris & Co., 'Boston', p. 11.

102 This display practice, which does not demonstrate the use of the objects in a domestic setting, would later be adopted by the Arts and Crafts Exhibition Society. Morna O'Neill argues that the absence of complete interior schemes in the ACES's section at the Turin exhibition of 1902 provided a marked contrast to the practice favoured by the exhibition's Art Nouveau contributors ('Rhetorics of Display: Arts and Crafts and Art Nouveau at the Turin Exhibition of 1902', *Journal of Design History*, XX (Autumn 2007)).

103 NAL, 276.C Box 1, Morris & Co., 'Boston', p. 14.

104 NAL, 276.C Box 1, Morris & Co., 'Boston', p. 19.

105 The analogy between looking and hearing recalls Ruskin's need for a 'perfect being to listen', which I discussed in Chapter 1 (Ruskin, *Stones of Venice*, *Works*, XI, p. 213).

106 On the basis of Morris's designs, Watkinson argues that Morris 'thinks not only of the pattern, but of its *use*' (*William Morris as Designer*, p. 51, italics original).

107 NAL, 276.C Box 1, Morris & Co., 'Boston', p. 18.

108 Morris, 'Art and its Producers' (1888), an address delivered in Liverpool before the NAAAI, *Works*, XXII, p. 343 and 'The Arts and Crafts of To-day' (1889), an address delivered in Edinburgh before the NAAAI, *Works*, XXII, p. 359.

109 NAL, 276.C Box 1, Morris & Co., 'Boston', p. 19.

110 For a brief analysis of *Fruit*, see Watkinson, *William Morris as Designer*, p. 45.

111 Crawford (ed.), *By Hammer and Hand*, p. 9.

4 ✧ The Arts and Crafts Exhibition Society

THE ARTS AND CRAFTS Exhibition Society (ACES) was founded in 1887 and opened its first exhibition at the New Gallery, Regent Street, in October 1888. Its first president was Walter Crane and its members included many of the figures we have already encountered, such as T. J. Cobden-Sanderson, W. R. Lethaby and L. F. Day. The ACES was concerned with moral, commercial and aesthetic issues.[1] Tillyard sees this as a fundamental problem for the Society. She claims that the ACES brought into focus a 'disagreement about the role of the object itself'.[2] As a result, 'Instead of being a product of the Arts & Crafts Movement, objects on display at the ACES became the Arts & Crafts Movement's response to the demands of fashion and the pressures of commercial society'.[3] This idea that the 'movement' was somehow above or beyond 'commercial society' is not uncommon in Arts and Crafts scholarship. According to Lynne Walker, for example, 'Arts and Crafts practice was anti-commercial and opposed to trade practices'.[4] Similarly, we saw in the last chapter that the commercial success of Morris & Co. has seemed incompatible with some accounts of the firm's ideals.

Tillyard's remark also suggests that because fashion and commerce are two of the ingredients that make up the ACES, no object it displayed could be 'a product of the Arts and Crafts Movement'. For Tillyard, 'fashion' seems to be synonymous with the aesthetic. There was conflict, she claims, over whether the 'movement' should 'produce the moral object with its overtones of social regeneration, or the art object which had overtones of a more purely aesthetic appreciation and more fashionable connotations'.[5]

This chapter investigates the interrelation between the aesthetic, commercial and moral aspects of the ACES. It explores how aesthetics

functioned in the Society in ways that cannot be written off in terms of 'fashion'. It shows how the relationship between these three things at the ACES further emphasises the fact that the artificially separated histories of the period overlapped and connected. Tillyard's answer is to conclude that the ACES was not properly Arts and Crafts. The alternative view proposed in this chapter is that we need to rethink our understanding of what 'Arts and Crafts' means.

These questions are particularly important for this context, since it is at the ACES that we find the concept of a 'movement' taking shape. Accounts of the 'Arts and Crafts movement' have often been based partly on the appearance of the word 'movement' in the history of the ACES. This chapter analyses the use of the term 'movement' in this context. It also looks at the ways in which retrospective accounts of the Society link it to a movement. For example, in 1916, the Society's president, Henry Wilson, claims that the first exhibition in 1888 was 'literally the birth of the Arts and Crafts movement'.[6] In the secondary scholarship, the ACES is seen as the movement's 'form', 'substance',[7] 'public face'[8] and 'coherent public identity'.[9] In the light of this, the instability of Morris's relationship with the ACES, for example, which emerges in this chapter, questions many of our assumptions about Arts and Crafts. This, combined with other areas of conflict and contradiction within the Society, has implications for our concept of a unified and 'coherent' 'Arts and Crafts movement'.

The evolution of the Arts and Crafts Exhibition Society

Like Morris & Co. and the Schools of Art (see Chapters 3 and 5), the ACES was formed to fulfil multiple, and not always compatible, aims. In the case of the ACES, this feature found in most co-operative organisations was exacerbated because the Society grew from the merging of pre-existing groups. Though this alliance was motivated by a sense that the groups shared a common aim that could be better achieved by collaboration, it nevertheless necessitated compromise.

The prehistory of the Society consists of two key stages. While its forerunner was the Art Workers' Guild (AWG), this in turn was formed by joining two separate groups, the St George's Art Society and The Fifteen.[10] The St George's Art Society was an architects' association, while The Fifteen was a society founded by Day, 'which met monthly for reading and

discussing papers on Decorative Art'.[11] According to H. J. L. J. Massé, the AWG developed from the St George's Art Society's efforts to bring together those 'who were neither the oil-painters of the [Royal] Academy nor the Surveyors of the Institute [of British Architects], but craftsmen in Architecture, Painting, Sculpture and the kindred Arts'.[12] Massé thus presents the AWG as an alternative to the Academy and the Institute. Twenty-five craftspeople attended the meeting that represented the beginning of the AWG in 1884, a combination of members from both of the above groups.[13]

One problem with the AWG was that it failed to provide opportunities for members to exhibit their work.[14] While the St George's Art Society had considered exhibitions an important part of its project, the AWG, Massé claims, was unsupportive of exhibitions, even refusing to use a magazine as its 'mouthpiece', because the Guild 'had systematically avoided any such publicity'.[15] Hitchmough offers a possible explanation for this: 'A knowledge of the practicalities of organising exhibitions, however, the double risk of financial disaster and professional humiliation led the painters in the AWG to counsel caution when their architect colleagues proposed a public exhibition.'[16] Whatever the underlying causes of the lack of publicity, it seems to have been this that prompted some members of the Guild, apparently led by W. A. S. Benson, to seek to form a separate organisation.[17]

In these circumstances, the exclusivity of the Royal Academy exhibitions seems to have been felt particularly keenly.[18] On 1 September 1886, *The Artist* published a crucial letter under the heading, 'The Royal Academy'. It was signed by Crane, George Clausen and William Holman Hunt. The letter declares that the Academy 'should be left to enjoy its rights in peace' and calls for 'the establishment of a really national exhibition, which should be conducted by artists on the broadest and fairest lines – in which no artist should have rights of place; and all works should be chosen by a jury elected by and from all artists in the kingdom'.[19] Just over two weeks later, an article in the *British Architect* announced the development of a 'Programme for a National Art Exhibition'. This article states that 'artists are now publicly invited to elect whether they will continue to support an unreformed Royal Academy or join an artistic co-operative society, in which all who join it will have a distinct voice in its management'.[20] It continues, 'when there are sufficient guarantors a circular explaining the "movement" will be sent at once to the suffrage'.[21] This circular, entitled

'National Exhibition of the Arts', was signed by three hundred and ninety-nine artists, and promoted the principle 'that the juries for selecting and placing Works of Art must be elected from, and by, the Artists of the Kingdom'; recipients were invited to 'form one of a provisional committee to consider the best means of carrying it into effect'.[22]

Once this provisional committee had been formed, Crane expressed the opinion that 'the aims of the movement which the present Provisional Committee represent are larger than any reform of the Royal Academy will cover' and advised, 'it is desirable to work on independent lines to obtain our object'.[23] A few days after this meeting, however, Crane writes to Benson in some disappointment that 'the movement which I thought was to be a wide one will narrow itself to the action of a clique'.[24] The appearance of the word 'movement' in this process will be addressed shortly.

Later that year, the new society sent out a circular to invite guarantors under the title, 'The Combined Arts'.[25] This name seems to reflect the combination of painters, sculptors, architects and decorative artists in the society. In this document, the society's stated role is to 'supply a stimulus' to workers in the handicrafts and to 'draw artistic invention and skill again to the arts in their endless forms of application to daily life'. The circular concludes, 'It is obvious … that the projected exhibition will occupy entirely new ground, with distinct aims, and objects differing from any existing exhibition.'[26]

In 1887, the group was renamed 'The Arts and Crafts Exhibition Society' at T. J. Cobden-Sanderson's suggestion.[27] The adoption of this name indicates that one of the key driving forces behind the new society was the determination to fill the gap in the AWG's activities by mounting exhibitions of its members' work. Making a profit was not among the Society's aims.[28] Crane tells us in 1907 that the guarantors had been called upon once, in 1890, but were later reimbursed, and he is quick to add that the exhibitions were 'never run for profit, and our only object was to pay our expenses while enabling designers and craftsmen to show their work'.[29] Recourse to the guarantors was not, he claims, due to reduced attendance, but was instead necessitated by heavy expenses. Indeed, according to Crane, the exhibitions were consistently popular.[30]

The word 'movement' appears several times during this course of events. In this context, the word is being used, it seems, to refer specifi-

cally to a rebellion against the Royal Academy's monopoly over exhibiting opportunities rather than to a movement concerned explicitly with the ethics of production and craftsmanship, which is what would usually be understood by the 'Arts and Crafts movement'.[31] Cobden-Sanderson supports this interpretation in *The Arts and Crafts Movement* (1905), which provides an account of how the ACES came into being. He writes that because the Royal Academy was restricted to painting, sculpture and architecture, 'protesters' formed the ACES, which 'initiated the wider movement which, from itself as source, has spread the world over'. This is a 'movement' which any artist opposed to the Royal Academy can be involved in.[32] The word is thus being used to mean something very broad and all encompassing, and if there is any specific emphasis, it is on the opportunity to exhibit.

As the Introduction observed, it seems that the word 'movement' was used quite casually at this stage, to mean various different things at different times. An article by Crane from 1898 supports this interpretation. One 'movement', in his account, was 'the revival of design and handicraft which the late WM [William Morris] and his colleagues initiated by starting workshops and producing furniture, textiles, stained glass and decorations of all kinds'.[33] Crane then goes on to talk about 'Another phase of the movement', which occurred 'when a few designers gathered together from time to time under each other's roofs and discussed subjects connected with the theory and practice of their art'. Crane tells us that this 'little society' became 'absorbed' into the AWG, which suggests he is referring to The Fifteen. He adds that 'another movement, with a distinct practical object, grew out of the guild'.[34] By this, he means the ACES. Of course, it is clear that Crane considers these events to be connected. Yet, crucially, he calls the ACES 'another movement', rather than suggesting that one movement flowed directly from the founding of MMF & Co. to the foundation of the ACES. These investigations support the Introduction's claim that Crane both used the word 'movement' liberally, and perceived there to be a number of 'movements', rather than a single one that we can identify as the 'Arts and Crafts movement'.

Publicity at the Arts and Crafts Exhibition Society

Arts and Crafts exhibitions were held annually between 1888 and 1890. After this time, because more than a year was needed to generate a new supply of exhibits, they occurred triennially until 1899. A gap of four years then took place, explained by the Society's involvement in the 1902 Turin exhibition, before the next exhibition in 1903, after which the triennial pattern was re-adopted, with occasional longer gaps.[35]

Unlike the AWG, the ACES was not formally closed to women.[36] The Society could be considered progressive in that its exhibitions regularly included work by female artists.[37] Perhaps unsurprisingly for this period, women were less well represented at the level of management. By 1899, twelve out of the Society's one hundred members were female, but no women were on the Committee.[38] May Morris was the first woman to serve on the Committee when she was elected in 1900.[39]

From the very beginning, the Arts and Crafts exhibitions were accompanied by a catalogue, although the kind of information included changed over the years, as we shall see. The catalogues represented an opportunity to put into practice one of the Society's main priorities, the acknowledgement of each individual contributor's name. Wherever possible, the designer, the executant and the exhibitor were identified, a move that was intended to bring the status of the craftsperson in line with that of fine artists.[40]

The first exhibition catalogue implicitly presents the ACES as a counterbalance to the Royal Academy. In the Preface, Crane declares, 'We cannot concentrate our attention on pictorial and graphic art without losing our sense of construction and power of adaptation in design to all kinds of very different materials and purposes.'[41] In particular, equality in terms of public exposure is sought, as it is the Society's goal to provide a chance for decorative artists to appeal to 'the public eye ... upon strictly artistic grounds in the same sense as the pictorial artist'.[42]

This was a particularly important change introduced by the ACES. Previous exhibitions of 'decorative' art had discouraged judgements based on 'artistic grounds'. For example, in his review of the International Exhibition of 1862, F. G. Stephens writes that some MMF & Co. painted cabinets are 'really fine works of design, both in colour and construction, setting aside, of course, the artistic merit of the decorations, as foreign to our

question in hand'.[43] The distinction Stephens is making between 'really fine works of design' and 'artistic merit' is by no means a straightforward one, but it is clear that he believes his analysis should be restricted by the specific concerns of the exhibition. The ACES is thus providing an alternative arena in which such objects can legitimately be judged upon 'strictly artistic grounds'. Perhaps Crane fears that the Arts and Crafts exhibitions might be considered siblings of the Great Exhibition and its descendents, which put the emphasis on 'industry' rather than 'art'.

In the 1889 catalogue, an attempt is made to situate the Society in the context of recent developments in art. Crane claims that a 'Movement … towards a revival of design and handicraft, the effort to unite … the artist and craftsman … has been growing and gathering force for some time past', although it is 'under many influences and impelled by different aims'. For some, Crane continues, it is a question of England's 'commercial prosperity' and 'her prowess in the competitive race for wealth', and for others, a question of the 'social well-being and happiness of her people', a desire that 'the touch of art should lighten the toil of joyless lives'.[44] Crane is thus acknowledging that, as we saw in Chapter 1, Arts and Crafts can be related to a variety of sources. His use of the word 'movement', in this context, seems to refer to the developments in design since the Select Committee inquiry of 1835 (see Chapter 1), whose concern was precisely England's 'commercial prosperity' and 'her prowess in the competitive race for wealth'. However natural it might seem to us to read 'Arts and Crafts movement' for 'movement' in this instance, Crane seems to be referring, here, to a much more general tendency. Crane's reference to two parallel threads in the recent history of design improvement situates the Schools of Art, and their trade-oriented policies, in opposition to the attitude characterised by judging work conditions according to the accessibility of creativity, and associated with figures such as Ruskin and Morris. As Chapter 1 demonstrated, this simplified dichotomy between commerce and ethics tells only part of the story.

The tone Crane adopts in differentiating these two tendencies carries a clearly implied evaluation of the motivations behind them. It is evident that Crane admires an ambition to 'lighten the toil of joyless lives' more than an eagerness to succeed in the 'race for wealth', since he juxtaposes the emotionally provocative words 'well-being', 'happiness' and 'joyless' with the much colder words, 'prowess' and 'competitive'. To oppose the

two strands in such a simplified way certainly ignores aspects of each. The consequences of this appear to have emerged before the next exhibition. In the third catalogue, the Society announces:

> In some quarters it appears to have been supposed that our Exhibitions are intended to appeal, by the exhibition of cheap and saleable articles, to what are rudely termed 'the masses'; we appeal to *all*, certainly, but it should be remembered that cheapness in art and handicraft is well nigh impossible, save in some forms of more or less mechanical reproduction.[45]

This statement implies that a connection had been drawn from the socialistic implications of allying the Society with a school of thought that prioritised 'social well-being', and sought to 'lighten the toil of joyless lives', to a direct concern with furnishing the needs of the working class. Such an interpretation is expressed in the *Magazine of Art*'s review of the second exhibition. The author argues that while the exhibition 'has once more taught us that there is no reason why the houses of the wealthy should be hideous to look upon', it has failed to address the question of how 'persons with narrow means' can 'preserve their homes from cheap suites and curtains of strident hue and mechanical design'. In conclusion, the author reproaches the Society with the challenge, 'to answer this question, as we understand it, is one of the objects of Mr Crane's Society'.[46]

The defensive tone used in the third catalogue's discussion of this issue suggests that the Society's members were unsure whether to emphasise the quality, and thus, inevitably, the expense of the goods exhibited, or whether to underline the inclusiveness fundamental to the Society. Moreover, the catalogue's comment alludes more to the working life than the domestic life of the 'masses', since while making no claim to exhibit goods within their means, the author suggests that cheapness bears witness to 'mechanical' labour and implies that high cost is, conversely, a guarantor of non-alienated labour.

In an article on the first Arts and Crafts exhibition, the *Magazine of Art* emphasises the Society's ideological role. An illustration at the beginning of the article shows craftspeople labouring under the oppressive rule of 'over-production', while other hindrances, such as 'middlemen' and 'competition', weave themselves in and out of the group. At the end of the article, the craftspeople in the drawing are free, governed instead by 'manufacture', and they pour out of what we suppose to be metaphorical

prison gates.[47] Whether the intention is to suggest that the Arts and Crafts exhibition displays the results of this happy transformation, or whether this is a more long-term goal in the eyes of the Society, is unclear. The ambiguity allows us to read the illustrations in either or both of these ways. Even to those who have not yet read, or may never see, an Arts and Crafts catalogue, the exhibitions are thus presented in the context of their political motivation. The fact that this article is written by Day, a member of the ACES, suggests, unsurprisingly, that it was the Society's intention to frame itself in this way.

Yet the *Art Journal*'s reviewer does not consider the ACES to be entirely successful in its role. For example, the author observes that in textile and mural decoration, there is 'a little too much evidence of the hand of the single gentlewoman with a mission; there are (that is) too many overgrown school-girl exercises' of 'small practical value', since 'they have not been, and are unlikely to be, embodied in trade productions'. This comment reveals much about the reviewer's prejudices regarding the Society's role. The idea that the exhibited designs should be realised in trade cannot have been gleaned from the exhibition catalogues. It seems to have much more to do with the history of the Schools of Art, and the government effort to improve the standard of British design in manufacture.[48]

In 1903, Day, also writing in the *Art Journal*, expresses a similarly patronising attitude. He refers to Phoebe Traquair's embroidered panels, entitled *The Entrance, The Stress, The Despair* and *The Victory*, and declares that she 'attempts, perhaps, more than should be asked of the needle, but she goes near enough to success in her endeavour'.[49] Day's comment seems to reinforce the boundary between fine and decorative art by implying that 'the needle' has limited potential. On the other hand, since embroidery is associated almost exclusively with women, Day's reservations about Traquair's panels may be a manifestation of his generally misogynistic tone.[50] Another critical account of an Arts and Crafts exhibition appears in *The Studio* in 1903. The author refers dismissively to the 'display of miscellaneous works in a place they were never intended to adorn'.[51]

The fact that criticism in the press sometimes came from members of the Society, such as Day, points to the presence of conflict within the ACES. Members had other ways of communicating their own views to the public. They did this through the catalogues and in lectures that ran alongside the exhibitions. This verbal aspect of the Society's activities was

made all the more official by the publication, in 1893, of *Arts and Crafts Essays by Members of the Arts and Crafts Exhibition Society*. This volume was joined later by two more ACES publications, *Art and Life, and the Building and Decoration of Cities: A Series of Lectures Delivered at the Fifth Exhibition of the Society in 1896* (1897) and Cobden-Sanderson's *The Arts and Crafts Movement* (1905).

Morris and the Arts and Crafts Exhibition Society

Morris edited the *Arts and Crafts Essays*, providing a preface that served as an introduction to and, to an extent, a justification of, the ACES. He writes,

> It is this conscious cultivation of art and the attempt to interest the public in it which the Arts and Crafts Exhibition Society has set itself to help, by calling special attention to that really most important side of art, the decoration of utilities by furnishing them with genuine artistic finish instead of trade finish.[52]

In these words, there are echoes of something Ruskin said to Morris in 1878: 'How much good might be done by the establishment of an exhibition, anywhere, in which the Right doing, instead of the clever doing, of all that men know how to do, should be the test of acceptance.'[53] Mackail argues that 'this was one main object with which the Arts and Crafts Society was founded', thereby presenting the Society as the embodiment of Ruskin's dream.[54] The words 'genuine' and 'right' indicate an eagerness to attribute moral value to the objects and their makers, with the 'clever' processes of 'trade' occupying an inferior ethical realm. This distinction seems to parallel Crane's evaluation, in 1889, of the two separate kinds of motivation for design improvement. The view of Arts and Crafts as anti-'trade' has been taken up by many secondary scholars, as we saw at the beginning of the chapter.[55]

Since Morris had taken over from Crane as president of the ACES in 1891, it was natural that he should edit the collection of essays.[56] Yet Morris had not always shown such firm support for the Society.[57] On 31 December 1887, he writes a letter outlining his many misgivings towards the venture. He asks who is to 'find the money' and predicts that attendance will be low 'after the first week or two' since 'the public don't care

one damn about the arts and crafts'. This letter also suggests that Morris does not believe a significant gap will be filled by the Society. He writes, 'our customers can come to our shops to look at our kind of goods', and claims that while Crane and Burne-Jones's works would be 'worth looking at', the rest 'would tend to be of an amateurish nature, I fear'. In conclusion, Morris admits, 'I rather dread the said exhibition.'[58]

Morris seems to see the Arts and Crafts exhibitions as fulfilling a similar function to that performed by the International Exhibition of 1862 or the Boston Foreign Fair (see Chapter 3). Those events provided opportunities for his firm to display its goods to the public, and Morris assesses the proposed Arts and Crafts exhibitions in terms of their suitability to do precisely this. Morris seems to be missing, for the moment at least, the point that the Arts and Crafts exhibitions were not aimed solely at customers. Indeed, the ACES planned to 'supply a stimulus' to craftspeople and 'draw artistic invention and skill again' to the decorative arts. It carried out this plan by extending opening hours so that the exhibitions were accessible to working people and by often allowing craftspeople and art students free access. Importantly, the Arts and Crafts exhibitions were not presented, certainly initially, as fairs primarily aimed at customers looking to buy. They claimed a much more ambitious role, namely that of cultivating, nourishing and bearing witness to a flowering of 'artistic invention and skill' in the field of decorative art.

The wider aims of the ACES give the objects displayed a different kind of potential from that offered by the individual shops and firms from which they originated. At the Arts and Crafts exhibitions, objects take part in a story of national design improvement, and stimulate aspiring artists to contribute to that story. As we shall see in Chapter 5, objects performed the same kind of function at the Manchester Municipal School of Art. Morris's shop perhaps offered objects a more elevated role than most shops, considering, for example, the grand claims made for the Hammersmith Carpets as modern (and western) inheritors of a superior ancient (and oriental) tradition. Nevertheless, the majority of people drawn to such shops would have been customers. Morris's initial opinion of the Society may have been affected by his misunderstanding its goals.[59]

Though Morris's enthusiasm for the Society grew with its success, he remained doubtful of its effectiveness. In an interview conducted at the 1893 exhibition, Morris declared,

The object of the Arts and Crafts is to give people an opportunity of showing what they could do apart from the mere names of firms … The executant generally gets in. It is impossible, besides, to give the name of everybody concerned in the production … A work of art is always a matter of co-operation. After all, the name is not the important matter. If I had my way there should be no names at all.[60]

Morris's dismissal of the Society's goal to acknowledge individual input seems at first surprising in the light of his crusade to improve the craftsperson's lot. It indicates that Morris did not consider success to be synonymous with status, fame or public recognition. What he wished for on behalf of the worker was more to do with job satisfaction and the freedom to create. Moreover, Morris's ideal of work was fundamentally collaborative, embodied in the medieval guilds and revived briefly at Red House, in the early years of MMF & Co. and in organisations such as the Guild and School of Handicraft.[61] Instead of bringing the decorative arts up to the level of the Royal Academy exhibitions, something the ACES seemed keen to do,[62] it seems Morris's scheme for levelling the arts was to absorb the fine arts into the world of decorative art, a realm in which individual genius was less important than co-operation to produce the best possible result. As we have seen, there is a tension between this ideal and the reality of the market, in which the names of famous individuals (Morris and Burne-Jones) win customers for the firm. Morris's indifference to the question of public status is at odds with Crane's statement, in 1910, that one of the 'principles' on which the Society 'set out, in our efforts to unite Design and Handicraft', was 'to open a field for personal artistic distinction therein'.[63]

The gap between Morris's views and those of the ACES sometimes goes unacknowledged, however, most notably in George Wardle's account. Wardle writes that 'as a founder of the Arts and Crafts Exhibitions William Morris established the principle of recognising all help he received in his work', implying that Morris was not only a supporter, but a direct instigator, of a practice that, on the contrary, he displayed indifference towards.[64] 'Recognising' help is not, of course, the same as publicly announcing the names of one's helpers, which perhaps explains how Wardle could make this claim.

The fact that Morris died on the opening day of the fifth Arts and Crafts exhibition in 1896, combined with the Society's decision to postpone

the opening as a result, may have served to symbolise the perceived close relationship between him and the Society. In addition, a retrospective dedicated to him was held as part of the next exhibition (in 1899), which again may have gone some way towards further conflating the history of Morris and that of the ACES.[65] Webb believed that the Arts and Crafts exhibition 'would gain in relief and interest by setting apart some space for William Morris's work and that his work would also gain in interest by being shown with contemporary work which he has so largely influenced'.[66]

The question of how Morris should be remembered, which is central to this book's exploration of a perceived 'Arts and Crafts movement', seems to have brought to the surface a tension between the two perceived roles of the ACES as a celebrator of past achievement, on the one hand, and as a chronicler of current advances, on the other.[67] This emerges from the ACES minutes, which have not been closely analysed in relation to this issue before. It appears that after Morris's death, the New Gallery suggested mounting an exhibition of his work along with Rossetti's. The ACES Committee thereupon discussed the extent to which the Society should be involved in such an exhibition. Webb proposed that the Society might hold its own Morris exhibition alongside an ordinary Arts and Crafts exhibition. He and Mackail strongly opposed the suggestion of exhibiting Morris's and Rossetti's work together. It may be that Morris's friends were more aware than most that his relationship with Rossetti had not been a happy one (see Chapter 2), and that they considered a joint exhibition to be inappropriate.[68]

Others, who were perhaps more interested in the benefit of a Morris exhibition to the Society as a whole than in memorialising Morris, were anxious to present him as part of something larger. For example, the minutes state that Crane 'would like to enlarge the scope and make a complete exhibition of the complete movement'.[69] Cobden-Sanderson, on the other hand, appears to have been in favour of the separate New Gallery exhibition, arguing that while Morris had been a key figure in the past, the ACES should focus on the future. He is recorded as having said that 'the works of William Morris were congruous with the Arts and Crafts, but this particular time seems an historic moment, and whilst the Society exhibits the <u>movement</u> [sic], the New Gallery would exhibit what was done and accomplished, and would be monumental in character'.[70]

In these instances, Crane and Cobden-Sanderson seem to be using

the word 'movement' to mean different things. Crane is talking about a 'movement' in the past, while Cobden-Sanderson is concerned with a 'movement' taking place in the present and future.[71] For Crane, Morris was the key figure of a past 'movement'. Later in 1897, he writes, 'I have spoken of the movement in art represented by William Morris and his colleagues as really part of a great movement of protest ... This protest culminated with Morris when he espoused the cause of Socialism.'[72]

These contrasting views highlight a growing uncertainty as to whether Morris's influence itself should be considered part of the past, or part of the present and future. *The Studio*'s position, for example, appears to have shifted rapidly. In a review of the 1896 Arts and Crafts exhibition, we read that 'The real influence of Mr Morris' is 'apparent in dozens of examples not of his design; for he initiated so much, and, by a steady adherence to certain principles, restrained the English decorative movement from excesses which the work of other nations proves to be very near at hand'.[73] While the author's main aim here may be to caution against the onset of Art Nouveau, in doing so he or she notes Morris's role as a continuing inspiration with approval.[74] Two years later, *The Studio*'s account of Morris is less enthusiastic. 'There is danger', observes an author in 1899, 'lest the work of many a good ally may be forgotten if the cuckoo cry that Morris was not only the greatest but the only leader of the movement is left without occasional protest.'[75]

By 1903, *The Studio* is dismissive of Morris's contemporary relevance. Criticising the Arts and Crafts exhibition, a contributor characterises the Society's 'leaders' as 'the custodians of the Morris tradition in art, rather than the founders of a living tradition of today', observing that the 'Morris tradition' displays a 'medieval reliance', whereas 'the problem is to discover good decorative material in modern life'. This comment reveals that the question of Morris's 'medieval' influence, which was discussed in Chapter 3, has not been settled even by 1903. The author goes on to say that Voysey comes nearest to the 'ideal', unattained by Morris, of establishing 'good work and good materials' among 'the necessaries of life' for the poor. According to *The Studio*, the 'keynote' of Voysey's work is 'what would be called a Puritan severity but for that air of ampleness and ease so rarely united with singleness of motive and economy of ornament' (figure 29).[76] By praising these particular characteristics *The Studio* draws an implicit contrast with the more generous ornament associated with

29 C. F. A. Voysey, metalwork. Photograph from *The Studio*, XXVIII (1903), p. 28.

the 'Morris tradition'. The reader is invited to draw the conclusion that the 'Morris tradition' is outdated.[77]

The relationship between Morris and the ACES caused unrest, both within the ACES and outside it. It appears that the Society's relationship with Ruskin came under similar scrutiny. Evidence of this appears in the minutes of 9 February 1899. The subject under discussion is the question of whether a letter should be sent by the Committee to Ruskin on the occasion of his approaching birthday. Reginald Blomfield is strongly opposed to this suggestion, arguing that the letter raises 'formidable issues' and commits 'the Society definitely to an endorsement of Ruskin's teaching'. He goes on to say that the proposal is 'outside the province of the Society' which, he claims, is 'an Exhibition Society and nothing else'.[78] Following the discussion, it is decided that the letter should be withdrawn.

The fact that Ruskin's relationship with the Society is called into question is significant for our understanding both of the ACES and of Arts and Crafts more broadly. First, it is yet another reminder that the Society did not constitute a fully harmonious group of people united by a common ideology, and that instead members of the Society often had conflicting motivations, beliefs and priorities. Secondly, it suggests that Ruskin's role as forefather of Arts and Crafts was not accepted by all concerned as unquestioningly as we might expect. As we saw in the Introduction and in Chapter 1, accounts of the 'Arts and Crafts movement' usually make room for Ruskin and Morris as key figures in its development. However, there seems to have been a split around the turn of the century between those who continued to embrace the influence of Ruskin and Morris, and those who perceived it with uneasiness. This further emphasises the lack of homogeneity within Arts and Crafts, once again dissuading us from perceiving it as a linear and internally unified phenomenon.

The question of 'movements'

The 1903 Arts and Crafts catalogue includes a translation of a speech given by one of the jurors, M. Folcka, at the Turin exhibition in 1902. In this speech, Folcka sees the Turin exhibition as 'the actual results' of 'a movement which began more than thirty years ago, and with which are inseparably joined the names of William Morris, of Edward Burne-Jones, and Walter Crane'.[79]

In 1906, Crane's foreword to the eighth exhibition catalogue includes the following statement:

> What is known as the Arts and Crafts Movement continues to show a steady growth and development ... The remarkable work now produced in many of our Municipal Schools of Art and Technical Institutes in recent years, and the facilities and advantages frequently offered in such institutions, including often the best expert advice and artistic teaching available, must be counted as important factors in the progress of the movement.[80]

As we saw, when Crane wrote about a 'movement' in 1889, he seemed to perceive the Schools of Art as a crucial part of it. Now, although he has added the prefix 'Arts and Crafts' to the 'movement', he seems to have in mind the same broad development. Crane offers another summary of the Society's historical position in his autobiography of 1907, claiming that the ACES represented a 'further step in the same direction in which most of us had been working for some years in our endeavours to assert the claims of decorative design and the artistic handicrafts to their true position in relation to architecture and the arts commonly called "Fine"'.[81]

Metford Warner, head of Jeffrey & Co., the company responsible for printing Morris & Co. wallpapers from 1864, sees the ACES's impact on national trade as its most important aspect. He declares in 1910 that as a result of the ACES, 'many artists whose work would not otherwise have been known got into touch both with the public and the manufacturer and both France and Germany recognised its service in stimulating originality in design'.[82] It may be that Warner is keen to connect the ACES with the genealogy of European modernism, as Pevsner was later to do. His comment also seems to support the ACES's affiliation with the first of Crane's two motivations for design improvement, a concern with the promotion of the country's contribution to a world market. Although in 1889 Crane clearly expressed more sympathy for the inclination to 'lighten the toil of joyless lives', the Society, like other aspects of Arts and Crafts, seems to have grown out of both strands.

During these years, 1903–10, it seems to have become important that the ACES should be set in a historical context and attributed a significant position in the recent history of design. One way of securing the Society's status was to promote it as the culmination of a 'movement', suggesting

that its existence was the almost inevitable result of important national developments in the field. By giving the 'movement' the same name as the Society, this link is underlined all the more forcefully. To see it as a step forwards, moreover, as Warner and Cobden-Sanderson do, is to broaden its significance. Not only is it caused by past events, but it is itself a cause with an effect, spreading awareness of British design. These comments therefore indicate a desire to understand the Society as a pivotal feature of a historical theme on a major scale.

Crane's reference to the Municipal Schools of Art has other implications apart from emphasising the Society's historical position in a movement. In the first place, his admiration for the 'advantages' presented to the Schools must be interpreted in the knowledge that, in the case of the Manchester School, he himself represents the 'best expert advice' available. As we shall see in the next chapter, Crane had recently acted as Director of the Manchester Municipal School of Art. He thus subtly weaves himself into the different stages of the history he relates. Yet it is not simply a self-flattering comment since he also praises the work done in the Schools, of which he is certainly a qualified judge, having witnessed it at first hand in Manchester during the 1890s.

Crane's reasons for mentioning the Schools of Art may, though, be more complex. Officials from the Schools were among the important visitors and purchasers at the Arts and Crafts exhibitions, and this comment may have been included primarily for their benefit, a move that could have had several purposes. First, this could be an acknowledgement of the Schools' support of the Society during the preceding years, characterised in part by their purchasing of objects for their own collections, which contributed to the 'facilities' Crane admired. It could also be a means of encouraging these representatives to continue their support by emphasising the idea of a common aim and history shared by the Schools of Art and the ACES. Furthermore, by implying that the Schools of Art are part of the same 'movement' as the Society, Crane invites the Schools to consider themselves responsible for spreading the philosophy of the 'Arts and Crafts movement', as defined by him.

Commerce at the Arts and Crafts Exhibition Society

By the time these accounts were written, the ACES had developed into a much more business-like organisation. The Society's policy on selling, for example, underwent some significant changes fairly quickly. The 1889 catalogue stated: 'The Society will undertake the sale of works where instructions have been received as to their price, but will undertake no responsibility, either with regard to payment, or to the delivery of works.' The Secretary would 'register the purchase', and 'communicate the fact to the Exhibitor', but would not 'receive money' or undertake further negotiations.[83]

The ACES's policy on transactions in its early years seems to be consistent with that of the Royal Academy. No prices were displayed in the Royal Academy catalogues, which stated that 'Communications with regard to the Price and Sale of Works' should 'be addressed to "The Secretary"'; that 'All purchases will be registered'; and that 'The Academy can undertake no responsibility with regard to either the payment for the Works purchased, or their delivery to the purchaser.' There were special 'Price Catalogues' on display that included the 'Prices of Works to be disposed of'.[84] The similarities between the Royal Academy and ACES catalogues demonstrate further that the ACES was self-consciously presenting itself as the equivalent of the Academy.

In 1893, the year of the fourth exhibition, the rules at the ACES were changed, however. Now, the Secretary would take the purchaser's details and accept a 25 per cent deposit. This was the same catalogue in which the volume of *Arts and Crafts Essays* was first advertised, at the price of 5s 8d. The coincidence of the two implies that the Society was becoming more confident in handling money and in its status as, in some respects, a business, albeit what we would now call a 'non-profit' organisation.

There are signs that the Society's attitude towards sales was changing in the ACES minutes for 1901. Cobden-Sanderson, in his role as Honorary Secretary, is recorded as having 'deprecated the Exhibition being turned into a shop for sale of wares'.[85] This suggests some conflict, perhaps, among the members of the Society regarding its relationship with potential customers.[86] Prices are shown in the catalogue itself for the first time in 1903; previously, they could be had from the Secretary only. The deposit remains at 25 per cent and purchasers are advised to check the prices with

the Assistant Secretary. Apparently, Cobden-Sanderson's objections did not hold back the Society's development in this direction.

These changes suggest that the Society was adapting to suit the purposes of the visitors and exhibitors, enough of whom seem to have seen the exhibitions as opportunities to buy and sell (as Morris had done from the very beginning) to prompt some changes in policy. The Society needed both of these groups in order to succeed. Without the highest quality contributors, its exhibitions would lose their status, and unless visitors were encouraged to return, revenue would decrease.

The rapid changes in selling conditions also suggest that rather than appealing to 'the masses', which, as we saw, the Society had apparently been charged with in 1889, the exhibitions appealed to those with purchasing power. This conclusion is supported by the *Daily News Chronicle*'s description of the 1893 exhibition as a 'fashionable art show'.[87] The prices of objects, as listed in the 1903 catalogue, for the most part set them out of the reach of 'the masses'. A William de Morgan vase cost £13 5s, while Crane's drawings for wallpaper were priced at £10 or more. Some items were less expensive, including a bowl by Howson Taylor at £1 5s, for example, and a design for a Christmas card marked at £1 11s 6d. Affordable objects of this kind were balanced, however, by the opposite extreme. The set of four embroidered silk panels by Traquair that Day praised grudgingly was priced at £1,000, an exceptionally high price for the Arts and Crafts exhibitions but nonetheless an indication of the anticipated clientele.[88] Commentators in journals criticised the prohibitive prices, finding at the exhibitions 'nothing for the poor or middle classes'.[89] One of the Society's main aims was to raise the status and profile of decorative artists, and perhaps it emerged that shifting the emphasis towards commerce was an effective way to achieve this.[90]

We have seen that the Society's activities extended far beyond the gathering of objects for exhibitions. Lectures and essays also formed an important part of its work. In fact, it would appear, from reading the 1888 catalogue, that the Society's first aim was to express certain ideas, and that the exhibitions themselves were secondary to and illustrative of those ideas. For example, in this catalogue Crane rehearses a typically Morrisian derision of contemporary design, quoting Morris's view that 'life is growing "uglier every day"', then identifies ways in which the situation might be, and has begun to be, improved. Following this, Crane

declares, 'It is with the object of giving some visible expression to these views that the present exhibition has been organised.'[91] This approach, in which objects are employed to illustrate ready-formed ideas, goes some way, perhaps, towards explaining why Arts and Crafts is perceived as a 'movement' of ideas first and foremost, with objects taking a subsidiary role. If the president of the ACES is promoting this hierarchy of ideas and objects, it could seem reasonable to apply it to the 'movement' as a whole. There are two factors, however, that limit the appropriateness of this assumption.

First, it is important to note that efforts were made to make the exhibitions accessible to practicing craftspeople. For example, in 1890, the catalogue announced that entry was free on Monday evenings to 'craftsmen and others who may be unable to attend during the day'. In the same year, students 'of any recognised Art School' were also admitted free of charge at any time.[92] This suggests that the exhibits themselves, and not only the ideas communicated in the Society's literature, are considered to be of instructive value to these groups (see Chapter 5).

Secondly, the 1888 Preface contains a clue to the way in which objects were treated at the exhibitions. One goal is to enable decorative artists and craftspeople to appeal to 'the public eye' 'upon strictly artistic grounds in the same sense as the pictorial artist'.[93] Hence the products on display are being presented as equal to the more traditional contents of an art exhibition, paintings. Crane seems to be arguing not only that the objects exhibited should be taken seriously as the focus of contemplation, but also that other considerations should be minimised, since the grounds for judging the objects are to be 'strictly artistic'. Consequently, the question of price should not guide the viewer's response, which explains, perhaps, why prices were not originally advertised. The fact that this policy changes later on indicates a shift in the function of the exhibitions, but does not necessarily mean that 'artistic' appreciation of the objects should be undermined. The interaction of viewers and objects does, however, become more complex as the commercial side of the exhibitions becomes more explicit. Though Crane encourages visitors to consider the 'artistic' merit of the exhibits, the presence of a price tag immediately introduces alternative terms for valuing an object. Indeed, if we look in more detail at the exhibitions themselves, it is questionable how much provision was made for the close visual analysis of objects.

Objects at the Arts and Crafts Exhibition Society

Unlike the Morris & Co. literature, the ACES catalogues offer no advice about how to look at individual objects. In the case of Morris & Co., we were able to use the Boston catalogue as a guide when looking at specific wallpaper designs.[94] It was also possible to test the company's claims by examining a particular example, the *Bullerswood* carpet (see Chapter 3). In the case of the ACES, the literature does not provide us with a method for assessing the suitability of objects for different uses. We can, nevertheless, test some of the Society's written claims by looking at the visual evidence available, just as we did to test verdicts on Morris's homes.

Surviving photographs of the Arts and Crafts exhibition spaces provide clues about how visitors were expected to approach the exhibits (figures 1 and 30). In a photograph of the West Gallery from 1896 (figure 30), the wall space is made full use of. Objects are hung close together, often on several levels, and some effort is made to create an overall sense of symmetry in the arrangement of the walls. In the Annual Report for the year 1896–97, it is recorded that 'Exhibits had in the main been distributed so as to establish a balance of mass and colour and form.'[95] This goal seems to have inspired a certain amount of dispute, since, according to the General Committee minutes from November 1896, one of the reasons for Day's resignation was that 'the general effect of the galleries was considered at the expense of the feelings and interests of the individual contributors'.[96] Such problems continued into the next decade, when Christopher Whall declined to exhibit 'any works of great importance at the coming exhibition owing to the lack of successful placing last time'.[97] There thus seems to have been conflict over whether part or whole should be prioritised at the ACES, which, as we have seen, has both aesthetic and political implications.

Looking at the photographs (figures 1 and 30), it is clear that certain exhibits would not have been easily accessible to viewers. For example, the upper parts of the stained glass cartoons would have been too high to examine closely. Yet this could be explained by the fact that, according to the ACES minutes, it was also a conscious aim of the Committee to place 'each work after its kind in positions that would best explain their purpose'.[98] Since stained glass is usually viewed at some distance, the positioning of the cartoons at an elevated level is consistent with their

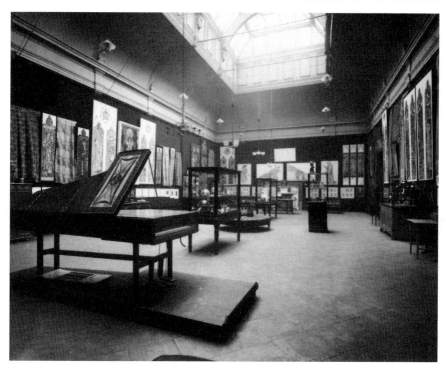

30 Emery Walker, photograph of the Arts and Crafts exhibition, West Gallery, 1896.

use. It does, nevertheless, make an analysis of the cartoon's 'artistic' merit practically difficult. Cartoons also lack the advantage given to stained glass windows by the light that shines through them, making them stand out, even from a distance. This positioning suggests that the objects were more important collectively, as a demonstration of the scale and cohesion of contemporary achievement in decorative art, than individually. It may have been hoped that the objects, together, would explicitly embody the spirit of the age. Morris's (and Ruskin's) ideal of the architectural 'unit' may also have been in mind.[99] At the same time, the prices in the catalogue divided up those collectives by valuing their components separately, in financial terms.

Despite the pricing system, which arguably put exhibitors first, Day argued that the 'feelings and interests of the individual contributors' were

31 Edward Burne-Jones, design for a mosaic for the American Episcopal Church in Rome, shown at the first Arts and Crafts exhibition, 1888. Bodycolour and gold on paper.

disregarded in favour of a harmonious overall effect. Day's complaint calls into question the extent to which the ACES did in fact exist for the sake of individual craftspeople, as it claimed. What seems to be prioritised by this style of display is a hypothetical, conceptualised craftsperson, or a community of craftspeople. While the catalogues drew attention to the makers' names, the displays drew attention to the produce of decorative artists generally and more anonymously.

We can explore this question further by considering an exhibit at the first Arts and Crafts exhibition, a study by Burne-Jones for a mosaic in the American Episcopal Church of St Paul, Rome (figure 31).[100] Burne-Jones was disappointed with the design's reception, claiming that, to his knowledge, 'no one even looked at it when it was shewn [sic] in the New Gallery. They only saw that it wasn't oil-painted; and yet it said as much as anything

I have *ever* done.'[101] The work's architectonic nature is evident, since the mouldings of the wall are included in the design. This emphasises its preparatory nature, which might have led viewers to consider it unfinished.

The aim of the ACES was to allow decorative artists and craftspeople a chance of displaying their work to the public, an opportunity Burne-Jones, as a successful and well-known painter, was not in great need of. If painters who were also decorative artists, such as Burne-Jones, were to be accommodated by the Society, the emphasis would have to be on providing an opportunity for decorative art, rather than for its makers. It seems unlikely, however, that the ACES Committee would have seen the Society's role from this point of view, since so much emphasis was put on including each contributor's name and raising the status of such artists.

It was nevertheless the case that Burne-Jones was a regular contributor to the Arts and Crafts exhibitions, suggesting that in practice, the work itself rather than the maker determined suitability. Although the study is a figurative image, as a design for a mosaic it would not have found a place at the Royal Academy on the grounds that it was decorative, rather than fine, art.[102] This brings us back to the conclusion that an important function of the ACES was to promote decorative art as much as decorative artists, and to provide an arena for its display. As we have seen, Morris saw the potential presence of Burne-Jones's work as one of the Society's few prospective redeeming features. For Morris, it was the quality of the objects that counted, above all. As we saw at the beginning of the chapter, elevating the 'role of the object' causes problems for the conventional understanding of Arts and Crafts.

Conclusion

It is possible to summarise Arts and Crafts ideology in a way that dissuades us from using it to look at the objects. We could argue that Arts and Crafts is primarily about craftspeople because it aims to win them greater creative freedom in their work and a status equal to that of other artists. According to this version, objects represent their makers. The status of the maker corresponds to the fate of the product; for example, if the latter is publicised and exhibited in ways comparable to fine art, the implications of this reflect back on the maker. Similarly, if a designer enjoys a degree of autonomy in his or her work, that work is embodied in the objects

that result from it. Whatever objects might look like, what is important, according to this interpretation of Arts and Crafts ideology, is the value society places on the activities that produce them. If society considers the role of 'decorative artist' to be one worth investing in, through the encouragement of aspiring craftspeople and the promotion of their work, then the ideological aims of Arts and Crafts are being served.

The improvement of the craftsperson's lot is an important ideal in Arts and Crafts contexts and it should not be overlooked. As we have seen, however, underlying much of the rhetoric surrounding the contexts discussed in this book is the conviction that the appearance of objects is important. For example, the Society's assertion that its exhibitions demonstrate a reaction against a situation in which 'life is growing "uglier every day"' involves the implicit claim that the contents of those exhibitions possess qualities that bear out that assertion. The Society is declaring first, that 'ugliness' matters; secondly, that it is being addressed; and thirdly, that proof of its being addressed can be found at the exhibitions. Morris's accounts of the ACES demonstrate that he sees decorative art as the Society's cause. He emphasises, for example, its efforts to call 'special attention to that really most important side of art, the decoration of utilities'. In expressing concern that exhibits will be 'of an amateurish nature', Morris implicitly values the quality of the objects themselves over the interests of potential contributors.[103]

Objects are thus important at the ACES, and not only from the point of view of 'fashion' or commerce. The aesthetic quality of objects is taken seriously. This chapter has argued that rather than indicating the Society's failure to be a proper Arts and Crafts context, this raises questions about the narrow perception of Arts and Crafts as an essentially non-aesthetic category, in which the importance of objects is minimal.

We have also seen that the ideological standpoint of the ACES is far from coherent. The Society accommodates individuals with conflicting priorities and motivations, and the result is that commercial, moral and aesthetic concerns come together here in complex ways. This does not mean that the ACES was led away by commerce and fashion from the pure path of Arts and Crafts. Instead, it calls into question the assumption that we can separate Arts and Crafts from these other motivations.

This chapter has developed the argument that the history of design during this period cannot be divided up into the moral (represented

by Arts and Crafts), the aesthetic (represented by Aestheticism) and the commercial (represented by the Schools of Design, whose aim was to improve national trade). The next chapter examines another context that brings together the moral, aesthetic and commercial: the Manchester Municipal School of Art. Although the motivation behind the Schools of Design grew from concerns about the country's ability to stand up to international competition in trade, the idea that this problem could be solved by improving national training in design involves an assumption that the visual characteristics of objects made a significant difference to the quality of goods. A similar assumption about the importance of the appearance of objects underlies the social motivations of the ACES, as we have seen. A reason for valuing the craftsperson is the contribution his or her products make to society. If those products are not valued, then the activities that give rise to them have little cause to be valued. Chapter 5 develops further the argument that the relationship of the aesthetic to both the moral and the commercial aspects of design in this period is more complex than is usually acknowledged. At the Manchester Municipal School of Art, we find once again that the aesthetic cannot be reduced to 'fashion', and has far-reaching implications.

Notes

1 For more on the Arts and Crafts Exhibition Society, see Stansky, *Redesigning the World*; Parry, *Textiles*; and Livingstone, 'Origins and Development', in Livingstone and Parry (eds), *International Arts and Crafts*.

2 Tillyard, *Impact of Modernism*, p. 10.

3 Tillyard, *Impact of Modernism*, p. 11.

4 Lynne Walker, 'The Arts and Crafts Alternative', in Judy Attfield and Pat Kirkham (eds), *A View from the Interior: Feminism, Women and Design* (London: Women's Press, 1989), p. 167.

5 Tillyard, *Impact of Modernism*, p. 10.

6 ACES Catalogue, 1916, p. 34.

7 Stansky, *Redesigning the World*, p. 12.

8 MacCarthy, *William Morris*, p. 593.

9 Hitchmough, *Arts and Crafts Home*, p. 19.

10 See H. J. L. J. Massé, *The Art Workers' Guild 1884–1934* (Oxford, 1935), and Stansky, *Redesigning the World*, pp. 119–70, 136–40.

11 See Massé, *Art Workers' Guild*, p. 9.

12 Massé, *Art Workers' Guild*, p. 7.

13 Another precursor of the AWG, according to Watkinson, was the Century Guild, which 'contributed directly to the founding of the Art Workers' Guild' (*William Morris as Designer*, p. 71).

14 Naylor, *Arts and Crafts Movement*, pp. 122–3.

15 Massé, *Art Workers' Guild*, pp. 81–2.

16 Hitchmough, *Arts and Crafts Home*, p. 18.

17 Mackail, *Life*, II, p. 199. See also Massé, *Art Workers' Guild*, p. 26 and Stansky, *Redesigning the World*, p. 190. Benson became director of Morris & Co. after Morris's death.

18 For an account of the attack on the Academy from the perspective of its president, Leighton, see Leonée and Richard Ormond, *Lord Leighton* (New Haven and London: Yale University Press for the Paul Mellon Centre for Studies in British Art, 1975), pp. 103–4.

19 'Correspondence', *The Artist (and Journal of Home Culture)*, VII (1 September 1886), p. 301.

20 In practice, artists did not have to choose between the two alternatives. Burne-Jones, for instance, who was a prominent figure at the ACES, was elected an Associate of the Academy in 1885 and did not resign until 1893. Ormond and Ormond note, however, that Burne-Jones 'never gave his loyalty to the Institution' (*Lord Leighton*, p. 105). See notes 32 and 102.

21 'Programme for a National Art Exhibition', *British Architect* (17 September 1886), p. 277.

22 AAD, ACES Papers, AAD 1/2 – 1980, 'National Exhibition of the Arts', n.d.

23 AAD, ACES Papers, AAD 1/5 – 1980, 'Agenda of the Second Meeting of the Provisional Committee', 19 February 1887.

24 AAD, ACES Papers, AAD 1/8 – 1980, Crane to W. A. S. Benson, 23 February 1887.

25 Crane, *An Artist's Reminiscences*, p. 298.

26 ACES circular cited in Crane, *An Artist's Reminiscences*, pp. 299–301.

27 AAD, ACES Papers, AAD 1/40 – 1980, ACES minutes, 25 May 1887, pp. 6–7. The motion was suggested by Cobden-Sanderson, and seconded by Day.

28 AAD, ACES Papers, AAD 1/609 – 1980, ACES Rules, 1902, XII.

29 Crane, *An Artist's Reminiscences*, p. 349.

30 Crane, *An Artist's Reminiscences*, p. 348.

31 See Charles Rowley, *Fifty Years' Work Without Wages* (London: Hodder & Stoughton, 1912), p. 167.

32 Although the ACES represents itself as opposed to the RA, there were overlaps between the institutions. For example, some members of the ACES, such as Hunt and de Morgan, had been trained at the RA. See notes 20 and 102.

33 Crane, 'The Work of Walter Crane', p. 13.

34 Crane, 'The Work of Walter Crane', p. 14.

35 The ACES kept its name until 1959, when it became the Society of Designer Craftsmen.

36 See Callen, *Angel in the Studio*, p. 15; Marsh, 'May Morris', in Elliott and Helland (eds), *Women Artists*, p. 43; and Massé, *Art Workers' Guild*, p. 71.

37 See Marsh, *Jane and May Morris*, pp. 168–71 and 219–20.

38 ACES Catalogue, 1899, p. 12.

39 AAD, ACES Papers, AAD 1/631 – 1980, Annual General Meeting, 1900 [unpaginated]. May Morris appears in the list of committee members in the ACES Catalogue, 1903, p. 7.

40 AAD, ACES Papers, AAD 1/609 – 1980, ACES Rules, 1902, X.4. The difficulty of implementing this rule with accuracy had the potential to ruffle feathers. Oswald Reeves is reported as having complained that 'in several instances it had not been correctly stated in the catalogue that the design of his pupils' work as well as the execution had been carried out under his direction. He much resented being only catalogued as a workman.' (AAD, ACES Papers, AAD 1/50 – 1980, ACES minutes, 4 February 1910 [unpaginated].)

41 Crane, ACES Catalogue, 1888, p. 7.

42 Crane, ACES Catalogue, 1888, p. 5.

43 F. G. Stephens, 'Applied Art at the International Exhibition', *Weldon's Register* (November 1862), p. 171.

44 Crane, ACES Catalogue, 1889, pp. 8–9.

45 ACES Catalogue, 1890, p. 8.

46 'The Arts and Crafts Exhibition', *Magazine of Art* (1889), p. vi.

47 Lewis Foreman Day, 'Art and Handicraft', *Magazine of Art* (1888), pp. 410–11.

48 'The Arts and Crafts', *Art Journal* (1888), p. 349.

49 Lewis Foreman Day, 'The Arts and Crafts Exhibition', *Art Journal* (1903), p. 91. See ACES Catalogue, 1903, nos. 40, 41, 42 and 43. For more on Traquair, see Elizabeth Cumming, 'Patterns of Life: The Art and Design of Phoebe Anna Traquair and Mary Seton Watts', in Elliott and Helland (eds), *Women Artists*.

50 See, for instance, Day, 'The Woman's Part in Domestic Decoration'. See Marsh, 'May Morris', in Elliott and Helland (eds), *Women Artists*, pp. 36–7.

51 'The Arts and Crafts Exhibition at the New Gallery', *The Studio*, XXVIII (1903), pp. 27–8.

52 Morris, 'Preface', Arts and Crafts Exhibition Society, *Arts and Crafts Essays by*

Members of the Arts and Crafts Exhibition Society, 1893, with an Introduction by Peter Faulkner (Bristol: Thoemmes Press, 1996), p. xiii.

53 BL, Add. MS 45345, Morris Papers, VIII, fol. 19, Ruskin to Morris, 3 December 1878. Also cited in Mackail, *Life*, II, p. 202.

54 Mackail, *Life*, II, p. 202.

55 Walker, 'The Arts and Crafts Alternative', in Attfield and Kirkham (eds), *View from the Interior*, p. 167 and Tillyard, *Impact of Modernism*, pp. 10–11.

56 For more on Crane at the ACES, see Spencer, *Walter Crane*, pp. 101–2.

57 Morris had not been a member of the AWG at first either. Indeed, MacCarthy observes that 'there was apparently some opposition to his eventual election in 1888' (*William Morris*, p. 595). Morris was nevertheless elected Master of the AWG in 1892.

58 Morris to unknown recipient (possibly W. A. S. Benson), 31 December 1887. Cited in Kelvin (ed.), *Letters*, II, p. 730. Crane gives further evidence of Morris's connoisseurship, claiming that 'he was a keen judge and examiner of work' ('William Morris', p. 93).

59 Despite his misgivings, Morris was present at the Private View of the first Arts and Crafts exhibition, on 29 September 1888 (BL, Add. MS 52772, Cockerell Papers, S. C. Cockerell Diaries).

60 HF, DD/341/319 a–c, 'Art, Craft and Life: A Chat with William Morris', *Daily News Chronicle* (9 October 1893).

61 For more on the Guild, see C. R. Ashbee, *The Manual of the Guild and School of Handicraft* (London: Cassell & Co., 1892) and Annette Carruthers and Frank Johnston, *The Guild of Handicraft 1888–1988*, exh. cat. (Cheltenham: Cheltenham Art Gallery and Museums, 1988).

62 Crane, *An Artist's Reminiscences*, p. 298.

63 ACES Catalogue, 1910, p. 14.

64 BL, Add. MS 45350, Morris Papers, XIII, Wardle, pp. 14–15.

65 The Catalogue includes a 'Note on the late President of the Society, William Morris' by Crane, ACES Catalogue, 1899, pp. 11–15.

66 AAD, ACES Papers, AAD 1/43 – 1980, ACES Minutes of the General Committee, 1889–96, 24 November 1896, p. 208.

67 See note 57.

68 AAD, ACES Papers, AAD 1/43 – 1980, ACES minutes, 16 February 1897, pp. 224–5.

69 In a letter read at an ACES meeting shortly after Morris's death, Crane had expressed a similar view, insisting that 'the Society was by no means a one-man movement' and maintaining 'the impossibility of separating Morris's work from that of his colleagues'. AAD, ACES Papers, AAD 1/43 – 1980, ACES minutes, 13 November 1896, pp. 204–5. In the light of Crane's commitment

to socialism, it is unsurprising that he so firmly asserts the collaborative nature of Morris's work and of the Society.

70 AAD, ACES Papers, AAD 1/43 – 1980, ACES minutes, 16 February 1897, pp. 225–6.

71 According to Durant, Day's view of Morris was similar to Crane's. See note 50 in the Introduction.

72 Crane, 'William Morris', p. 96.

73 'The Arts and Crafts Exhibition', *The Studio*, IX (1897), p. 55.

74 See Day, 'The Arts and Crafts exhibition', *Art Journal* (1903), p. 93. See also the *Art Record*, I (10 August 1901), pp. 395–6. As we saw in Chapter 1, the AWG was also hostile to Art Nouveau (see MacCarthy, *William Morris*, p. 593). For more on the relationship between Arts and Crafts and Art Nouveau, see Tschudi Madsen, *Sources of Art Nouveau*, pp. 148–63; Aslin, *Aesthetic Movement*, pp. 175–80; and O'Neill, 'Rhetorics of Display'.

75 'The Work of Christopher Dresser', *The Studio*, XV (1899), p. 108.

76 'The Arts and Crafts Exhibition at the New Gallery', *The Studio*, XXVIII (1903), pp. 30–5.

77 In 1904, Voysey was to resign from the ACES committee on similar grounds, declaring that 'the Society had done its work, and that British Arts and Crafts could now stand by their own effort' (AAD, ACES Papers, AAD 1/49 – 1980, ACES minutes, Committee Meeting, 1 December 1904 [unpaginated]). In this way, he distances himself from something that he feels has run its course.

78 AAD, ACES Papers, AAD 1/48 – 1980, ACES minutes, AGM, 9 February 1899 [unpaginated].

79 ACES Catalogue, 1903, p. 13.

80 ACES Catalogue, 1906, p. 12.

81 Crane, *An Artist's Reminiscences*, p. 298.

82 NAL, 86:HH:12, Metford Warner, 'The Progress of Design in Paper Hangings', read at the Incorporated Institute of British Decorators, 10 January 1910, p. 34.

83 ACES Catalogue, 1889, p. 104.

84 Royal Academy of Arts, *The Exhibition of the Royal Academy of Arts: The One Hundred and Twentieth* (London: Royal Academy, 1888), p. 2.

85 AAD, ACES Papers, AAD 1/48 – 1980, ACES minutes, Extraordinary General Meeting, 20 March 1901 [unpaginated].

86 This ambiguity leads us to question the straightforwardness with which the ACES is labelled a centre for commerce in many accounts. Tillyard, for instance, claims: 'Because the articles were for sale, in one sense the Society's exhibitions were simply a forum for generating commissions and revenue' (*Impact of Modernism*, p. 10).

87 HF, DD/341/319 a–c, 'Art, Craft and Life: A Chat with William Morris', *Daily News Chronicle* (9 October 1893).

88 1903 and 1906 ACES Catalogues.

89 *The Artist* (4 November 1893). Cited in Livingstone, 'Origins and Development', in Livingstone and Parry (eds), *International Arts and Crafts*, p. 52.

90 Hitchmough observes that the status associated with the New Gallery contributed to the Society's success: 'The exhibitions were held at a progressive London gallery, accentuating the claims of the exhibits as works of art and providing a favourable context for the high prices attached to them' (*Arts and Crafts Home*, p. 20). Livingstone suggests that the New Gallery was secured on account of Burne-Jones's involvement in the Society ('Origins and Development', in Livingstone and Parry (eds), *International Arts and Crafts*, p. 52).

91 Crane, ACES Catalogue, 1888, pp. 7–8.

92 ACES Catalogue, 1890, p. 137.

93 Crane, ACES Catalogue, 1888, p. 5.

94 NAL, 276.C Box 1, Morris & Co., 'Boston'.

95 AAD, ACES Papers, AAD 1/629 – 1980, Annual Report, 1896–97 [unpaginated].

96 AAD, ACES Papers, AAD 1/43 – 1980, ACES minutes, 13 November 1896, p. 204. The same document states, in the minutes for 24 November 1896, that Day responded to the Committee's request to reconsider his resignation with a letter 'regretting the impossibility of his coming to any other decision' (p. 207). Day is present at the AGM on 9 February 1899, suggesting that the rift was not permanent, but by 7 February 1900, at an AGM, Day was again threatening that 'he could not serve on the committee if it was to be constituted in the same way. The committee was far too large and that in practice ⅓ of the number did the work.' Day's recommendation was that the Committee should be subdivided so that exhibits were judged by experts in each field (ACES Papers, AAD 1/48 – 1980, ACES minutes [unpaginated]). Further reports of dissatisfaction within the Committee, on the part of Reynolds Stephens and W. A. S. Benson, are recorded the following year (ACES Papers, AAD 1/48 – 1980, ACES minutes, Extraordinary General Meeting, 20 March 1901 [unpaginated]).

97 ACES Papers, AAD 1/49 – 1980, ACES minutes, 18 October 1905 [unpaginated].

98 ACES Papers, AAD 1/42 – 1980, ACES minutes, 9 May 1888 – 13 December 1892, p. 9.

99 See Morris, 'The Arts and Crafts of To-day' (1889), *Works*, XXII, p. 359 and Ruskin, 'Modern Manufacture and Design' (1859), *The Two Paths*, *Works*, XVI, p. 320.

100 For more on Burne-Jones's designs for the Episcopal Church in Rome, see Aymer Vallance, 'The Decorative Art of Sir Edward Burne-Jones', *Easter Art Annual*, extra number of the *Art Journal* (1900), pp. 14–16.

101 Edward Burne-Jones, *Burne-Jones Talking: His Conversations 1895–1898, Preserved by his Studio Assistant, Thomas Rooke*, ed. Mary Lago (London: Murray, 1982), p. 34 (italics original). Quoted by Karen Livingstone in '"Moot Points": Art, Industry and the Arts and Crafts Exhibition Society', paper given at the Victoria and Albert Museum, 'International Arts and Crafts' conference, 22–3 April 2005.

102 Burne-Jones, whose period as an Associate of the Royal Academy included the Academy exhibitions between 1886 and 1892, exhibited only one painting at the Academy, in 1886. See Royal Academy, *The Exhibition of the Royal Academy of Arts*, catalogues (London: Royal Academy, 1886–92). See notes 20 and 32.

103 This is further evidence that objects were important to Morris. His concern for the worker did not eclipse his commitment to quality.

5 ✧ The Arts and Crafts Museum at the Manchester Municipal School of Art

AS WE HAVE SEEN in previous chapters, events in the field of design from the 1830s onwards cannot be separated out into distinguishable 'movements'. This chapter demonstrates that even at the turn of the twentieth century, efforts to improve national design for the purposes of trade are interrelated with the activities we associate with Arts and Crafts. The Arts and Crafts Museum at the Manchester Municipal School of Art not only exemplifies this interrelationship, but also provides a further illuminating insight into how Arts and Crafts objects were viewed and interpreted in the later period. This chapter explores how and why the School established its museum, placing the history of the School in the context of the other events and institutions discussed in the book. It also investigates how exhibits were selected and how the museum was arranged. Much of this information has been gathered from archival sources that have previously received little or no attention.[1] In the light of these sources, the chapter explores possible interpretations of examples from the collection. Given the limited scholarship on this topic, the chapter begins by tracing the history of the School's museum.[2]

The history of the School and its plans for a museum

Before it became the Manchester Municipal School of Art, the School was known as the Manchester School of Art, and before that, it was the Manchester School of Design. The idea of forming a School of Design in Manchester stemmed from the combined impact of the 1835 Select Committee inquiry (see Chapter 1), the influence of painter Benjamin Robert Haydon, and the enthusiasm of members of the Royal Manchester Institution (RMI), a society 'for the promotion of literature, science and

art'.[3] In 1837, the year in which the first School of Design was established in London at Somerset House, Haydon, who was lecturing in painting at the RMI, proposed a Manchester School of Design.[4] As Quentin Bell observes, Haydon had drawn inspiration from Joshua Reynolds's *Discourses*, which, he found, 'placed such reliance on honest industry' and 'expressed so strong a conviction that all men were equal and that application made the difference, that I fired up at once'.[5] Haydon's belief, influenced perhaps by Reynolds, in the efficacy of art education led him to support the promotion of the Schools of Design.[6] At this time, Manchester was an important industrial centre, particularly in the field of textiles, and its trades were growing and developing rapidly. Manchester was therefore considered a particularly appropriate site for a School of Design.

A sub-committee set up by the RMI supported Haydon's suggestion, but the main committee was deterred by financial obstacles. In the end, a 'meeting of gentlemen favourable to the establishment of a School of Design' provided subscribers willing to fund the venture. It was thus thanks to enterprising private patrons that a School of Design could be set up the following year, and when Haydon returned to London, he recorded in his diary that he had 'accomplished all I left town to do – the establishment of a School of Design in Manchester'.[7] The *Manchester Guardian* reported that the city required a School of Design to 'enhance the value of the manufactures of this district; to improve the taste of the rising generation; to infuse into the public mind a desire for symmetry of form, and elegance of design; and to educate for the public service, a highly intelligent class of artists and civil engineers'.[8]

The School was opened in 1838 and came under the control of the London School, at Somerset House, in 1842. Even before the School was established, the task of bringing together a collection of the 'useful' arts was considered a necessary part of such a scheme.[9] In 1837, for example, when the idea of founding a Manchester School of Design was under discussion, one writer proposed that 'the first grand step towards making a School of Design useful, will be to bring together such a collection of the productions of the useful arts, as they [the working classes] will take a delight in reviewing'.[10] When the new School produced a document listing its 'Laws and Regulations' in 1839, it reiterated this intention. It declared the formation of 'a Museum for the Exhibition of Casts, Models, Paintings, Designs, Mechanical Inventions and other Works of Art' to be one

of its aims.[11] Despite this, the museum was not opened until 1898, sixty years after the School was founded. A closer look at the School's history presents three main reasons for the delay.[12]

Throughout its early history, the School was hampered by financial insecurity; it was involved in an ongoing struggle to establish a permanent location;[13] and its stability was threatened by disunity among its leaders.[14] In 1842, four years after its inception, the School received its first grant from the Board of Trade, a development that brought with it the need to adhere to Somerset House's strict regulations. The School's staff had to negotiate their way through conflicts with locals and with the authorities based at Somerset House, and the demands of an inconsistent, centralised governing policy led to a swift leadership turnover.[15]

One of the most contested issues was whether or not the teaching of life drawing should be permitted.[16] John Zephaniah Bell, the School's first headmaster, was a portrait painter who started each pupil's training with life drawing.[17] After the School was granted funding from Somerset House in 1842, however, Bell's methods were criticised.[18] Somerset House's Superintendent, William Dyce, inspected the School in 1843 and reminded Bell, 'It is termed a School of Design, not a School of Drawing', adding that 'the study of drawing must in every instance be conducted with reference to the use to which it is to be applied'.[19] Bell resigned in November 1843 to be succeeded the following month by George Wallis, who, as we saw in Chapter 1, would later become headmaster at the Birmingham School of Art.[20] In 1846, after three years of conflict with Somerset House and local groups, Wallis departed, criticising in his 'farewell letter' the imposed 'duty of masters', which was 'simply to follow every change ordered to be made at head-quarters – good, bad or indifferent'.[21]

Under the next two masters, the School's pupils decreased and debts increased, until the appointment in 1849 of John Hammersley.[22] His leadership met with praise from the Manchester School's supporters, one of whom rejoiced that now 'instead of too much talking there is a great amount of labour, and in the place of theory actual practice'.[23] Hammersley still faced obstacles, however, and he and his successors, over the next forty years, struggled to balance the provision of art teaching with that of design training.[24] The officials were keen to suppress any tendency that might encourage students to consider themselves 'fine' artists. For them, the Schools' role was to teach not art, but design, which, it was

assumed, belonged specifically to the realm of industry. As we saw in Chapter 1, conflict with the Royal Academy, which saw the Schools of Design as competition, led to the rule 'That no person should enter the classes for the purpose of studying as a painter or sculptor.'[25]

Many students did, however, try to use the Schools as paths to become painters. As we saw in Chapter 1, Somerset House eventually changed its policy, renaming the Schools of Design as Schools of Art in 1853. This was a countrywide development instigated by Cole, then General Superintendent at Somerset House. Despite the new name, the goal of the Manchester School, at least, did not shift away from the improvement of design in manufacture.[26] In February 1854, the year after it was renamed the Manchester School of Art, it demanded that 'every student shall state, within the first three months of attendance, to what department of manufacture or Decorative Art he intends to apply his studies.'[27] This ruling would, it was hoped, prevent students who did not intend to enter a trade that could be defined as 'manufacture or Decorative Art' from studying at the School of Art.

Much later, in 1888, the *Journal of Decorative Art* described 'A Visit to the Manchester School of Art', declaring that the School won an exceptional number of medals and prizes.[28] The article re-emphasised the special need for such an institution in this particular city, observing that 'to a manufacturing community, therefore, like Manchester, it is of supreme importance that a knowledge of art and skill should be developed amongst the people.'[29]

The curriculum at this time consisted of the Department of Science and Art's 'National Course of Instruction in Art', whose main focus was drawing.[30] Students were required to copy from casts, for example, and their efforts would be entered into national competitions. Their achievements translated into grants for their Schools.[31] In 1892, the Manchester School of Art came under municipal control to be run, along with the Technical School, by the Technical Instruction Committee (TIC).[32] As John Davis observes, this meant that the School was less firmly tied to the National Course, since it had other sources of funding.[33]

In the light of these circumstances, it is not surprising that the School did not acquire a museum during its rocky early decades. The time and attention such a project would have required was instead taken up assessing and reassessing teaching methods and dealing with practical

considerations. Only when the running of the School was relatively smooth could an additional project be contemplated. As the Manchester Municipal School of Art, the institution acquired a stability and efficiency that could accommodate a new challenge.

The creation of the School's museum

In 1893, five years before the museum was to open, the Chairman of the School of Art Committee, Charles Rowley, appointed his friend Walter Crane as Director of Design.[34] Rowley had met Crane through Morris, with whom he shared a commitment to socialism.[35] Before he took up the directorship, Crane delivered a report comprising *Recommendations and Suggestions* regarding the running of the Manchester School.[36] Here, Crane writes that 'a museum of carefully selected examples of the best kinds of design in various materials ... would be a most important and necessary thing in connection with the School of Art' and adds that 'it would, indeed, form a kind of object lesson and reference library in the solid to students in design, and its value and influence could hardly be over-estimated'.[37]

When Rowley and Crane paid a visit to the South Kensington Museum on 22 December 1893, the museum's Director, J. H. Middleton, expressed surprise that, in Rowley's words, 'there was nothing in the way of an Industrial Art Museum under the control of the Technical Instruction Committee'.[38] Middleton followed up the conversation with a letter elaborating on the advantages of such a museum, insisting that the 'illustrative object' was worth more than 'theoretical instruction' and that the student's 'examination' of good examples was to be encouraged as 'the qualities which make a design good or bad are often much too subtle for description in words'.[39] The letter also declared that 'the training of the eye which is thus given may be of great value even to those occupied with lines of work which, at first sight, may seem to be but little connected with the fine arts'.[40]

The combined influence of Crane and Middleton was well received by the School of Art Committee, which had long been preparing to develop a collection, and which now granted £50 for the purchase of contemporary objects. This sum was spent in June 1894 by Crane and Rowley, who selected tiles, vases and 'other embellished pottery' by de Morgan and

32 W. A. S. Benson & Co., hot water pot, purchased from the maker in 1894 by Manchester Municipal School of Art. Copper, brass and ebony.

'a representative selection of Benson metalwork' (see plate 7 and figures 32 and 33).[41] A month later, the Committee learned that an anonymous donor had agreed to pay for a copy of Morris & Co.'s *Adoration of the Magi* tapestry for the School (figure 34).[42] The School already possessed a selection of patterns designed by Morris that had been donated by C. P. Scott of the *Manchester Guardian* in 1884.[43] Rowley had expressed his admiration for these particular artists in a meeting of the TIC in July 1893, when he declared that 'the art craftsman's work of Morris, Benson and

33 W. A. S. Benson & Co., kettle with stand and spirit lamp, purchased from the maker in 1894 by Manchester Municipal School of Art. Copper, brass and ebony with wicker bound handle.

De Morgan, and the designs and workmanship of English furniture, are instances of the acknowledged superiority of English artistic ability and skill'.[44] Emphasising English 'superiority', Rowley seems to have the goals of the 1835 Select Committee inquiry in mind.[45]

By October 1894 the School of Art Committee had 'resolved upon the immediate formation of a Museum of fine examples of Textiles and Printed Fabrics'.[46] It became possible to develop this scheme more fully when, in March 1895, the Whitworth Institute allocated £10,000, part of

the revenue from the 1887 Royal Jubilee Exhibition, to the School of Art for the 'erection and equipment of a new section/wing'.[47] With a suitable venue in prospect at last, the School began to take more seriously the task of building up its collection. By June 1895, the School was ordering 'examples for art instruction' direct from manufacturers such as Elkington & Co. and Maw & Co. (see plate 8).[48] From the 1896 Arts and Crafts exhibition were purchased two cups and a fruit bowl, by Ashbee and the Guild and School of Handicraft (see plates 9 and 10), along with glass cases for the purpose of displaying the collection.[49]

It was not only the School's growing permanent collection that the new wing would accommodate. In the summer of 1895, the School of Art Committee discussed the proposal that 'the provision of suitable galleries and wall space' in the planned extension would improve the chance of 'co-operation' with the Department of Science and Art 'in the display from time to time, to the great advantage of the art loving public of the city, some of the treasures of art craftsmanship in the National Museum at South Kensington'.[50] Indeed, in future years, temporary loans from South

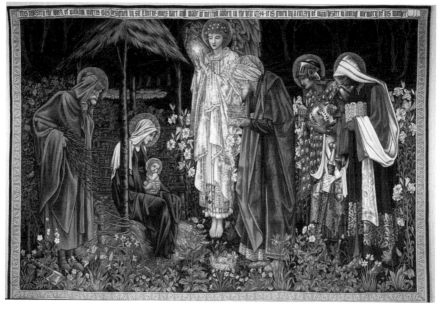

34 Morris & Co., *Adoration of the Magi* tapestry, 1894. Wool and silk.

Kensington were to form an important part of the new museum.

Although the 'art loving public of the city' are mentioned as an imagined audience, the goal of the new wing as understood in 1895 by the architect, Mr J. Gibbons Sankey, was to accommodate 'works of art, that they may be open to the study and inspection of students'.[51] In the following year, Rowley recognised the need to fulfil both of these goals, recommending the purchase of objects 'of a suitable kind to help in art training, and yet be of sufficient interest to attract the general public'. By this time, the City Art Gallery had offered the School some textile collections that had 'never been properly displayed for want of suitable rooms'.[52]

Members of the School of Art Committee were now given the freedom to 'purchase objects as they come in the market' as national goods were 'now becoming in greater demand for continental and American institutions'.[53] At the same time, Crane warned against a haphazard or unselective approach to the purchase of objects for the collection. He advised that 'in forming and arranging an art museum, its practical bearing and collective influence should be kept in view rather than the accumulation of miscellaneous objects solely for their archaeological or intrinsic value'. This 'antiquarian or merely curious interest' was to be distinguished from 'artistic value'.[54] Crane insists that a group of objects 'representing in their proper relation the arts of a particular period or century would be more valuable and instructive than a multitude of miscellaneous objects of many different periods in no relation to each other', arguing that 'too much thought cannot be expended' upon this 'careful selection'. A group of objects of a given period, Crane explains, give a more complete 'sense of their relation to each other and to the life of man, than would be possible to gain from the same objects if scattered about'.[55] Crane's view on this subject seems to be based on the intellectual tradition discussed in Chapter 1, in which art is a reflection of the society in which it is made, and whose key figures are Pugin and Ruskin.

In November 1896, a month after another £100 had been allocated to be spent at the Arts and Crafts exhibition, Rowley proposed making a gift to the museum, which for the most part consisted of objects made by contemporary British designers, including Morris, Burne-Jones, Ford Madox Brown and Crane.[56] By January 1898, a Miss Fisher had been engaged as curator of the new museum.[57] The museum officially opened on 28 October 1898.[58]

PLAN OF THE MUSEUM.

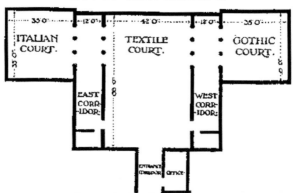

35 Plan of the Arts and Crafts Museum, Manchester Municipal School of Art. From *A Descriptive Catalogue of the Arts and Crafts Museum*, 1903.

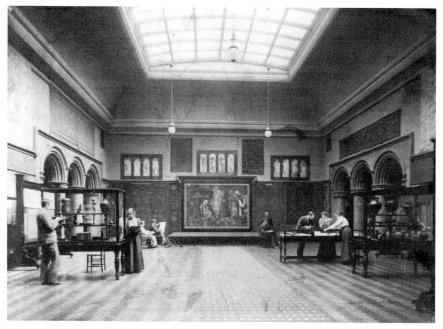

36 Textile Court, Arts and Crafts Museum, Manchester Municipal School of Art, *c.* 1900.

The museum was made up of six linked display spaces (figure 35). An entrance corridor led to the main exhibition room, known as the Textile Court (figure 36). Turning left at the end of this room, the visitor would enter the East Corridor, which led into the Italian Court; turning right, he or she would pass through the West Corridor into the Gothic Court (figure 37).[59] The Gothic Court contained, for example, casts of a doorway from a French Romanesque church and of the eighth-century Ruthwell Cross, while the Italian Court's display included casts of sculptures by Ghiberti and Donatello.[60] Davis notes that the reproductions within the collection symbolised the continuing influence of traditional methods of art training, which were heavily reliant on copying from casts.[61] The rest of the museum contained not only examples of contemporary design, but also casts of Della Robbia ware; examples of Chinese pottery; Egyptian fabrics from the third century AD; and Greek vases from the ninth to the third century BC.[62]

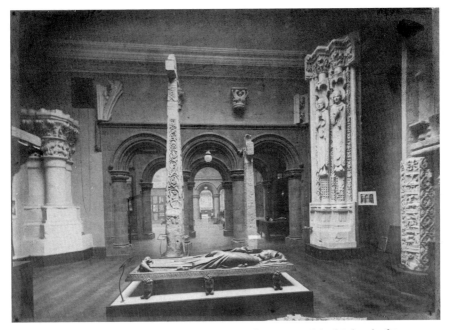

37 Gothic Court, Arts and Crafts Museum, Manchester Municipal School of Art, *c.* 1900.

During its first year of opening, the museum received 7,355 visitors and at the end of its second year, Rowley reported that 'the Museum is mainly used by the teachers and students – for whom, indeed, it is chiefly intended'.[63] Once the museum was open, the collection continued to grow. In 1902, Rowley indicated the 'desirability of increasing the number of fine objects of artistic workmanship for the arts and crafts museum', whereupon the purchase of objects from the seventh Arts and Crafts exhibition in 1903 was authorised and carried out.[64] The museum was also used as a venue for various public and private events, particularly lectures and meetings. In 1900, the Committee resolved to 'bring together on separate evenings in the first week of the new session persons engaged in the different artistic trades of the city to hear in the museum a general address on the advantage of art instruction to such persons by the school staff'.[65] This indicates that the School still viewed itself in the context of local manufacture, being anxious to maintain a good relationship with active tradesmen in the city by demonstrating the School's potential to act in their interests.

The purpose of the lectures was twofold, as they were designed to appeal to both employers and employees in the various trades. First, they aimed 'to show the foremen masters and craftsmen of the different crafts, the efficiency of our equipment and teaching staff for the art training of craftsmen'. Second, it was hoped they would 'induce the pupils and younger craftsmen to join our various classes as a part of their study and practical training'.[66] After these 'addresses' had taken place, it was reported that 'each lecture was made as instructive as possible by the large number and appropriateness of the examples selected from our splendid collection in the school'.[67] That year it was also agreed that certain societies should be invited to hold meetings in the museum 'with the purpose of bringing before them the various exhibits and the object the museum seeks to serve'.[68]

Having outlined the history of the School's collection, and the evolution of the museum, the chapter will now go on to explore what we can learn about the role of Arts and Crafts objects here, and about the overall purpose of the museum, from its arrangement.

The arrangement of the museum

The main section of the museum was the Textile Court, which, as its name implies, was dominated by textiles, both contemporary and historical, hung around the walls. However, it did incorporate other types of object. Examples of contemporary design in various media were displayed in so-called 'modern' cases in the Textile Court. Proportionally, the modern objects formed a fairly modest contribution to the collection, and this is reflected in a catalogue from 1903, whose passages of description and elaboration relate mainly to the older objects.[69] The museum's arrangement creates a different impression of the importance of the modern objects, however. The most prominent exhibition space in the museum was the south wall of the Textile Court, which was visible from the building's entrance. This position was occupied by a modern exhibit, the Morris & Co. *Adoration of the Magi* tapestry; indeed, a place was specially made for it in the centre of this wall. Combined with its size, the important position of this contemporary work, in the largest, central part of the museum, ensured that it acquired a high status among the exhibits. Looking at the plan of the Textile Court, we can see that the tapestry took the position of an altarpiece within a space strikingly suggestive of a nave and transept. The display format thus appears to present the tapestry for contemplation as the epitome of design achievement.

The cases of contemporary manufactures that were located in this primary exhibition space also imposed themselves on the visitor's attention. The decision to make these objects so easily accessible suggests that they were considered a particularly important part of the collection. This claim is supported by the fact that the earliest acquisitions were modern products and, also, that the School supported the purchase of modern manufactures as soon as they came on the market. The way that these decorative, secular objects were displayed in a space with strong liturgical overtones emphasises the impression that viewers were encouraged to approach with a sense of awe at the superior quality of the exhibits presented to them.

The Manchester City Art Galleries' 1994 catalogue of the collection refers to the museum of the Manchester Municipal School of Art as a 'decorative arts museum'.[70] This is not unreasonable, as many of the objects displayed, such as vases, wallpaper designs and cups, would traditionally

be assigned to the 'decorative art' category. Yet we have also seen that during this period, such divisions were being questioned and challenged. When we look at the collection as a whole, it does not constitute a 'decorative arts museum' in the traditional sense. For example, it contained casts of Italian sculptures by Donatello, of 'Gothic' jamb figures from cathedral portals, and of Celtic crosses, despite the fact that sculpture is usually considered a 'fine' art (see figure 37).[71] While many of these works are in relief, a category that is sometimes distinguished from 'sculpture', others were 'in the round'.[72] On the other hand, many of the sculptures included here are decorative in Ruskin's sense of the word, in that they are sculptures 'fitted for a fixed place'.[73]

According to Rowley, the collection included 'everything but pictures',[74] although his understanding of the word 'picture' seems to be limited to the finished oil painting, since many objects in the museum have qualities that could be defined as 'pictorial'. The Morris & Co. tapestry, for example, performs a loosely pictorial function, while alongside it in the Textile Court were displayed twelve cartoons for stained glass by Brown and others by Burne-Jones (both men being famous primarily as painters).[75] These works were certainly perceived as 'decorative art' in this context, since the author of the 1903 catalogue and headmaster of the School, Richard Glazier, declares that 'One of the most encouraging signs of the times is the association of men of high attainments in the Fine Arts with the Applied Arts.'[76]

Although students were encouraged to examine the objects in the museum for their qualities of design, in the catalogue Glazier observes the 'intensity of expression' and 'religious ideals' of Burne-Jones's cartoons, praising them in terms that relate to their representative qualities rather than technique or design.[77] We saw in Chapter 4 that Stephens did not consider it appropriate to discuss objects at the International Exhibition of 1862 in terms of their artistic qualities. At the Manchester School in 1903, a different kind of apprehension seems to be promoted. This may be a result of the ACES's perhaps successful campaign to enable decorative art to be judged on 'strictly artistic grounds'.

The inclusion of loosely pictorial art, as well as sculpture, in the collection, particularly in this arrangement, suggests that those in charge of the museum were interested in reshuffling artistic categories. All of these objects were brought together to be subjected to close visual

analysis by design students. Implicitly, the museum thus declared that all of these arts were relevant to design training. The museum project, which took for granted the value of examining decorative art for its aesthetic character and theoretical significance, denied the conventional division between decorative art and the supposedly more intellectual fine arts. It was precisely the visual appearance of the objects that was prized in this collection.[78] By studying these examples, students would, it was hoped, absorb the principles of good design. Regardless of style, the objects in the museum shared these principles, which, once learned, would equip the student to make objects that could rival the visual appeal of continental goods. The concept of 'principles' was also fundamental to the activities of the Cole circle around the middle of the century.[79] The School's approach was to instil a sensitivity to form, pattern, colour and texture in each student, preparing him or her to approach a variety of tasks and materials.

As Middleton observed, the qualities that make a design good or bad do not lend themselves easily to verbal expression, whereas a collection of examples provides students with the means of learning directly from visual sources, rather than by clumsy translation into words. There is thus an assumption that a kind of visual language exists, through which objects communicate. Crane's comments in the 1898 *Easter Art Annual* demonstrate that he was a firm believer in such a visual 'speech' or 'language': 'Years of work and experiment' teach the artist to form from his material 'the speech and language which seems to him best fitted to embody and convey to the world what he has in his eye and mind'.[80] Whether the object is a painting, a sculpture, a vase or a tapestry, the process of expression through a special visual language is the same.[81] Crane presents similar arguments in *The Bases of Design* (1898) and *Line and Form* (1900), both of which were based on lectures he gave to the Manchester School.[82] In the former, he declares that '*all art is, primarily, the projection or precipitation in material form of man's emotional and intellectual nature*'.[83] In the latter, he claims that line is 'a language, a most sensitive and vigorous speech of many dialects' and that it can appeal 'to our emotions and thoughts by variations and changes in its direction, the degree of its emphasis, and other qualities'.[84]

The museum at the Manchester Municipal School of Art therefore contained a collection that was valued for its potential to develop students' awareness of various forms of visual expression embodied by objects. The

students were thus encouraged to examine the objects closely in order to identify what visual principles lay behind their success as designs, and what the maker was expressing through those designs. Not only were students invited to analyse these objects visually, but there was also a belief that the arrangement and distribution of objects had a significant impact on the way they would be experienced and the message they could convey. As we have seen, Crane recommended considering which objects would fit best together, allowing displays to demonstrate relationships.[85] Hence parts of the museum were arranged historically, in particular the Gothic and Italian Courts, and there were 'modern cases' in which contemporary objects were displayed together.

According to the 1903 catalogue, one of the functions of the modern exhibits was to exemplify the influence of high-quality designers of the past on modern manufactures.[86] There was thus a strongly emphasised link between the different objects in the museum, despite their widely varying geographical and historical origins. The exhibits were connected by a perceived chain of influence, or, perhaps, evolution, with the modern objects being presented as the up-to-date equivalent of the older examples.[87]

As well as presenting objects to be admired for their beauty and analysed for their embodiment of design principles, the museum thus demonstrated to pupils how influence could take place without direct imitation. Though the relationship between ancient and modern objects was emphasised, it was made clear that simple copying was not to be encouraged. Instead, modern designers had been inspired by, for example, the 'individuality' and 'craftsmanship' shown in these older objects,[88] qualities that could be imitated without restricting a designer's originality. In turn, the students were invited to add another stage to this chain of influence. Observing how modern designers had drawn inspiration from the past while nevertheless developing new styles, students could learn from both ancient and modern objects, enabling them to create new designs incorporating the fundamental qualities exemplified by those models.

The display of different kinds of object within one room is not, therefore, inconsistent with Crane's advocacy of emphasising relationships rather than individual qualities through display. A relationship is indeed elucidated by the arrangement of the Textile Court, one that underlines

the function of the museum as a place where design students learn about the process of influence and inspiration. A common high standard links all the objects, since, unlike London's Museum of Ornamental Art at Marlborough House, the Manchester Municipal School of Art museum did not contain a 'Chamber of Horrors' to illustrate bad principles of design.[89]

There are, however, exclusions that indicate which kinds of objects were not admired by those building up the Manchester collection. It is interesting, for example, that all the British examples in the museum were either contemporary (products of the late nineteenth and very early twentieth century), or items in the Gothic Court.[90] This suggests an adherence to the Ruskinian view that contemporary British craft should be aiming for the standard attained by medieval carving. The museum's curators seem to have been implying that there were two closely related periods of high achievement in British design, the Gothic and the contemporary. While there were some examples of contemporary design from other countries in the museum, the majority of the modern exhibits were British, particularly those in prominent locations. There is an implicit suggestion that the most up-to-date design could be found in Britain, a claim that encouraged the School's students to see themselves as inheritors of a responsibility to uphold this superiority. Observing how contemporary designers imbued their objects with principles gleaned from older examples, the students were presented with a model of creative imitation to emulate. They were encouraged to spend time studying and sketching the exhibits, for which purpose chairs were provided in the museum (see figure 36).

Despite the insistence on close study, many objects were displayed in glass cases, making them less accessible and limiting their visibility. One possibility is that items were removed from the cases for instructive purposes, although no mention is made of this in the documents. Opportunities for the temporary removal of objects would have been provided by the lectures held in the Textile Court, which were often 'illustrated' with examples from the collection.[91] Unless the lecturer was required to lead the audience around the museum, it is likely that a selection of objects may have been brought together for the lecturer to refer to. An engraving of a lecture on ironwork at the South Kensington Museum in 1870 shows a number of specimens displayed behind the speaker in the lecture theatre, suggesting that this might have been the practice elsewhere.[92]

Nevertheless, since there is no evidence that the objects from the Manchester museum were made available for study outside the cases, and even if they were, they would usually have been viewed within them, we must consider how this limitation might have affected students' use of the exhibits.[93] It was not only their visible features, but also their tactile qualities, such as textured surfaces, that contributed to the objects' character and value. Without being able to handle the objects, therefore, the students would have been unable to achieve the fullest understanding of them. Because of the cases, certain parts of the objects, in particular their bases and insides, would frequently have been obscured from view. Only a small number were on shelves at a level that would allow visitors to view them satisfactorily while standing normally. Visitors would often have been obliged to crouch down or strain upwards in order to obtain a better view. For a 'decorative' art object to make such demands is significant. Conventionally, the supposed purpose of traditional 'decorative' art is to serve society by performing its expected function. Here, however, we see such objects asserting a kind of autonomy by preventing their 'users' (or viewers; in this context, use becomes synonymous with viewing) from having control over them. Their use becomes an aesthetic one; they are there to be looked at, even at the expense of the viewer's comfort.[94] Not only are these objects deemed so precious that they must be kept safe in glass cases, but their worth is precisely not determined by the intrinsic value of their materials (a point Crane was anxious to emphasise). Instead, it is determined by the quality of their design. Their perceived aesthetic value serves to raise their status in the hierarchy dividing the so-called decorative or applied arts from the fine arts. Having established that visitors to the museum, particularly the students, were encouraged to spend time examining these works, our next question is how they would have looked at them.

The use of the collection

Clues about how these objects were approached during this early period of the museum's existence can be found in Crane's writings and in the 1903 catalogue. For example, in a special issue of the *Art Journal* from 1898 – the year of the museum's foundation – Crane produced an article elaborating some of his theories about decorative art. He writes

that decorative design 'is of the nature of a kind of music appealing to the eye, and relying upon the association of ideas of linear beauty and harmonious suggestion'.[95] Crane's reference to decorative art as 'a kind of music', combined with his description, cited earlier in this chapter, of a visual 'speech' or 'language' through which an artist conveys what is in 'his eye and mind', invites a close analysis of these objects. Since literature and music had long been considered 'liberal' arts, these metaphors also reassert the equality of design with the fine arts. We can experiment with these ways of looking by focusing on some of the earliest acquisitions: the Benson metal work; the tazza by de Morgan; the ewer designed by Crane himself; the two cups by Ashbee and the Guild and School of Handicraft; and some Powell glass (figures 32, 33, 38 and 39 and plates 7–10).

Guided by Crane, the students might have approached these objects looking for an expressive 'speech' or 'language', 'a kind of music appealing to the eye', and 'harmonious suggestion'. One thing these objects have in common is a juxtaposition of delicate, slender forms with a contrasting wideness, a bulbousness that seems almost luxurious. Instead of a smooth gradation between wide and narrow, there is a sharp change in breadth, accentuating each extreme. This serves to divide the objects into parts. For example, if we look at the two-handled cup (plate 10), the smooth bowl's relatively large surface area distinguishes it from the other parts; the handles and the part of the stem just below the bowl make a tripartite group of similar, more delicate forms; while the base is separate again, being more substantial than the upper part of the stem, and weighed down visually by a cluster of spheres. If we connect the areas linked by repeated motifs, we can see various visual patterns emerging. For example, if we draw a line between the spheres grouped at the top of the handles, mid-stem, and at the base, we describe the basic shape of the cup. On the other hand, the pattern made by the handles and the top part of the stem accentuates the cup's luxurious width, while the bowl emphasises the cup's depth by its curvaceous volume. The cup seems to be stretching out in all directions, as though the designer is playing with the simple 'cup' form, exploring its different components.

The other cup by Ashbee and the Guild places more emphasis on verticality. The bowl is once again visually separated from the other parts of the cup by its smoothness and roundness. While the base serves to

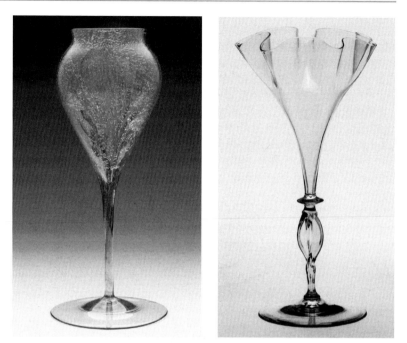

38 [*left*] James Powell & Sons, goblet, purchased from the Arts and Crafts exhibition, 1899. Pale green glass with blue trails and aventurine.
39 [*right*] James Powell & Sons, vase, purchased from the maker 1894 or 1899. Pale green glass with twisted stem and crimped bowl.

balance the breadth, depth and weight of the bowl to an extent, its shape complicates the cup's form. A seven-pointed base with defined corners is juxtaposed with a hemispherical bowl. This brings out different qualities of the metal, contrasting sharpness with curved smoothness. Going back to Crane, we can identify qualities that could be analogous to music; the repeated motifs like a theme in variations, and the juxtapositions creating harmonies. The overall impression is of different parts working together to produce a unified whole. This has potential political implications, of course, suggesting that each part, though different, plays a necessary role in creating harmony.

Next, we turn to William de Morgan's tazza (plate 7). This object displays the iridescent lustre effects that de Morgan had famously redis-

covered. Like the cups by Ashbee and the Guild and School of Handicraft, the tazza also divides visually into parts. From the top, the plate seems suspended in space, as the base is invisible. The functionality of the base compared with the plate is marked by its much simpler design. The floating impression is emphasised by the spreading, horizontal pattern on the plate, which is actually a shallow bowl, though the pattern's flattening effect makes this less apparent. The peacock design reaches out to the edges of the plate, each feather presented as if viewed straight on, minimising perspective and depth. While flatness makes us think of Greenbergian modernism, it had also been important to design reformers since the middle of the century.[96] Given that peacocks are a central motif of Aestheticism, de Morgan's tazza brings Arts and Crafts together with the Aesthetic movement and the mid-century design reformers.

When we examine the objects in this way, guided by Crane's theories of decorative art, the objects come across as experiments in the treatment of standard forms. The designers and makers seem to be exploring how these traditional shapes lend themselves to creative manipulation to produce visually engaging objects, and how the shapes can be exploited to best present the qualities of the material. For example, lustre shows itself best on curved surfaces, while corners and curves reflect light in different ways, and can bring out a variety of tones in apparently monochrome materials. We can see this tendency to embrace the qualities of the material as a development from Pugin. Crane too encouraged the acknowledgement of each material's individual characteristics, declaring that 'technical conditions and limitations' 'really form the instruments upon which [the designer] plays'.[97]

Turning to the 1903 catalogue, we find numerous, but imprecise, terms in which the modern objects in the collection are to be praised. We are told that these examples display 'invention, skill and personality'. Objects also apparently demonstrate 'delightful freshness of conception and reticence of treatment'.[98] Each of the catalogue's descriptive words carries an ambiguity as to how we might actually identify it in a given object. The same is largely true even of the information given about specific exhibits. For example, the Powell glass demonstrates 'beauty of form' and 'delicacy of detail' in 'a material which so soon responds to the impress of thought, action, and fertility of conception' (see figures 38 and 39).[99] The last of these comments is particularly revealing, as it can

be related to Crane's concept of a speech or language through which the artist can make a material convey what is in 'his eye and mind'.

These descriptions provide clues as to how the quality of a design was judged. 'Personality', for example, could be interpreted as something about an object that makes it stand out, be it the slight smile on the peacock's beak (on the de Morgan tazza), the feet on the Benson kettle stand, or, on Crane's ewer, the bird-shaped prows of the ships and the octopus-shaped handle (figure 33 and plates 7 and 8). We can understand 'freshness of conception' as the adoption of a new approach to traditional forms, as demonstrated by the Guild and School of Handicraft cups. There is something potentially liberating about this suggestion of looking at everyday objects with new eyes. Meanwhile, 'reticence of treatment' may mean the discipline of keeping colour limited in a complicated pattern, for example, or repeating several motifs rather than allowing endless variety. Reticence, of course, calls to mind the preoccupation with holding back discussed in Chapter 1, which was expressed in Pugin's terms as a 'self-denying Catholic principle', and in Ruskin's as 'Temperance'.[100]

This section has evoked ways in which contemporaries appear, according to the evidence, to have looked at these objects. Visitors to the museum were encouraged not only to consider the impact of the collection as a whole, but also to look carefully at each individual object in order to appreciate fully its potential meaning and expressiveness.

Conclusion

These findings have implications for our understanding of the status of the decorative object not only at the turn of the twentieth century but also more generally as a subject for art-historical study. In the context of a system geared towards design for industry, we encounter a process of looking at and valuing objects that we would associate more with fine art. This investigation also calls into question the helpfulness of labels such as the 'Arts and Crafts movement' to explain and summarise developments during this period. In this museum the history of Arts and Crafts, represented by Crane and by many of the objects displayed, meets the history of the government effort to improve the quality of British design through the Schools of Art. This is the case despite Pugin's and Ruskin's criticisms of the Schools of Art, which, like the Arts and Crafts Exhibition Society's

reluctance to embrace Ruskin wholeheartedly (see Chapter 4), challenges further the notion of a unified Arts and Crafts trajectory beginning with Pugin and Ruskin.[101]

Davis's article on the collection acknowledges that the relationship between the museum and the 'Arts and Crafts movement' is not a straightforward one. Davis observes that the industrial agenda of the School of Art did not fit very comfortably with the Arts and Crafts associations introduced by Crane and the objects acquired for the collection. He writes that these two contributions to the School's development

> had a distinctly Arts and Crafts orientation, and can, in retrospect, therefore be seen as a rather anti-industrial response to a problem that had been identified as inhibiting Britain's industrial performance. Indeed, it could be argued that both initiatives were also part of a separate, more localised agenda.[102]

Davis presents us with a more fragmented and disjointed 'Arts and Crafts' than many accounts leave room for. His account recognises that 'Arts and Crafts' overlaps with other tendencies and traditions. Davis identifies a problem we keep encountering. The Manchester Municipal School of Art is not the only Arts and Crafts context that manifests 'a separate, more localised agenda'. In each of the contexts discussed in this book, specific conditions contribute to a distinct 'agenda', and sometimes more than one, that cannot be comfortably accommodated by the concept of a unified 'Arts and Crafts movement'. Davis situates the problem in the mismatch of 'anti-industrial' and 'industrial' and in the specificity of Manchester's needs.[103] This book argues that it is the desire to frame these events and objects with the idea of a 'movement' that makes this a problem in the first place. When we look closely, there does not appear to be a context that does embody 'the Arts and Crafts movement' fully and unproblematically. In the absence of such a paradigm, the Manchester School's failure to fit the bill is only to be expected.

Davis draws a conclusion that implicitly points to the limitations of the 'movement' concept. It would be 'easy', he observes, 'to construct too simple a dichotomy between official orthodoxy on one hand, and Arts and Crafts radicalism, as represented by Crane, on the other'.[104] These two things are not directly opposed and, we have already seen, they are not eminently compatible. In other words, Arts and Crafts overlaps with other

tendencies in intricate and unavoidable ways. This is not only the case with the Manchester School but with all the contexts examined in the preceding chapters.

If we try to fit the museum of the Manchester Municipal School of Art into existing histories of this period, it becomes clear that the School's identity, in terms of its ideology and influences, is complex. On the one hand, its creation (as the Manchester School of Design) was the result of a government-led, countrywide initiative in the interests of improving national manufacture and trade. Yet this was not the sole cause of the School's existence. As we have seen, the establishment of a School of Design was promoted by influential members of Manchester society. While the School was intended to fulfil national objectives, therefore, the specific needs of Manchester also required attention. As Davis observes, the School served a 'localised' agenda.

The fact that the School's history consists in part of repeated conflicts between the School's staff and centralised authorities demonstrates that a simplified view of the School as limited by a narrow, bureaucratic system would not be appropriate. In the same way that the School's very existence emerged from multiple influences, its character in later years was also moulded by a variety of circumstances. Individual members of staff were responsible for guiding the School in a certain direction. Rowley in particular, as Chairman of the School of Art Committee, played an important part in initiating new projects. He was also instrumental in encouraging the School to support certain contemporary designers not only by purchasing their products, but also by engaging them to give occasional lectures. Under his leadership, the exemplary role models presented to the students included figures such as Day, Cobden-Sanderson, Lethaby and May Morris.[105]

Crane, as co-purchaser for the museum and as Director of the School of Art, likewise had influence over the School's development. His role was limited by the amount of time he was able to spare for Manchester, but his 1893 *Recommendations and Suggestions*, and his connections in the art world, contributed to the School's progress during this period. As well as sharing figures such as Crane and Cobden-Sanderson, the Arts and Crafts Exhibition Society and the Manchester School were connected in other ways. For example, to call the new wing the 'Arts and Crafts Museum' was to associate it with the ACES. On hearing this name, it is likely that

visitors, whether students, staff or members of the public, would already have in mind a connection between the museum and the Society. This impression would be confirmed by the fact that, under the influence of Rowley and Crane, the collection acquired a significant number of objects purchased at the Arts and Crafts exhibitions.

Yet the Manchester School's museum was far from being a mini-Arts and Crafts exhibition. We might argue that the contemporary objects purchased at the Arts and Crafts exhibitions were transferred from an environment in which they were subject to the powerful gaze of the potential purchaser to a context in which they exerted their autonomy as the focus of aesthetic contemplation. Alternatively, taking the more conventional line, we might see the Arts and Crafts exhibitions as situating objects in an ethically self-conscious and dominantly left-wing environment, while the Manchester museum endowed them with the capitalist, nationalist associations of the Government design campaign.

The museum at the Manchester Municipal School of Art cannot be simplistically summed up as either a wholly aesthetic or a wholly commercial space. Its contents were intended for close, disinterested examination based on aesthetic, not commercial, value, but the museum was indirectly linked to the world of commerce and consumption by the School's declared aim of training designers for industry, thus benefiting regional and national trade. In 1893, Rowley described the School in these terms, writing that 'if the right methods were devised, the large annual expenditure now made upon foreign designs for calico printing, wall papers, and textiles in general could be diverted and spent upon designs of native production, the work of designers trained in the Schools of Art'.[106]

While the students remained at the School, their highest aim was to acquire the ability to create quality designs, with the help of the good examples that the museum set before them; once they left the School, however, these efforts had to be seen in the context of their new goal, which was to achieve economic success in a commercial market. Rowley was aware of the realities facing students, explaining in his autobiography that 'the trained art student from our schools has to adapt himself to the demands of the market. If he does not, if he determines to do only his best as he knows it, he has a fearful struggle against the commercial giants of the time'.[107]

It is clear from the Report of the Proceedings of the TIC for the

year ending October 1900 that the School still broadly defined itself as belonging to the process of design improvement anticipated by the Select Committee inquiry of 1835. Included in this Report is a diagram illustrating 'the correlation of education in the city of Manchester', in which 'Studies for Industrial Life' are placed lower than 'Studies for Professional Life'. Both the Technical School and the School of Art belong to the former.[108]

In the history of the School, compromise emerges as a continuous theme. Ideals promoted by individuals were balanced by the official practical objectives of the School as a whole. Crane, in his autobiography, admits, 'I found it a little difficult to graft the kind of study I had found practically useful in my own work as a designer on to the rather cut and dried and wooden courses prescribed by the Department, or rather, to dovetail new methods with the existing curriculum.'[109] In 1895, *The Studio* had acknowledged this, observing that Crane's recommendations were 'adopted, not, indeed, as the dominant principles of the school system, but as materials for an alternative and complementary course worked in with the older arrangements, and fitted on to them as much as possible'.[110] The coexistence of these two methods is embodied, in a sense, by the museum. David Jeremiah attaches each course to a different section of the museum. In the Textile Court, he explains,

> textiles were complemented by ceramics, metal and stained glass, providing a centre for the comprehensive teaching of design, in contrast to the two cast courts, which perpetuated those traditions of academy drawing that had been sustained by the National drawing competitions.[111]

The compromise and internal conflict we find at the Manchester School of Art fit the model of Arts and Crafts that is emerging from this book. It has become clear that if we resist conceptualising certain individuals and institutions as distinct strands of history with separate, and internally unified, ideologies and motivations, the exchange and interrelation of ideas and concerns among those assigned to different groups may become more apparent. The conditions of the museum at the Manchester School grew out of circumstances both within and external to the Schools of Design system which converged at a particular time in a particular place. Similarly, these conditions have implications beyond that system which can be related to other events in the period. The history of the

museum at the Manchester Municipal School of Art involves interweaving networks of influence and collaboration in which the activities and hopes of a variety of groups and individuals have, for a time, been focused on the same, temporary, opportunity. Whatever trajectory or movement we choose to place it in, the museum requires us to take seriously the task of looking at Arts and Crafts objects.

Notes

1 See Local Studies and Archives, Manchester Central Library (hereafter MCL), 'Proceedings of the Technical Instruction Committee', Manchester, I–VII; MCL, 'Laws and Regulations of the School of Design, Manchester', 1839; MCL, 'Manchester School of Art, Reports &c.', 1837–58. See also All Saints' Library, Manchester Metropolitan University (hereafter MMU), Manchester School of Art archive, MSA/3/1/1/1, 'Museum Accession Register' (n. d.); MMU, Manchester School of Art archive, MSA/3/1/1/3/1, 'Museum Stock Register' (n. d.); MMU, Manchester School of Art archive, MSA/3/2/2/1/2, 'Municipal School of Art Museum Exhibits Ledger' (1911); MMU, Manchester School of Art archive, MSA/11/1/2/2/1–3, photographs of the School (*c.* 1900).

2 For more on the Arts and Crafts Museum at the Manchester Municipal School of Art, see John Davis, 'A Most Important and Necessary Thing', *Journal of the Decorative Arts Society: 1850 to the Present*, XVIII (1994) and Ruth Shrigley (ed.), *Inspired by Design: The Arts and Crafts Collection of the Manchester Metropolitan University*, exh. cat. (Manchester: Manchester City Art Galleries, 1994).

3 MCL, Royal Manchester Institution (RMI) Council minute book 1823–25, 'First Resolution of the First Meeting', 1 October 1823, p. 1. For more on the RMI, see Stuart Macdonald, 'The Royal Manchester Institution', in John H. G. Archer (ed.), *Art and Architecture in Victorian Manchester* (Manchester: Manchester University Press, 1985). For more on Haydon, see Benjamin Haydon, *The Life of Benjamin Robert Haydon, Historical Painter, His Autobiography and Journals*, ed. Tom Taylor, I (London: Longman, Brown, Green and Longmans, 1853).

4 For more on the Normal School of Design at Somerset House, see Macdonald, *History and Philosophy of Art Education*, pp. 73–8 and Bell, *Schools of Design*.

5 Haydon, *Life*, I, p. 16.

6 Bell, *Schools of Design*, p. 38.

7 Macdonald, 'The Royal Manchester Institution', in Archer (ed.), *Art and Architecture*, pp. 40–1.

8 *Manchester Guardian*, quoted in David Jeremiah, *A Hundred Years and More* (Manchester: Manchester Polytechnic, 1980), p. 4.

9 For more on Victorian collections of art in Manchester, see Elizabeth Conran, 'Art Collections', in Archer (ed.), *Art and Architecture*.

10 George Jackson, 'Essays on a School of Design for the Useful Arts', 2 October 1837 in MCL, 'Manchester School of Art, Reports &c.', p. 8.

11 MCL, 'Laws and Regulations of the School of Design, Manchester'.

12 For more on the Manchester School of Art, see Jeremiah, *A Hundred Years and More*; Jeremiah, *Object Lessons: A College Collection of Art and Design 1840–1980*, exh. cat. (Manchester: Manchester Polytechnic, 1982); and Alan Fowler and Terry Wyke, *Many Arts, Many Skills: The Origins of the Manchester Metropolitan University* (Manchester: Manchester Metropolitan University, 1993).

13 Macdonald, 'The Royal Manchester Institution', in Archer (ed.), *Art and Architecture*, p. 42.

14 See David Jeremiah, 'Lessons from Objects: A Museum of Art and Design', *Journal of Art and Design Education*, III: 2 (1984), p. 216.

15 Macdonald, 'The Royal Manchester Institution', in Archer (ed.), *Art and Architecture*, pp. 41–2.

16 Macdonald, 'The Royal Manchester Institution', in Archer (ed.), *Art and Architecture*, p. 41.

17 Macdonald, 'The Royal Manchester Institution', in Archer (ed.), *Art and Architecture*, p. 41 and Bell, *Schools of Design*, p. 111.

18 Macdonald, 'The Royal Manchester Institution', in Archer (ed.), *Art and Architecture*, p. 41, and *History and Philosophy of Art Education*, p. 86–7.

19 Quoted in Bell, *Schools of Design*, p. 112.

20 See Macdonald, 'The Royal Manchester Institution', in Archer (ed.), *Art and Architecture*, p. 41; Macdonald, *History and Philosophy of Art Education*, p. 88; and Bell, *Schools of Design*, pp. 113–20.

21 George Wallis, *A Farewell Letter to the Council, Subscribers, Friends and Students of the Manchester School of Design: Containing a Full Exposition of the Circumstances Leading to His Resignation*, 1 May 1846 (London and Manchester, 1846), p. 14. For more on Wallis's resignation, see Macdonald, *History and Philosophy of Art Education*, pp. 93–4.

22 Macdonald, 'The Royal Manchester Institution', in Archer (ed.), *Art and Architecture*, p. 42 and Bell, *Schools of Design*, p. 120.

23 George Jackson, quoted in Bell, *Schools of Design*, p. 121.

24 See Bell, *Schools of Design*, p. 121.

25 Wallis, *Schools of Art*, p. x.

26 Macdonald, 'The Royal Manchester Institution', in Archer (ed.), *Art and Architecture*, p. 42.

27 MCL, 'RMI Special Extension Committee Minutes', 16 February 1854.

28 Anon., 'A Visit to the Manchester School of Art', *Journal of Decorative Art* (December 1888), p. 183.

29 Anon., 'A Visit to the Manchester School of Art', p. 184.

30 For more on the National Course, see Macdonald, *History and Philosophy of Art Education*, pp. 188–92 and 388–91.

31 See Macdonald, *History and Philosophy of Art Education*, pp. 207–25.

32 See Arthur Redford and Ina Stafford Russell, *History of Local Government in Manchester*, III (London, New York and Toronto: Longmans and Co., 1940), p. 154.

33 Davis, 'A Most Important and Necessary Thing', p. 15.

34 For more on Crane at Manchester, see Spencer, *Walter Crane*, pp. 161–6 and Morna O'Neill, *'Art and Labour's Cause is One': Walter Crane and Manchester, 1880–1915* (Manchester: Whitworth Art Gallery, 2008).

35 For more on Rowley and Morris, see May Morris, *William Morris: Artist, Writer, Socialist*, pp. 184–5. For more on Rowley's politics, see Audrey Kay, 'Charles Rowley and the Ancoats Recreation Movement, 1876–1914', *Manchester Region History Review*, VII (1993).

36 In appointing Crane, Manchester 'set a good example in choosing for director of its Municipal School of Art a distinguished designer, and one practically acquainted with the technicalities of design' ('Art Notes', *Art Journal* (1893), p. 363).

37 Crane, *Recommendations and Suggestions for Adoption, either as Distinct from, or in Addition to, the Present System of Instruction in Art in the Manchester School of Art and Technical School, especially with Reference to the Study and Practice of Design*, dated March 1893, p. 14. Included in MCL, 'Proceedings of the Technical Instruction Committee, Manchester' (hereafter 'Proceedings of the TIC), II, 22 June 1893, p. 67.

38 MCL, 'Proceedings of the TIC', II, 18 January 1894, p. 140.

39 Middleton's argument corresponds to Orrinsmith's: 'The best art education is to be found in recourse to approved examples of decoration, and constant familiarity with fine qualities as to which there cannot be two opinions' (*Drawing Room*, p. 7).

40 MCL, 'Proceedings of the TIC', II, J. H. Middleton to Charles Rowley, 18 January 1894, pp. 140–1.

41 MCL, 'Proceedings of the TIC', II, 19 June 1894, p. 197.

42 MCL, 'Proceedings of the TIC', II, 19 July 1894, p. 198.

43 Jeremiah, *A Hundred Years and More*, p. 24.

44 MCL, 'Proceedings of the TIC', II, 8 July 1893, 'Notes' following Crane's *Recommendations*.

45 In contrast to the Manchester School, which actively sought British manufactures for its collection, the London School's early collection consisted mostly of items bought in Paris by William Dyce. This suggests that while in 1842, France was still the dominant provider of designed goods, by the 1890s Britain considered itself to have achieved 'superiority', in Rowley's words, in this field (Burton, *Vision and Accident*, p. 30.)

46 MCL, 'Proceedings of the TIC', II, 19 July 1894, p. 198. Textiles and fabrics were considered particularly appropriate for the task of linking 'the Art teaching of the School to the practical work of Calico Printing' (II, 20 September 1894, p. 225).

47 MCL, 'Proceedings of the TIC', III, 27 March 1895, p. 61.

48 MCL, 'Proceedings of the TIC', III, 20 June 1895, p. 89.

49 MCL, 'Proceedings of the TIC', III, 20 June 1895, p. 89.

50 MCL, 'Proceedings of the TIC', III, 'Report upon the Proposed Extension of the Municipal School of Art, Manchester, 1895', 15 August 1895, p. 122. See also V, 17 March 1898, p. 25.

51 MCL, 'Proceedings of the TIC', III, 15 August 1895, p. 122.

52 MCL, 'Proceedings of the TIC', III, 20 February 1896, p. 200.

53 MCL, 'Proceedings of the TIC', III, 20 February 1896, p. 200.

54 There seems to have been disagreement as to how far the South Kensington Museum should observe this kind of rule. The *Art Record* asks, 'Is nothing to be exhibited at the "S. K." that is not a perfect example of design and workmanship for students to study and emulate? Is everything of purely historic interest to be banished?' (10 August 1901, p. 395).

55 MCL, 'Proceedings of the TIC', III, 20 February 1896, p. 200.

56 MCL, 'Proceedings of the TIC', IV, 19 November 1896, p. 77.

57 MCL, 'Proceedings of the TIC', V, 20 January 1898, p. 3.

58 See *Manchester Guardian* (29 October 1898), p. 7 and *Manchester Courier* (29 October 1898), p. 9.

59 The Textile Court was 68 ft x 42 ft; the two corridors were 60 ft x 12 ft, and the two side Courts were 35 ft square (Manchester Municipal School of Art, *A Descriptive Catalogue of the Arts and Crafts Museum* (Manchester, 1903), p. 9).

60 Middleton had advised, in 1894, that 'copies are as good as the originals for teaching' (MCL, 'Proceedings of the TIC', II, 18 January 1894, p. 140).

61 Davis, 'A Most Important and Necessary Thing', p. 21. For more on art training, see Macdonald, *History and Philosophy of Art Education*. The London School also used casts and reproductions for teaching (Burton, *Vision and Accident*, pp. 20–1).

62 MMU, Manchester School of Art archive, MSA/3/2/2/1/2, 'Exhibits Ledger'.

63 MCL, 'Proceedings of the TIC', VI, p. 98, 'Report of Proceedings of the Technical Instruction Committee' (for the year ending October 1900), p. 24.

64 MCL, 'Proceedings of the TIC', VII, p. 164.

65 MCL, 'Proceedings of the TIC', VI, 17 May 1900, p. 39.

66 MCL, 'Proceedings of the TIC', VI, 18 October 1900, p. 90.

67 MCL, 'Proceedings of the TIC', VI, 18 October 1900, p. 90.

68 MCL, 'Proceedings of the TIC', VI, 21 June 1900, p. 51.

69 I am grateful to John Davis for drawing my attention to this catalogue.

70 John Davis, 'An Arts and Crafts Education', in Shrigley (ed.), *Inspired by Design*, p. 9.

71 See Manchester Municipal School of Art, *Descriptive Catalogue*, pp. 46–52 and 60–2.

72 For more on the history of relief, see Penelope Curtis (ed.), *Depth of Field: The Place of Relief in the Time of Donatello*, exh. cat. (Leeds: Henry Moore Institute, 2004).

73 Ruskin, 'Modern Manufacture and Design' (1859), *The Two Paths, Works*, XVI, p. 320.

74 Rowley, *Fifty Years' Work*, p. 73. Rowley's exclusion of 'pictures' may have had something to do with his friendship with Crane, who, as we saw in Chapter 4, was involved in opposing the Royal Academy and its bias towards painters.

75 See Manchester Municipal School of Art, *Descriptive Catalogue*, pp. 22–6. The Manchester School was not unique in displaying objects of this kind to its students. For instance, at the Birmingham School, Crawford observes, students were taught 'the elements of figure design' in 'a room hung with stained glass cartoons by William Morris and Ford Madox Brown' ('The Birmingham Setting', in Crawford (ed.), *By Hammer and Hand*, p. 28).

76 Manchester Municipal School of Art, *Descriptive Catalogue*, p. 22.

77 Manchester Municipal School of Art, *Descriptive Catalogue*, p. 22.

78 The Select Committee of Arts and Manufactures had acknowledged that Britain was a successful producer of 'the general manufacture' but identified weaknesses in the field of 'design' (House of Commons, Report, p. 391).

79 See Chapter 1, note 67.

80 Crane, 'The Work of Walter Crane', p. 32. Lethaby made a similar statement in a lecture delivered to the Birmingham Municipal School of Art in October 1901: 'Just as there is gesture language and speech language, so art, through the eye, like music, through the ear, signals, as it were, by a code of its own, ideas to the mind' (*Morris as Work-Master* (London & Birmingham, 1901), p. 17).

81 From his Addresses to the students of the RA, it seems that Leighton also perceived the arts in terms of a visual language (*Addresses Delivered to the Students of the Royal Academy* (London: Kegan Paul & Co., 1896), pp. 14–16).

82 See Davis, 'A Most Important and Necessary Thing', p. 17.

83 Walter Crane, *The Bases of Design* (London: George Bell & Sons, 1898), p. 3 (italics original).

84 Walter Crane, *Line and Form* (London: George Bell & Sons, 1900), pp. 21–3. For more on Crane's theorisation of art and language, see O'Neill, *Walter Crane*.

85 MCL, 'Proceedings of the TIC', III, 20 February 1896, p. 200.

86 Manchester Municipal School of Art, *Descriptive Catalogue*, p. 9.

87 For more on Crane and evolutionary theory, see O'Neill, *Walter Crane*.

88 Manchester Municipal School of Art, *Descriptive Catalogue*, p. 9.

89 The 'Chamber of Horrors' was a popular name for a corridor entitled 'Decorations on False Principles' in the Museum of Ornamental Art at Marlborough House, which opened in 1852 (see Burton, *Vision and Accident*, p. 32). See also Macdonald, *History and Philosophy of Art Education*, pp. 178–9 and Kriegel, *Grand Designs*, pp. 145–8 and 154. For a contemporary view, see Henry Morley, 'A House Full of Horrors', *Household Words*, IV: 141 (4 December 1852).

90 According to Manchester Municipal School of Art, *Descriptive Catalogue*, the casts in the Gothic Court were 'chiefly of Romanesque and early Gothic sculpture from representative French examples', but also included casts of 'two famous Celtic crosses, the Ruthwell cross from Dumfrieshire and the Irton cross from Cumberland' (pp. 46 and 50).

91 See, for example, MCL, 'Proceedings of the TIC', VI, p. 172.

92 Burton, 'The Uses of the South Kensington Art Collections', p. 80.

93 A photograph, probably dating from *c.* 1900, depicts students sketching from casts of Classical sculptures in what looks like a classroom. These casts do not appear to have been displayed in the museum. MMU, Manchester School of Art archive, MSA/11/1/2/2/3.

94 This kind of viewer-object relationship calls to mind George du Maurier's satirical *Punch* cartoons, in which Aesthetes aspire to 'live up to' their blue china. See Ormond, *George du Maurier*, p. 294.

95 Crane, 'The Work of Walter Crane', p. 31.

96 See Pugin, *True Principles*, p. 26 and *Journal of Design and Manufactures*, VI (September 1851 – February 1852), p. 137. See Clement Greenberg, 'Modernist Painting', in *Clement Greenberg: The Collected Essays and Criticism*, ed. J. O'Brian, IV (Chicago: University of Chicago Press, 1993).

97 Crane, 'The Work of Walter Crane', p. 31.

98 Manchester Municipal School of Art, *Descriptive Catalogue*, p. 32.

99 Manchester Municipal School of Art, *Descriptive Catalogue*, p. 54.

100 Pugin, *Contrasts*, p. iii and Ruskin, *Stones of Venice*, *Works*, XI, p. 6.

101 See Pugin's letter to J. R. Herbert from *The Builder* (2 August 1845); Bell, *Schools of Design*, Appendix II, pp. 267–8; and Ruskin, Preface, *Laws of Fésole*, *Works*, XV, p. 344.

102 Davis, 'A Most Important and Necessary Thing', p. 23.

103 For more on Victorian Manchester, see Archer (ed.), *Art and Architecture*; Asa Briggs, 'Manchester: Symbol of a New Age', in *Victorian Cities* (London: Odhams Press, 1963); Clare Hartwell, *Manchester* (New Haven and London: Yale University Press, 2002); and Gary S. Messinger, *Manchester in the Victorian Age* (Manchester: Manchester University Press, 1985).

104 Davis, 'A Most Important and Necessary Thing', p. 16.

105 MCL, 'Proceedings of the TIC', IV, 16 July 1896, pp. 20–1 and V, 19 January 1899, p. 121.

106 MCL, 'Proceedings of the TIC', II, 8 July 1893, 'Notes' following Crane's *Recommendations*.

107 Rowley, *Fifty Years' Work*, p. 76.

108 MCL, 'Proceedings of the TIC', VI, p. 98, 'Report of the Proceedings of the Technical Instruction Committee' (for the year ending October 1900), p. 9.

109 Crane, *An Artist's Reminiscences*, p. 417. Crane is here referring to the Department of Science and Art. For more on Crane's recommended curriculum, see Spencer, *Walter Crane*, pp. 162–5.

110 A. Lys Baldry, 'The Manchester School of Art', *The Studio*, V (1895), p. 109.

111 Jeremiah, 'Lessons from Objects', p. 221.

Conclusion: Arts and Crafts legacies

THE STORY OF ARTS and Crafts objects presented in this book draws to a close around the beginning of the twentieth century. This concluding chapter asks what happened next. It will be possible only to ask, not answer this question here, since the subject would fill at least another volume, but the chapter aims to highlight some of the directions that future research might take, and point to some of the broader implications of the argument put forward.

This book has been about objects – single objects, groups of objects and objects in interiors – and it has also been about ways of looking at objects. It has argued that the Arts and Crafts figures and organisations discussed developed highly sophisticated modes of analysing things conventionally assigned to the category 'decorative art'. These themes continue to be my primary concern here. By posing questions about Arts and Crafts legacies, this chapter aims to explore what happened to the ways of looking at decorative objects that the preceding chapters traced. It is important to spell this out in order to make it very clear that this chapter will not be making claims for the fate of an 'Arts and Crafts movement'.

Investigations of the continuing legacies of the 'Arts and Crafts movement' are, of course, abundant. The Introduction addressed some of these arguments; for example, it identified the limitations of a Pevsnerian approach that focuses on the perceived legacies of Arts and Crafts for continental modernism. Others will be examined here. Analysing retrospective accounts of an 'Arts and Crafts movement' helps us to see how concepts of a 'movement' were reinterpreted by and for different groups in the early twentieth century, generating tensions between the various concerns and priorities identified. Among these discussions we can find

clues as to the ways in which Arts and Crafts modes of looking shifted, and for what reasons.

This chapter examines three retrospective accounts of Arts and Crafts in the early twentieth century. These are A. R. Orage's 'Politics for Craftsman' (1907); Eric Gill's 'The Failure of the Arts and Crafts Movement' (1909); and C. R. Ashbee's 'The English Arts and Crafts Exhibition at the Royal Academy' (1916). The first two demonstrate that the explanations for the perceived 'failure' of the 'Arts and Crafts movement' are not necessarily applicable to the legacies of the Arts and Crafts contexts discussed in this book. The third helps us to understand why. It suggests that while neither the objects nor the modes of looking came to a sudden end, it may have been the case that what had been one story about engaging with decorative objects branched into several separate stories.

'The Arts and Crafts movement has failed almost entirely in one at least of its original objects', claims A. R. Orage.[1] He is referring to the movement's 'sociological objects'. Rather than achieving the political goals of its 'pioneers', the movement has lost its 'virtue'.[2] To leave us in no doubt of the movement's fate, Orage adds that 'The history of the Arts and Crafts during the last five or ten years is the record of a series of inept, hopelessly private, genteel and useless attempts to make and sell beautiful things in the face of a public demand for ugly things.'[3] By associating beauty and privacy with ineptitude, gentility and uselessness, Orage prefigures the anti-aesthetic and anti-domestic trends in twentieth-century culture that have been analysed and challenged by Prettejohn and Christopher Reed respectively.[4]

Published in 1907, Orage's dismissal of the 'last five or ten years' leaves very little room, if any, for a successful 'Arts and Crafts movement', since, as we have seen, the phrase was first coined only eleven years earlier in 1896 (see the Introduction). For its loss of virtue Orage blames the interaction of the 'Arts and Crafts movement' with the socialist movement:

> For on the one hand the Socialist movement may be said to have absorbed the political enthusiasm of the Arts and Crafts movement, and on the other hand the craftsmen were, as craftsmen, too much engrossed in their work not to be willing, after Morris's death, to resign the political propaganda, for which they felt themselves unfitted.

According to Orage, the two movements, though 'closely allied', have failed to work together, and have instead proved divisive.[5] The result, he claims, is a narrow socialist movement on the one side and the 'private, genteel and useless' activities referred to above on the other. Despite these criticisms, Orage does attribute success to one of the goals of the 'Arts and Crafts movement', observing approvingly that the 'traditions of handicraft have been revived'.[6] The legacies of this craft revival have been explored, most notably in Tanya Harrod's comprehensive survey.[7] While Orage, whose priority is socialist politics, shows some interest in 'craft', he seems less concerned with the 'Arts' in 'Arts and Crafts'. Another account of the 'failure' of the 'Arts and Crafts movement' helps us to understand why that might be.

'The Arts and Crafts movement is now more or less discredited.' So writes Eric Gill in 1909. The comment appears in the *Socialist Review* in an article entitled 'The Failure of the Arts and Crafts Movement'. Unlike Orage, Gill does not qualify his judgement of failure by identifying specific 'objects' that the 'movement' has failed to fulfil. Instead, only thirteen years after the idea of an 'Arts and Crafts movement' had been fully formed, it is already being labelled a complete 'failure'. Like Orage's, Gill's definition of the 'Arts and Crafts movement' is in many respects a familiar one. He names the usual names – Ruskin and Morris – and sees the Arts and Crafts Exhibition Society as the movement's representative institution. Summarising the movement's aims, he writes, 'It is a movement of revolt against the state of affairs wherein design and execution are two distinct departments of production, wherein the designer and craftsman, if he may be so-called, being more often a machine minder, are two separate persons.'[8] Gill attributes heavy responsibilities to this movement, arguing that 'Its object was to raise the conditions of ordinary workers and the quality of ordinary workmanship, and it has not even begun to do it.'[9] The reason for this failure, according to Gill, is 'too much art talk'.[10] 'The error', he explains, 'began in supposing it desirable to turn the workman into an artist. It is not.'[11] Gill adds that 'Art, in the simple sense in which craftsmen understand it, is nothing more nor less than the exuberance, the overflowing of good workmanship.'[12]

The problem that Gill identifies is a gap between design and execution, not one between art and design. It is not the unity of the arts that he is concerned with, or that he believes the 'Arts and Crafts movement' to

be concerned with, but the provision of conditions in which craftspeople can do good work in both design and execution. Gill's account dismisses many of the contexts discussed in this book. For example, the ACES is criticised because it resulted in 'a fashion for the "artistic"', which in Gill's terms renders it irrelevant to the cause.[13] Similarly, the Manchester School of Art would be written off as part of the 'Art School invasion', whose 'inadequacy' resulted in 'the manufacture of the mere designer'.[14] Even more importantly for the broader implications of this book, one of the key themes it has identified in Arts and Crafts contexts would be rejected by Gill. As the foregoing chapters have shown, Arts and Crafts contexts repeatedly display a sophisticated mode of attention to objects that, although conventionally categorised as 'decorative', are treated like 'fine art'. Since one of the goals of the ACES was to offer decorative artists the opportunity to have their products presented for the same kind of considered analysis given to fine art, it is unsurprising that Gill is unimpressed by the Society, in the light of his objection to 'too much art talk'. While the story of Arts and Crafts objects told in this book is not incompatible with politics, it does seem to be incompatible with Gill's definition of an 'Arts and Crafts movement'.

The position taken by Gill is an extreme one, which provides for a very narrow interpretation of Arts and Crafts. While some Arts and Crafts objects may have done, or been expected to do, the things that Gill demands from an 'Arts and Crafts movement', other objects had different functions, and were subjected to different expectations. If we look at the legacies of the sophisticated modes of looking and the complex relationships between parts and wholes that this book has identified in Arts and Crafts contexts, we may open up new ways to trace the continuing history of Arts and Crafts objects. Before going on to suggest some of the directions that this investigation might take, we will examine a third early twentieth-century account, which offers us a further insight into the role of 'art' in assessments of Arts and Crafts legacies.

Ashbee tells this third story of demise, this time directed explicitly at the Arts and Crafts Exhibition Society rather than a 'movement', in 1916. In a long, illustrated letter entitled 'The English Arts and Crafts Exhibition at the Royal Academy', published in the *American Magazine of Art* in 1917, Ashbee narrates a shift in priorities between the early years of the Society and the time of writing. He recalls how, 'twenty-five years ago', a

Royal Academician responded to Ashbee's claim that the ACES exhibitions should be held at the Royal Academy with the retort, 'My dear young man, you surely don't expect us artists to allow our galleries to be turned into a furniture shop?'[15] In relating this anecdote, Ashbee emphasises that a driving motivation at the Society's inception was competition with, and resentment towards, the Academy and the hierarchical system it represented, as Chapter 4 demonstrated. Now, in 1916, the Society is at last exhibiting at Burlington House, the site of the Royal Academy shows. The goal of appealing to 'the public eye' 'upon strictly artistic grounds in the same sense as the pictorial artist' appears to have been achieved.[16] One might, then, expect this to be a letter of triumph and celebration.

It is not. At the beginning of his letter, Ashbee observes that the exhibition arouses not only 'hope' but also 'uneasiness'.[17] One problem he identifies is that the Society is not perceived to be moving with the times; on the contrary, it seems, to some observers, to be stuck in the past. This concern, which emerged, as we saw in Chapter 4, at the turn of the century, has intensified by 1916. Ashbee cites a passage from the *Cambridge Magazine*, in which the fictitious 'Althea' writes, 'I really hoped that we had heard the last of the late Mr Morris; but, except for a wretched little corner devoted to Omega, and for some of the crockery and stuffs in the small room next to it, there's scarcely a thing that isn't an echo of the affectations of the eighties.'[18]

While Ashbee acknowledges the truth of this criticism, he has a second reason for doubting the exhibition's success, one that has much more serious implications for the Society's mission and future. The very premises on which the Society was founded, Ashbee claims, no longer represent the key objectives of decorative art. He spells out very clearly the change that has taken place since the 1880s: 'Our problem now is a new problem. It is not any longer a question of how we can best exhibit and "get before the public" in galleries and shows, our problem now is coordination and continuity within the industrial life that is crumbling to pieces all around us.'[19] Elsewhere in the letter, Ashbee clarifies that 'the war is the final expression' of this 'breakdown of industrial life'.[20]

Just at the point when the Royal Academy finally provides a forum for the Arts and Crafts exhibitions, when the potential of decorative art to be treated like fine art finally appears to be realised, that potential is dismissed as irrelevant to the cause. According to Ashbee, indeed, this

situation is well recognised by the exhibition's participants. W. T. Whitley explains in *The Studio* that the Society's president, Henry Wilson, had chosen to 'remodel' the galleries to create a complex interior setting in which to display the exhibits.[21] For Ashbee, this new format is symbolic of the new challenges facing the Society. 'There is no doubt', he writes, 'that the show at Burlington House carries within itself the protest of the artists against exhibition as a method of meeting the aesthetic need.' The message, Ashbee perceives, is that 'These Arts and Crafts are no longer to be frill work, and pastime for rich men and dilettantes, but a part of the structure of society … They are to be part of life.' Ashbee – together, he claims, with the exhibitors themselves – is calling for the retreat of Arts and Crafts objects from the gallery back into the world. This is not to say that Ashbee considers the exhibition's location to be, in this case, a misguided decision. On the contrary, he argues, 'One has a feeling that this real effort that is being made to determine the proper limitations of mechanism in modern life is rightly made in the sacred precincts of the Royal Academy.'[22] Ashbee's point seems to be that the exhibition itself, though effective, is not the ultimate goal, but that instead the role of Arts and Crafts objects in 'life' and 'the structure of society' is the prime concern.

Ashbee's account helps us to see why the achievements of the Arts and Crafts contexts explored in this book might have fragmented in the early twentieth century. Throughout the period discussed, it was assumed that persuading people to pay attention to decorative objects was the most desirable goal, for both political and aesthetic reasons. If people cared enough about the objects they were surrounded with in their daily lives, the argument went, they would care about the makers who communicated through those objects, and learn to appreciate high quality. The taste manuals, the interiors of Morris's homes, the marketing strategies at Morris & Co., the exhibitions of the ACES and the museum at the Manchester Municipal School of Art all presented models for spending time looking closely at decorative objects (and groups of objects), although often with very different motivations. With the establishment of the ACES, the exhibition format became the paradigm. People knew how to look at fine art, and if they could be encouraged to look at 'decorative' objects in the same way, they might come to value such objects as much as fine art.

Ashbee's view, in 1916, is that the question of how to produce goods in an industrialised society supersedes that of the status of decorative art

vis-à-vis fine art. At this point, the legacy of the Arts and Crafts contexts this book has discussed breaks into separate strands. A concern with production for industry heads off in one direction. A continued insistence on the importance of handicraft leads in another. The socialist movement, as Orage and Gill observe, finds new priorities outside the realm of art. These are familiar ways of tracing the legacy of Arts and Crafts.[23] The legacies of Arts and Crafts strategies for analysing decorative objects, however, remain unidentified. The remainder of this concluding chapter will suggest some directions for future research in this area.

Tanya Harrod's study of twentieth-century craft discusses how some of the techniques and philosophies of making championed in Arts and Crafts contexts were adopted in craft activities up to the 1980s. Harrod's case studies might be a good place to begin searching for signs of the survival of Arts and Crafts ways of looking. We might, for example, focus on the ways in which objects created through self-conscious handcraftsmanship have been exhibited, exploring whether the most common display strategies in twentieth-century craft circles allow for or even encourage the kinds of visual analysis promoted in Arts and Crafts contexts. We might also examine the ways in which viewers have been encouraged to perceive and interpret those objects, considering how far those methods are consistent with Arts and Crafts modes of looking.

A brief look at the evidence suggests that this approach might be successful. Bernard Leach, for example, writes in 1928 that 'In Tokio [sic] ... The pots were bought by people who looked, and were accustomed to looking, for the same essential qualities in handicraft as in so-called pure art.'[24] Similarly, Malcolm Haslam writes that William Staite Murray 'wanted his pottery to be seen and criticised in the context of modern painting and sculpture' and quotes Murray's description of 'potting as a fundamental abstract art'.[25] Another possible context for exploring the legacies of Arts and Crafts looking in craft circles might be the Exhibitions of Cotswold Art and Craftsmanship, which ran between 1935 and 1939.[26]

Yet these kinds of questions are not usually the first ones asked by scholars of craft contexts, and for good reasons. The very concept of 'craft' prioritises production over reception. Even *Pioneers of Modern Craft: Twelve Essays Profiling Key Figures in the History of Twentieth-Century Craft*, from which the Leach and Haslam quotations cited above are taken, emphasises production both implicitly, in its title and structure, and explicitly,

in its introduction.[27] The word 'craft' directs our attention to the processes through which an object has been made, leading us to focus on the maker rather than the viewer. Once we have defined our field of interest according to the kind of activity undertaken, it is not surprising that questions of perception, consumption and even interpretation may become secondary to questions of labour and performance. Whereas the literature on Arts and Crafts has also tended to emphasise production over consumption, this book has tried to redress the balance. Since, here, we are concerned with the reception of objects as well as their production, we may need to look beyond contexts defined by the concept of 'craft' to find the legacies of Arts and Crafts modes of looking.

As a model for exploring reception rather than production, we might look to Tillyard. The Introduction discussed Tillyard's argument that Arts and Crafts provided a vocabulary and an audience for the Post-Impressionist art that Roger Fry promoted in the 1910s. We return to this argument here to see how far this link between the reception of Arts and Crafts and the reception of modernism might help us to track the legacies of the Arts and Crafts modes of looking discussed in this book.

Having demonstrated that the demise of the 'Arts and Crafts movement' left a market ready to be tapped, Tillyard argues that it was this audience that would have responded to Fry's defence of Post-Impressionism. The second chapter of Tillyard's book is an insightful account of how Fry was able to invest Post-Impressionism with meaning and value for a British audience. Tillyard identifies a number of important parallels between the priorities of 'Arts and Crafts writers'[28] and the principles on which Fry based his admiration for the Post-Impressionists. Up to a point, then, Tillyard's argument seems relevant for investigating the legacy of Arts and Crafts ways of looking. It appears to be concerned precisely with the audience for Arts and Crafts objects, the audience that would have been taught, via the Arts and Crafts contexts discussed in this book, to look at objects as attentively as they would fine art.

On reading Tillyard's account, however, it very quickly becomes apparent that although she is writing about Arts and Crafts audiences, she is not primarily concerned with Arts and Crafts viewers. In line with the trend that perceives Arts and Crafts as a 'movement' of 'ideas' rather than objects,[29] Tillyard is interested in the reception of Arts and Crafts ideas rather than the reception of ways of looking at Arts and Crafts

objects. As a result, the parallels she identifies between Arts and Crafts and early English modernism include ideas such as 'the notion of purity' and the 'religiosity' apparent in each case, and the comparable 'tenor' of the writings produced.[30] In other words, Tillyard is arguing that Fry's promotion of modernism would have engaged audiences who had read Arts and Crafts texts. What she does not claim is that Fry would thus have tapped audiences familiar with looking at Arts and Crafts objects. According to Tillyard, audiences would have learned from the modernists that, for example, direct stone carving should be valued for its 'truth to materials', just like Arts and Crafts objects. They would not, however, have learned from the modernists how to look at carved stone sculptures, or not, at least, from the Arts-and-Crafts-inspired passages Tillyard quotes. Tillyard's powerful argument makes an important contribution to our understanding of early English modernism, and how it was marketed to British audiences. It leaves us still uncertain, however, as to the legacies of Arts and Crafts modes of looking.

This book has aimed to present a new perspective on Arts and Crafts objects and to highlight an important aspect of Arts and Crafts contexts that has hitherto been under-explored. The viewer's encounter with decorative objects became theorised in innovative ways in these contexts, particularly with regard to the relationship between parts and wholes. Audiences were encouraged to take into account an object's surroundings and to consider the collective impact of groups of objects. To an extent, Arts and Crafts contexts invited viewers to look at decorative art as if it were fine art, but the implications of Arts and Crafts conceptions of parts and wholes pointed in a direction very different to that taken by modernist fine art. As Michael Fried famously argued in 'Art and Object-hood' (1967), what distinguished modernism as art was that all the relevant relationships were to be found within the work itself, whereas in minimalism (which, for Fried, was modernism's opposite), 'nothing' within the viewer's 'field of vision' 'declares its irrelevance in any way'.[31] For Fried, this makes the minimalist work an 'object', whereas 'a work of art' is 'in some essential respect *not an object*'.[32] While modernist contexts would go on to isolate fine art works from all distractions, insisting that a work should in itself inspire 'conviction' regardless of any 'relation' it might have with its surroundings,[33] Arts and Crafts contexts brought interrelationships between objects to the foreground. Whether such an ambitious

and sophisticated exploration of the possibilities of an inclusive and unified, yet disparate, form of viewing has been attempted since, is for future studies of the legacies of Arts and Crafts looking to discover.

Notes

1 A. R. Orage, 'Politics for Craftsmen', *Contemporary Review*, XCI (June 1907), p. 782.

2 Orage, 'Politics for Craftsmen', p. 783.

3 Orage, 'Politics for Craftsmen', pp. 787–8.

4 See Prettejohn, *Beauty and Art* and Christopher Reed (ed.), *Not at Home: The Suppression of Domesticity in Modern Art and Architecture* (London: Thames and Hudson, 1996) and *Bloomsbury Rooms*.

5 Orage, 'Politics for Craftsmen', p. 783.

6 Orage, 'Politics for Craftsmen', p. 783. This was still a concern in 1919, when Lethaby wrote that the 'Situation has greatly changed' as 'We are not now pleading for an artistic preference for handwork; the question now is – and it must be considered soon, or the opportunity will have gone – shall the traditional handicrafts of the country pass and be forgotten; or shall we consciously preserve them as being necessary for our own preservation?' (p. 1). Lethaby adds that 'The very life of the State may be bound up with the survival of the crafts and the types of inventiveness and initiative they produce' (Arts and Crafts Exhibition Society, *Handicrafts and Reconstruction: Notes by Members of the Arts and Crafts Exhibition Society* (London, 1919), p. 3).

7 Tanya Harrod, *The Crafts in Britain in the Twentieth Century* (New Haven, Conn.: Bard Graduate Center/Yale University Press, 1999).

8 Eric Gill, 'The Failure of the Arts and Crafts Movement', *Socialist Review*, IV (September 1909 – February 1910), p. 289.

9 Gill, 'The Failure of the Arts and Crafts Movement', p. 297.

10 Gill, 'The Failure of the Arts and Crafts Movement', p. 299.

11 Gill, 'The Failure of the Arts and Crafts Movement', p. 298.

12 Gill, 'The Failure of the Arts and Crafts Movement', p. 300.

13 Gill, 'The Failure of the Arts and Crafts Movement', p. 297.

14 Gill, 'The Failure of the Arts and Crafts Movement', pp. 296–7.

15 C. R. Ashbee, 'The English Arts and Crafts Exhibition at the Royal Academy', dated December 1916, *American Magazine of Art*, VIII (February 1917), p. 137.

16 Crane, ACES Catalogue, 1888, p. 5.

17 Ashbee, 'The English Arts and Crafts Exhibition', p. 137.

18 Ashbee, 'The English Arts and Crafts Exhibition', p. 141.

19 Ashbee, 'The English Arts and Crafts Exhibition', p. 142.

20 Lethaby too issues a statement on the effect of the war on craft (in 1919), although his primary concern seems to be the potential loss of national skills (see note 6).

21 W. T. Whitley, 'Art and Crafts at the Royal Academy', *The Studio*, LXIX (1916), p. 70.

22 Ashbee, 'The English Arts and Crafts Exhibition', p. 137.

23 There are, of course, many other facets to the afterlife of Arts and Crafts contexts. For example, the emphasis upon authenticity had important implications for conservation (see Chris Miele (ed.), *From William Morris: Building Conservation and the Arts and Crafts Cult of Authenticity, 1877–1939* (New Haven and London: Yale University Press for the Paul Mellon Centre for Studies in British Art and the Yale Center for British Art, 2005), while the principle of ethical consumption can be seen as an ancestor of Fair Trade (see Rosalind P. Blakesley, *The Arts and Crafts Movement* (London and New York: Phaidon Press, 2006), p. 245).

24 Bernard Leach, 'A Potter's Outlook' (1928), cited in Oliver Watson, 'Bernard Leach: Rewriting a Life', in Margot Coatts (ed.), *Pioneers of Modern Craft: Twelve Essays Profiling Key Figures in the History of Twentieth-Century Craft* (Manchester: Manchester University Press, 1997), p. 26.

25 Malcolm Haslam, 'William Staite Murray', in Coatts (ed.), *Pioneers of Modern Craft*, pp. 48 and 58.

26 Annette Carruthers and Mary Greensted, *Good Citizen's Furniture: The Arts and Crafts Collection at Cheltenham* (Cheltenham: Cheltenham Art Gallery and Museums in association with Lund Humphries, 1994), pp. 41–2.

27 Coatts (ed.), *Pioneers of Modern Craft*, pp. xii–xvi.

28 Tillyard, *Impact of Modernism*, p. 47.

29 For example, see Cobden-Sanderson, *The Arts and Crafts Movement*, p. 29.

30 Tillyard, *Impact of Modernism*, pp. 48 and 52–60.

31 Fried, *Art and Objecthood*, p. 153.

32 Fried, *Art and Objecthood*, pp. 151–2 (italics original).

33 Fried, *Art and Objecthood*, pp. 165 and 155.

Select bibliography

Manuscripts and archival sources

All Saints' Library, Manchester Metropolitan University

'Municipal School of Art Museum Exhibits Ledger' (1911), MSA/3/2/2/1/2.
'Museum Accession Register' (n. d.), MSA/3/1/1/1.
'Museum Stock Register' (n. d.), MSA/3/1/1/3/1.
Photographs of the School (*c.* 1900), MSA/11/1/2/2/1–3.

Archive of Art and Design, London

Arts and Crafts Exhibition Society Papers, AAD 1 – 1980.

British Library, London

Cockerell Papers, Add. MS 52772.
George Wardle, manuscript history of Morris & Co., Add. MS 45350, Morris Papers, XIII.

Hammersmith and Fulham Archives and Local History Centre, London

Morris & Co. minute book, DD/235/1.

Local Studies and Archives, Manchester Central Library

'Laws and Regulations of the School of Design, Manchester', 1839.
'Manchester School of Art, Reports &c.', 1837–58.
'Odds and Ends by A's and B's', XLV (1899), manuscript magazine.
'Proceedings of the Technical Instruction Committee, Manchester', I–VII.
'RMI Council minute book', 1823–25.

National Art Library, London

Morris & Co., 'The Hammersmith Carpets', October 1882, 276.A Box 1; circular, *c.* 1882, London, 276.A Box 1; 'The Morris Exhibit at the Foreign Fair, Boston', 1883, 276.C Box 1.

George Warington Taylor, Philip Webb Correspondence, 86.SS.57.

Metford Warner, 'The Progress of Design in Paper Hangings', read at the Incorporated Institute of British Decorators, 10 January 1910, 86:HH:12.

William Morris Gallery, London

A. H. Mackmurdo, 'History of the Arts and Crafts Movement'.

Published sources

Alexander, Edward P., *Museum Masters: Their Museums and Their Influence* (Nashville, Tenn.: American Association for State and Local History, 1983).

Allen, Rob, 'Why William Morris Left His Joyous Gard', *Journal of the William Morris Society*, XIV: 3 (Winter 2001).

Anon., *Artistic Homes or How to Furnish with Taste* (London: Ward, Lock & Co., 1881).

Anon., 'Representative Men at Home: William Morris at Hammersmith', *Cassell's Saturday Journal* (18 October 1890).

Anon., 'The Poet as Printer: An Interview with Mr William Morris', *Pall Mall Gazette* (12 November 1891).

Anscombe, Isabelle, *A Woman's Touch: Women in Design from 1860 to the Present Day* (London: Virago Press, 1984).

Anscombe, Isabelle and Charlotte Gere, *Arts and Crafts in Britain and America* (London: Academy Editions, 1971).

Archer, John H. G. (ed.), *Art and Architecture in Victorian Manchester* (Manchester: Manchester University Press, 1985).

Arscott, Caroline, *William Morris and Edward Burne-Jones: Interlacings* (New Haven and London: Yale University Press, 2008).

Arts and Crafts Exhibition Society, Catalogues (London, 1888–1916).

Arts and Crafts Exhibition Society, *Arts and Crafts Essays by Members of the Arts and Crafts Exhibition Society*, 1893, with an Introduction by Peter Faulkner (Bristol: Thoemmes Press, 1996).

Arts and Crafts Exhibition Society, *Handicrafts and Reconstruction: Notes by Members of the Arts and Crafts Exhibition Society* (London, 1919).

Arts Council, *Morris & Co.: A Commemorative Centenary Exhibition* (London: Arts Council, 1961).

Ashbee, C. R., *The Manual of the Guild and School of Handicraft* (London: Cassell & Co., 1892).

Ashbee, C. R., *An Endeavour Towards the Teaching of John Ruskin and William Morris* (London: Edward Arnold, 1901).

Ashbee, C. R., 'The English Arts and Crafts Exhibition at the Royal Academy', dated December 1916, *American Magazine of Art*, VIII (February 1917).

Ashbee, Felicity, *Janet Ashbee: Love, Marriage, and the Arts and Crafts Movement* (Syracuse, N. Y.: Syracuse University Press and London: Eurospan, 2002).

Ashwin, Clive (ed.), *Art Education Documents and Policies 1768–1975* (London: Society for Research into Higher Education, 1975).

Aslin, Elizabeth, *The Aesthetic Movement: Prelude to Art Nouveau* (London: Elek, 1969).

Atterbury, P. and C. Wainwright (eds.), *Pugin: A Gothic Passion* (New Haven and London: Yale University Press in association with the Victoria and Albert Museum, 1994).

Attfield, Judy and Pat Kirkham (eds), *A View from the Interior: Feminism, Women and Design* (London: Women's Press, 1989).

Auerbach, Jeffrey A., *The Great Exhibition of 1851: A Nation on Display* (New Haven and London: Yale University Press, 1999).

Banham, Joanna and Jennifer Harris (eds), *William Morris and the Middle Ages* (Manchester: Manchester University Press, 1984).

Banham, Joanna, Sally MacDonald and Julia Porter, *Victorian Interior Design* (London: Cassell, 1991).

Barlow, Paul and Colin Trodd (eds), *Governing Cultures: Art Institutions in Victorian London* (Aldershot: Ashgate, 2000).

Beerbohm, Max, *Rossetti and His Circle*, 1922 (New Haven and London: Yale University Press, 1987).

Bell, Quentin, *The Schools of Design* (London: Routledge & Kegan Paul, 1963).

Bell Scott, William, *Autobiographical Notes of the Life of William Bell Scott*, ed. W. Minto (London: Osgood, McIlvaine & Co., 1892).

Blakesley, Rosalind P., *The Arts and Crafts Movement* (London and New York: Phaidon Press, 2006).

Blunt, Wilfrid Scawen, *My Diaries: Being a Personal Narrative of Events, 1888–1914* (London: Martin Secker, 1919).

Bollas, Christopher, *Being a Character: Psychoanalysis and Self-Experience* (New York: Hill & Wang, 1992).

Bourdieu, Pierre, *Distinction*, trans. Richard Nice (London: Routledge & Kegan Paul, 1979).

Briggs, Asa, *Victorian Cities* (London: Odhams Press, 1963).

Briggs, Asa, *Victorian Things* (London: Batsford, 1988).

Bryson, John (ed.), in association with Janet Camp Troxell, *Dante Gabriel Rossetti and Jane Morris: Their Correspondence* (Oxford: Clarendon Press, 1976).

Burne-Jones, Edward, *Burne-Jones Talking: His Conversations 1895–1898, Preserved by His Studio Assistant Thomas Rooke*, ed. Mary Lago (London: Murray, 1982).

Burne-Jones, Georgiana, *The Memorials of Edward Burne-Jones*, 2 vols (London: Macmillan & Co., 1904).

Burton, Anthony, *Vision and Accident: The Story of the Victoria and Albert Museum* (London: V&A Publications, 1999).

Burton, Anthony, 'The Uses of the South Kensington Art Collections', *Journal of the History of Collections*, XIV: 1 (2002).

Callen, Anthea, *Angel in the Studio: Women in the Arts and Crafts Movement, 1870–1914* (London: Astragal, 1979).

Carpenter, Edward, *Civilisation: Its Cause and Cure* (London: Swan Sonnenschein & Co., 1889).

Carpenter, Edward, *My Days and Dreams: Being Autobiographical Notes* (London: George Allen & Unwin, 1916).

Carruthers, Annette and Mary Greensted, *Good Citizen's Furniture: The Arts and Crafts Collection at Cheltenham* (Cheltenham: Cheltenham Art Gallery and Museums in association with Lund Humphries, 1994).

Carruthers, Annette and Frank Johnston, *The Guild of Handicraft 1888–1988*, exh. cat. (Cheltenham: Cheltenham Art Gallery and Museums, 1988).

Cartwright, Julia, 'William de Morgan: A Reminiscence', *Cornhill* (April 1917).

Catleugh, Jon, *William de Morgan Tiles* (London: Trefoil, 1983).

Coatts, Margot (ed.), *Pioneers of Modern Craft: Twelve Essays Profiling Key Figures in the History of Twentieth-Century Craft* (Manchester: Manchester University Press, 1997).

Cobden-Sanderson, T. J., *The Arts and Crafts Movement* (London: Hammersmith Publishing Society, 1905).

Cole, Henry, *Observations on the Expediency of Carrying out the Proposals of the Commissioners for the Exhibition of 1851, for the Promotion of the Institution of Science and Art at Kensington* (London, 1853).

Conway, Moncure, *Travels in South Kensington* (London: Trubner & Co., 1882).

Cooper, Nicholas, *The Opulent Eye: Late Victorian and Edwardian Taste in Interior*

Design, with photographic plates by H. Bedford Lemere (London: Arch Press, 1976).

Corbett, David Peters, *The World in Paint* (Manchester: Manchester University Press, 2004).

Crane, Walter, *Of the Decorative Illustration of Books Old and New* (London and New York: George Bell & Sons, 1896).

Crane, Walter, 'William Morris', *Scribner's Magazine*, XXII (July 1897).

Crane, Walter, *The Bases of Design* (London: George Bell & Sons, 1898).

Crane, Walter, 'The Work of Walter Crane', *Easter Art Annual*, extra number of the *Art Journal* (1898).

Crane, Walter, *Line and Form* (London: George Bell & Sons, 1900).

Crane, Walter, *An Artist's Reminiscences* (London: Methuen & Co., 1907).

Crawford, Alan, *C. R. Ashbee: Architect, Designer and Romantic Socialist* (New Haven and London: Yale University Press, 1985).

Crawford, Alan (ed.), *By Hammer and Hand: The Arts and Crafts Movement in Birmingham* (Birmingham: Birmingham Museums and Art Gallery, 1984).

Cumming, Elizabeth and Wendy Kaplan, *The Arts and Crafts Movement* (London: Thames & Hudson, 1991).

Curtis, Penelope (ed.), *Depth of Field: The Place of Relief in the Time of Donatello*, exh. cat. (Leeds: Henry Moore Institute, 2004).

Davis, John, 'A Most Important and Necessary Thing', *Journal of the Decorative Arts Society: 1850 to the Present*, XVIII (1994).

Day, Lewis Foreman, 'The Woman's Part in Domestic Decoration', *Magazine of Art* (1881).

Day, Lewis Foreman, *Every-day Art: Short Essays on the Arts Not Fine* (London: B. T. Batsford, 1882).

Day, Lewis Foreman, 'Decoration by Correspondence', *Art Journal* (1893).

Day, Lewis Foreman, 'The Art of William Morris', *Easter Art Annual*, extra number of the *Art Journal* (1899).

Design Council, *William Morris and Kelmscott* (London: Design Council, 1981).

Dresser, Christopher, *Principles of Decorative Design* (London: Cassell, Petter and Galpin, 1873).

Droth, Martina, 'The Statuette and the Role of the Ornamental in Late Nineteenth Century Sculpture' (PhD thesis, University of Reading, 2000).

Droth, Martina, 'The Ethics of Making: Craft and English Sculptural Aesthetics *c*. 1851–1900', *Journal of Design History*, XVII (2004).

Dufty, A. R., *Morris Embroideries: The Prototypes* (London: Society of Antiquaries of London, 1985).

Dufty, A. R., *Kelmscott: Exoticism and a Chair by Philip Webb*, reprinted from the

Antiquaries Journal, LXVI: 1 (London: Design Council, 1986).

Eastlake, Charles, *Hints on Household Taste* (London: Longmans, Green & Co., 1st edn, 1868; 2nd edn, 1869; 3rd edn, 1872; 4th edn, 1878, with a new Introduction by John Gloag (New York: Dover, 1969); 1st American edn, Boston: J. R. Osgood, 1872).

Edis, Robert, *Decoration and Furniture of Town Houses* (London: Kegan Paul & Co., 1881).

Edwards, Jason, *Alfred Gilbert's Aestheticism: Gilbert Amongst Whistler, Wilde, Leighton, Pater and Burne-Jones* (Aldershot: Ashgate, 2006).

Edwards, Jason and Imogen Hart (eds), *Rethinking the Interior, 1867–1896: Aestheticism and Arts and Crafts* (Aldershot: Ashgate, forthcoming).

Eisenman, Stephen F., 'Class Consciousness in the Design of William Morris', *Journal of William Morris Studies*, XV: 1 (Winter 2002).

Elliott, Bridget and Janice Helland (eds), *Women Artists and the Decorative Arts 1880–1935: The Gender of Ornament* (Aldershot: Ashgate, 2003).

Elliott, David, 'Burne-Jones and the Dissolution of Morris, Marshall, Faulkner & Co.', *Journal of the William Morris Society*, XIV: 3 (Winter 2001).

Evans, Wendy, Catherine Ross and Alex Werner, *Whitefriars Glass: James Powell and Sons of London* (London: Museum of London, 1995).

Fairclough, Oliver and Emmeline Leary, *Textiles by William Morris and Morris & Co. 1861–1940* (London: Thames and Hudson, 1981).

Faulkner, Peter, *Against the Age: An Introduction to William Morris* (London: Allen and Unwin, 1980).

Faulkner, Peter, 'Pevsner's Morris', *Journal of William Morris Studies*, XVII: 1 (Winter 2006).

Faulkner, Peter (ed.), *Jane Morris to Wilfrid Scawen Blunt: The Letters of Jane Morris to Wilfrid Scawen Blunt together with Extracts from Blunt's Diaries* (Exeter: University of Exeter, 1986).

Ferry, Emma, '"Decorators May be Compared to Doctors": An Analysis of Rhoda and Agnes Garrett's *Suggestions for House Decoration in Painting, Woodwork and Furniture* (1876)', *Journal of Design History*, XVI (2003).

Flestrin, Quinbus, 'Interview with William Morris', *Clarion* (19 November 1892).

Fletcher, Ian, 'Bedford Park: Aesthete's Elysium?' in Fletcher (ed.), *Romantic Mythologies* (London: Routledge & Kegan Paul, 1967).

Floud, Peter, 'William Morris as an Artist: A New View', *The Listener* (7 October 1954).

Floud, Peter, 'The Inconsistencies of William Morris', *The Listener* (14 October 1954).

Floud, Peter, 'Dating Morris Patterns', *Architectural Review*, CXXVI (July 1959).

Floud, Peter, 'The Wallpaper Designs of William Morris', *Penrose Annual*, LIV (1960).

Floud, Peter (ed.), *Catalogue of an Exhibition of Victorian and Edwardian Decorative Arts* (London: Victoria and Albert Museum, 1952).

Fowler, Alan and Terry Wyke, *Many Arts, Many Skills: The Origins of the Manchester Metropolitan University* (Manchester: Manchester Metropolitan University, 1993).

Frank, Isabelle (ed.), *The Theory of Decorative Art 1750–1940: An Anthology of European and American Writings* (New Haven and London: Yale University Press, 2000).

Fredeman, William (ed.), *The Correspondence of Dante Gabriel Rossetti, II The Formative Years 1835–1862* (Woodbridge: D. S. Brewer, 2002).

Freedman, Jonathan, *Professions of Taste: Henry James, British Aestheticism, and Commodity Culture* (Stanford, Calif.: Stanford University Press, 1990).

Fried, Michael, 'Art and Objecthood' (1967), reprinted in *Art and Objecthood: Essays and Reviews* (Chicago and London: University of Chicago Press, 1998).

Gagnier, Regenia, 'Production, Reproduction and Pleasure in Victorian Aesthetics and Economics', in Richard Dellamora (ed.), *Victorian Sexual Dissidence* (Chicago and London: University of Chicago Press, 1999).

Gaunt, William and M. D. E. Clayton-Stamm, *William de Morgan* (London: Studio Vista, 1971).

Gere, Charlotte, with Lesley Hoskins, *The House Beautiful: Oscar Wilde and the Aesthetic Interior* (London: Lund Humphries in association with Geffrye Museum, 2000).

Gill, Eric, 'The Failure of the Arts and Crafts Movement', *Socialist Review*, IV (September 1909 – February 1910).

Girouard, Mark, *'Sweetness and Light': The Queen Anne Movement 1860–1900* (Oxford: Clarendon Press, 1977).

Glasier, J. Bruce, *William Morris and the Early Days of the Socialist Movement*, 1921 (Bristol: Thoemmes, 1994).

Goodman, Judith, 'William de Morgan at Merton Abbey', *Journal of the William Morris Society*, XIII: 4 (Spring 2000).

Greenwood, Martin, *The Designs of William de Morgan* (Ilminster, Som.: Richard Dennis and William E. Wiltshire III, 1989).

Hamilton, Walter, *The Aesthetic Movement in England* (London: Reeves & Turner, 2nd edn, 1882).

Harrison, Martin, *Victorian Stained Glass* (London: Barrie and Jenkins, 1980).

Harrod, Tanya, *The Crafts in Britain in the Twentieth Century* (New Haven, Conn.: Bard Graduate Center/Yale University Press, 1999).

Hart, Imogen, Review of Elizabeth Prettejohn, *Beauty and Art*, *Visual Culture in Britain*, VIII: 1 (Summer 2007).

Hart, Imogen, '"The Arts and Crafts Movement": *The Century Guild Hobby Horse* (1884–94), *The Evergreen* (1895–7), and *The Acorn* (1905–6)', in Peter Brooker and Andrew Thacker (eds), *The Oxford Critical and Cultural History of Modernist Magazines*, I (Oxford: Oxford University Press, 2009).

Hartwell, Clare, *Manchester* (New Haven and London: Yale University Press, 2002).

Harvey, Charles and Jon Press, *William Morris: Design and Enterprise in Victorian England* (Manchester: Manchester University Press, 1991).

Hatt, Michael, 'Edward Carpenter and the Interior: Home and Homosexuality', paper given at Institute for English Studies, University of London, 'The Aesthetic Interior: Neo-Gothic, Aesthetic, Arts and Crafts', 28–9 October 2005.

Haweis, Mrs (Mary Eliza), *The Art of Decoration* (London: Chatto & Windus, 1881).

Haweis, Mrs (Mary Eliza), *The Art of Housekeeping: A Bridal Garland* (London: Sampson Low & Co., 1889).

Haydon, Benjamin, *The Life of Benjamin Robert Haydon, Historical Painter, His Autobiography and Journals*, ed. Tom Taylor, I (London: Longman, Brown, Green and Longmans, 1853).

Henderson, Philip, *William Morris: His Life, Work and Friends* (London: Thames and Hudson, 1967).

Hitchmough, Wendy, *The Arts and Crafts Home* (London: Pavilion, 2000).

House of Commons, Report from the Select Committee of Arts and Manufactures (London: House of Commons, 1835).

I. H. I., 'The Kelmscott Press: An Illustrated Interview with Mr William Morris', *Bookselling* (Christmas 1895).

Jeremiah, David, *A Hundred Years and More* (Manchester: Manchester Polytechnic, 1980).

Jeremiah, David, *Object Lessons: A College Collection of Art and Design 1840–1980*, exh. cat. (Manchester: Manchester Polytechnic, 1982).

Jeremiah, David, 'Lessons from Objects: A Museum of Art and Design', *Journal of Art and Design Education*, III: 2 (1984).

Jervis, Simon, *High Victorian Design* (Woodbridge, Suffolk: Boydell Press, 1983).

Johnson, R. V., *Aestheticism* (London: Methuen, 1969).

Jones, Owen, *The Grammar of Ornament* (London: Day, 1856).

Kay, Audrey, 'Charles Rowley and the Ancoats Recreation Movement, 1876–1914', *Manchester Region History Review*, VII (1993).

Kelvin, Norman (ed.), *The Collected Letters of William Morris* (Princeton and Guildford: Princeton University Press, I, 1984; II, 2 vols, 1987; III, 1996; and with Holly Harrison (asst. ed.), IV, 1996).

Kirk, Sheila, *Philip Webb: Pioneer of Arts and Crafts Architecture* (London: Wiley-Academy, 2005).

Kriegel, Lara, *Grand Designs: Labor, Empire, and the Museum in Victorian Culture* (Durham, N. C.: Duke University Press, 2007).

Lakeland Arts Trust, *The Ceramics of William de Morgan* (Bowness: Blackwell, 2002).

Lambourne, Lionel, *The Aesthetic Movement* (London: Phaidon, 1996).

Le Bourgeois, John Y., 'William Morris at St James's Palace: A Sequel', *Journal of the William Morris Society*, III: 1 (Spring 1974).

Leighton, Lord Frederic, *Addresses Delivered to the Students of the Royal Academy* (London: Kegan Paul & Co., 1896).

Lethaby, W. R., *Morris as Work-Master* (London and Birmingham, 1901).

Lethaby, W. R., *Philip Webb and His Work* (London: Oxford University Press, 1935).

Livingstone, Karen, '"Moot Points": Art, Industry and the Arts and Crafts Exhibition Society', paper given at the Victoria and Albert Museum, 'International Arts and Crafts' conference, 22–3 April 2005.

Livingstone, Karen and Linda Parry (eds), *International Arts and Crafts*, exh. cat. (London: Victoria and Albert Museum, 2005).

Loftie, Mrs, *The Dining Room* (London: Macmillan & Co., 1878).

Loftie, W. J., *A Plea for Art in the House* (London: Macmillan & Co., 1876).

Lucie-Smith, Edward, *The Story of Craft: The Craftsman's Role in Society* (Oxford: Phaidon, 1981).

Mabb, David, with essays by Caroline Arscott and Steve Edwards, *William Morris* (Manchester: Whitworth Art Gallery, 2004).

MacCarthy, Fiona, *The Simple Life: C. R. Ashbee in the Cotswolds* (London: Lund Humphries, 1981).

MacCarthy, Fiona, *William Morris: A Life for Our Time* (London: Faber and Faber, 1994).

Macdonald, Stuart, *The History and Philosophy of Art Education* (London: University of London Press, 1970).

Mackail, J. W., *The Life and Work of William Morris*, 1899, 2 vols (London: Longmans, Green & Co., 1901).

Manchester Municipal School of Art, *A Descriptive Catalogue of the Arts and Crafts Museum* (Manchester, 1903).

Marillier, H. C., *History of the Merton Abbey Tapestry Works Founded by William Morris* (London: Constable & Co., 1927).

Marsh, Jan, *Back to the Land: The Pastoral Impulse in England, from 1880 to 1914* (London: Quartet, 1982).

Marsh, Jan, *The Pre-Raphaelite Sisterhood* (London: Quartet, 1985).

Marsh, Jan, *Jane and May Morris: A Biographical Story 1839–1938* (London and New York: Pandora, 1986).

Marsh, Jan, *William Morris and Red House: A Collaboration between Architect and Owner* (London: National Trust, 2005).

Marsh, Jan and Pamela Gerrish Nunn, *Women Artists and the Pre-Raphaelite Movement* (London: Virago, 1989).

Massé, H. J. L. J., *The Art Workers' Guild 1884–1934* (Oxford, 1935).

Meier, Paul, *William Morris: The Marxist Dreamer*, trans. Frank Gubb with a Preface by Robin Page Arnot (Hassocks, Sussex: Harvester Press, 1978).

Merrill, Linda, *A Pot of Paint: Aesthetics on Trial in Whistler v. Ruskin* (Washington and London: Smithsonian Institution Press in association with the Freer Gallery of Art, 1992).

Merrill, Linda, *The Peacock Room: A Cultural Biography* (Washington, D. C.: Freer Gallery of Art and London: Yale University Press, 1998).

Messinger, Gary S., *Manchester in the Victorian Age* (Manchester: Manchester University Press, 1985).

Miele, Chris (ed.), *From William Morris: Building Conservation and the Arts and Crafts Cult of Authenticity, 1877–1939* (New Haven and London: Yale University Press for the Paul Mellon Centre for Studies in British Art and the Yale Center for British Art, 2005).

Mitchell, Charles, 'William Morris at St James' Palace', *Architectural Review*, CI (January 1947).

Moholy-Nagy, Laszlo, *The New Vision*, 1928, trans. Daphne M. Hoffman (New York: Wittenborn, Schultz, 4th revised edn, 1947).

Mordaunt Crook, J., *William Burges and the High Victorian Dream* (London: John Murray, 1981).

Morris & Company, Decorators, Ltd, *A Brief Sketch of the Morris Movement and of the Firm Founded by William Morris to Carry Out His Designs and the Industries Revived or Started by Him* (London: Morris & Co., 1911).

Morris, Barbara, 'William Morris', *The Handweaver and Craftsman*, XII: 2 (Spring 1961).

Morris, Barbara, 'William Morris: His Designs for Carpets and Tapestries', *The*

Handweaver and Craftsman, XII: 4 (Fall 1961).

Morris, Barbara, 'William Morris and the South Kensington Museum', *Victorian Poetry*, XIII: 3/4 (1975).

Morris, Barbara, *Inspiration for Design: The Influence of the Victoria and Albert Museum* (London: Victoria and Albert Museum, 1986).

Morris, May, *William Morris: Artist, Writer, Socialist*, 1936, II (New York: Russell, 1966).

Morris, May, *Introductions to the Collected Works of William Morris*, 1910–15 (New York: Oriole, 1973).

Morris, William, 'Gossip About an Old House on the Upper Thames', *The Quest* (November 1894).

Morris, William, *The Collected Works of William Morris, with Introductions by His Daughter May Morris*, 24 vols (London: Longmans, Green & Co., 1910–15).

Moyr Smith, J., *Ornamental Interiors: Ancient and Modern* (London: Crosby Lockwood & Co., 1887).

Muthesius, Hermann, *The English House*, 1904, ed. Dennis Sharp and trans. Janet Seligman, with a Preface by Julius Posener (London: BSP, 1987).

Myers, Richard and Hilary Myers, *William Morris Tiles: The Tile Designs of Morris and his Fellow Workers* (Shepton Beauchamp, Som.: Richard Dennis, 1996).

National Association for the Advancement of Art and its Application to Industry, *Transactions of the National Association for the Advancement of Art and its Application to Industry 1888–1891* (New York and London: Garland, 1979)

Naylor, Gillian, *The Arts and Crafts Movement: A Study of its Sources, Ideals and Influence on Design Theory* (London: Studio Vista, 1971).

Needham, Paul (ed.), *William Morris and the Art of the Book* (New York: Pierpont Morgan Library and London: Oxford University Press, 1976).

O'Neill, Morna, 'Rhetorics of Display: Arts and Crafts and Art Nouveau at the Turin Exhibition of 1902', *Journal of Design History*, XX (2007).

O'Neill, Morna, *'Art and Labour's Cause is One': Walter Crane and Manchester, 1880–1915* (Manchester: Whitworth Art Gallery, 2008)

O'Neill, Morna, 'Walter Crane: The Arts and Crafts, Painting, and Politics, 1870–1890', manuscript in preparation.

Orage, A. R., 'Politics for Craftsmen', *Contemporary Review*, XCI (June 1907).

Ormond, Leonée, *George du Maurier* (London: Routledge and Kegan Paul, 1969).

Ormond, Leonée and Richard Ormond, *Lord Leighton* (New Haven and London: Yale University Press for the Paul Mellon Centre for Studies in British Art, 1975).

Orrinsmith, Mrs (Lucy), *The Drawing Room* (London: Macmillan & Co., 1877).

Parry, Linda, *William Morris Textiles* (London: Weidenfeld and Nicolson, 1983).

Parry, Linda, *Textiles of the Arts and Crafts Movement* (London: Thames and Hudson, 1988).

Parry, Linda (ed.), *William Morris: Art and Kelmscott*, Occasional Papers of the Society of Antiquaries of London, No. 18 (Woodbridge: Boydell and Brewer, 1996).

Parry, Linda (ed.), *William Morris*, exh. cat. (London: Philip Wilson in association with the Victoria and Albert Museum, 1996).

Pater, Walter, *The Renaissance: Studies in Art and Poetry*, 1873 (Oxford: Oxford University Press, 1986).

Pater, Walter, 'The School of Giorgione', reprinted from *Fortnightly Review* (October 1877), London, National Art Library, ref. Box 4, 40. F.

Pearson, Hesketh, *The Life of Oscar Wilde* (London: Methuen, 1946).

Peterson, William S., *The Kelmscott Press: A History of William Morris's Typographical Adventures* (Berkeley: University of California Press, 1991).

Peterson, William S. (ed.), *The Ideal Book: Essays and Lectures on the Arts of the Book by William Morris* (Berkeley and London: University of California Press, 1982).

Pevsner, Nikolaus, *Academies of Art, Past and Present* (Cambridge: Cambridge University Press, 1940).

Pevsner, Nikolaus, *High Victorian Design: A Study of the Exhibits of 1851* (London: Architectural Press, 1951).

Pevsner, Nikolaus, *Pioneers of Modern Design: From William Morris to Walter Gropius* (Harmondsworth, Middx: Penguin, 1960).

Pevsner, Nikolaus, *Sources of Modern Architecture and Design*, 1968 (London: Thames and Hudson, 1985).

Pinkney, Tony (ed.), *We met Morris: Interviews with William Morris, 1885–96* (Reading: Spire Books, 2005).

Pollock, Griselda, *Vision and Difference: Feminism, Femininity and the Histories of Art* (London: Routledge, 1988).

Post, Lucia van der, *William Morris and Morris & Co.* (London: V&A Publications in association with Arthur Sanderson & Sons, 2003).

Prettejohn, Elizabeth, *Beauty and Art, 1750–2000* (Oxford: Oxford University Press, 2005).

Prettejohn, Elizabeth, *Art for Art's Sake: Aestheticism in Victorian Painting* (New Haven and London: Yale University Press for the Paul Mellon Centre for Studies in British Art, 2007).

Prettejohn, Elizabeth (ed.), *After the Pre-Raphaelites: Art and Aestheticism in Victorian England* (Manchester: Manchester University Press, 1999).

Proctor, Helen, *The Holy Grail Tapestries Designed by Edward Burne-Jones, William Morris and John Henry Dearle for Morris & Co.* (Birmingham: Birmingham Museums and Art Gallery, 1997).

Pugin, A. W. N., *Contrasts: Or, A Parallel between the Noble Edifices of the Middle Ages, and Corresponding Buildings of the Present Day; Showing the Present Decay of Taste* (London, 1st edn, 1836 and 2nd edn, 1841 (Reading: Spire, 2003)).

Pugin, A. W. N., *The True Principles of Pointed or Christian Architecture*, 1841 (Leominster: Gracewing, 2003).

Purbrick, Louise (ed.), *The Great Exhibition of 1851: New Interdisciplinary Essays* (Manchester: Manchester University Press, 2001).

Redford, Arthur and Ina Stafford Russell, *History of Local Government in Manchester*, III (London, New York and Toronto: Longmans and Co., 1940).

Redgrave, Richard, *On the Necessity of Principles in Teaching Design* (London, 1853).

Reed, Christopher, *Bloomsbury Rooms: Modernism, Subculture, and Domesticity* (New Haven and London: Bard Graduate Center/Yale University Press, 2004).

Reed, Christopher (ed.), *Not at Home: The Suppression of Domesticity in Modern Art and Architecture* (London: Thames and Hudson, 1996).

Rodgers, David, *William Morris at Home* (London: Ebury Press, 1996).

Rosen, Charles and Henri Zerner, *Romanticism and Realism: The Mythology of Nineteenth Century Art* (London: Faber, 1984).

Rowley, Charles, *Fifty Years' Work Without Wages* (London: Hodder & Stoughton, 1912).

Royal Academy of Arts, *The Exhibition of the Royal Academy of Arts*, catalogues (London: Royal Academy, 1885–93).

Ruskin, John, *The Works of John Ruskin*, ed. E. T. Cook and Alexander Wedderburn, 39 vols (Cambridge: Cambridge University Press, 1996).

Salmon, Nicholas and David Taylor, 'Morris & Co. in Manchester', *Journal of the William Morris Society*, XII: 3 (Autumn 1997).

Saxby, David, *William Morris at Merton* (London: Museum of London Archaeology Service and London Borough of Merton, 1995).

Schaffer, Talia and Kathy Psomiades (eds), *Women and British Aestheticism* (Charlottesville and London: University Press of Virginia, 1999).

Schwartz, Sheila (ed.), *From Architecture to Object: Masterworks of the American*

Arts and Crafts Movement (New York: Dutton Studio Books in association with Hirschl and Adler Galleries, 1989).

Shaw, George Bernard, *William Morris as I Knew Him* (New York: Dodd, Mead & Co., 1936).

Shrigley, Ruth (ed.), *Inspired by Design: The Arts and Crafts Collection of the Manchester Metropolitan University*, exh. cat. (Manchester: Manchester City Art Galleries, 1994).

Smith, Greg and Sarah Hyde, *Walter Crane: Artist, Designer and Socialist* (London: Lund Humphries in association with the Whitworth Art Gallery, University of Manchester, 1989).

Society of Antiquaries of London, *Kelmscott Manor: An Illustrated Guide* (London: Society of Antiquaries of London, 1999).

Sparke, Penny, *Design in Context* (London: Bloomsbury, 1987).

Sparling, Henry Halliday, *The Kelmscott Press and William Morris Master-Craftsman* (London: Macmillan & Co., 1924).Spencer, Isobel, *Walter Crane* (London: Studio Vista, 1975).

Spencer, Robin, *The Aesthetic Movement: Theory and Practice* (London: Studio Vista, 1972).

Stansky, Peter, *Redesigning the World: William Morris, the 1880s and the Arts and Crafts* (Princeton, N. J.: Princeton University Press, 1985).

Stephens, F. G., 'Applied Art at the International Exhibition', *Weldon's Register* (November 1862).

Stirling, Anna, *William de Morgan and His Wife* (London: Thornton Butterworth Ltd, 1922).

Sutton, George, *Artisan or Artist? A History of the Teaching of Arts and Crafts in English Schools* (Oxford: Pergamon Press, 1967).

Swanwick, Helena M. Sickert, *I Have Been Young* (London: Gollancz, 1935).

Temple, Ruth Z., 'Truth in Labelling: Pre-Raphaelitism, Aestheticism, Decadence, Fin de Siècle', *English Literature in Transition*, XVII: 4 (1974).

Thompson, E. P., *William Morris: Romantic to Revolutionary* (London: Merlin Press, revised edn, 1977).

Thompson, Paul, *The Work of William Morris* (London: Quartet, revised edn, 1977).

Tillyard, S. K., *The Impact of Modernism 1900–1920: Early Modernism and the Arts and Crafts Movement in Edwardian England* (London: Routledge, 1988).

Todd, Pamela, *Pre-Raphaelites at Home* (New York: Watson-Guptill Publications, 2001).

Triggs, Oscar Lovell, *Chapters in the History of the Arts and Crafts Movement* (Chicago: Bohemia Guild of the Industrial Art League, 1902).

Troy, Nancy J., *Modernism and the Decorative Arts in France: Art Nouveau to Le Corbusier* (New Haven and London: Yale University Press, 1991).

Tschudi Madsen, Stephan, *Sources of Art Nouveau*, trans. Ragnar Christophersen (Oslo: H. Aschehoug & Co., 1956).

Upton, Dell, 'Pattern Books and Professionalism: Aspects of the Transformation of Domestic Architecture in America, 1800–1860', *Winterthur Portfolio*, XIX: 2/3 (Summer-Autumn, 1984).

Vallance, Aymer, 'The Revival of Tapestry-weaving: An Interview with William Morris', *The Studio*, III (1894).

Vallance, Aymer, *The Life and Work of William Morris*, 1897 (London: Studio Editions, 1995).

Vallance, Aymer, 'The Decorative Art of Sir Edward Burne-Jones', *Easter Art Annual*, extra number of the *Art Journal* (1900).

Wainwright, Clive, 'Principles True and False: Pugin and the Foundation of the Museum of Manufactures', *Burlington Magazine*, CXXXVI: 1095 (June 1994).

Wainwright, Clive, 'The Making of the South Kensington Museum', part I, ed. Charlotte Gere, *Journal of the History of Collections*, XIV: 1 (2002).

Wallis, George, *A Farewell Letter to the Council, Subscribers, Friends and Students of the Manchester School of Design: Containing a Full Exposition of the Circumstances Leading to His Resignation* (London and Manchester, 1846).

Wallis, George, *Schools of Art: Their Constitution and Management* (London: Simpkin, Marshall, and Co.; Birmingham: B. Hall, 1857).

Wallis, George, *British Art: Pictorial, Decorative and Industrial. A Fifty Years' Retrospect 1832–1882* (London: Chapman & Hall; Nottingham: Thos. Foreman & Sons, 1882).

Watkinson, Ray, *William Morris as Designer* (London: Studio Vista, 1967).

Weekley, Montague, *William Morris* (London: Duckworth, 1934).

Whitley, W. T., 'Art and Crafts at the Royal Academy', *The Studio*, LXIX (1916).

Wilde, Oscar, *Essays and Lectures* (New York and London: Garland, 1978).

Williams, Raymond, *Culture and Society: Coleridge to Orwell*, 1958 (London: Hogarth, 1987).

Wornum, Ralph, 'The Exhibition as a Lesson in Taste', *Art Journal: Illustrated Catalogue of the Exhibition* (1851).

Index

Page numbers in *italic* refer to illustrations.
Colour plates are listed after page numbers and are referred to as *'plate 1'* etc.